The Practice of Public Art

Routledge Research in Cultural and Media Studies

The Practice of Public Art

Edited by Cameron Cartiere
and Shelly Willis

 Routledge
Taylor & Francis Group
New York London

First published 2008
by Routledge
270 Madison Ave, New York, NY 10016

Simultaneously published in the UK
by Routledge
2 Park Square, Milton Park, Abingdon, Oxon OX14 4RN

Routledge is an imprint of the Taylor & Francis Group, an informa business

Typeset in Sabon by IBT Global.
Printed and bound in the United States of America on acid-free paper by IBT Global.

Library of Congress Cataloging in Publication Data

The practice of public art / edited by Cameron Cartiere and Shelly Willis.
 p. cm. — (Routledge research in cultural and media studies ; 14)
 Includes bibliographical references and index.
 ISBN 978-0-415-96292-6
 1. Public art. I. Cartiere, Cameron. II. Willis, Shelly.
 N8725.P684 2008
 707.9—dc22
 2007049697

ISBN10: 0-415-96292-7 (hbk)
ISBN10: 0-203-92667-6 (ebk)

ISBN13: 978-0-415-96292-6 (hbk)
ISBN13: 978-0-203-92667-3 (ebk)

Contents

PART II
Into Practice

PART III
Mapping the Lineage

List of Illustrations

TIMELINE FIGURES

Acknowledgments

Like many anthologies, this one has had a long and laborious birth. We would like to thank all of the authors who contributed—not only their work, but also their enthusiasm and unwavering support for the project. We would particularly like to acknowledge and thank our research assistant Rosemary Shirley for her excellent work, and our indexer Noeline Bridge. Thank you to our editor Erica Wetter, editorial assistant Elizabeth Levine, and Max Novick.

And our appreciation goes out to Susan Lawson, Charlotte Humphrey, and I.B. Tauris for graciously allowing us to reprint the essay by Jane Rendell.

The development of the timelines was greatly supported by reviews and suggestions from individuals in both the USA and the UK, including Jack Becker, Public Art Review; Barbara Goldstein, San Jose Public Art Program; Jeremy Hunt, Art & Architecture Journal; Jonathan Banks, IXIA; Vivian Lovell, Modus Operandi; Louise Trodden, Art in the Open; David Harding, Kristine Miller, Maggie Henton, Pallas Lombardi, and B+B.

We would like to give special thanks to Laurence Campling, Nicolas Kojey-Strauss, Rhoda London, Matt Peiken, Janet Zweig, the Sonoma Community Center, and Birkbeck, University of London.

Introduction

Cameron Cartiere and Shelly Willis

When did *public art* become akin to a dirty word?

Despite the myriad social and cultural contributions of public art, it has never gained credibility as a fine art discipline. There seems to be an unspoken consensus in the fine art establishment that public art is synonymous with compromise, dilution, and dependency. In the forty years since *public art* was coined as a term it hasn't yet surfaced in the index of Abrams' *History of Art*. Yet public art is an expanding practice that continues to incorporate every medium and discipline from painting to new media, sculpture to design, architecture to performance. With the evolution of the field comes an acknowledgement of the complexity of the practice—public art is still lost between the commercial art market and public institutions. It is time to reexamine public art as a contemporary fine art practice and as a significant contributor to art history.

While artists may readily accept a public art commission, in general they appear resistant to being identified as a public artist. This is evidenced by artists, critics, and academics in art journals and books referring to work made in the public realm in terms of interventions, socially engaged practice, political activism, service art, site-specific works, community-produced projects, spatial practice, interdisciplinary activism, contextual practice, and social practice art—as anything but public art. Only public art administrators and officials seem willing to use the term *public art* to describe municipal, county, and state government programs.

Public art is in our daily lives, and millions of dollars are spent commissioning public works. According to the latest survey (2001) by Americans for the Arts, there were 350 public art programs.[1] In the United Kingdom, Arts Council England incorporates nine regional offices, many of which have art officers who are charged with public art programming. In addition, dozens of cities and townships across the United Kingdom have local public art councils. It is estimated that by the close of 2021, the ACE Lottery Scheme, a national program which funds cultural programs, will have spent £1 billion (the equivalent of $2 billion) on public art projects over twenty-six years.[2]

So why is public art still marginalized by the fine art community? Lack of public art criticism, education, evaluation, and confusion about the definition of public art are all contributing factors. Despite the proliferation of programs and funding for public art, there is still a disconnection between the work produced and critical analysis. Newspaper art critics and feature writers seem to limit their coverage of public art to summer features or color commentary. Unless public art creates some kind of controversy it is seldom addressed by the general press. Today there are only two publications that are devoted solely to public art, *Public Art Review* in the United States and *Public Art Forum* in the United Kingdom. For many in academia, the discourse and history of public art is frozen at the base of Richard Serra's *Tilted Arc*. Those critics and art historians that do venture beyond the controversy of public art have historically limited their critique of public art to its relationship with site and architecture.

In 1995 the book *Mapping the Terrain* championed the need for a different form of criticism for public art, whose core was a socially engaged practice. This mode of public artwork became identified as *new genre public art*.[3] Since *Mapping the Terrain*, there have been several anthologies that have examined varying aspects of new genre public art including art activism, performance, and site-specificity. Yet somewhere in our enthusiasm to explore the "new" we have left uncharted vast territories in the discourse on permanent public art works.

Artists are commissioned to make public art, but then must practice in public. Unlike studio artists who can hone their skills within the safety of art schools and their own private studios, most public artists must learn from their mistakes with an audience watching every step of the way. There are very few educational institutions teaching the practice. There are only two degree programs in the United States that focus on public art.[4] In the United Kingdom the only undergraduate and graduate degrees offered in public art were available from the Chelsea College of Art & Design. However, the program is currently being restructured and reduced to a handful of classes that have been absorbed into the general arts curriculum of the institution.

Limited evaluation of artworks, commissioning processes, and programs are also contributing factors to the marginalization of public art. Public art advocates claim that public art contributes to the ongoing desire to identify who we are, beautifies, contributes to social change, shocks, excites, challenges social conventions, has meaning, educates, inspires, celebrates and remembers, draws us together, envisions new paradigms and crosses disciplines, and is a catalyst for change. But there is little research to draw upon to understand *how* public art accomplishes all of these things. Traditional art institutions have entire curatorial and education departments that deal with program evaluation. Percent-for-Art programs are rarely required to evaluate the public art that is produced with public money. Lack of evaluation limits a public art practitioner's ability to substantiate the value of public art to our society.

Ownership and funding issues also contribute to the confusion of public art's place within fine art. Some "public" artworks are funded by private institutions or individuals and located on public property. Access to public art can also be limited. Art in airports can only be accessed if you have a boarding pass. Art in corporate plazas can be limited to areas accessible only by employees and select visitors with permission from the owner. However, regardless of the limitations on physical access or how public art is ultimately paid for, these projects are still perceived by the public as existing in the public domain.

As the editors of this anthology, we believe that the lack of a discernible definition for public art is a major barrier to understanding public art's position within the fine art field. But developing such a definition proved to be a formidable challenge. Even with a combined forty years of experience in the field we debated the possibilities for days. We grappled with issues of funding, location, interest, and intention. In the end, we realized that the terminology needed to be as flexible as the medium itself. The resulting layered definition we developed, found in the essay "Coming in from the Cold: A Public Art History", was tested against a vast range of contemporary public art examples such as temporary works, performance, functional art, community engagement, new media, and permanent sculpture. In the end we agreed that while we could encompass the range of current practice, new developments within the field could render it obsolete within years. However, the critical contribution of this definition is to mark this particular moment in art history, to acknowledge the breadth of practice, and to provide a recognizable foundation for the continual evolution of public art.

Public art in the United Kingdom and the United States has a shared history, and this book brings together a collection of essays by practicing artists, curators, activists, art writers, administrators, landscape architects, and educators that places the practice of public art firmly back into fine art and educational discourse. The essays examine the continual evolution of public art, from contemporary monuments, memorials, and permanently sited works through the expanded forms of socially engaged public art practice and temporary public art projects. Theory and practice are given equal consideration. Writers explore the challenges of public art versus public design, the pedagogy of public art practice, and the art commissioning process, and unravel the relationships between public artists and the communities they serve.

Writings within this book examine two of the only degree-awarding programs for artists in public art education in the United States and the United Kingdom: "Toward a Celebratory and Liberating System of Teaching Public Art" considers the University of Monterey's public art program, which was founded on the principals of new genre public art, whereas the essay "A Fine Public Art & Design Education" tells the story of the Chelsea College of Art & Design's program, which had its roots in the trade school tradition.

Public art practice is unraveled through artist interviews and essays such as "In the Storms of the World" and "As Rich as Getting Lost in Venice," which highlight the long careers of established public artists. The interconnection between politics, culture and public art is investigated in the essay "The Millennium Park Effect," and "Reinventing the System" looks in depth at the process of commissioning artists through a major commission that "failed." The relationship between memorials, memories, and intentionality is addressed in the essay "Critical Spaces—Monuments and Changes," and Suzanne Lacy revisits new genre public art after more than a decade.

One of the challenges of developing this anthology was creating public art historical timelines for the United Kingdom and the United States. The timeline is specifically limited to the United States and the United Kingdom because of the unique developments in policy and funding that form the foundation of the shared history between these two countries. The timelines begin at the end of the nineteenth century, but are primarily focused on the twentieth and twenty-first centuries.

Through this anthology, we want to claim the history of public art. We expect contradictions and hope to inspire debate. We want to offer solutions to be challenged and tested out in the trenches. The work that falls within the category of public art should not remain disenfranchised, but recognized as a valid voice in the canon of contemporary art.

NOTES

1. The average annual budget for these programs is $780,000. The average public art budget in the United States nearly doubled between 1998 and 2001—increasing an average of 23.5 percent annually.
2. In addition to government programs, private nonprofit organizations in the United States and the United Kingdom such as Artangel, the Public Art Trust, FORECAST Public Artworks, the Public Art Fund, the Public Art Commissions Agency, and InSite have been founded to support public art.
3. In her introductory essay to *Mapping the Terrain*, Suzanne Lacy (p.19) coined the phrase *new genre public art* to describe "visual art that uses both traditional and nontraditional media to communicate and interact with a broad and diversified audience about issues directly relevant to their lives." The key identifier for *new genre* was public art "based on engagement."
4. California State University, Monterey Bay offers a degree in Visual and Public Art, and the University of Southern California offers a degree in Public Art Administration.

Part I
Out of Theory

1 Coming in from the Cold
A Public Art History

Cameron Cartiere

It is a sunny morning in the spring of 2002 and Anissa Mack has just finished setting out the first of many apple pies she will be making that day inside a tiny single-room cottage situated on Grand Army Plaza in the heart of Brooklyn. The cottage looks like it has sprung out of the pages of a fairy tale, complete with pale blue shutters, a Dutch door, window boxes planted with petunias, and a bouquet of flowers painted over the entrance. Surely Hansel and Gretel will be arriving any moment. The pie sits cooling on the windowsill, crust golden brown, as the aroma of apples and cinnamon floats across the plaza enticing pedestrians over to the cottage. Mack is hoping that one of them will steal the pie, thus completing a cycle of her performance *Pies for a Passerby*. Over the course of six weeks[1] Mack, dressed in a variety of floral and gingham aprons, baked countless pies (one at a time), and set each in turn on the windowsill to cool and hopefully be "snatched" by an opportunistic member of the public who happened to be walking by. This performance and installation was sponsored by the Public Art Fund, based in New York. At the same time, across the East River in Central Park the Public Art Fund also sponsored *Bluff*, a work by Roxy Paine.[2] "Planted" between the Sheep Meadow and the Mall, *Bluff* was a fifty-foot stainless steel tree weighing thousands of pounds. Complete with parasitic steel fungi "growing" off its two-foot-wide trunk, *Bluff* shimmered against the stark background of a stand of deciduous trees that had yet to come into leaf, "like an oak designed by Frank Gehry."[3]

Pie still in hand, one could have easily gone from Mack's work in Brooklyn to Paine's piece in Central Park via the subway, taking the C line to 81st street and exiting the train under the Natural History Museum to encounter a series of bronze, granite, ceramic, and glass mosaic murals of lizards and geckos seemingly climbing along the white tile walls of the subway station. These murals, called *For Want of a Nail* (1999/2001), were created by the MTA Arts for Transit Design Team and are part of an elaborate collection of public artworks commissioned by the Metropolitan Transit Authority for the stations along the New York City Transit lines (the subway), the Long Island Railroad, and the Metro-North Railroad. They include sculptures, murals, seating, gates, handrails, and windows.

Across the Atlantic Ocean in England on that same spring day, one could have been participating in an artist walk lead by PLATFORM through London tracing the last remnants of the once great East India Company, or experiencing Atom Egoyan's installation *Steenbeckett* in the former Ethnography Museum. For a day out of the city, one could have taken a trip up to Lancashire County to explore the Irwell Sculpture Trail. In 2002 the project was celebrating the final year of its five-year artist-in-residency funding initiative, which commissioned work from more that fifty regional, national, and international artists.

A woman baking pies, a fifty-foot steel tree, a mural, a walking tour, an installation, and more that fifty sculptures along a river. Six very different projects utilizing a broad range of approaches—all paid for, to some degree, with public funds and all falling under the ever-expanding category of public art.

This essay focuses on the often unrecognised contributions of public art to art history and on the ongoing debate on the merits of public art practice as a fine arts discipline. Public art touches the daily lives of millions, and millions of dollars are spent commissioning public works around the world. Yet despite the proliferation of public art, its critical recognition remains limited. With so much investment in the development of new projects, why is the field still marginalized by the fine art community? Public art is a complex, multifaceted discipline and it is this diversity and multiplicity that lies at the heart of its struggle for critical recognition. Lack of historical context, evaluation, and confusion about the definition of public art are all contributing factors.

For some scholars, public art has been with us since the dawn of recorded history, in the form of the cave paintings of Lascaux. Others could argue that public art was not a recognized practice until 1967, when the National Endowment for the Arts created its Art in Public Places program. Some historians mark the beginning of public art as 1935, when the Works Progress Administration (W.P.A.) was created to help provide economic relief to the citizens of the United States who were suffering through the Great Depression. The Federal Art Project (F.A.P.) was one of the divisions of the W.P.A. created under Federal Project One. Yet even this date might be contested, as President Roosevelt had made several attempts prior to the F.A.P. to provide employment for artists on relief, namely the Public Works of Art Project (P.W.A.P.), which operated from 1933 to 1934.

The timeline for the development of public art is just one of the complications in understanding the relationship to public art and art history. The definition of public art is also at issue. Over forty years since *public art* was coined as a term, it has yet to be clearly defined in any art history text. This is partially due to the relationship between public art, architecture, and urban design. Much of contemporary public art history is linked to Percent-for-Art initiatives that have combined the requirement for public art to be part of new building projects in many cities around the world. Such

links have led some critics to view public art as a commercial art or an art form produced by committee.

For others, it is the variety of continually evolving terms that are used within public art that creates the critical difficulty—terms such as interventions, political activism, service art, site-specific works, community-produced projects, spatial practice, interdisciplinary activism, contextual practice, and social practice art. Strikingly, it is only the public art administrators and officials who seem willing to simply use the term *public art*. In their framework, however, public art is often used to describe only municipal, county, and state government programs. Yet the evolution of the terminology to describe public art is an acknowledgement of the complexity of the practice.

The lack of a clear definition for public art is one of the greatest obstacles to fully understanding public art's place in the field. A clear definition is elusive because public art is simply difficult to define. Under the vast umbrella of public art one finds permanent works, temporary works, political activism, service art, performance, earthworks, community projects, street furniture, monuments, memorials, and—let us not forget —"plunk" and "plop" art. Temporary works can be site-specific and memorials can exist as interventions; the practice of public art weaves in and around itself, existing in layers. Public art can incorporate a single object or an entire streetscape. Public art exists in urban centers, suburbia, and rural regions. Public art has crept into every corner of our society and perhaps, in part, that is why it is one of the most controversial and misinterpreted art disciplines today. In order to better understand the genealogy of public art, it is helpful to revisit the critical evolution of sculpture and installation as the field expanded off the pedestal and into our daily lives.

TOWARDS THE FURTHER-EXPANDED FIELD

Strolling down Pinckney Street in Charleston, South Carolina, during the Spoleto Festival USA in 1991, one would have come across number 45, a single-story abandoned brick building, former site of Mike's Garage. A single post with the phrase "Places with a Past" marked the site as part of a city-wide public art project. Within the vaulted space sat a huge mound of folded clothing, seven tons of work shirts and trousers in various shades of indigo. The piece was *Indigo Blue*, a temporary "place-specific" public artwork created by Ann Hamilton.

Indigo Blue was a piece that, like much of Hamilton's work, reflected the value of manual labor. The initial inspiration for the piece came from indigo, a crop introduced by Eliza Lucas Pinckney in 1744 and cultivated in Charleston. Hamilton used indigo in a contemporary context as the color of workers' garments and selected the site, a former auto repair shop located on Pinckney Street. Hamilton filled the garage with 48,000 blue shirts and

trousers (14,000 pounds) that were folded and stacked, layer upon layer, to create this homage to blue-collar workers. The viewer would have been informed that *Indigo Blue* was a work about place and was part of a public art project in the accompanying catalog[4], but how was the categorization of the piece derived? What does it mean for a work to be place-specific (versus site-specific), and why was the work considered public art and not sculpture or installation?

Over the past four decades there has been continual debate to define the terminology to describe the increasingly diversified genres that were often inadequately grouped under the single, generalized heading of *sculpture*. From the minimal sculptures and happenings of the 1960s, one can trace the roots of installation, earthworks, interventions, and public art. Yet ask any number of artists to define the term *installation*, and one is likely to receive an equal number of varied interpretations; adding the phrase *site-specific* only compounds the confusion. In the early development of the field, *installation* often referred to three-dimensional sculptural elements that either created an environment (often in a gallery), such as the works by Christian Boltanski, or large-scale works that incorporated and/or interacted with the environment, like those of Christo and Jeanne-Claude. As the discipline became more prevalent, the boundaries of what artists referred to as "installation" began to deteriorate. Installation has grown into a hybrid discipline with multiple histories, including architecture and performance art. Contemporary installations can incorporate video, performance, and viewer participation. Some installations, like those of Frank Wilson or Hans Haacke, utilize the museum as a medium for their installations. In *Give & Take* (2001), a collaborative exhibition between the Serpentine Gallery and the Victoria and Albert Museum, Hans Haacke was given unprecedented access to the Museum's collections to create his gallery-wide installation, *Mixed Messages* (2001), at the Serpentine Gallery.[5]

In my own curatorial experience, I have seen a wide range of works identified by the artists as installations, including an "installation" in an artist's studio that consisted of a landscape painting and a rock on the floor. However, stretching the definitions of installation to include such pieces denigrates the overall impact of the genre and does little to help define the unique qualities of works that fall between our understanding of traditional sculpture and installation. In the mid-1990s, as I witnessed more and more artists struggling for a phrase that defined their "not-quite"-installation installations, I adopted the term *component sculpture* to describe such in-between works and began using it to describe these works in exhibition signage and catalogs. I categorized component sculptures as generally small-scale projects, installed primarily in galleries or museums, that had moved off the pedestal while retaining an aphoristic quality, but did not expand into the multilayered structural complexity inherent in the realm of installation.

Throughout the 1990s, as installation and environmental works continued to increase in notoriety, frequency, and complexity, the term *site-specific* in relation to such works fully entered the lexicon.[6] Site-specific installation often refers to works that respond to the topography of a site. This site can be in both interior and exterior locations. British sculptor Andy Goldsworthy was one of the contemporary forerunners of site-specific installation during this period. Much of Goldsworthy's work also proves that installations need not be large to inspire awe. Well known for such pieces as his delicate leaf-and-berry installations floating on ponds, constructed entirely from materials found onsite, Goldsworthy photographs his works for documentation and representation in the gallery.

Goldsworthy, like sculptors Patrick Dougherty, Chris Drury, and Richard Long, also collects material from sites of installations and reinstalls that material within a gallery or museum context.[7] While some artists are reworking their installations so that they can be returned to a more traditional gallery or museum setting, many others are continuing to look outside the museum walls as works grow in scale, become bearers of messages with political and social context, and/or are connected to specific locations or settings. Mary Jane Jacob noted that " . . . the use of exhibition locations outside the museum has been motivated not only by a practical need for space, but also by the meaning that such places convey and contribute to the work of art, the freedom they allow for innovation, the potential they offer for public accessibility, and the psychic space they afford artists and audience."[8] Here Jacob alludes to the growing importance of place within the contextualization of the developing direction of art beyond museum boundaries.

The struggle to define and categorize installation and site-specific work is linked to minimalist artists who began redefining the relationship between sculpture and space in the 1960s. This struggle was similar, if not on a direct art historical trajectory, to the debates around the characterization of current public art methodologies. Understanding some of the theories that enabled the art world to eventually embrace the once "outsider" practices of installation and site-based work provides potential systems that could allow public art to come in from the cold and join the canon.

Perhaps the most comprehensive model developed to address the radical shifts in postmodern sculpture during the 1960s and 1970s was created by Rosalind Krauss. In the 1979 article "Sculpture in the Expanded Field," Krauss addressed a number of issues regarding the inadequacy of the historically recognised terminology of modernist sculpture to encompass contemporary works that had moved off the pedestal, into the gallery, and out to the environment. Krauss began her model from the point that modernist sculpture, such as works like Robert Morris's gallery-installed "quasi-architectural integers" and outdoor-exhibited mirrored boxes, "had entered the full condition of its inverse logic and had become pure negativity: the combination of exclusions." Krauss described this condition as

entering into a category that "resulted from the addition of the not-land-scape to the not-architecture." [9]

Working from this base, Krauss continued to expand the model of exclusions through a binary model[10] so that not-architecture became another way of expressing landscape, and not-landscape became architecture. Continuing a logical expansion of these sets of binaries, the model is "transformed into a quaternary field which both mirrors the original opposition and at the same time opens it."[11]

This model, which Krauss referred to as the "expanded field," was a means for defining works that had moved beyond the historically recognized boundaries of modernist sculpture. Utilizing Krauss's model, large-scale constructions by artists such as Alice Aycock, Robert Irwin, and Mary Miss, which were both "landscape" and "architecture," become "site-constructions"; earthworks such as Robert Smithson's *Spiral Jetty* or temporary works such as Christo's *Running Fence*, which were both "landscape" and "not-landscape," are "marked-sites"; and interventions into architectural spaces as seen with works by Richard Serra and Sol LeWitt, which were both "architecture" and "not-architecture," fall into the category of "axiomatic structures" (or self-realized structures).

Krauss developed the expanded-field model in 1979, and since then the boundaries of that field have continued to expand and develop. In the 1980s and 1990s the development of new categories occurred, and installation art rushed to the forefront as artists continued to push at the perimeters of the fine art canon. Artists continued to move beyond the gallery confines and the museum walls and further into the public realm. Earthworks were moving out of the desert and other remote locations and into town commons and public parks. Postmodern constructions took hold in city centers and public plazas, some as self-contained works and others as contemporary monuments. The evolution of installation and public art has moved beyond the expanded-field model. One could attempt to locate these various "new" developments within Krauss's model; however, attempting to do so leaves one wrestling with similar issues of historicism as those that inspired Krauss to initially develop her model. "Historicism works on the new and different to diminish newness and mitigate difference."[12] In order to avoid the historicism trap and to help define some of these movements and continually developing genres within the logic of the expanded field, I have further expanded Krauss's original model by adding an additional layer to include place-specific and site-specific public art, component sculpture, and installation.[13]

If one is to extend the same logic utilized by Krauss, this "further-expanded field" could more aptly define public artworks by such artists as Buster Simpson, Nancy Holt, and Isamu Noguchi, whose public works are often "site-constructions" and "axiomatic structures," as "site-specific public art." Similarly, environments created by Damien Hirst, Joseph Beuys, and Louise Bourgeois, which contain sculptural elements and the marking

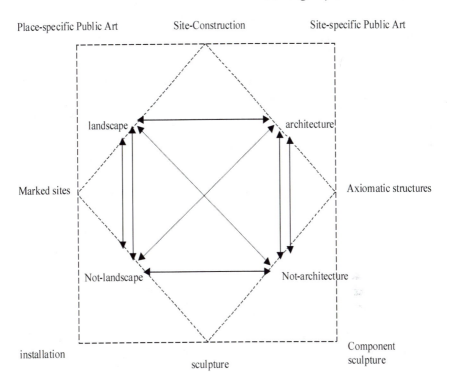

Place-specific Public Art Site-Construction Site-specific Public Art

landscape architecture

Marked sites Axiomatic structures

Not-landscape Not-architecture

installation Component sculpture

sculpture

Figure 1.1 The Further-expanded Field.

of site (that site often being within a gallery or museum context) are "installations"; multifaceted sculptural work by artists such as Annette Messager or Jessica Stockholder that bridge "sculpture" and "axiomatic structures" become "component sculpture"; and finally, public works created for and from specific locations such as Rachel Whiteread's *House* (1993) or Sheila de Bretteville's *Biddy Mason—Time and Place* (1991), incorporating "site-constructions" and "marked sites," are classified in this expanded model as "place-specific public art."

De Bretteville's piece is an early example of a place-specific work whose development was influenced by the history of the location. This permanent public artwork, located in downtown Los Angeles, is an eight- by eighty-two-foot sculpted timeline in a wall created to honour Biddy "Grandma" Mason, a former slave who became a midwife, landowner, and founder of the African Methodist Episcopal Church (the first African-American church in Los Angeles). Located at the site of Mason's original homestead, the wall includes engraved squares of text and photographic images that trace Biddy Mason's life and the parallel history of the city over the course of eight decades (1820–1900).

As with Krauss's original model, the further-expanded field only extends to a limited, specific degree and is not representative of the genealogy of place-specificity, although it does bring to light some of the hereditary connections to modernist sculpture and installation. As a structuralist model, it does not readily incorporate place-specific works that are about process and are not based in site-constructions. Such a model would need to be multidimensional in order to attempt to specifically categorize all the variations of contemporary public artwork such as performance, intervention, and works based in virtual places such as internet-based works. The intent is not for the further-expanded field to serve as an exhaustive, scientific, or structuralist methodology; but rather to provide a critical art historical platform and to develop an understanding of the geneses of contemporary public art practices from a more open-ended perspective.

TRACING THE FAMILY TREE

To trace all the roots of contemporary public art would be, at best, a Herculean task. The genealogy of the field would not only incorporate numerous fine art movements and parallel disciplines such as design and craft; it would also branch out into a range of other academic arenas. Public art exists in multiple forms and across multiple disciplines, including such fields as city planning, architecture and landscape architecture, cultural studies, political science, urban design and urban studies, social science, public policy, environmental studies, history, feminist studies, geography, ethnography, and anthropology.

Focusing just within the fine art discipline, numerous theorists and critics such as Claire Doherty, Eleanor Heartney, and Hilde Hein[14] have linked various public art practices to a host of art movements, including Fluxus happenings, Berlin Dada, the Situationists, conceptualism, minimalism, Surrealist wanderings, Bauhaus, and the Russian Constructionists. From a historical perspective one could argue that the relationship between art in the public realm and architecture, while often contentious, is also a long and varied one. From the Ghiberti doors (1424) to Richard Wilson's latest public art work in Liverpool, *Turn the Place Over* (2007–2008)[15], the practice of working via commission, with fabricators, and as architectural collaboration is well established within the fine art tradition. Perhaps the time has come to simply accept the art historical paternity of public art and focus the critical debate not on the question of "is it art?" but on the art itself.

DEFINING THE RULES OF THE GAME

As one of the first steps for bringing public art back into academic and critical discourse we need to define public art at the beginning of the twenty-first

century. This was a very difficult process, and together Shelly Willis and I struggled with the complexity of such a task. In the end, we realized that while a definitive, single-sentence definition of public art may never be attainable, there are recognized directions within public art practice that serve to define the field. The following working definition of public art allows for this complexity and is the result of our joint efforts and combined experience in the field.[16]

Public art is art outside of museums and galleries and must fit within at least one of the following categories:

1. in a place accessible or visible to the public: *in public*

2. concerned with or affecting the community or individuals: *public interest*

3. maintained for or used by the community or individuals: *public place*

4. paid for by the public: *publicly funded*

This working definition allows us to embrace the term *public art* as the signifier of a legitimate discipline, a layered practice, an area of study, and a significant contribution to fine art. Because the spectrum of practice within the field is so vast, having a definition also helps to clarify terminology, allowing discourse to move beyond what public art *is* to actually critiquing the work itself. Understanding the possibilities in which public art can be defined also sets a foundation upon which critical discourse can be further established.

More than a decade has passed since Suzanne Lacy called for criticism of new genre public art to do more than simply describe the work but rather "to look more closely at what exists within the borders of this new artistic territory."[17] Since then numerous scholars such as Suzi Gablik, David Harding, Lucy Lippard, Patricia Phillips, and Nancy Princenthal have contributed to the criticality of the breadth of public art practice. In her article "Responsible Criticism: Evaluating Public Art," Harriet Senie explores a range of possible approaches for evaluating public art within an "art-world standard" which when filtered down result in asking of any public artwork, three crucial questions:

1. Is it good work, according to its type: art, urban design, or community project?

2. Does it improve or energize its site in some way—by providing an aesthetic experience or searing (or both), or by prompting conversation and perhaps social awareness?

3. Is there evidence of relevant or appropriate public engagement or use?

According to Senie, "successful public art has to score on all three or it isn't (successful)."[18] This list of criteria is certainly a reflection of the aims that public art can achieve as a fine art practice.

But even if a public artwork can satisfy Senie's three-question criteria, such works still need time to settle into the landscape, be it urban or rural—an adjustment period, to adapt to the site beyond the initial scepticism that accompanies the installation and unveiling process. The work needs time to survive the often reactionary emotional response that seems to plague most artwork placed in the public realm. *Angel of the North*, heralded as an iconic symbol for northern England and Newcastle in particular, was fraught with controversy from concept to completion. Newspapers ran editorials predicting massive traffic jams on the motorway that ran past the piece, and local councillor Martin Callanan was particularly vocal in his opposition to the work. However, since the installation of *Angel of the North* in 1998, Gateshead Metropolitan Council traffic engineers say there is no evidence that the work has caused any accidents. Still the angel was not embraced by the region until later in 1998, when a giant Newcastle United football jersey was draped over the piece in a midnight guerrilla action by local team supporters.[19] The jersey was quickly removed, but it seemed to signal a turning point in the emotional response to the piece. While *Angel of the North* will always have its detractors, it is estimated that eight thousand visitors a week come to the site.

Perhaps the greatest obstacle to fully being able to appreciate the role and place of public art within the contemporary art historical canon is postmodernism itself. In a period fraught with notions of the spectacle, relational aesthetics, and immediacy, there is little room for conventional museum- and gallery-based work, much less work in the public realm, to acquire any patina of history. In order to fully comprehend the breadth of influence the vast range of public art practice (through permanent and temporary projects) has contributed to the field, we need to allow for the grace of time to filter out the mediocrity that is endemic within all art disciplines, not just public art, and see what work stands the test of time.

NOTES

1. *Pies for a Passerby*, May 17 to June 23, 2002, Brooklyn Public Library at Grand Army Plaza, Brooklyn.
2. *Bluff*, March 7 to May 30, 2002, Central Park, New York City. The overlap when both *Pies for the Passerby* and *Bluff* could be viewed was thirteen days.
3. T., Eccles et. al, *PLOP: Recent Projects of the Public Art Fund* (New York: Merrell, 2004), 194.

4. M.J. Jacob, curator, *Places with a Past: New Site Specific Art at Charleston's Spoleto Festival*, New York, 1991.

5. Haacke was also given access to the collection of the Museum of Childhood, Bethnal Green, London.

6. The concept of site specificity in contemporary art can be traced back to influences generated through the work of minimalist artists in the 1960s; however, the association of the term to installation and public art did not become commonly recognized until later years.

7. Some of Goldsworthy's works, such as the *Snowballs in Summer* (2000) series, are examples of works that do not simply exist outside of the museum context, responding to their sites—in this case an urban context—but that also generate reaction because they are seemingly out of place. Such site-specific inversions continue to push at the boundaries that define site-specificity.

8. Jacob, *Places with a Past*, 50.

9. R. Krauss, "Sculpture in the Expanded Field," *October* 8, (Spring 1979): 37.

10. Krauss based the expansion on a method known as a Klein group when utilized mathematically, and it has various other designations, such as the Piaget group, when utilized by structuralists involved in mapping operations within the human sciences.

11. Krauss, "Sculpture in the Expanded Field," 31.

12. Ibid., 31.

13. Within the expanded model the axioms would continue outwards, as represented by the ←→ symbols, to include the additional categories.

14. See C. Doherty, ed., *Contemporary Art: From Studio to Situation* (London: Black Dog Publishing, 2004); E. Heartney, "The Dematerialization of Public Art," *Sculpture*, March/April (1993): 44–49; H. Hein, *Public Art: Thinking Museums Differently* (Oxford: Alta Mira Press, 2006).

15. Co-commissioned by the Liverpool Culture Company and the Liverpool Biennial, this temporary work is an 8-meter ovoid cut from the façade of Cross Keys House and designed to oscillate in three dimensions. The revolving façade works with a specially designed giant rotator and acts as a huge window, offering recurring glimpses of the building interior as the ovoid opens and closes during its daytime cycle.

16. This definition was developed in collaboration with coeditor Shelly Willis in 2005. The definition was first presented at the symposium "Building Cultures: Art and Our City," Tate Modern, May 8, 2006.

17. S. Lacy, ed., *Mapping the Terrain: New Genre Public Art* (Seattle: Bay Press, 1995), 41.

18. H. Senie, "Responsible Criticism: Evaluating Public Art," *Sculpture* 22 no. 8 (December 2003), 7.

19. The jersey carried the number 9—the number of football favorite and team captain Alan Shearer, whom fans refer to as "angel of the north."

2 Time in Place
New Genre Public Art a Decade Later

Suzanne Lacy

It has been over ten years since the publication in 1995 of *Mapping the Terrain: New Genre Public Art* (by Bay Press, now in a third printing in English and a first in Chinese). This book, a collection of articles by artists, critics, and curators, and a compendium of artists' work by Susan Steinman, came at the right time in a field that was attracting attention. The term *new genre public art*, first coined in the book, was not meant to identify a form of art so much as to pose a challenge to a discourse developing around public art during the 1980s.

In 1992, working with several artists, curators, and academics (including Cameron Cartiere, coeditor of this book) I convened the "Mapping the Terrain" project: a public forum at the San Francisco Museum of Art, a private retreat with over thirty international participants, and the subsequent book. At the retreat we considered a range of work from ninety artists working between 1960 and 1990. We focused on the work of artists from the United States, but it was evident even then that the "practice" under consideration was worldwide. While different from each other in critically acknowledged respects, these works had unrecognized similarities that constituted grounds for an expanded conversation about public practices. We discussed notions of public; alternative histories of public art; collaboration, political analysis and democratic processes; engaging multiple and diverse audiences; individual and community transformation; artists' roles and responsibilities; and relationships between curation, criticism, and art practices. Many of these themes were later expanded and developed into essays for the book.[1]

The book distinguished an artistic practice, setting it apart from what at the time was known as public art. It explored conceptual, performance, and installation projects within a set of common strategies and intentions. It provided a lens through which to inspect cross-disciplinary experiences, relationships to audiences, and political positions, resulting in a more nuanced notion of art in public. *Mapping the Terrain* captured the moment and tilled an existing field, laying the ground for what would come next as we headed into the twenty-first century.

When the term *new genre public art* was first coined, it seemed to capture the profession's imagination. Other terms are now also in common usage, many used interchangeably: dialogic art, civic art, community-based art, engaged art, relational aesthetics, and art as community cultural development. There is a satisfying complexity now: a worldwide exchange of practices, engagement from various theoretical perspectives, and blurred lines between field- and museum-based practices. Complicated interdisciplinary collaborations occur within ever more encompassing social and political contexts, raising new issues, muddying the waters, and then bursting forth with astounding clarity, as in the performance of John Malpede, *RFK in EKY*, to which I will return later in this essay. The fluid terminology surrounding this work tracks an evolution in the nuances of both practice and discourse.

Those of us who began our work in the 1970s look with bemusement on the increasing interest process-based public art has attracted. What was, in the early 1990s, a network based on friendships, similar values, and a knowledge of each other's practice, can today more plausibly be called a "field," or at least intersecting forms of practice, with support by major funders, applications in education, and a body of critical research. We are now aware of related practices in Asia, eastern Europe, Africa, western Europe, the United States, and South America. Numbers of case studies by mature artists working for years to perfect their craft are now available in print and on film, demonstrating extensive and long-term work in communities. Young artists are drawn to these art forms and can now find college-level course offerings in new genre public art practices. There are many different but acceptable ways of speaking metaphorically and materially about social issues, and there are many differently imagined audiences or publics. There are projects that are specific, local, and immediate, and those that combine global scope and digital communication. Rather than fading, these practices have clearly grown, and following I will discuss some recent developments in US funding, criticism, and practice. Other chapters in this book discuss related developments in education.

PHILANTHROPY

In the 1970s, an era when the National Endowment for the Arts was committed to experimental frontiers, the New Genres category of the Visual Artists Fellowship Program, along with occasional cooperation from the Art in Public Places and Inter-Arts Programs, provided key sources of support for theoretical and non-object-oriented art. This support was critical, as most experimental work was not marketable. Advocacy dissolved following widespread controversies surrounding the work of Robert Mapplethorpe and four controversial performance artists, circa 1990, resulting in the loss of the Visual Artists Fellowship Program. Hereafter, government

funding for artists projects was dispersed through sponsoring organiza-
tions, museums, and the like, making artist-generated works more difficult
to fund. This had implications for practice, of course, discouraging self-
motivated explorations by artists, while introducing public practices into
art institutions.

Private foundations partially filled the gap left by the demise of NEA
individual artist's fellowships. Because of the broader philanthropic agen-
das of education and community development, progressive program offi-
cers often made the case to support the intersection of aesthetics and public
life. The Nathan Cummings Foundation, the Rockefeller Foundation, the
Surdna Foundation, the Lila Wallace Foundation, and the Ford Founda-
tion, among others, have created initiatives that enabled artists, organi-
zations, and schools to develop a range of case studies.[2] As *Mapping the
Terrain* was being written, artists Rick Lowe and Deborah Grosfeldt were
just beginning *Project Row Houses*, a ten-year site-specific "social sculp-
ture" that significantly involves artists in neighborhood revitalization, edu-
cation, community service, and historic preservation. The community, still
going strong today, consists of a series of renovated shotgun-style houses
and buildings in an economically depressed neighborhood in Houston's
Third Ward, with artist residency studios and exhibition galleries that cel-
ebrate African-American heritage and culture, housing for single moth-
ers, art classrooms, and social services. *Project Row Houses'* funding has
included traditional arts funders, but they have also appealed successfully
to builders and contractors, local businesses and government, housing cor-
porations, and oil companies. They have been supported by national foun-
dations for their pioneering model of social sculpture.

In 1994, the Ford Foundation made a major financial commitment,
convening artists and writers from across the country to make recom-
mendations on how to identify and support civic arts. A ten-year, 16-mil-
lion-dollar initiative was launched to fund three major components: the
Institute on the Arts and Civic Dialogue, led by performer and playwright
Anna Deavere Smith; the American Festival Project, a national consortium
of community-based performance groups; and Animating Democracy, a
program operated by Americans for the Arts. The Animating Democracy
Initiative (ADI), under the leadership of independent consultants Barbara
Schaffe-Bacon and Pam Korza, is worth mentioning for its extensive scope
and its continuing impact on the field.

The Animating Democracy Initiative's premise that democracy can be
animated by the multiple perspectives of an informed public evolved into
what they called "arts-based civic dialogue"—art that, in the words of
Korza and Schaffe-Bacon, consciously incorporates civic dialogue as part of
an aesthetic strategy. The Animating Democracy Initiative selected thirty-
two exemplary projects nationwide and set out to nurture both the artists
and the presenting cultural institutions and, in so doing, to support the
emergence of art that operates with authority in the public realm. Artists

from visual art, theater, music, and dance were paired with specialists in community dialogue and received financial and advisory support. One of the interesting aspects of this initiative is its commitment to ongoing learning for artists and institutions. The ADI Lab is a dialogic forum for artists and community partners that features publications, a Web site, and national conferences with practitioners, scholars, civic leaders, critics, and the media.

The aim of *Mapping the Terrain*, project and publication, was to frame the discourse and establish a new approach to thinking about visual art and the public, but it ignored the performing arts. The Animating Democracy Initiative took up the next project—the nuanced exploration of case studies within both visual *and* performing arts, also exploring criticism appropriate to the genre. The Animating Democracy Initiative also meant to strengthen cultural institutions' interest in sponsoring such work, but the jury is still out on whether institutions will embrace this labor-intensive art form with its uncertain outcomes. What is clear, however, is that the Ford Foundation and Americans for the Arts have, through ADI, greatly expanded new genre public art through advocacy, unification of the discourse, communication with a broader public, and the development of an embedded art criticism.

CRITICISM

Today biennales and exhibitions bring international artists together in unprecedented numbers. Many practices relate to public or community life in rural and urban regions, from India to Argentina. Since *Mapping the Terrain*'s publication, digital communication has made a world of simultaneously occurring "locals" commonplace. Diasporic artists, as well as those well rooted in specific communities, reveal through art a world of interdependence and global significance, a world in which local issues are now understood as internationally relevant.

The international scope of local art practices only increased the problems for art critics, because meaning in this art is so dependent upon context: the work is extensive, covers a range of issues, is culturally specific, calls on expertise in fields outside of the arts, and takes a long time to produce. Simple observation over a short period of time provides little real insight. Projects that can be exhibited in art venues do not reveal the depth and quality of prior or coincident engagements they are seen to represent. How is such work to be evaluated critically? Where is the meaning in public practices?

Let us look at three potentially fruitful directions for critical strategies: the "close reading" of specific projects embedded in their locality; "multivocal" criticism that compiles diverse viewpoints; and alignment with economic, aesthetic, and cultural theories that draw on the "continental

theory canon" but do not necessarily give it priority over other histories or theories. Each approach supports a critical discourse that is relevant to building the practice, and it is possible that no single method will provide the full picture.

Close reading critique is developed through legwork and immersion. A writer with intimate access follows the process of the work, describing and analyzing, somewhat like being in the studio from inspiration to exhibition. Moira Roth is a prolific writer who has followed the development of avant-garde and performance art for several decades, writing on artists from Marcel Duchamp to Robert Smithson to Sutipa Biswas. Roth brings her own aesthetics into her critical practice: conversation, relationality, research, associative referencing, poetic narrative, and subjectivity. The result, when applied to a lengthy production phase of a work, offers an intimate look at the processes involved in new genre public art. Roth followed the final preproduction weeks of *Code 33—Emergency: Clear the Air,* when a team of artists led by myself, Unique Holland, and Julio Morales created a performance with 100 police officers and 150 youth in downtown Oakland, amidst a conflicted public and media environment. Published in *Performing Arts Journal,*[3] the close reading of process provided an entertaining and revealing narrative that encompassed the personal and strategic demands of this work and its complications.

The critical practice of close reading expands, amplifies, and adds complexity to the discourse. Conversation rather than visual experience is foregrounded as a method of inquiry, which explains the spate of books that feature conversation: *Dialogues in Public Art* by Tom Finkelpearl; *Conversations before the End of Time* by Suzi Gablik; *Conversations at the Castle: Changing Audiences and Contemporary Art* by Mary Jane Jacob and Michael Brenson; and *Conversation Pieces: Community and Communication in Modern Art* by Grant Kester.

Multivocal criticism is a term I use to describe an evaluation that includes many voices but that is qualitative, not quantitative. The *Animating Democracy Initiative's Critical "Perspectives"* project, directed by Caron Atlas, combined up to three writers on a single project. The writers brought creative, documentary, and critical perspectives from within and outside the local community to consider the project's aesthetic and civic process. In one example, Dell 'Arte, a physical theater group in a rural region of northern California, explored the economic impact and cultural and political conflict surrounding the construction of a Native American casino. Writers David Rooks, an Ogallala Lakota tribal member and journalist; Ferdinand Lewis, playwright and arts writer; and Jim O'Quinn, arts writer, critic, and editor of *American Theatre* magazine, all worked in close range with each other, the artists, and the town residents, exploring perspectives both within the Native American culture and the community at large. This team of writers worked in a semi-embedded way, returning repeatedly to witness progress.

Seeking to develop sustainable creative practices that would provide a richer value to the life of residents, the "On the Edge" program from Gray's College of Art created a web of authority and responsivity between community residents, academics, and artists working together in the Shetland Islands in northern Scotland. Project leaders Carole Gray and Anne Douglas embedded a model of multivocal criticism into their research. "Shapers" were simultaneously researchers, practitioners, managers, and participants in the exploration of creativity and its role in contributing to the social and economic well-being of the community. Community residents were "Shapers" on five local projects, from craft production to the design of social systems. Papers, processes, conferences, and reports ensued from this ethnographic model of subjective and embedded critique, challenging the notion of the primacy of the single critical voice.

Multivocal criticism features contributions from varied positions of expertise to a multifaceted and coherent whole—one that includes aesthetics. While there are many projects where people are given voice as participants, the focus has been on description, testimonial, or personal anecdote. One challenge to including nonartist partners in critique is accounting for differences between avant-garde and popular concepts of art. Another challenge involves how to integrate the institutional and political perspectives of partners with artistic process.

The third critical strategy links public practices to theory, history, and broader spheres of cultural production. Critiques of public practices, increasingly framed by political, cultural and social theory, are beginning to follow precedents set when art critics vigorously embraced continental theory during the 1980s. Such analyses are welcome additions to the fray, but unfortunately some writers have little experience of actual field practices and tend to apply unexamined stereotypes to work they have only read about or witnessed from a distance. However, now that strategy, concept, and even imagery are shared by artists operating *inside* as well as *outside* of traditional art venues, claiming that community-based art projects are inferior or "not art" has become more difficult. In *Relational Aesthetics*[4] Nicolas Bourriaud attempts to establish clear distinctions. He heralds a group of artists who operate "relationally" but whose work is utopian and without application or "usefulness" in the world outside of the social environment created by the work, as different from artists who make clear claim to function in civic life. Conveniently, the work he reports on can easily be found in the presenting platforms of choice, exhibitions and biennales, although some of the best of this work takes place in harder-to-access artist-initiated venues.

On the other end of the spectrum, coming from those who are building a case for art's usefulness in regeneration (in the United Kingdom) or its role in civic discourse (in the United States), functionalism is actually prioritized. Pairing art with civic process can seem to some a deceptively simple matter. National advisor for ADI Wayne Winborne suggests that

art is a catalyst for the political issues of the day: "Art allows us to get at things that people can't get at on their own." There is art, and there is dialogue, he seems to be saying, and when they join hands in public, art is operationalized in the service of a civic agenda. This approach makes criticism a handmaiden of politics and does not account for functionalism as a strategy consciously adopted by the artist to unravel and nuance the aesthetic dimensions of fragile human negotiation.

It is time for a critical unpacking of the stereotype *use + art = bad art*—one that draws from the range of practices in the field, the voices of those who participate, and the history and theory that frames and informs the work. Grant Kester takes on the canon of art criticism, theorizing the emergence and practice of new genre public art within the contexts of history, art history, and theory, and (more broadly understood) critical theory in his recent book *Conversation Pieces: Community and Communication in Modern Art*. Analyses of public practices from an art theoretical position are rarely as informed, as is Kester's, by a close reading of individual artists' practices where and when they occur, in the field. He travels extensively, using case studies from artists around the world to demonstrate an evolving argument that links the aesthetics of framing conversations to the legacy of the avant-garde. "A work of art can elicit a more open attitude toward new and different forms of experience, while challenging the assumption that avant-garde art must be shocking or difficult to understand,"[5] Kester suggests, adding that normative assumptions of art criticism that centralize the art object and presume a specular relationship with an audience do not translate well to work that is durational, collaborative, and not particularly conducive to visual pleasure. Instead, he builds his argument on modern art criticism's focus on communicability as he interrogates the distaste for functionalism within the practice of modern art. According to Kester, changes in 1960s and 1970s art practices introduced direct and unmediated experience, duration, and transience, and delivered a concept of dialogic aesthetics linked to Jurgen Habermas's "discourse ethics," Pierre Bourdieu's work on processes of delegation, and Jean-Luc Nancy's work on community.

Attempts to reconcile critical and cultural theory with public practices are further problematized by the emergence of global cultural differences in intellectual organization and aesthetics, suggesting that for artists whose inspirations range far afield from those of "art-for-art's-sake" artists, discourses outside of the visual arts could be more relevant to explain the work. As one example, the influence of Buddhism on American art during the 1950s in the United States resulted in artists whose experimental and genre-bending ideas set the aesthetic stage for new genre public art. Today there is a resurgence of interest in Buddhist art and many longtime community-based artists have more than a passing interest in Buddhist spirituality, a referential system they find more conducive to their intentions. The theme of stewardship is finding its way into practices such as those of artist Brett

Cook-Dizney, whose community organizing/art education installations in Black and Hispanic neighborhoods can be understood as a form of service. This tricky concept—service—will need to be better understood as part of an art practice, and it is questionable whether an adequate foundation will be found exclusively in the work of Western European theorists.

CASE STUDIES

Extensive case studies written by artists and curators who began their work in the 1970s, often extending over several years and involving hundreds of people, offer a platform for theorizing the practice, aesthetics, and results of new genre public art. Of the original participants in the Mapping conversation in San Francisco, most continue with increasingly complex and meaningful work. Below are four sketches of multiyear projects, necessarily limited here in terms of space, but each with a book in the works for those interested in further research.

Judy Baca, the Great Wall of Los Angeles, and International Digital-based Organizing

In the *Mapping the Terrain* artists' compendium, artist Judy Baca represented the Great Wall of Los Angeles, started in 1974 and unfinished still at 2,754 feet. One of the country's most monumental self-initiated murals, the Great Wall represents the history of women and people of color in California. It was painted over five summers by four hundred youths from diverse social and economic backgrounds working with artists, oral historians, ethnologists, scholars, and hundreds of community members. Multicultural youth teams focused on the roots of racial conflicts and were empowered to propose solutions in terms of the imagery and in actuality. The Great Wall is a permanent addition to the Tujunga Flood Control Channel of the San Fernando Valley, with an accompanying park and bike trail hosting thousands of visitors every year.

Today Baca continues her work on the Great Wall through civic dialogue, research, metaphor making, and sophisticated online interactive projects. A planning commission composed of veteran youth mural makers, artists, and sponsors will formulate future panels. The Social and Public Art Resource Center (SPARC) is gathering images and text toward the creation of this major work. In its online site SPARC poses two questions inviting collaboration in the final phases of the Great Wall: What is a metaphor that defines one of the last four decades of the twentieth century? What is an artwork from one of the last four decades that symbolizes the spirit of that time?[6]

Judy Baca practices a combination of local community organizing, place making through installations and murals, and globally dispersed organizing

through digital technology. Working with the staff of the UCLA Visualiza-tion Portal, the Great Wall of Los Angeles mural site and the surrounding city area has been modeled in 3-D. At the 160-degree IMAX style screen at UCLA, viewers can navigate through the virtual Great Wall in real time, flying through the river channel to view the mural from perspectives not possible at the actual site. The virtual model helps pre-visualize how the next four decades of the Great Wall of Los Angeles will look before they are actually installed. When completed, the mural will run for nearly a mile, bringing the mural's narrative to the present.

Places with a Future, Spoleto Festival USA

In 1991 the Spoleto Festival USA (SFUSA), an annual performing arts series in Charleston, South Carolina, undertook a major visual arts exhibition, com-missioning twenty-three artists who drew upon the history of this colonial city and eighteenth- and nineteenth-century global world power and created installations embedded in places of memory and cultural pain. This exhibi-tion, "Places with a Past," curated by Mary Jane Jacob—one of the authors in *Mapping the Terrain* and an important force behind the development of new genre public art—was chronicled in a richly illustrated book of the same name. It proved to be formative, helping to define site specificity, leading SFUSA in 1997 to organize another regional approach to "place" ("Art and Landscape"), and spawning still other investigations of such rich and con-flicted histories (from Fred Wilson's "Mining the Museum," The Contempo-rary, Baltimore, 1992 to "Revelation," Port Arthur, Tasmania, 2007).

When in 2001 SFUSA sought to further its explorations of contemporary practice variously called site-specific, community-based, or public art, it was able to build on changed awarenesses emerging from personal experience, catalyzed by the insightful and poignant artworks of the previous decade which, while temporarily sited, continue to percolate in the conscious-ness of the city's constituencies. This program, curated annually by Jacob, reemerged in 2001 with the intent to be multiyear and, taking a longer and more complex view of the area, to invest in a process of dialogue between individuals with long family histories and newer residents who all had a stake in the past and future of the region. Placing primary value on community voices, the program has at its core an annual series of Stakeholder Forums. These convenings bring together otherwise discrete community constituen-cies, uncommonly crossing racial, economic, and geographic lines. Unlike other community meetings (for example, city hearings or planning depart-ment charrettes), Stakeholder Forums aim to be places of possibility in which people can think broadly and cooperatively, determining together the critical questions to ask of this place today.

The first series was "Evoking History," for which Jacob commissioned artists particularly interested in critical modes of public engagement, working directly with marginalized communities. While their craft in all

instances was collaborative, the artists' work was not circumscribed by a single style, and so projects ranged from community-based performances and projects (2001) to beautifully sited installations activated by community programs (2002) to artist-designed community discussions to temporary sculptures as visual mappings aimed to manifest historical, cultural, and ecological connections in the region (2004). The resulting artworks, nearly always undertaken with Jacob and invited artists in collaboration with area organizations and individuals, expanded SFUSA's realm of relationships beyond its usual audiences who attend performances. The experience of these community partners, many of them new to the arts and to the festival, reaffirmed the value of art itself: in providing a window into the past and into the lives of others, art can enable us to see our own lives more clearly and consider our place within society. And pivotal in this development was the 2003 program by Suzanne Lacy and Rick Lowe—a grand forum—that coalesced research on the rapidly increasing redevelopment, powerful evidencing through the presence of the three hundred audience participants of their shared concerns about the health of the region. It helped lead the way, too, for the current series, "Places with a Future."

Art as shared inquiry can build investment on the part of all involved: artists can enrich their realm of knowledge; community members can glean new perceptions on their own lives; and opportunities arise for joint projects of mutual benefit. This is the mode of practice steering SFUSA's ongoing, now year-round endeavors that honor the stake people have in their history and their right to a sustainable future in this place. "Places with a Future" seeks to effect the development of three particular locations, having concrete, long-term outcomes working with interdisciplinary teams of professionals and citizens. The Borough Houses are two small historic homes at the Port of Charleston whose African-American owners have withstood various waves of community erasure and new building; they intend for this site to be a heritage center, and SFUSA works with this preservation effort and the creation of a heritage garden, linking it via family roots to the great Palladian plantation home Drayton Hall. The Memminger District has resulted in a public garden (artists' team: Kendra Hamilton, Walter Hood, and Ernesto Pujol) as part of SFUSA's renovation of the adjoining theater, and aims to continue with sensitive reintegration of prominent though invisible constituencies on that site (public elementary school students, subsidized retiree housing center, and public housing community). The same artists' team is addressing the multifaceted issues facing rural Phillips Community, founded by freemen, having succeeded thus far in warding off a bisecting highway through intelligent, sustainable design as part of a "Lifeways Plan."

John Malpede and *RFK in EKY*

John Malpede, also a participant in the *Mapping the Terrain*, formed the Los Angeles Poverty Department (LAPD) in 1985, the first performance

group in the nation comprised entirely of homeless and formerly homeless people. Since then, Malpede has continued to work in communities around the world, recruiting homeless people and creating performances on specific local issues. Between 2002 and 2004, Malpede was at Appalshop in the Appalachian Mountains of Eastern Kentucky. There he created a project that includes a theater production (Fall 2004), a documentary film, and a historical and documentary book. The project, *RFK in EKY*, recreated Robert Kennedy's two-day, two-hundred-mile "poverty tour" of southeastern Kentucky in 1968. The performance was a series of public conversations and activities centered around the real-time, site-specific inter-media performance that recreated all aspects of Kennedy's tour, including two official hearings of the Senate Subcommittee on Employment, Manpower, and Poverty (held in the rural towns of Vortex and Fleming-Neon), roadside visits with individual families, walking tours of small communities and strip mine sites, stops at one-room schoolhouses, and speeches at courthouses and colleges.

Local citizens, some of whom saw Kennedy as schoolchildren in 1968, played their parents, and regional political and community leaders played their past counterparts. Seemingly simple and unassuming—the attention to timing was more "life as theater" than theater—the artwork was massive in scope, addressing multiple themes: the construction of memory and commemoration, environmental sacrifice, economic self-determination, and failed federal policy promises. Amidst surprising moments of emotion and throughout a three-day demonstration of his deep relationship with local Mountain people, Malpede's project revealed both the imbalances inherent in our society and the extraordinary people attempting to expose and rectify them.

With the inevitable comparisons between 1968 and 2004, we revisited the essential questions raised in Kennedy's original visit—the representation of marginalized populations in the national consciousness; the role of government in maintaining quality of life by fostering sustainable economic development and educational advancement; protection against the loss of natural resources; and the priorities of a government administration engaged in a protracted war. The creators of *RFK in EKY*, like Kennedy and those who created his tour, recognized these questions are part of an important national dialogue for which Appalachia is only one of many possible settings.

The Oakland Projects and *Code 33*

Urban youths—facing impoverishment, dysfunctional homes, race discrimination, inadequate schooling, and stereotyping by mass media culture—first appeared large on the public agenda in the 1990s. Throughout that decade photographer Chris Johnson and I collaborated with scores of local artists and youths to produce performances and installations. We tackled the public schooling, health care, criminal justice, and public policy

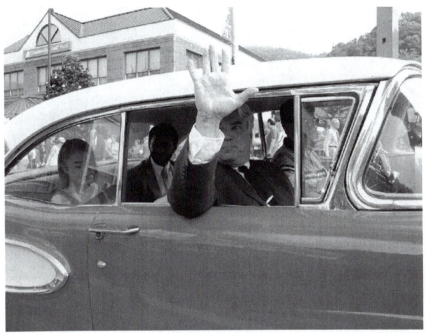

Figure 2.1 "RFK Arriving in White," John Malpede. Whiteburg, Kentucky. Credit: John Malpede.

issues adversely impacting the lives of Oakland's disproportionately youthful population. Our pedagogy included reflection on core issues (community policing, schooling, neighborhood safety, youth leadership, and civic participation); skill building (public speaking, computer literacy, writing, video, and photography); and youth workshops on team building, mentoring, and antiracism.

Each Oakland project grew out of the prior one and each engaged significantly with relevant institutions and policy makers. After *The Roof is on Fire* (1994), a performance with 220 students from eight public high schools expressing their opinions and experiences on education and other youth-selected topics before a national news audience, youth leaders asked us to address sexuality in *Expectations* (1997), a six-week summer-school program and installation on gender issues, institutional support systems, and political manipulation of teen parenting. Youths also led us to focus on police–youth relations in *Youth, Cops, and Videotape* (1995), a police training videotape, *and No Blood/No Foul* (1996), a highly publicized basketball-game-as-performance between police and youth to support the passage of the City's first official youth policy.

By the time we produced *Code 33*, we had developed a model that included an extensive workshop period prior to a large public installation or theatrical event. For two years before this performance, multiple

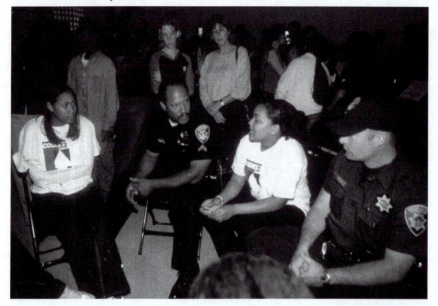

Figure 2.2 "Code 33," Suzanne Lacy. Oakland, California. Credit: Suzanne Lacy.

activities were constructed to serve a need and configured as "acts" within the theatrical whole: a youth leadership team; youths presentations before Neighborhood Crime Prevention Councils; art workshops for 350 youths from probation programs and high schools; local politician engagement; collaboration with nonprofits; an artist team responsible for designing the *Code 33* public event; and a youth police training series. For five weeks we held carefully moderated encounters between eighteen youths and twelve police officers to explore stereotypes and develop an underlying fabric of relationship that might carry over to their encounters on the streets. These workshops were televised and the program continues to be a model for the police department.

Almost a decade after we began, dozens of black, red, and white cars with headlights blazing converged on the rooftop of the City Center Garage for *Code 33*. In the spotlight of these beams, one hundred police officers met in small groups with 150 local youths to talk candidly and intensely about crime, authority, power, and safety. An audience of one thousand community members roamed freely between cars witnessing the spontaneous dialogue of youth and police as they explored stereotypes of each other. Named after the police radio code for "emergency, clear the air waves," *Code 33* was the result of a three-year public art project to explore institutional intervention through performance art, to practically reduce police hostility toward youth, and to provide youth with a set of skills and a public context conducive to their civic inclusion. The performance oriented the gaze of a large public audience and local media, with visual and contextual metaphors

set in an unremarkable garage site that was temporarily filled with significance: an elevated stage seven stories above the city streets, urban lights (car headlights, stage lights, lit windows of nearby office buildings, a circling police helicopter spotlight, and the setting sun), art props drawn from daily life (red, white, and black cars parked together in fields of solid color, a ring of thirty television monitors on walls overlooking the city, white picket-fence- and grass-covered stages), and community members participating in different ways (media stations staffed by youths, a large X-shaped table for mentorship sign-up, residents discussing their neighborhoods, and youth dancers).

The spectacle framed a multivocal civic discourse spotlighting the relationship between youth and police. As the sun went down, the earlier tensions caused by the uniqueness of the situation, by being witnessed, and by substantive disagreements subsided, and performers traversed roles: some police dropped their impenetrable façade and expressed vulnerability or fear, some youths calmly advised police, and often one heard adult bewilderment at the chasm that existed between youths and police.

LOOKING FORWARD TO NEW TERRITORIES

The thirty-year trajectory of new genre public art—with its challenges to governmental and corporate motivations; its presentation of the larger historical frame of power relations; its deep commitment to the enfranchisement of all; its naïve belief in the ability of the public agenda to right itself with enough information; its practice of bringing the voiceless into the public sphere with dignity, through their stories; its increasingly adept strategies of dissent, community organizing, and political critique; its ethical questions; and its hybridity of thought, media, and approaches—is one that mimics a trajectory of civic life, with its discourses, institutions, and public policies.

It is important to locate these art practices within the trajectories of art history and cultural theory to give real texture and meaning to the notion of artist citizenship, and in so doing reconstruct the civic relevance of art. In the intervening years since *Mapping the Terrain*, connections to materiality in contemporary art have continued to decay. Ephemeral and publicly located processes have become a new "materiality." It is process art, solidly grounded in expressive and analytic practice, but the materiality is that of life itself rather than a metaphor for life. What the *Mapping the Terrain* project accomplished was not another name in a growing litany of names. Nor is the term itself particularly precious. Rather, it was the close scrutiny of the space between public and art and the articulation of some of the meanings possible there, that suggested a new road map for public art practices.

NOTES

1. Articles by Judith F. Baca, Suzi Gablik, Guillermo Gómez-Peña, Mary Jane Jacob, Allan Kaprow, Jeff Kelley, Suzanne Lacy, Lucy R. Lippard, Estella Conwill Majozo, Patricia C. Phillips, and Arlene Raven.
2. The conference that resulted in the publication of *Mapping the Terrain* was sponsored by the Rockefeller Foundation, and The Oakland Projects received major support by the Surdna Foundation and the Nathan Cummings Foundation.
3. Moira Roth, "Making and Performing Code 33: A Public Art Project with Suzanne Lacy, Julio Morales and Unique Holland." *Performing Arts Journal* 69, 23, no.3 (September 2001) 47–62.
4. Nicholas Bourriaud, *Relational Aesthetics* (Dijon, France: les Presses du Reel, 2002; English version).
5. Grant Kester, Conversation Pieces: Community and Communication in Modern Art (Berkeley: University of California Press, 2004).
6. The author thanks the direct reports and the Web sites of included artists, curators, and organizations for material included in this report.

3　Space, Place, and Site in Critical Spatial Arts Practice[1]

Jane Rendell

In producing artworks outside the gallery, new forms of curating have increasingly emphasized the importance of space, place, and site. This chapter relates current discussions concerning off-site curating and site-specific art to the critical debates around site that emerged in connection with minimalist and land art in the late 1960s, and to theories of space and place in contemporary cultural geography.

Today's interest in "site-specific" art has developed an understanding of site beyond its location as the place of the work in relation to performance and ethnography. Nick Kaye, for example, has made an argument for site as a performed place, while various other authors have positioned site within an ethnographic perspective that includes the research processes of fieldwork as well as the artist as a contemporary ethnographer.[2] These new understandings do not define sites in terms of geometry but in relation to the cultural and spatial practices that produce them, including the actions of the critics and artists themselves. Indeed, Hal Foster has noted self-critique, along with culture, context, alterity, and interdisciplinarity, as particular aspects of anthropological research to have impacted on fine art practice.[3]

In her recent publication, *One Place after Another*, Miwon Kwon suggests that site specificity has been "embraced as an automatic signifier of 'criticality' in current art practice."[4] In her opinion, much site-specific work lacks criticality, since, for Kwon, the radical potential of site-specific practice is always open to cooption by institutional and market forces. The very title of the book sounds a warning of what Kwon calls "undifferentiated serialization," one of the dangers she associates with taking one site after another without examining the differences between them.[5] Instead, Kwon points to Homi Bhabha's concept of "relational specificity" as a way of thinking about the particularity of the relationships between objects, people, and spaces positioned, like James Clifford's notion of site, as a mobile place located between fixed points. Such an understanding develops site as a specific but also relational term.[6]

Perhaps Robert Smithson's dialectic of "site" (nongallery) and "non-site" (gallery), manifest in artworks and writings in the 1960s and early 1970s,

could be described as an earlier exploration of relational sites through art practice. In the first section, I examine the current interest in locating work outside the physical confines of the gallery in relation to Smithson's dialectic. The Dia Center for the Arts, located at 548 West 22nd Street in Chelsea, New York City, part of a much larger network of artworks sited across the city and the United States, is taken as a point of departure. The section also looks at the United Kingdom, where recent curatorial practices have located art outside the gallery in multiple sites, citywide or even countrywide. The term *off-site* has been adopted by many contemporary galleries to describe the commissioning and curating of works situated outside the physical confines of the gallery, where, in a strange reversal of Smithson's dual relationship, the gallery is the "site."

If the spatial organization of artworks in the first section could be described as dispersed from an originating point, in the second section there is no reference to the central, if absent, site of the gallery. Instead the second section examines projects such as *In the Midst of Things* (1999) in Bourneville, where the decision to locate a number of specially commissioned artworks across a specific territory is the strategic and conceptual decision of independent curators. This kind of work takes its inspiration from the ongoing projects at Munster and Documenta at Kassel, where artworks are curated throughout the city.

This simultaneous production of a number of artworks across multiple sites can be considered in relation to Rosalind Krauss's notion of an "expanded field," first introduced in 1979 to describe the work of artists producing interventions into the landscape. When Krauss expanded the term *sculpture* in relation to architecture and landscape, she did so by examining individual artworks. But contemporary practice seems to raise new questions concerning terminology and method. Is the expanded field best understood in terms of site, place, or space? Can the processes of art, architecture, and landscape design be better described in an interdisciplinary way as spatial practices?

In the 1970s one of the main projects for cultural geographers was the "reassertion of space in social theory."[7] In Marxist thought, time had been taken to be the active entity in shaping social production; space was merely the site in which social relations took place. For the first time, geographers such as David Harvey, Doreen Massey, and Edward Soja argued for the importance of space in producing social relationships and in so doing turned to the work of French philosopher Henri Lefebvre.[8] In *The Production of Space*, Lefebvre noted that one of the key problems with studies of space was the understanding of spatial practice as the "projection" of the social onto the spatial field. Lefebvre suggested instead that this relation was two-way: "Space and the political organization of space express social relationships but also react back upon them."[9] Soja described this concept of Lefebvre's as the "fundamental notion of the sociospatial dialectic: that social and spatial relations are dialectically inter-reactive, interdependent;

that social relations of production are both space-forming and space-contingent."[10]

In highlighting the importance of space rather than time in the postmodern period, cultural geography's "spatial turn" attracted academics from all kinds of disciplines. And by 2002 the time had come to reflect upon what could be called the "geographic turn." In *Thinking Space*, a collection of essays edited by geographers Mike Crang and Nigel Thrift, authors reviewed the "seminal" theorists whose "spatial thinking" had influenced geographers.[11] *Thinking Space* identifies a number of new themes in spatial thinking, such as experience and travel, trace and deferral, mobility, practice, and performance. Interestingly, such themes could also describe the focus of much recent art theory and practice, marking a new intersection between art and geography around spatial practice.[12]

Along with Lefebvre, the other equally influential thinker in the field of spatial theory is anthropologist Michel de Certeau, who, in his seminal text *The Practice of Everyday Life* develops an understanding of place and space connected to linguistic practice.[13] Drawing on Ferdinand de Saussure's notions of langue and parole (where langue is the complex of rules and conventions that constitute a language and parole is the practice of speech), for de Certeau "space is a practiced place."[14] While de Certeau's understanding of space as socially produced and experienced resonates with the work of cultural geographers, his arguments concerning "place" seem to be more problematic. In arguing for space as dynamic and constituted through practice, place somehow becomes fixed and passive in his writings, indeed at one point de Certeau compares place to a "tomb."[15]

The third section of this chapter looks at site-specific art in relation to de Certeau's notion of "space as a practiced place" and argues that in "practicing" specific places, certain artworks produce critical spaces. This last section examines the work of commissioning agencies such as Artangel, who work with selected artists to produce art in unexpected places in the city. The artworks produced by such commissioning agencies can be considered constellations, a little like a view of the night sky, where each one of the many stars we can see has a different life span. At a given moment each individual artwork can be understood as an isolated spot; however, when viewed as a constellation over time, places in the city are positioned in relation to one another, temporally as well as spatially.

Such a view fits very well with the understandings of place put forward by many of the authors in Steve Pile and Michael Keith's edited collection of essays, *Place and the Politics of Identity*.[16] And Doreen Massey has argued for an understanding of place as "unfixed, contested, and multiple." For Massey, although a place may comprise one articulation of the spatial or one particular moment in a network of social relations, each point of view is contingent and subject to change.[17] "Unfixing" place operates as a critique of writings in recent human geography and architectural theory that have emphasized the specific qualities of particular places, as if

they are somehow pre-given and not open to change or connected to wider conditions.[18] This work, including Yi-Tu Tuan's notion of topophilia and Gaston Bachelard's concept of topoanalysis, has been invaluable in emphasizing a humane, imaginative, and sensual understanding of place. Yet the focus on "genius loci," in architecture in particular, has had essentializing tendencies.[19] As Harvey has pointed out, highlighting the specific qualities of particular places is particularly problematic within the context of the expansion of postmodern global capitalism: " . . the less important the spatial barriers, the greater the sensitivity of capital to the variations of place within space, and the greater the incentive for places to be differentiated in ways attractive to capital."[20] The writings of Harvey and Massey, as well as Kwon and others, stress the importance of understanding the specifics of particular sites and places, but only in relational terms as parts of larger networks, systems, and processes, physically, and ideologically.

SITE, NON-SITE, AND OFF-SITE

Robert Smithson's *Spiral Jetty* (1970) was the focus of a conference held at Tate Britain in London in 2001. One of the key issues that emerged was our "distance" today from works of land art produced in the 1960s and 1970s, both historically and physically. It was mooted that this very remoteness has allowed the work to resonate in more speculative ways. Indeed the imagination of the audience might today be the most potent place land art occupies.[21]

Spiral Jetty, located on the Great Salt Lake in Utah, is an enormous coil that reaches into the lake counterclockwise. Fifteen hundred feet long and fifteen feet wide where it joins the shore, the jetty is made of 6,650 tons of black basalt rocks and earth taken from the site.[22] As part of his desire to "return to the origins of material" held in the site, along with other so-called land artists such as Michael Heizer, Nancy Holt, Walter De Maria, Mary Miss, Robert Morris, and Dennis Oppenheim, Smithson intervened in the landscape on a huge scale, often moving massive quantities of natural material.[23] *Spiral Jetty* has been discussed in terms of its impressive size and also, having been submerged by the lake for a long period, its visibility. Smithson's death in a plane accident in 1973 while surveying the site of another piece of work, *Amarillo Ramp* (1973), lends *Spiral Jetty* a heroic quality. Stimulated largely by the film Nancy Holt and Smithson made of its construction, more recent criticism has focused on the performative aspects of the work, while Tacita Dean's journey to find the jetty, *Trying to find the Spiral Jetty* (1997), locates *Spiral Jetty* as a site of pilgrimage.

Between 1965 and 1966 Smithson worked as a consultant artist to the architecture firm TAMS on designs for Dallas-Forth Worth Airport. This project alerted him to ways of working outside the gallery, to consider

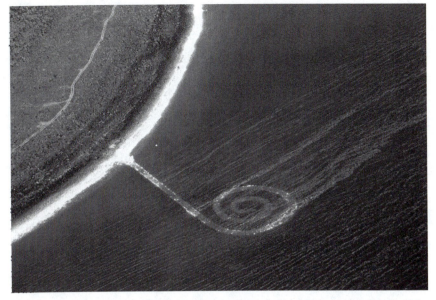

Figure 3.1 "Spiral Jetty," Robert Smithson. 1970, 6,650 tons of black basalt rocks and earth, 1,500' × 15', Salt Lake, Utah. Credit: Conford & Cross (2002).

31 subdivisions based on a hexagonal "airfield" in the Woodmansie Quadrangle–New Jersey (Topographic) map. Each subdivision of the *Nonsite* contains sand from the *site* shown on the map. Tours between the *Nonsite* and *site* are possible. The red dot on the map is the place where the sand was collected.[28]

Over the same time period Dennis Oppenheim had also been developing a similar interest in site. For example, in *Site markers with information* (1967) Oppenheim marked sites with aluminum posts which he photographed and described in writing.[29] "The site markers," he wrote, "effectively clouded the traditional distinctions between the artwork and the utilitarian object, and between the art context and the outside world."[30] Yet Smithson saw a number of differences between his own and Oppenheim's approaches to "the dialectic between the outdoors and the gallery":

> I think that what Dennis is doing is taking a site from one part of the world and transferring the data about it to another site, which I would call a dis-location . . . Where I differ from Dennis is that I'm dealing with an exterior and an interior situation as opposed to two exterior situations . . . I like the artificial limits that the gallery presents; I would say my art exists in two realms—in my outdoor sites which can be visited only and which have no objects imposed on them, and indoors, where objects do exist . . . [31]

The most comprehensive description of Smithson's concept of the dialectical relationship between site and nonsite can be found in his 1972 essay on *Spiral Jetty*. Here he lists the qualities of sites and "nonsites": the former have open limits, a series of points, outer coordinates, subtraction, indeterminate certainty, scattered information, and some place (physical), while the latter have closed limits, an array of matter, inner coordinates, addition, determinate uncertainty, contained information, and no place (abstraction).[32] Although Smithson stressed the relational or dialectical aspect of site and non-site, by using the term *non* the implication is that the site is assigned the more privileged position in the relationship. The inconsistent use of the hyphen complicates things further: *non-site* suggests a term whose identity is always related to a site and only by not being identical to it, whereas in *nonsite* the identity of the site and its negation are terms less clearly held in opposition.

From 1987 to 2006, the Dia Art Foundation had an exhibition program at the Dia Center for the Arts in a four-story renovated warehouse at 548 West 22nd Street in Chelsea, New York, but this gallery space was only one of a much larger collection of artworks sited in other parts of the city and state, as well as diverse locations in far-flung corners of the United States. From its early days Dia has supported projects that because of their nature and scale require unusual locations.[33] For example, one of De Maria's sculptures funded by the Dia Art Foundation is to be found in the high desert of southwestern New Mexico. *The Lightning Field* (1971–1977) consists of 400 stainless steel poles situated in a rectangular grid measuring one mile by one kilometer. To experience the work you must book in advance to stay in a residence at the site (which takes a maximum of six visitors), and visit at a time of year when lightning is expected. The artist describes how the work is to be viewed:

> The land is not the setting for the work but part of the work. A simple walk around the perimeter of the poles takes approximately two hours. Because the sky–ground relationship is central to the work, viewing "The Lightning Field" from the air is of no value. It is intended the work be viewed alone, or in the company of a very small group of people, over at least a 24-hour period.[34]

Inseparable from its context, much land art was intended as a critique of the gallery system and the role of art as commodity. However, resisting the site of the gallery by locating work outside its physical limits does not necessarily involve operating outside the institution of the gallery, economically and culturally. Indeed many works of land art would not exist without the funding of private patrons.[35] And although land art is often cited as a precedent for public art today, it was not always the aim of the artists of the 1960s and 1970s that their work be accessible. De Maria claimed that "Isolation is the essence of land art," and tightly controlled

the photographic documentation of his work and the conditions under which it was to be viewed.[36] Many works of land art, like *Spiral Jetty* and *The Lightning Field*, positioned in remote sites, have resulted in audiences composed only of dedicated specialists. Robert Morris suggests that land art is a paradoxical precedent for the rationale of accessibility that accompanies the "off-site" programs of many contemporary galleries:

> It would not be accurate to designate privately funded early works of Smithson or Heizer or De Maria in remote parts of the desert as public art. The only public access to such works is photographic.[37]

Located in SoHo, the art district of New York that preceded Chelsea in the history of gentrification, are two other works by De Maria, *The Broken Kilometer* (1979) and *The New York Earth Room* (1977). Originally commissioned by the Dia Foundation, they continue to be supported by Dia. At 393 West Broadway, on a polished wood floor, between the grids of the iron columns, De Maria placed five hundred brass rods in five parallel rows of one hundred rods each. Each rod is positioned such that the distance between the rods increases by five millimeters consecutively from front to back. This is the companion piece to De Maria's *Vertical Earth Kilometer* (1977), where a brass rod of the same diameter, total weight, and total length is inserted one thousand metres into the ground. Around the corner, at 141 Wooster Street, De Maria's *The New York Earth Room* is an interior earth sculpture, 335 meters square and fifty-six centimeters deep that, unlike his two other earth room sculptures in Munich (1968) and in the Hessisches Landesmuseum, Darmstadt (1974), still exists.

Along the street in Chelsea where Dia was located is a row of gray rocks, each one partnered by a young tree. The rocks are waist-high and the trees, though taller than the rocks, are still slender. In time they will grow to overshadow their markers, and in a time even further distant, the trees will die and only the row of rocks will remain, looking just as they do today. The rocks and trees are part of Joseph Beuys's project *7000 Oaks*, begun in 1982 at Documenta 7 in Kassel, Germany, and completed by the artist's son at the opening of Documenta 8 in 1987. Beuys's plan was for the planting of 7,000 trees, each paired with a basalt column, throughout the city and then the world. Beuys intended the work to be a social sculpture, a work of art made by many, transformed each time a tree was planted and a marker sited. In 1988 Dia installed five basalt stone columns, each paired with a tree, at 548 West 22nd Street, and in 1996 another eight tree/basalt pairs were planted down 22nd Street from 10th to 11th Avenues. In 2007 the trees mark the site once occupied by the Dia Center for the Arts.[38]

This work, like those of De Maria, sets up an interesting set of relationships between sites, yet says less about the particularities of the sites in which they are located. In Beuys's work growing tree and static stone are positioned in relation to one another and it is here that the dialectical

tension of the work resides. De Maria's choice of materials, implacable brass and earth treated with chemicals to keep it inert, are those that refuse change, but the contexts into which these materials have been inserted are in constant flux, culturally and economically as well as physically. In SoHo rents have risen dramatically since the original commissions twenty years ago. In *If You Lived Here . . .* , a project also commissioned by Dia between 1987 and 1989, ten years after De Maria's work, Martha Rosler emphasized gentrified places as sites of contestation and connected the arrival of art galleries in SoHo with the rising property prices.[39] Is this social context, the location where the work is "sited," also the work?

Between city and sky in a small urban park set among the rooftops of New York is a glass rectangle circling a cylindrical form, also constructed from glass.[40] The cylinder is almost the same size and shape as the water towers perched on the surrounding roofs. At times it is possible to see through the pavilion to the distant skyscrapers of downtown, to look through to the gap on the skyline where the twin towers used to be. At other times you are confronted by your own reflection. Whether the surface you face is glass or mirror depends on the weather and where you stand. In this work, like many others by Dan Graham, the cube references the grid of the city and modernist architecture, while the cylinder relates the surface of the body to the horizon line. Yet the positioning of this particular piece allows it to articulate questions concerning the limits of sites, of the gallery, and of the artwork, its particular position making it perhaps more pertinent than some of Graham's other works. On the roof you are inside the artwork, outside the building, yet still occupying territory owned by the gallery. Does the physical edge of a gallery mark the boundary of its site? Or, in Smithson's terms, does the rooftop become a site to the non-site of the gallery?

Looking up at the Camden Arts Centre, London, from the street below, the scaffolding wrapped around the first floor of the building suggests that construction works are underway. Inside, the gallery is empty except for a platform of scaffolding poles and planks positioned along the edge of the two walls making the corner. By stepping up onto the platform you can walk outside through a window. This installation by Mexican artist Jose Davila marked the start of a major refurbishment of the gallery in the summer of 2002, continuing "North London Link," a two-year program of off-site projects that had started in June 1999 and prompted a new series of works.[41] Unlike Graham's rooftop park, where one occupies the same physical boundary—its condition as a site changes conceptually—Davila's work negotiates the changing material conditions at the boundary of the site of the gallery, allowing the viewer to occupy a series of positions which change one's relationship to the physical edge of the art institution.

"North London Link" aimed to work with groups and communities within Camden. When Adam Chodzko was invited to make a piece of work as part of this off-site program he questioned the notion of an identifiable

"public" and accessibility. His intervention, *Better Scenery* (2000), was "an escapist proposition" consisting of two signs, one in the Arizona Desert and the other in the car park of a new shopping center, the O2 Centre, in Camden.[42] The O2 Centre is a highly simulated environment consisting of fake rock walls, a subtropical forest, water features, and palm trees. A slice of Las Vegas on the Finchley Road, it is the kind of place that could easily be described as an empty signifier.

Both signs are black; in plain yellow lettering each one gives clear directions of how to get to the other. Both sets of directions end with the phrase, "Situated here, in this place, is a sign which describes the location of this sign you have just finished reading."[43] The signs relate the two sites dialectically, giving neither one preference. But in pointing only to each other, their relationship is entirely self-referential; they make no attempt to relate to their immediate context. Neither sign can be described as site or non-site; the two are entirely equivalent, each one bound up in the other. In speaking only about where they are not Chodzko's signs question the ethos of site specificity and accessibility behind many off-site programs.

When the Ikon Gallery in Birmingham moved site, artist Tania Kovats worked with architects Levitt Bernstein, supported by a Royal Society of Arts grant, to generate ideas for the new building. Kovat's initiative was to clad the "plinth" on which the building sits in slate to increase its visual clarity. As you exit the Ikon you do so down steps profiled against a slate-gray plinth.[44] But where exactly is this artwork located, in a site, non-site or off-site? Walking away from the gallery through the city, you circle the edge of the infamous Bull Ring, one of the structures that inspired Pierre Huyghe's *Concrete Requiem* (2000), an orchestral composition created with composer James Bentley, played by the Birmingham Contemporary Music Group for the opening of "as it is," a series of artworks commissioned by the Ikon but located outside the gallery.[45]

It is hard to locate Birmingham "as it is," since the transformation of a city connected with industry, canals, and Spaghetti Junction is already accompanied by a nostalgia towards the concrete architecture of the recent past, as well as a cynicism towards the supposedly affluent global future. As you approach the canal, new designer shops and bars line the water's edge. Japanese artist Tadashi Kawamata made a meditation space here, a boat made out of discarded material, looking a little like the structure a homeless person might sleep in.[46]

In a nearby street, on the first floor of a warehouse in a neighbourhood undergoing regeneration, is a room with an invigilator seated behind a table laid out with art brochures and a sign-in book. The space beyond is occupied by ten boxes stacked two high, made of metal frames covered in plywood panels with circular holes cut out. The whole structure is no more than two meters tall. You can crawl onto the pink carpet floor though an entrance hole. In one place you can stand full height and look into all the rooms; two have sleeping sections with clean white duvets, another has a

television, in a fourth is a computer. Artist Andrea Zittel lived here, in her artwork *A-Z Cellular Compartment Units*, for a short period.

Zittel's work speaks of our aspirations for dwelling, from the hermit existing in splendid isolation to the fun we have playing "house." Set inside a warehouse building due to be converted into luxury new apartments, the work raises important issues concerning housing: the amount of space each person needs, the difficulties of sharing living accommodation, and the desire to compartmentalize activities. On first glance *A-Z Cellular Compartment Units* looks a little like a show house at an Ideal Home Exhibition, but on closer inspection the construction does not reveal the qualities of a prototype or a functional structure. The lack of weatherproof finishes, the omission of any plumbing, and the difficulty the construction creates for its occupants in terms of size and scale make it clear that this machine is not easy to live in. This work might look like architecture but Zittel does not intend us to take up residence here, rather to think about what that might mean.

Despite being located outside the physical confines of the gallery, the visible invigilation operates to maintain the institutional boundary of the gallery and position the work as art. Such works are commissioned as part of off-site programs, usually the domain of a different team of curators from those that curate the internal spaces of the gallery. These artworks are usually expected to be accessible to a general public and aligned with the needs of the educational program, their functionality, or directed social use, often resulting in a lower status for the work. "Off-site" programs may be carried out for pragmatic rather than for ideological reasons, for example, when the gallery premises are compromised by relocation or repairs. For this reason, I would argue against curators such as Elizabeth McGregor, one-time director at the Ikon, who in 1999 stated that the distinction between art commissioned inside and outside the gallery was becoming "less and less relevant."[47] On the contrary, precisely because certain kinds of curatorial practice, those that work with sites outside the gallery, continue to be downgraded within the gallery system, the differences that exist between sites, non-sites, and off-sites, demand critical investigation.

THE EXPANDED FIELD

Bourneville was built in the late nineteenth century as a village and factory complex in the British midlands. A paternalist development, it was conceived of by an enlightened capitalist, chocolate manufacturer George Cadbury, who wanted to create a pleasant environment for his workers. Despite the fact that it is built around a factory, an industrial development, Bourneville is modeled on the English village, with a green and bandstand, country-styled "cottages," and a row of shops. For "In the Midst of Things," curators Nigel Prince and Gavin Wade invited twenty-seven artists to make

works at Bourneville, both outside and in the buildings themselves.[48] "We were interested," they said, "in developing an exhibition that would provide a critique of existing social models and begin to move toward offering new propositions."[49]

In her 1979 essay "Sculpture in the Expanded Field," Krauss adopted the term *expanded field* from Robert Morris, as an extended physical and mental terrain for understanding "sculpture."[50] Krauss argued that in post-Renaissance art sculpture was defined as not-architecture and not-landscape, but that modernist sculpture had lost any relation to site, even a negative one, and become an abstraction or pure negativity. Adopting a technique called the "Klein" group, Krauss repositioned contemporary sculpture in relation to the positive as well as the negative aspects of landscape and architecture.[51] Within this field, as well as "sculpture" (not-architecture and not-landscape), Krauss identified three new sculptural conventions, "site construction" (landscape and architecture), "marked site" (landscape and nonlandscape), and "axiomatic structure" (architecture and nonarchitecture).[52]

The central feature of the method used by Krauss is the semiotic square.[53] Fredric Jameson has described this square as "the supreme achievement of Greimassian semiotics."[54] Based on binary opposition, or in philosophical logic a contrary or strong opposition, for example black versus white, the semiotic square is capable of generating at least ten positions. First there are the contradictory or simple negatives of the two dominant terms, nonwhite and nonblack, then the compound, white and black, known as the complex or utopian term, and finally the neutral term, nonblack and nonwhite. Jameson suggests that the square offers a "discovery principle," one that can be used to "map out and articulate a set of relationships." However, he emphasizes the importance of the "inaugural decision," the choice and arrangement of the terms of the original opposition, as well as the "peculiar nature" of the fourth term or "the negation of the negation."

> This must be (when the operation is successful) the place of novelty and of paradoxical emergence: It is always the most critical position and the one which remains open or empty for the longest time . . . The semiotic square is thus not static but dynamic.[55]

Krauss's inaugural decision, the placing of *nonarchitecture* and *non-landscape* in opposition to one another as a response to the term *sculpture*, limits the potential of possibilities for the square, especially for the fourth term or the negation of the negation. Her expanded field produces a set of categories which in their different combinations extend the possibilities for sculpture, but avoid the temporal aspect of the square and so the importance of discovering the potential of the fourth term. In a response to Krauss's essay Craig Owens critiqued her method, arguing that post-structuralist discourse should involve a questioning of categories based on logic,

rather than their reassertion.[56] A later publication, *The Optical Uncon-scious*, was a move in this direction. Here Krauss again uses the semiotic square, this time to rethink the relation of figure and ground in modernism. Reflecting a little more on her own method and aim to understand mod-ernism as a "graph or table rather than a history," Krauss highlights her preference for exploring logic "as a topography rather than following the threads of it as a narrative." Again she generates a square out of an opposi-tion, this time figure ground, but in order to develop a more process-based operation, Krauss juxtaposes her square with Jacques Lacan's "Schema L," bringing vision and consciousness into her argument.[57]

In 1979 Krauss's term *the expanded field* indicated the need to extend the critical discourse of art in order to accommodate new kinds of artworks produced in the 1960s and 1970s. Today, Hal Foster has suggested that the expanded field described by Krauss has imploded and that the categories are no longer held in productive contradiction.[58] In my opinion this does not mean that we should abandon all attempts to think through categories, but rather that we might question the sufficiency of the kinds of categories we use, that those we employ to explore art still tend to prioritize questions of form. Instead we need to generate new categories, ones that allow us to understand artworks as products of specific processes, of production and reception, operating within an expanded and interdisciplinary field. Artists choose to operate at sites within, at the edge of, between, and across dif-ferent disciplinary territories, for example, art, design, architecture, and landscape, and they do so by adopting methods that call into question dis-ciplinary procedures.

Concern for the single women working in the factory at Bourneville resulted in the "Women's Recreation Area," a space just for women with a pond and a fountain. This area had not been maintained and Cornford & Cross decided to restore it for their project *Utopia (Wishful Thinking)*. The artists refilled the pond with water dyed purple, installed two splash-ing fountains and had new paving stones laid around the edges. Purple is the trademark color of Cadbury's, and, with white and green, is also one of the three colors of the suffragette movement. Dye prevents photosyn-thesis from taking place, so slowly the plant life in the pond died away. Since the artists spent their budget on repairing and restoring part of the property, in a sense their art is an offering, a gift to Bourneville, but as with all gifts there is something expected in return. In referencing the sickly and suffocating effect of paternalism, the work questions the ideal-ism of utopian schemes, hinting perhaps at a patronizing and controlling edge to the apparently benign aspirations at Bourneville. This work given as gift challenges the ideology and values of Bourneville and demands critical thinking as its countergift.[59]

On first glance, *Utopia (Wishful Thinking)* could easily be confused for a piece of design rather than fine art. It is only the lifelessness of the pond, perceptible only after several minutes, and still possible to ignore,

that gives the game away. The work raises a thematic that appears in the projects of many of the artists invited to participate in "In the Midst of Things"—the crossover between art as a critical venture and design as a problem-solving exercise. The new canopies on the canteen provide an example of another artwork that also "looks like" design. Kathrin Böhm started her research by finding out from members of staff at Cadbury's if there was a need, anywhere on the site, for an artist who worked with public space and color.[60] Böhm produced fabric "canopies" for the canteen in bright stripes of blue and yellow, stating, "I wanted to respond to a need rather than just go looking for a possibility offered up by the site."

How is this work different from what a textile designer might produce? Why is one thing designated art and another design, we might ask? These are questions increasingly emerging as a growing number of artists engage in territories usually associated with urban design and architecture. As well as "looking like" design—a piece of paving or a canopy—these artists adopt design-like working methods, for example, responding to a need or fixing things that are broken, activities that would usually fit within the architect's brief or the repair and maintenance schedule. The artists in "In the Midst of Things" appear to be "designing" objects, but not in the way a designer might. Is it the reflexive nature of the practice that makes this work art and not design?

Utopian design visions have often addressed social problems by attempting to solve them. Modernism had it that new designs and spaces would determine new forms of social relation. Architecture, as Le Corbusier was keen to point out, was the alternative to social revolution.[61] But the curators and artists involved in "In the Midst of Things" are not interested in a modernist utopia that attempts to solve all the problems of the world through design. The projects that tend toward the utopic in their vision have questions rather than answers as their intentions. It is in this sense that art can offer architecture and design a chance to think critically about their recent history and present aspirations.

Many of the invited artists made pieces of architecture that required occupation to allow them to function. Liam Gillick's *Big Conference Platform Platform* (1998), a "canopy" grid of anodised aluminum and perspex jutting out into an interior space above head height, was a continuation of his exploration of the tensions between planning and speculation through the language of architecture.[62] Placed on the green and open at both ends, *Holy Ghost*, Jacqueline Donachie's Quaker-inspired shed-hut, became inhabited by a group singing "Amazing Grace" and surrounded by a crowd drinking beer.[63] A group of ten kiosks for dialogue, Lucy Orta's *Life nexus Fete*, created another social space.[64] In line with their attempt to realize a utopian village and free state of their own called AVL-Ville, Atelier van Lieshout made *AVL-Canteen*, the transformation of a forty-foot sea container into a kitchen.[65]

In February, 1966, in "Notes on Sculpture, Parts 1 and 2" Robert Morris argued that unlike pictorial work sculpture was not illusionist, that it had a "literal nature," and that clearer distinctions needed to be made between sculpture's "tactile nature" and the "optical sensibilities involved in painting."[66] In June of the same year, David Antin wrote that sculpture was "a specific space in which the observer is thrust, i.e., it is a place."[67] And again in the same year, this time in October, David Bourdon quoted Carl André's account of the development of modern sculpture from form, through structure, to place, and his statement on *Cuts*, André's show in March, 1967 at the Dwan Gallery in Los Angeles, "I now use the material as the cut in space."[68] In the same issue of *Artforum*, in Part 2 of his "Notes on Sculpture," Morris, following Tony Smith, took up the question of scale and located minimalist work at a human scale between the private object and public monument, as one term in an expanded situation.[69] Smithson describes the shift in his own thinking at this time, from an interest in specific objects to a more relational way of "seeing" the world where the works "became a preoccupation with place."[70] For Dennis Oppenheim, 1967 was the year when the "notion of sculpture as place was manifest."[71]

The discovery of sculpture as a place articulated above by a number of prominent artists was startlingly new in 1966 and 1967. An interest in the relationship between art and space continues to underscore much contemporary practice, but what distinguishes much of today's artwork from the work of the 1960s and 1970s is the process-based nature of the spatial interest and the kind of occupation that many artworks require in order to function. Krauss's expanded field might be a physical extension of the terrain of the gallery and an expansion of the category of sculpture in terms of its relation to landscape and architecture, yet it does not question the ideological territory of the gallery nor discuss how we might extend the possibilities of making and viewing objects and places in ways that go beyond traditional art discourse to consider function and use, words usually associated with design-based disciplines. The other structures that populate sites outside the gallery, as well as the diverse practices and meanings that inhabit these places, are not brought into play, either by the artists or by the critic herself. So how can we expand the field further, to think of art not in a site or as a place but in terms of spatial practice, and consider the relationship between art practice and those practices that occur beyond the gallery, those not normally associated with art?

At Bourneville Darren Lago demanded participation through gardening to produce his artwork. He worked with the Gardener's Association to create a series of cabbage beds scaled off the size of a chocolate bar. Chocolate was included in the soil and the cabbages were grown in purple dye so that they looked faintly purplish in color. *Chocolate Garden* was planted like a series of ornamental rose beds in the green lawns of Bourneville. In England, where the vegetable patch is usually associated with the back garden

rather than the flowerbeds of the front garden or park, they felt strangely out of place.[72]

In Foster's reading of minimalism, in relationship with the viewer, the sculpture is off the pedestal, "re-positioned among objects and re-defined in terms of place."[73] Foster argues that the need to create a direct physical relationship with the viewer was part of an attempt to avoid positioning the work as idealist, and that for certain artists, minimalism replaced the idealist Cartesian "I think" and the abstract expressionist "I express" with "I perceive." Today's artworks located outside the gallery cannot be fully grasped through perceiving. Many require both perception *and* conception as responses from the subject; they position themselves as places for both physical and intellectual engagement, and in some cases, imagined occupation as well as actual inhabitation.

Gary Perkins makes models of interiors, sometimes of domestic settings or the inside of lorries and vans. He places cameras in some of the models and relays the image to a nearby monitor. As we gaze from a safe distance into spaces that have been miniaturized and which prioritize our view in, Perkins's work locates us, as viewers, as omnipotent subjects, and draws on certain voyeuristic aspects of looking. The piece of work Perkins made for Bourneville was prompted by a visit to London's Millennium Dome. *Soon All This Will Be Yours* consisted of a half-circle of rooms complete with the detritus of simple everyday activities like mending the car.[74] Despite being perfectly made and representing ordinary domestic settings, the scenarios Perkins replicates are strangely disturbing. We are torn between wanting to decipher the "real" spaces they refer to and avoiding the issue by thinking instead of these places as fictions.

Placed within architectural discourse, Perkins's scenes would be understood as scale models of existing spaces or proposals for new designs, but by positioning them as artworks we are able to consider them more critically. Conventional architectural design prefers to locate the model either as a representation of real space or as a fiction, not as both. Models might be used as conceptual diagrams or research tools for clarifying an idea or as scaled-down replicas of the "real thing" that demonstrate to the client, developer, or end user the way the building will look and be constructed. Taken out of such a context and presented with no such proposal of intention, no site plan or map, the architecture model can operate both as determination and speculation.

Nathan Coley's *A Manifesto for Bourneville* also uses architectural models but in a different way. His project reworks the famous "New York Skyline" of 1931, a photograph taken at the Beaux Arts Ball in Manhattan, where the architects of famous buildings such as the Chrysler Building came dressed as their own work. Coley created a series of architectural models that could be worn as hats, including a model of the rest house in Bourneville, as well as a Frank Gehry and a Mies van der Rohe building. Coley then asked a photographer to take an image of five people with these

cardboard models on their heads. A text placed below suggested that the models were responses to an invitation to redesign the rest house. The photograph, measuring six feet by three feet, was placed at the end of a tunnel that ran from the Women's Recreation Ground to the factory. This involved developing a site not previously open to the public. Since the Men's Recreation Grounds were located at the far end of the tunnel, Coley speculated that the tunnel might have been used as a place for secret assignations.[75]

By choosing a place with a contentious social and architectural history, for "In the Midst of Things" the artists were able to expand the field of art practice towards complex territories of interdisciplinary working and the sociospatial as well as the aesthetic qualities of sites. In a radical development of the choice Foster describes between the perceptual experience offered by minimalism and the intellectual challenge posed by conceptualism, many works produced for "In the Midst of Things" demanded both intellectual engagement and active occupation. The scale of Bourneville made it possible to walk through the entire site and to see works sequentially and in juxtaposition. A work might occupy the foreground and then recede to become a backdrop, offering the viewer multiple, changing, and sometimes conflicting ways of experiencing art.

SPACE AS A PRACTICED PLACE

For *Breakdown*, Michael Landy decided to destroy everything that he owned, 7,010 objects in fifteen days.[76] From a pair of slippers to a drawing given as a gift by artist friend Tracey Emin, each object was placed in a plastic bag, labeled with an inventory number, and circulated on a large conveyor belt running around the center of a vacant C&A store at the western end of Oxford Street near Marble Arch in London. Men and women dressed in blue overalls took the objects apart and in some cases broke down their material components as well, removing plugs and passing pieces of wood into shredders. Pinned onto the walls at the back of the one-time department store were lists of objects under categorical headings such as Electrical Equipment, Furniture, and Clothing.

In the context of Oxford Street, any attempt to refuse to buy, let alone to destroy commodities, is a strong one. But however clear the gesture, Landy's artwork raises a number of problems. Landy chose not to distinguish between different kinds of object—gifts, souvenirs, commodity consumables, originals, replicas—all were broken down.[77] Academic research into collecting, material culture, and gift economies, suggests complex discriminations exist between different kinds of objects. This is an essential aspect to any critique of commodity capitalism, given an added twist if we consider that the economic value of the art objects Landy himself makes will increase in relation to his status as an artist, possibly as a direct result of the destruction of these objects. But perhaps this is doing

Landy a disservice: the bluntness of the breakdown may well be intended to bring us to our senses and make us think about the sheer number of objects that exist in the world, partly as an effect of the increasingly particular demands we in the West exert as consumers.

Performance plays a major role in *Breakdown*. Activities that take place on the production line, in the recycling plant, and at the landfill site are referenced by being performed, and in so doing make connections to a number of different sites linked to the lives of commodities. But what kind of relationship is Landy trying to establish between these sites, and how does he use performance to make his points? Irony, parody, mimicry—all these are modes of performance whose relationships with the "original" action differ: some copies aim to be exact whereas others exaggerate difference for comic effect. The problem with *Breakdown* was the lack of precision with which the objects were broken down. Some were taken apart physically, but not all and not to the same extent; some component materials were destroyed, but the logic of this was not based on the need to recycle, but on a bizarre sort of pragmatics. As far as I could see, the only material that was fully broken down was wood, since wood was the only material the shredder on site could shred!

De Certeau's understanding of the difference between space and place is closely related to his notions of practice, tactic, and strategy. In de Certeau's terms, practices move across divisions between place, time, and types of action, allowing connections to be made between places and their counterpoints or activities and their variants located elsewhere. As types of practice, strategies seek to create places that conform to abstract models; tactics do not obey the laws of places.[78] In the case of *Breakdown*, Landy's reference to sites located elsewhere, those involved in the breakdown of commodities, demanded that shoppers reflect upon the predominant activity of Oxford Street—shopping or the accumulation of commodities—in an extended manner, in relation to variants of that activity. Yet the decisions made by Landy concerning the performance itself seemed to be based less on aesthetic criteria and critical tactics and more on what it was possible to achieve in the given context. Landy created a space that practiced a critique of the place of commodity consumption, but exactly what he had to say about the lives of different kinds of object and the ethical issues around consumption is less clear.

Jeremy Deller's *The Battle of Orgreave* (June 17, 2001) was a restaging of one of most violent confrontations of the miners' strike, an act of resistance that took place on June 18, 1984 in the town of Orgreave outside Sheffield in the United Kingdom.[79] Although the site was the same, the cold and windy weather of 2001 compared to the boiling heat of 1984 made the crowd at the start of the day mutter that things weren't quite the same as they remembered them. But at the sound of the cry "Maggie, Maggie, Maggie. Out, Out, Out," the atmosphere changed. My own fury at the aggression of Margaret Thatcher's policies, the unrealistic characterization of the

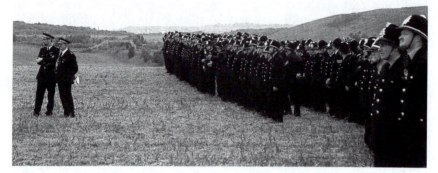

Figure 3.2 "The Battle of Orgreave," Jeremy Deller. 2001, Sheffield. Credit: Conford & Cross (2001).

mine workers, the dismissal of the unions, and worst, in the dreadful wake of Thatcherism, the apparent lack of dissent, all came flooding back. I felt vaguely uncomfortable with such a powerful emotional response. Although I had an affinity with Sheffield, I had chosen to live there because of what the place represented to me: "the socialist republic of South Yorkshire." I was not a miner and I had not been in Orgreave on that June day.

As a historian, I am slightly sceptical of empathy and the ease with which authenticity is ascribed to experiential accounts. There were plenty such testimonials to be told at Orgreave that day. Miners and their families were keen to discuss the battle and its ensuing ramifications. Local opinion favored Deller's work, focusing on how important it was to remember an event rather than worry about whether it was an accurate reconstruction of the past. Although Deller involved a battle reenactment society to restage the event, some of the miners chose to play themselves and some sons played their fathers. (It is worth noting that only one policeman played himself.) The presence of cameras filming the battle for broadcast as a documentary film directed for television by Mike Figgis enhanced the role-playing aspect of the event, prioritizing for viewers, especially those located behind the cameraman, a consideration of the "facts" not as they had occurred in the past but as they were being constructed in the present.

In his desire to examine a moment of resistance, Deller's work is clearly a piece of political art in a socialist tradition, but it is not a piece of social realism. Despite what we now know of the media's distortion of events and their misrepresentation of the actions of the police in this battle that served

to undermine the power of the trade union, Deller portrayed the day in a fairly even-handed manner, as a battle of two sides, miners and policemen. Somehow I would rather he had been a bit more Benjaminian, that he had "rubbed up" history against the grain. After all, Orgreave marked a turning point in the strike and the first use of military strategies by the police for settling resistance. But perhaps by appearing to fall in line with the reenactment society's dogged desire for so-called historical accuracy in replaying the battle scenes, Deller's approach revealed a certain irony and a mode of telling that was more self-conscious and critical in its attitude to historical representation than he let on.

In recreating a political struggle that took place at a specific moment, *The Battle of Orgreave* points to the importance of time in the practice of place, something that remains underdeveloped in de Certeau's theoretical propositions on space and place. By drawing on the importance of temporality of the practicing of place, Deller's work shows how an act of remembering the past can reconfigure a particular place in the present. *The Battle of Orgreave* points to the potential offered by a specific moment and the importance of repetition as remembrance in recognising this.

Both Deller's and Landy's projects were commissioned by Artangel, an agency who selects, funds, and helps artists produce mainly temporary work for unusual sites in the United Kingdom.[80] From magazine inserts to short films for television, from an empty clubhouse in London's West End to a suburban storage center, the constellation of sites mapped by Artangel projects follows the choices of the artists they have chosen to work with. It is interesting to compare this approach to that of the Public Art Development Trust (PADT), a public art consultancy set up by Sandra Percival, for whom the starting point is the site,[81] or to New York's Public Art Fund, who curate work for preselected locations in the city, including Madison Square Park, City Hall Park, the southeast corner of Central Park, and Metro Tech Center in Brooklyn, as well sites chosen by artists.[82] And, of course, there are similar organizations all around the world, each with their own particular approaches to the commissioning of artworks in the cities in which they operate.[83]

The works described above elaborate de Certeau's understanding of space as a practiced place through social explorations of the particular sites in which they are located, but also by intentionally positioning one site next to another. Through actions and occupations, these artworks practice places and explore the spaces between these places. They demonstrate that site-specific work is not necessarily a condition of "undifferentiated serialization" of "one place after another," but that by considering the particularity of one place in relation to another, certain artworks can be understood to, as Massey might put it, "unfix" places. Does the act of performing an activity in a displaced location or repeating an event have the potential to be transformative? By performing spatial practices art can focus attention on the critical potential of a place, and turn reactionary actions into de Certeau's "tactics," or what I might call critical spatial practices.

NOTES

1. This chapter is based on material from my sole-authored book on the subject of critical spatial practice. See Jane Rendell, *Art and Architecture: A Place Between* (London: IB Tauris, 2006).

2. See Nick Kaye, *Site-Specific Art: Performance, Place and Documentation*, (London: Routledge, 2000) and Alex Coles, ed., *Site Specificity: The Ethnographic Turn* (London: Black Dog Publishing, 2000). Julie H. Reiss argues that site specificity is one of the key characteristics of installation art. See Julie H. Reiss, *From Margin to Center: The Spaces of Installation Art* (Cambridge MA: MIT Press., 1999).

3. Hal Foster, *Design and Crime (and Other Diatribes)* (London: Verso, 2002), 91.

4. Miwon Kwon, *One Place After Another: Site Specific Art and Locational Identity*, (Cambridge, MA: MIT Press, 2002), 1.

5. Ibid., 166.

6. James Clifford, interviewed by Alex Coles, "An Ethnographer in the Field" in *Site Specificity*, 52–73.

7. Edward Soja, *Postmodern Geographies: The Reassertion of Space in Social Theory* (London: Verso, 1989).

8. See David Harvey, *The Condition of Postmodernity*, (Oxford: Wiley-Blackwell, 1989) and Doreen Massey, *Space, Place and Gender*, (Cambridge: Polity Press, 1994).

9. Henri Lefebvre, *The Production of Space*, (Oxford: Wiley-Blackwell, 1991), 8. This quote from Henri Lefebvre emphasized by David Harvey is discussed in Soja, *Postmodern Geographies*, 81. See footnote 4.

10. Ibid., 81.

11. Mike Crang and Nigel Thrift, eds., *Thinking Space* (London: Routledge, 2000).

12. Mike Crang and Nigel Thrift, "Introduction," in Crang and Thrift, eds., *Thinking Space*, 1–19, 24–30.

13. Michel de Certeau, *The Practice of Everyday Life* (Berkeley: University of California Press, 1988). See also Michel de Certeau, Luce Giard, and Pierre Mayol, *The Practice of Everyday Life, Volume 2: Living and Cooking*, (trans. Timothy J. Tomasik), (Minneapolis: University of Minnesota Press,1998).

14. de Certeau, *The Practice of Everyday Life*, p. 117.

15. Ibid., 118.

16. Michael Keith and Steve Pile, eds., *Place and the Politics of Identity* (London: Routledge, 1993).

17. Massey, *Space, Place and Gender*, 4–5.

18. See for example Gaston Bachelard, *The Poetics of Space* [1958], trans. Maria Jolas (Boston: Beacon Press, 1969) and Yi-Fu Tuan, *Topophilia: A Study of Environmental Perceptions, Attitudes, and Values* (New Jersey: Prentice Hall, 1974). See also Edward S. Casey, *The Fate of Place: A Philosophical History*, (Berkeley: University of California Press, 1997).

19. See for example Paul C. Adams, Steven Hoelscher, and Karen E. Till, eds., *Textures of Place: Exploring Humanist Geographies*, (Minneapolis University of Minnesota Press, 2001), xix.

20. Harvey, *The Condition of Postmodernity*, 296.

21. "Land Art: The Enigma of Robert Smithson's 'Spiral Jetty,'" Tate Britain, London (March 23, 2001).

22. Suzaan Boettger, *Earthworks: Art and the Landscape of the Sixties* (Los Angeles: University of California Press, 2002), 202.

23. Robert Smithson, "The Spiral Jetty," in *Robert Smithson, The Collected Writings*, ed. Jack Flam (Los Angeles, 1996), 143–153.

24. Boettger, *Earthworks*, 55–58. See Robert Smithson, "Towards the development of an air terminal site," in *Robert Smithson*, ed. Flam, 52–60 and "Interview with Robert Smithson for the Archives of American Art/Smithsonian Institution", Ibid., 270–296, 291.
25. "Earth (1969), Symposium at White Museum, Cornell University," in *Robert Smithson*, ed. Flam, 178.
26. See Robert Smithson, "Entropy and New Monuments,"in *Robert Smithson*, ed., Flam, 10–23 and Smithson, "A Tour of the Monuments of Passaic, New Jersey," Ibid., 68–74.
27. Discussions with Heizer, Oppenheim and Smithson/Liza Bear and Willoughby Sharp, in *Robert Smithson*, ed. Flam, 244. This discussion was first published in *Avalanche Magazine* Fall 1970, 3.
28. Boettger, *Earthworks*, 67.
29. Germano Celant, *Dennis Oppenheim* (Milan: Charta 1997), 28–29. See also Celant, "Dennis Oppenheim: Explorations," in *Dennis Oppenheim: Explorations*, by Germano Celant (Milan: Charta, 2001), 9–27.
30. Alanna Heiss, ed., *Dennis Oppenheim, Selected Work 1967–1990*, New York and London: ICA, PS1), 10.
31. Flam, ed., *Robert Smithson*, 244.
32. Smithson, The Spiral Jetty, (1972), in Flam, Robert Smithson, 152–153.
33. The original patronage of Philippa de Menil and Heiner Friedrich founded the Dia Foundation in 1974. Their interest was in commissioning and funding exceptional projects, such as "The Lightning Field" by Walter De Maria and works by Judd, Heizer, Turrell, and Beuys, among others. The Lone Star Foundation, set up in 1976, had a different objective—to make a collection. In 1987 Dia opened an exhibition space in Chelsea in Manhattan, whose exhibition program included the commissioning of new works by artists who came to maturity in the 1960s as well as younger and mid-career artists. The premise was long-term single-artist projects. Some of these works have entered the collection, for example, works by Robert Irwin and Bridget Riley. In May, 2003, a new space, Dia:Beacon, opened in upstate New York to put more of this permanent collection on display, to provide long-term and in-depth presentations of works by single artists. The building was renovated in consultation with American artist Robert Irwin and the architectural team Open Office. Artists were consulted regarding the choice of gallery space and disposition of their works. These comments are based on a discussion with the curator of the Dia Art Foundation, Lynne Cooke, in February, 2003. See also www.diacenter.org (accessed 14 March 2006).
34. Walter De Maria quoted in Nicolas De Oliveira et al., *Installation Art*, (London: Thames and Hudson, 1994), 34.
35. Boettger, *Earthworks*, 111–115, 215.
36. Walter De Maria quoted in de Oliveira et al., *Installation Art*, 34.
37. Robert Morris, Earthworks: Land Reclamation as Sculpture, in *Critical Issues in Public Art: Content, Context and* Controversy, eds. Harriet F. Senie and Sally Webster (New York: HarperCollins, 1992), 251.
38. The project, supported substantially by Dia, was managed through the Free International University (FIU). See Fernando Groener and Rose-Marie Kandler (eds) *7000 Eichen: Joseph Beuys* (Cologne, 1987).
39. Rosalyn Deutsch, "Alternative Space," in *If You Lived Here: The City in Art, Theory and Social Activism—A Project by Martha Rosler*, ed. Brian Wallis (Seattle: New Press, 1991), 55.
40. The park includes a pavilion designed by the artist Dan Graham in collaboration with architects Moji Baratloo and Clifton Balch, and a Video Salon with a coffee bar showing work selected by the artist. See also Dan Graham, *Pavilions*, (Munich: Kunstverein München, 1988).

41. This programme included Anna Best, "MECCA," State Mecca Bingo Hall; Felix Gonzalez-Torres "Untitled" (America), (1994–1995); Maurice O'Connell, "On Finchley Road," and Orla Barry, "Across an Open Space." Others artists worked with participants at Swiss Cottage library and the Royal Free NHS Trust.

42. See Will Bradley et al., *Adam Chodzko, Plans and Spells* (London: Film & Video Umbrella, 2002), 40–41. See also Adam Chodzko, "Out of Place," in *Out of the Bubble, Approaches to Contextual Practice within Fine Art Education*, eds. John Carson and Susannah Silver (London: Central Saint Martins College, 2000), 31–36.

43. Bradley et al., *Chodzko, Plans and Spells*, 40–41.

44. See Tania Kovat in collaboration with Levitt Bernstein Associates, New Ikon Gallery, Birmingham, *Frontiers: Artists and Architects, Architectural Design*, n. 128, (London, Ikon Gallery 1997), 94–95.

45. See *As It Is* offsite exhibition by Ikon Gallery, Birmingham Birmingham (2000); also Claire Doherty (ed) *Out of Here: Creative Collaborations beyond the Gallery* (Birmingham Icon Gallery 1998).

46. *As It Is*, 70–73. See also Tadashi Kawamata, *Field Work* (Hannover: Hatje Cantz Publishers, 1998).

47. Elizabeth McGregor, *Public Art Journal* 1, no. 1 (March 1999) 14.

48. See Nigel Prince and Gavin Wade, eds., *In the Midst of Things* (London: August Media Ltd., 2000). See also Gavin Wade, ed., *Curating in the 21ˢᵗ Century* (Walsall: New Art Gallery University of Wolverhampton, 2000).

49. Ibid.,12.

50. Rosalind Krauss, "Sculpture in the Expanded Field," in *Postmodern Culture*, ed. Hal Foster (UK: Pluto Press, 1985), 31–42. This essay was originally published in *October* 8 (Spring 1979).

51. Ibid., 36–38.

52. Ibid., 33.

53. Ibid., 43. See footnote 1. Here Krauss references Marc Barbut for a discussion of the Klein group and A. J. Greimas and F. Rastier for the Piaget group, two different versions of the square. See Marc Barbut, "On the Meaning of the Word 'Structure' in Mathematics," in *Introduction to Structuralism*, ed. Michael Lane (New York: Basic Books, 1970) and A. J. Greimas and F. Rastier, "The Interaction of Semiotic Constraints," *French Yale Studies*, n. 41, (1968), 86–105. Babut notes that the rediscovery of the Klein group in terms of its axiomatic basis and "operations of rudimentary logic" is called the Piaget group by psychologists. Barbut, "'Structure' in Mathematics," 379. In later writings. Krauss suggests that Greimas's work is a "transformation of the Klein group" and a reformulation of the semiotic square. See Rosalind E. Krauss, *The Optical Unconscious*, (Cambridge, MA: MIT Press, 1994), 28, Bibliographical Note.

54. Fredric Jameson, "Foreword," in *On Meaning: Selected Writings on Semiotic Theory*, Algirdas Julien Greimas (trans. Paul J. Perron and Frank H. Collins), (London: University of Minnesota Press, 1987), xiv-vi.

55. Ibid., vi.

56. see Jeffrey Kastner, ed., *Land and Environmental Art*, (London: Phaidon Press, 1998), 37 for a discussion of Craig Owens's "Earthworks" (1979).

57. Krauss, *The Optical Unconscious*.

58. Foster, *Design and Crime*, 126.

59. Prince and Wade, eds., *In the Midst of Things*, 116–119.

60. Ibid., 65.

61. See for example Neil Leach, "Architecture or Revolution?" in *Architecture and Revolution*, ed. Neil Leach(London: Routledge, 1999), 112.

62. Ibid., 72–73.
63. Ibid., 50–53.
64. Ibid., 60–63.
65. Ibid., 84–87.
66. Robert Morris, "Notes on Sculpture 1–3," in *Art in Theory 1900–1990: An Anthology of Changing Ideas*, eds. Charles Harrison and Paul Wood (Oxford: Blackwell, 1992), 814. Part 1 was first published in *Artforum* (February 1966), 42–44.
67. See David Antin, "What is an Environment?,"*Art News* (April 1966), referenced in Boettger, Earthworks, 211.
68. David Bourdon, "The Razed Sites of Carl Andre," in *Minimalism: A Critical Anthology*, ed. Gregory Battcock (Berkeley/Los Angeles: University of California Press 1995), 103–108. Reprinted from *Artforum* (October 1966), 103–104.
69. Morris, "Notes on Sculpture 1–3," 816. Part 2 was first published in *Artforum* (October 1966) 20–23.
70. "Interview with Robert Smithson," 296.
71. Celant, *Dennis Oppenheim*, 29.
72. Ibid., 58–59.
73. Hal Foster, *The Return of the Real: The Avant-Garde at the End of the Century* (Cambridge, MA: MIT Press, 2001), 38.
74. Prince and Wade, eds., *In the Midst of Things*, 88–91.
75. Ibid., 112–115.
76. Michael Landy, "Breakdown" (2001), C&A Store at Marble Arch, 499–523 Oxford Street, London, W1. See Gerrie van Noord, ed., *Off Limits, 40 Art Angel Projects* (London, Merrell 2002), 162–167 and Michael Landy, *Breakdown* (London: Artangel, 2001).
77. See for example Dave Beech, review of Michael Landy, "Breakdown," *Art Monthly* (March 2001), 30–31.
78. de Certeau, *The Practice of Everyday Life*, 29.
79. See van Noord, ed., *Off Limits*, 190–195 and Jeremy Deller, *The Battle of Orgreave* (London: Artangel, 2002). See also Dave Beech, review of Jeremy Deller, "The Battle of Orgreave," *Art Monthly* (July/August 2001), 38–39.
80. Artangel has been commissioning artworks since the early 1990s when the company was set up by James Lingwood and Michael Morris, both of whom had previously worked at the ICA (The Institute of Contemporary Arts) in London. See van Noord, ed., *Off Limits* and www.artangel.org.uk.
81. For work commissioned by Public Art Development Trust in London, see www.padt.org.uk and the series of publications, *PADT Documentary Notes*.
82. In New York the Public Art Fund has been operating for twenty-five years to support emerging and established artists' projects, installations, and exhibitions in alternative venues throughout New York City. PAF is a nonprofit arts organization; financial support comes from a combination of donations from individuals, foundations, and corporations, and as public funds from The New York State Council on the Arts and the New York City Department of Cultural Affairs. See the Public Art Fund Journal, *InProcess*, *Public Art Fund Publications* and www.publicartfund.org.
83. See for example Bulkhead (1999–2001) in Glasgow, Locus+ in Newcastle and Sunderland, and Arte Cuidad in Sau Paulo, Brazil. See Pauline van Mourik et al., *Locus Solus: Site, Identity and Technology in Contemporary Art* (London: Black Dog Publishing, 2000) and www.bulkhead.org.uk.

4 "Be a Crossroads"[1]
Public Art Practice and the Cultural Hybrid

Margaret Adamek and Karl Lorenz

". . . the future will belong to the mestiza. Because the future depends on the breaking down of paradigms, it depends on the straddling of two or more cultures."

(Anzaldùa, Borderlands/La Frontera: The New Mestiza, p. 80)

One may well ask what is still to be written about public art. At this point in its thirty-or-so-year history, articles and essays covering virtually all aspects of the public art process and practice have appeared. Case studies of the many facets surrounding the contracting, funding, consultation/collaboration phase, or working with architects, urban planners, and communities are readily available. Issues related to these partnerships have been surfaced and frequently discussed. Questions about the relevance of public art to the contemporary history of art making or regarding the quality of the work of an arts practice rooted in experimentation and community outside of the legitimizing framework of gallery, museum and, individual ownership are mainstays in the evolution and discourse of public art. Additionally, many have worried that public art is not genuinely a fine arts practice at all but merely community decoration or, at its best, competent urban design. Existing as it does at the fringe of mainstream art practice, how do we best understand public art and its legacy within the tradition of modernism? Or is public art simply *the* postmodern practice: vernacular, local, egalitarian, and quite possibly meaningless? These themes and many more are familiar to most involved in public art—its application and practice. Other than in crafting its obituary, where does the potential and impetus for continuing interest lie?

In fact, the many directions that public art has taken and the continued ongoing experimentation that exemplifies the field (as well as fractious disagreement on what even constitutes the practice) suggests that it is too early to proclaim its demise. Instead, one might argue, it represents a relatively

young movement reflective of postmodern aims and qualities, which must now increasingly express a multidimensional postcolonial sensibility. Early efforts to ally public art to the revolutionary spirit of modern democratic utopian aspirations ensured that it quickly became mired in the broader conversation of the deconstructed oppressive narrative of modernism and the postmodern generation of local meanings emergent from grassroots participation. The momentum of public art has now outpaced the practices and potentials of postmodernism with its self-limiting and ironic tendency to use a modernist-influenced, detached stance of critique; its primary methodological *modus operandi*—a holdover "trope," Kester suggests, from the *avant garde* days that ". . . . place[d] the artist outside or against society."[2] As arts practice becomes more democratized through the evolution of public art, as it was conceived to do, it continues to collide with publicly dictated content, meaning, and outcomes. Moreover, much work over the past decade has employed overly simplistic and unproblematized definitions of "public," effectively inhibiting a deeper exploration of the real complexities inherent in public spaces and meaning making. This is reinforced by a populist tendency towards superficial engagement through thinly considered notions of public meaning, engagement, practice, and place.

The role of the artist and the tenor of the practice thus must necessarily grow away from its attachment to *avant garde* detachment or paternalistic, overworked ironies (whether smug or well-intended) toward what Kester refers to as "dialogic art"[3] that embeds the artist intimately within community and is postcolonial in aims, expressions, and temperament. In this way, the artist is pulled from an elevated outsider status to sympathetic facilitator and engaged partner. Yet arguing for the role of the public artist as civic practitioner and facilitator to elicit and illuminate local meanings is hardly novel. It has its roots in the very inception of the practice, but becomes increasingly trenchant in the exploration of how public space is contextualized within the framework of intersecting worldviews and hybrid cultural identities and meanings. In summarizing Kester, Green suggests this relational and heretofore redefined space is located " . . . beyond critique . . ."; it comprises a "third" or "liminal" space, according to Bhabha, that is a " . . . site of conflict, interaction, and mutual assimilation that every encounter between cultures involves."[4] The emergence of meaning from experiences of *difference* is at the heart of the third space:

> Cultures and nations, for Bhabha, do not construct themselves out of their own essence; they do so through interactions with other cultures. Thus cultural identity is always and already a conglomeration of differences; traces and traits of the Other make up the identity of the self; and no cultural meaning is separable from its originally multi-cultural production.[5]

While the postcolonial project generally (Mishra and Hodge, 1991) and public art in the hybrid vein specifically concur with some aims of post-modernism—local, vernacular, democratized, and decentered, they both reject a single-minded focus on critiques of domination—*oppressor versus oppressed*—in favor of exploring what lurks in the overlapping and emer-gent third spaces between powerful and powerless. As Anzaldùa observes, ". . . I am participating in the creation of yet another culture, a new story to explain the world and our participation in it, a new value system with images and symbols that connect us to each other and to the planet . . ."[6].

In this context, public art becomes increasingly an artmaking of hybrid-ity—a novel means to interpret the multicultural character and origins of a postcolonial world; one where public space is conceived "globo-locally," and multiple worldviews, fundamental assumptions, iconography, and understandings of space and contesting sensibilities of the public sphere coalesce, conflict, and morph into the lived actuality of local meanings and metaphors. While the issues and publics are local in emphasis, the implica-tions of what meanings emerge come from and diffuse back into a global field. Bhabha's (2004) notion of hybridity

> refuses to accept the well-known narrative of colonialist authority silencing and repressing native tradition. Bhabha insists that the op-pressed culture is not simply rendered mute, but rather participates in the formation of an identity that is neither purely that of the colonists nor that of the colonized; it is a "third space" that is mutually forged. This is not to say that the powers in play are equal; it is simply to say that colonial relations never involve the simple imposition of one cul-ture on another. They involve rather a struggle in a constantly shifting space that results in all kinds of dominations, but at the same time cre-ates the possibility of displacements and subversions.[7]

Inasmuch as the meanings of all public spaces are necessarily contested in a pluralistic democratic community, public art presents a unique opportunity to fully explore and express the hybrid reality of the contemporary world as it is represented in the artist's experiences, approach to practice, content and exhibition of the work, designation of audience, as well as subversive aims and impacts of various projects. An effective and fully contextualized public art is by nature situated in this "third space," incorporating unique funding mechanisms, employing nontraditional approaches to installation and exhibition, incorporating marginalized and cross-cultural publics, and thereby subverting the values and power structure of the art world and society at large.

In an increasingly globalized, postcolonial world, artists who themselves understand hybridity—by virtue of birthright, biography or necessity—are uniquely positioned to ripen the emergent postcolonial qualities of pub-lic art through their own dialogic arts practice of elevating the contesting

dynamic narratives that broker the generation of unique meanings. Holding to the tension and inherent ambiguity of this effort allows for the recognition of thematic elements to emerge and for the artist to identify potential strategies in representing them.

THE WILD RICE STORY

For nearly a decade, I (Karl) have collaborated with the Anishinaabe people of the Great Lakes region (known colloquially—and inaccurately—to outsiders as Ojibwa or "Chippewa" Indians). My primary community partners are reservation-residing traditional tribal elders—medicine people, hereditary chiefs, activists, spiritual leaders, tradition bearers, and protectors. The Anishinaabe have lived in the upper midwest for centuries, first moving from the north Atlantic seaboard as a result of the Seven Sacred Fires prophecy that was given to elders by the Creator long ago. Their prophecy story tells of a millennia-long migration by Anishinaabe people that would end when their nation had encountered seven natural, perpetual fires along the way. The terminus of their journey would reveal itself when they came to the land where the *mahnomen* or wild rice grows over the water.

Still gathered today by hand in canoes from lakes and rivers, wild rice has not only been the primary staple food for the Anishinaabe but is also central to their creation story. Wild rice is thus a sacred food—a gift from the Creator. The Anishinaabe are bound by this prophecy to be guardians of *mahnomen.* Wild rice is not just what they eat; it is the defining substance of their cultural identity as well as an autonomous being worthy of respect. It also protected by federal treaty law—binding legal agreements second only to Constitutional law between the United States government and sovereign native nations that preserve the inherent rights of tribal peoples exercised long before European settlers formed their own government.

For over a century, white society via the University of Minnesota has engaged in research that has directly and indirectly affected the Anishinaabe's ability to protect wild rice and exercise their traditional practices. First engaging in bogus racial science at the end of the nineteenth century, which enabled the state of Minnesota to seize native land for commercial and governmental purposes, decades later launching a wild rice hybridization program, and most recently mapping the genome in preparation for potential genetic manipulation, native people in Minnesota have long distrusted the University's interest and involvement in Indian affairs. Wild rice is at the core of spiritual concern to the Anishinaabe, and they are acutely aware of the potential genocidal impact of ongoing university research. If wild rice disappears, so too do the Anishinaabe. After all, *mahnomen,* as the fulfillment of their destiny, is what defines them as a people.

Anishinaabe resistance to genomic research on wild rice became increasingly vocal and organized in recent years. I began working with tribal elders and sympathetic scientists at the University of Minnesota (unaffiliated with the wild rice research program, but with a history of collaborating on community nutrition as well as water and fisheries issues with Minnesota tribal communities) on a series of public arts endeavors that explored the contested meanings associated with wild rice among scientists, farmers, native people, and the academy.

What emerged were a series of artworks that reflected a multiplicity of approaches to installation and exhibition, depending on the context, needs, and audiences at play. For example, the recent work—*Keep It Wild*—was a billboard installed during the height of the ricing season in a large regional town (with a robust tourist economy) just outside the reservation borders. Adjacent to the Wal-Mart and the main arterial highway to the reservation, tribal members coming home to rice or visit families, non-native vacationers, and residents of the region saw a billboard constructed with traditional and contemporary images of ricing, where elders from the community leading the renaissance in traditional ricing among community members were prominently featured in a historically layered construction. The piece elicited significant buzz on the reservation, including features in the tribal newspaper, ongoing discussion via the "moccasin telegraph" (the local gossip chain traveling up and down extended family lines), and active community conversation. The billboard resulted in numerous requests from elders to continue this approach to public artmaking.

This billboard piece capped a five-year dialogue, guided by the coauthors with University scientists and tribal elders, around fundamental philosophical assumptions of European and native knowledge traditions that are at root in the conflict over wild rice. The first result was a series of "sculptural sketches" (temporary, full-size works) accompanied by multimedia presentations I delivered to joint conferences of Native American and academic participants as well as exclusively indigenous, interreservation tribal gatherings. These works culminated in a final piece fabricated from corrugated plexiglass, steel, wood, glass, and images sited for three years next to the administration building of the University of Minnesota's agricultural collegiate unit.

Funding support for these endeavors came from a variety of sources, including major national foundations (like Rockefeller and Kellogg Foundations) which focus primarily on community and leadership development, as well as support and collaboration from the University's public arts program, located at the Weisman Art Museum and the Minnesota State Arts Board (through a minority community partners grant program). The budgets and approach to artmaking associated with these works were larger than most local arts funders provided, requiring travel, funds for participation by elders, convening of large groups of people (lodging, meeting space, catering, etc.), in addition to the usual costs associated with fabrication of artworks (equipment, commission, etc.). The majority of the funding base, budget,

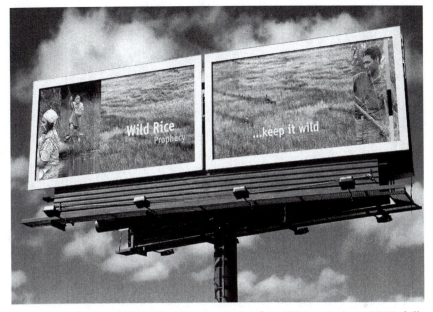

Figure 4.1 "Keep It Wild," Karl Lorenz, September 2006 to January 2007, billboard, 12' × 60', Detroit Lakes, Minnesota. Credit: Karl Lorenz.

and fundraising strategies were largely unconventional to mainstream arts *and* public arts programs, given the need to include large groups in dispersed geographic areas and the democracy/Indian nation-building interests inherent in the elders' agenda around the use of a public arts process to teach about and protect wild rice. All of these efforts evoked interest across Indian Country and were equally well received by participating faculty, who were surprised to find how effectively a public arts process could surface, explore, and generate contested meanings prompting difficult and important public conversations.

Kwon aptly describes this approach to artmaking in the newly emergent hybrid context: "Public art now includes temporary, community-oriented, immaterial, and 'site-sensitive' projects," which she suggests now results in a " ... hybrid form of exhibition."[8] Public artists must identify the best strategies, methods, and materials for how to design these works; the works themselves— content and style of exhibition—emerge from the context of the groups themselves and coincidentally accurately exemplify Kwon's descriptors. It is the liminal space of the borderlands that emerges by surfacing the contested meanings inherent in public spaces which demands this hybrid approach to artmaking. Moreover, the exhibits themselves do not travel to other gallery spaces via the conventional dictates of mainstream arts but instead are re-sited/reinstalled when new publics (not standard arts audiences) request access, involvement, and participation in the meaning-making enterprise. As Adams and Goldbard suggest, "Members of marginalized communities lack public space for their cultural expressions. Speaking concretely, they

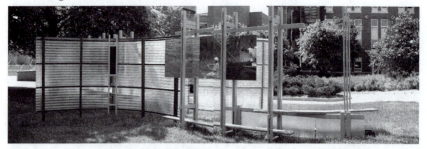

Figure 4.2 "Engagement Practice/Wild Rice," Karl Lorenz. 2005–2007, mixed media (steel, semitranslucent corrugated plastic sheeting, wood, and printed images), 8' × 18' × 37', St. Paul, Minnesota. Credit: Karl Lorenz.

seldom have institutions, facilities, or amenities equal to those available to more prosperous neighborhoods or communities."[9] Compounding this reality is significant geographic distance between reservation communities, which requires an appropriate approach to exhibition synchronous to the mode and moments of interreservation and intertribal gatherings.

The first *in situ* exhibitions of several of these works resulted in follow-up temporary presentation/installations in more conventional gallery settings for other publics, as well as presentations to university courses and university-based faculty development events. Both types of events were geared more toward the inclusion of additional publics into public process for their own meaning-making, rather than a didactic presentation on the original work.

Where does the standard arts establishment sit with respect to such work, which straddles multiple media, communities, contexts, and settings? Particularly when much of this work reflects a hybrid sensibility which makes it difficult to display in conventional gallery settings and often goes unnoticed by the mainstream art community. As Green suggests in her review of Kester's discussion of dialogic art, " . . . the best activist and dialogical art has left little trace in the critical literature almost as a result of the fact that the distance between the artist and audience was negligible—this is the goal, but it also indicates how marginalized this kind of practice remains within traditional art world venues and critical discourse. The best work slips under the radar."[10] Just as native people and their most prominent concerns are ancillary to most Americans, so too does the right type of public arts approach that is a good fit for tribal members evade notice by the arts community. There are two facets to this reality. The first touches upon the way that public arts process must be designed to fit the needs, interests, cultural traditions, and exhibition approaches of native communities. The hybridized forms of emergent, culturally hybrid and postcolonial public arts practice necessitates this adaptability by the artist. Secondly, adaptation of Western forms of scholarship, artmaking, and community development must not be "one size fits all" for any marginalized community. In Indian Country, these hybrid forms of public arts partnerships must contribute to native nation-building and the enhancement of sovereignty[11]— in content, intent, and process; an entirely

different and unique agenda for United States tribal communities than any other group.

Public artists understand that the route, outcomes, content, and approaches to installation and exhibition must be critically informed by the values and meanings of the participating communities, particularly because public arts process and contemporary forms of artistic expression are invariably redefined with each project. It is not the communities or (in this case) elders who must adjust. A truly public art must adapt to serve the involved communities. A sacrifice is thus made by the artist who may remain marginalized in the art world to be most effectively and fully embedded in a community oftentimes wholly outside the universe of the mainstream arts. In a step yet to be taken, the formal art world must, to some extent, transform and adapt the skills of hybridity and inclusion, just as those culturally hybrid artists and partner communities already have. Importantly, the dynamic tensions manifest in the plurality of voices that comprises a democratic society are elevated in a genuine public art.

HYBRID BIOGRAPHIES

Hybrid identities reflect the realities of many in a postcolonial context: spiritual and cultural polymaths who call many places—and therefore no place—home. Yet the democratic yearnings demand that this very place *can* be home if understood in its profundity and inherent complexity. This hybridity thus enables the artist to find the "third" or "liminal" space most comfortable as the site for artmaking, where the "public" dwells in ambiguous, dialogic disharmony with great potential for a coalescent emergent form and meaning. Having German/tribally-enrolled Native American bicultural heritage, I (Karl) have dwelled in this space throughout my life. As a cultural hybrid, I like many others have necessarily " . . . develop[ed] a tolerance for contradictions, a tolerance for ambiguity. . . . She (*sic*) learns to juggle cultures. She has a plural personality, she operates in a pluralistic mode—nothing is thrust out, the good the bad and the ugly, nothing rejected, nothing abandoned. Not only does she sustain contradictions, she turns the ambivalence into something else . . ."[12]. For public art to fully embrace the complexity of American meanings and identities requires the treatment of public space as liminal, dialogic, relational, hybrid, contradictory, ambiguous. Learning to tolerate ambiguity and manifest the tensions of "place" is critical in order to understand the broad meanings of the locales we inhabit. Enhancing this capacity develops civility and shared concern for the other. The hybrid practitioner skillfully navigates this third space, one they know so well. This navigational and interpretive dexterity is a transferable and portable skill set, one which is useful with a variety of publics and issues. It is an alchemical ability of sorts—applicable across contexts and uniformly useful. Artists who participate as cultural hybrids

are particularly well positioned to gain unique access to collaborating communities, to the depths and dimensions of the liminal public space, and to the new meanings that emerge from the exploration and experimentation of public art. Moreover, the mediating ability that comes from having to make sense of the complexities of a multicultural identity serves the artist well in building intimacy with community partners, teasing out the most salient aspects of contested meanings, and crafting works that express the hybrid qualities inherent to the public issues. Hybridity thus becomes civic practice, a sharing of concern through cross-cultural insight where the issues, artist, communities, and artwork are situated at the nexus of locally contested meanings.

The qualities of a postcolonial, culturally hybrid public art include the postmodern practices of decentering narratives, locally situating meanings, and exploring the experiences of those marginalized outside the dominant or mainstream paradigm. The postcolonial temperament expands these postmodern tendencies to also include an ephemeral, nomadic sensibility demonstrated in the forms and exhibition styles of the artworks; creation of a zone of uncomfortable, meaningful reciprocity between the traditional categories of powerful and powerless; presumption of a subversive dimension to the art designed both to upend mainstream cultural and artistic tropes and institutions to develop a new third space; exploration of the intersection between local and global meanings; and constructive exploitation of the artist's *skillful* cultural hybridity.

Postcolonial public art, however, runs a similar risk to the type of contemporary public art accused of glorified community decoration or design. In the wrong hands, it can quickly devolve into an unexamined embrace of meaningless, anemic millennial, multiethnic tropes, where postcolonialism becomes commodified. As radical cultural hybrid and Romany "Gypsy-Punk" musician Eugene Fütz explains:

> Even if you are a curious soul and ventured out to get something different, you very well end up with Buddha Bar or Putamaya record products which promises you something exotic but basically are traps for yuppies who would like to fancy themselves cultured. That is basically like attending a belly dance class in Wyoming with the hopes to understand Muslims. Even if a good artist shows up on a compilation like that after a labels re-mastering his work comes across as nothing but an ass-licking background singing for Starbucks coffee shop. This situation also prolongs total ignorance and confusion. You'll find millions of people not knowing if they support or oppose Globalization simply because they don't know what it means. Or thanks to great products like Global Lounge compilation you will find people who celebrate Globalization. And you'll think, wow man, I never thought that new Colonialism can be such a great cause for a party.[13]

If the artist lacks the long-term apprenticeship in cultural hybridity required to be genuinely innovative and skillful within the liminal space, postcolonial public art becomes shallow at best and ironically colonialistic at worst, thereby simultaneously committing the most venal of both modernist and postmodern sins. Therefore, what constitutes the postcolonial third space[14] and the artist's skills of cultural hybridity both require significant exploration, criticism, and discourse to evade the current tendency of public art to not pass the dual smell tests: for the fine-arts crowd, it is quality; for the communities and publics involved, it is authenticity. For the culturally hybrid, postcolonial public artist, it remains a question of the borderlands where one exists at the respective margins of fine arts, public art, contested publics, and their own multiple cultures. Learning to engage meaning making authentically in the context of complex local environments rather than superficially will be the mark of both a "fine" and "public" postcolonial public art.

NOTES

1. Excerpted from the poem, "To live in the Borderlands means you," by Gloria Anzaldùa in *Borderlands/La Frontera: The New Mestiza* (San Francisco, CA: Aunt Lute Books), 195.
2. Grant Keste, *Conversation Pieces: Community + Communication in Modern Art* (Berkeley, CA: University of California Press, 2004), 27.
3. Ibid.
4. Alison Green,,"Reading about Public Art," http://www.axisweb.org/dlFULL.aspx?ESSAYID=56 (August 20, 2007)
5. Bhabha, op.cit.
6. Anzaldùa, *Borderlands/La Frontera*, 81.
7. Bhabha, op. cit.
8. Miwon Kwon, *One Place after Another: Site-Specific Art and Locational Identity* (Cambridge, MA: MIT Press, 2004).
9. Donald Adams and Arlene Goldbard, *Creative Community: The Art of Cultural Development* (New York, NY: Rockefeller Foundation, 2001), 18.
10. Green, "Reading about Public Art."
11. Nicole Bowman "Tribal Sovereignty and Self-Determination through Evaluation" (paper presented at National Congress of American Indians Mid-Year Session, Sault Ste. Marie, MI, June 2006), http://nbowmanconsulting.com/NCAI %20afternoon%20session%20PP.ppt (August 20, 2007).
12. Anzaldùa, *Borderlands/La Frontera*, 79.
13. Eugene Fütz. "Hütznomovetz—Intro Word." http://www.myspace.com/gogolbordello (August 20, 2007).
14. Vihay Mishra and Bob Hodge, „What is Post(-)Colonialism?" *Textual Practice* 5, no. 3 (1991): 399–414.

5 Critical Spaces
Monuments and Changes

Malcolm Miles

BEGINNINGS

Public art began in the United States in 1967, the year of the Summer of Love in San Francisco, when the National Endowment for the Arts (NEA) instituted a fund for the commissioning of art in public places. The first commission was for a sculpture by Alexander Calder in Grand Rapids, Michigan. In an unrelated history, 1967 was the year of the first black-power wall paintings in Chicago, and of mass protest against the US war in Vietnam. Hippies followed the overland route to India while young people across North America dropped out and turned on, and the women's movement introduced the idea that the personal is political. In these days of liberation, Herbert Marcuse lectured at the Free University in Berlin, the Dialectics of Liberation Congress in London's Roundhouse, and the Conversations on Humanism in Salzburg. In New York and London small galleries proliferated during a boom in the market for contemporary art. In 1967, too, I began a foundation course at Chelsea School of Art, London. I smoked herbal tobacco in a cherry-wood pipe and wore orange beads and lilac and green chiffon scarves. I remain grateful for the optimism of that era but it was not until the mid-1980s, teaching art history in a provincial art school, that I heard about public art as a specialist area of graduate employment, and began to research it.

The emergence of public art as a new specialization was problematic from two distinct viewpoints, however. From a concern for the integrity of studio practice, John Beardsley wrote, "what has been good for public art and for the public space has not necessarily been good for art itself"[1]. From a position sympathetic to working in the public realm, Patricia Phillips wrote in *Artforum* that there was "good reason to be wary . . . when the signs of another specialization start emerging."[2] For Phillips, informed by Hannah Arendt's concern for the inter-activity of the public realm and the idea of the commons (or shared resources of a community), public art favored the pragmatic over the philosophical and saw its sites as physical spaces rather than as shared but contested locations of emotional ownership. My experience of public art in the United Kingdom since the 1980s inclines

me to share Phillips's doubts. With some exceptions, public art agencies in the United Kingdom suppressed the contestable aspects of public space in favor of design solutions they liked to see as ideologically neutral. Seeking larger budgets, and working on a percentage fee, they sought increasingly to introduce internationally recognized artists while expanding public art's bureaucratic infrastructure. Among the exceptions to this tendency were the Artists Agency in the northeast of England (now Helix Arts), which retained a regional base from which to build long-term partnerships with public authorities; and, taking a more avant-gardist approach, the Artangel Trust in London.

Artangel had independent funding and was able to facilitate experimental or politically charged projects in gallery and nongallery sites. In 1985 Artangel commissioned Californian artist Les Levine to produce billboards around London and an exhibition at the Institute of Contemporary Arts (ICA) on religion and conflict in the North of Ireland. Captions such as "Attack God," "Blame God," and "Execute God" accompanied schematized photographs of British troops, prison guards, and gangs of loyalists. The work achieved a high level of public and press comment. David Thompson wrote that such a "calculated and sickening insult to all Christians is absolutely inexcusable"; the Reverend Peter Keeffe suggested that the publics on whom the billboards were imposed should have a say in the selection of the work. Levine saw it as intervening in the medium of billboard advertising, not political art (which he read as aimed at an artworld audience) so that his images countered the media's simplification of events for a mass audience by setting up untenable distillations from it:

> The reason the media connect the war in Northern Ireland with religion is because that puts it, in liberal society, within the realm of the archaic. Old fashioned, ignorant attitudes that go way back in time, cannot be resolved . . . And this shows you . . . the way governments can induce media to become a weapon for them.

But such provocations were rare. More typical of 1980s public art but responding to the same situation was the siting in 1987 of three cruciform, cast-iron men by Antony Gormley on the old walls of Derry. Gormley was one of twelve artists selected to make site-specific works in different British cities in the project *TSWA-3D*. The figures occupied the dividing line between the territories of the nationalist and loyalist communities. Graffiti appeared on them, mainly in the form of spray-can genitalia, and one had a burning car tire put round its neck (when such "necklacing" was reported in broadcast news from South Africa). I went to Derry to see the work— walking down from the walls with a curator from the Orchard Gallery, we saw a British army patrol in jungle camouflage crossing the street in front of us. Derry is a city of red-brick terraced housing. Despite an intellectual knowledge of complementary colors, my fear was palpable. At a conference

at the ICA, Gormley said he put his body between the two sides to create a poultice to draw the poison from the wounds of Derry. The bombed-out buildings, the deaths and mutilations, the bereavements and broken lives which constituted those wounds—now encapsulated in history by the peace process—have a legacy dating to at least the military occupation of Ireland by William III in 1689, and for me the metaphor set up by Gormley's figures cannot carry the burden of the histories referenced. Irish critic Brian MacAvera, supporting local interventions over those of high-profile artists imported from England, described the work as site-general: "The concept is so vague that it will take the *imposition* of almost any roughly analogous situation where there are two sides plus a Christian element."[3]

Site-specific or site-general? In that duality is a minefield of difficulties for a practice which owed its origin to a funding category, and its proliferation to the creation of a professionalized bureaucracy. The contradictions of public art are, however, rehearsed elsewhere, as in Sara Selwood's *The Benefits of Public Art*[4]—in the event an ironic title. More interesting than rehashing those arguments now is that, in the 1990s, artists whose work in nongallery sites represented a desire to engage with social questions and nonart publics articulated a counterargument to that of public art. This produced a small literature on an art of public issues, participatory processes, and locality. The refusal of these artists to furnish urban embellishment for property developers might be taken as a departure from public art, itself a departure from gallery art, reiterating the model of avant-gardism. Yet it appears more accurate to say that public art in its institutionalized form, as a product of a funding category, was not a departure from but an adjunct to the mainstream, its claim to extend access to that mainstream being merely a cooption of further publics to it as justification of an expanding arts infrastructure. In this respect the move outside the gallery as exemplified has no connection to departures in the 1960s in happenings and the emergence of conceptualism as a refusal of the commodified art object of a capitalist system.

The aestheticization of space which began in public art in 1967 has since developed into a cultural expediency in which art is a low-cost means to displace factors such as economic decline and social exclusion, which result from other areas of government policy. Of particular interest, then, is a project by Hewitt + Jordan (artists Andy Hewitt and Mel Jordan) in the form of a billboard text in Sheffield in 2004 stating, "The economic function of public art is to increase the value of private property"—commissioned by Public Art Forum (PAF). Since PAF is a national UK network of public art agents and officers, and was in part responsible for the institutionalization of public art, the project appears an effort to bite the hand by which the now dissident public artist is fed. Jenny Holtzer's message-board texts may question the ordering of society by hinting at the hollowness of its categories and dubiousness of its assumptions but remain products of an aesthetic sensibility, while Hewitt + Jordan take a politicized approach. Holtzer's

message boards represent a move towards temporary projects on the part of public art's establishment in the 1990s, which can be seen in more than one way: either as reconstituting the gallery mixed show by other means, taking greater creative risk and avoiding the planning difficulties of permanent works while upgrading the status of the public art agent towards that of the curator; or, taking a more dialogic approach, inserting new ways of dealing with shared concerns. An example of the latter is *Intervention in a School* (1995) by the Austrian art collective WochenKlauser, consisting in the participatory redesign of a school classroom with clusters of semicircular seating to replace rows of desks facing the site of objective knowledge at the front. Grant Kester writes, "There is potentially some problem with advocacy projects that benefit disempowered populations . . . to speak for them through a phalanx of non-governmental organization (NGO) experts . . . [though] WochenKlauser appears to be cognizant of this problem."[5] Kester contrasts such localized efforts with the rhetoric of Joseph Beuys, and cites a member of the collective, Wolfgang Zinggl: "The context of art offers advantages when action involves circumventing social and bureaucratic hierarchies . . . to accomplish concrete measures."[6] Could this be said equally of art inside and outside gallery spaces, or in virtual spaces? I would suggest, from limited experience, that politicized art is found more often today in independently curated gallery sites than in public spaces.

For instance, as curator of "Documenta X," Catherine David adapted the French term for a political demonstration in terming the show a cultural *manifestation*. In "Documenta XI," Okwui Enwezor included Allan Sekula's photo–text *Fish Story* (1990–1995), which documents the "normally invisible and repressed working conditions of the maritime proletariat."[7] This is reminiscent of the Popular Front of the 1930s, in contrast to Jonathan Borofsky's claim that his *Hammering Man* (1992), sited outside the Fine Arts Museum in Seattle, represents "the worker in all of us." Contrasts such as this lead me to re-place conventional public art as less a departure from and more a derivation within mainstream art and its expanding markets—while emerging politicized tendencies both inside and outside the gallery become a resistant and critical tendency.

RE-PLACING PUBLIC ART

My underlying aim in this chapter is to ask what else might be possible apart from public art. In addressing this I look to literatures and frames of reference outside public art, avoiding the aestheticizing critiques of John Beardsley and Richard Cork. Rosalyn Deutsch gives a reason to read elsewhere:

> Most existing aesthetic approaches can neither account for current conditions of public art production nor suggest terms for an alternative,

possibly transformative practice. Even when familiar with issues of
the public sphere or informed by sophisticated materialist critiques
of aesthetic perception, they are generally formulated with little
knowledge of urban politics . . . traditional art-historical paradigms
cannot illuminate the social functions of public art . . . since they remain
committed to idealist assumptions that obscure those functions.[8]

First published in 1991 in an essay on public art in Battery Park City,
New York, Deutsch's comment emphasizes the uneven benefits of the
kinds of development in which public art had become a regular fixture.
Her criticism of traditional art historical approaches suggests the new
art histories informed by feminism, postcolonialism, and deconstructiv-
ism. I am intrigued by the phrase *possibly transformative practice*, which
implies the real possibility of Marxist critique, but need to ask where the
transformation is located. If it is not in an objectively given end of history,
and not in the literary-aesthetic realm of utopia, where (at the risk of rei-
fication) is it?

One response might be a reading of the literature of everyday life,
beginning in French Marxist thought in the 1960s, particularly in Henri
Lefebvre's theory of moments of liberation within the routines of everyday
lives—an early formulation of his more widely discussed work on the pro-
duction of space. Lefebvre argues that space is produced in society, which
may seem obvious, but the point is that space is not given but contingent on
factors in social life through which it is inflected and re-produced dialecti-
cally. Lefebvre develops a concept of lived spaces to denote the occupation
of space which gives rise to a continuous reinvention of the meaning—or
re-imagination—of a site. Lived spaces, then, complement the conceived
and unifying space of geometry, imaginatively and somatically transgress-
ing the reductive design of conceived space. If we trace the idea of lived
space in Lefebvre's writing we find it leads to lived time.

Lived spaces, a plural other to conceived space, constitute a dominated
and peripheralized realm in industrialized societies in which the public clock
marks out the required hours of labor; yet the realm of conceived space—
the space of plans, elevations, and geometries—is interrupted by human
occupation and its performance, from sitting on a bench to squatting a
redundant building. Deutsch cites Lefebvre, summarizing that he "provides
a starting point for cultural critiques of spatial design as an instrument of
social control."[9] But I want to linger on the theory of moments because it
brings into question the location of public art, by which I mean more than
placing in a geographical site.

The occurrence of moments of transformative awareness within every-
day lives illuminates a public sphere, then, not aligned with public squares
but with a dimension of imaginative as well as material reality. For Phil-
lips, "The public is the sphere we share in common" in "individual con-
sciousness and perception."[10] It is a sphere of contestation in which it is

possible to imagine alternative futures, as likely to occur in domestic as in public spaces. For example, in the pre-1989 Soviet Union the space of the kitchen was where "underground discussions were going on and alternative thought was formed."[11]

ORDER'S DEVICES

Through the work of David Harvey and Edward Soja, Lefebvre's ideas revolutionized the academic discipline of geography. The discipline was further recast through feminism, in the work of Doreen Massey, introducing a first-person narrative to reclaim the personal (as the political) from displacement to an anecdotal level hitherto barred from academic writing. One effect is that the text, no longer claiming objectivity, becomes a space of contingent observation and reformulation. This implies that no completion is possible, and by analogy questions the role of the designer as producer of a site completed in-building. This questions, too, notions of a city as an artifact. Jane Jacobs wrote in 1961 that "*a city cannot be a work of art* . . . although art and life are interwoven, they are not the same things. Confusion between them is, in part, why efforts at city design are so disappointing."[12] One of the differences between art and life is that most mainstream or institutionalized art represents an effort to produce a coherent image, a selective, aestheticized view of the world produced in a search for order. I find Jacobs's remarks incompatible with an assertion by Charles Landry and Franco Bianchini that "Urban design is essentially about knitting together different parts of the city into a coherent artefact."[13], though I read their approach as inherent in conventional place-making public art. Landry and Bianchini advocate a creative city in which art has a function of resolving a range of social and economic problems, but just as I ask who is included in Borofksy's generalization of the worker (above), I wonder who decides which coherent artifact a city resembles. Is London a tapestry of light, a teapot, or a toilet-bowl?

The confusion of a continuous reinvention of a city by its publics with the creation of an art-object is more than slack use of words. It leads to acceptance that a city—which might be understood as a series of events—can be reduced to a reified image for the purpose of control. Sociologist Sharon Zukin sees a city's reduction to a coherent visual image as characteristic of urban redevelopment: "culture as a 'way of life' is incorporated into 'cultural products,' i.e. ecological, historical, or architectural materials that can be displayed, interpreted, reproduced, and sold in a putatively universal repertoire of visual consumption."[14] I would argue that public art, in context of the cultural industries as perceived drivers of redevelopment, reinvents the tradition of the public monument. Statues in public parks and squares seem inoffensive as they blend, covered in moss and pigeon shit, into an urban landscape. But public monuments arose as one element in a

spectrum of public institutions which includes the workhouse, the prison, and the museum—products of nineteenth-century liberal reformism. The Tate at Millbank, London, for instance, built on the site of a prison with money from the sugar trade, served to educate the lower classes into the culture and orderly behavior of the upper class.

The production of orderly behavior takes place, too, in well-designed public spaces, while public monuments represent a received set of values in the guise of a canonical array of public figures. The recent fashion for setting them at ground level instead of on plinths does not change that. For Michel Foucault, the title of whose book might be translated as *Watch and Punish*,[15] discipline is self-produced by surveillance which leads the prisoner to behave *as if* observed even when not. Foucault reads self-coercion into a range of social situations in which we, as subjects, subjugate ourselves to perceived patterns of behavioral ordering. I would extend this to argue that in public monuments we observe and perhaps interject a specific representation of the society in which we live, which conditions our behavior when we comply with the order implicitly represented. Hence it is necessary, when power radically shifts, to destroy the monuments of the old regime as a reenactment of the change of regime, as if to prove that the shift of power has really occurred. When people spat on or kicked the statue of Bonaparte which was toppled during the Paris Commune of 1871, for instance, or of Stalin in the Hungarian uprising of 1956, they acted almost as if the statue *were* the figure represented.

How does public art continue the tradition of the monument? The means of representation have changed. Bronze likenesses of generals, statesmen, and public benefactors have given way to those, sharing the street with tourists and passersby, of literary and historical figures, and celebrities: James Joyce in Dublin, Fernando Pessoa in Lisbon, Cary Grant in Bristol. I return below to whether the monument can be democratized or not, but here would say only that the naturalism of today's bronze likenesses is no different in its implicit power relation to a public constituted as passive audience from that of the late-nineteenth-century statue. It represents power as if it is as natural that some people should have it as leaves falling off a tree in autumn. Of course, naturalism is not the mainstream of public art. More frequent is the commissioning of work in an idiom of contemporary art, such as the abstract forms and rusting steel of late modernism. Installation may cause controversy, though this is not unuseful to developers in distracting attention from the impacts of a development on the surrounding neighborhood; alternatively, the work may focus on itself an undercurrent of negativity, as with Rachel Whiteread's *House* (1993, demolished) or Gormley's iron men. These are not exactly public monuments, but if I go back to the assumptions from which public art arises as a funding category I would read as its key justification the notion of widening access to art.

This was a founding principle of the Arts Council and the NEA, and resurfaces in advocacy for public art in the 1990s. In a report on Percent-for-Art policy in Britain, for instance, a reason to commission public art

is given as "To make contemporary arts and crafts more accessible to the public."[16] Other reasons include making a place more interesting, creating employment for artists, and encouraging links between artists and other professionals of the built environment. But what power relations are implicit in all this? Here's the crunch: if public art represents to its defined or undefined publics a certain aesthetic order (the codes of which are determined by art's establishment), this aestheticizes but does not alter a power relation in which other codes of behavior and value are conveyed by public representation. The blandness of most public art advocacy conceals this, art being seen as noncontentious and of universal benefit, but the design brief will be as much an interpretation of the world for others (whom it assumes can make no such interpretation themselves, or must be prevented from doing so) as the selectivity of a national collection or—again—the decision as to which individuals and virtues are represented in public space. Against this, Warhol's idea that everyone should be famous for a while takes on a subversive color.

A way to intervene critically in this situation is to expose the power relation as it is. I see this in *Camelot* (1996), a steel security fence erected round a residual green space in Stoke-on-Trent by Cornford and Cross (artists Matthew Cornford and David Cross, based in London): "a literal interpretation of the 'City Limits' theme."[17] This is more a subversion of urban design than of the public monument or public art, but the outrage the work provoked in press and public comment was a means to draw attention to the lack of power citizens have over what they might choose to regard as their environment; or, might choose . . . if there were to be a means to take emotional ownership.

But to take ownership of a place does not only mean to reconfigure its built or natural form (though often it does). Another way is by (re)naming it. We meet traces of such acts in built and social environments. Lucy Lippard writes about naming in *The Lure of the Local*:

> Places to name must have seemed as infinite as the land and its resources for those colonizing North America in the seventeenth through nineteenth centuries. Wives, children, nieces, patrons, drunken fantasies, jokes, literary references, rude puns, and pure whimsy as well as deadpan descriptions enliven the maps of the West, whereas the East, in the beginning, was more soberly named for its old world predecessors or given the Native names already indelibly attached to some places. Cultural groups always carry old names into new places, where eventually they lose their meanings. . . . [18]

Lippard adds that names mutate, their origins seldom obvious. The ubiquitous *Guadelupe*, for example, is not a native Mexican term but an Arabic word for a river in a ravine. It seems that spatial practices also migrate. The plaza, for instance, was an Aztec model imported into Spain to be

reinscribed later as an ordering device in the conquered realm.[19] Perhaps to rename a street is a means to inscribe new values in a city, more pervasive than siting a piece of sculpture. But acts of naming are interesting, too, because just as they sediment the experiences of generations in the information of a map they embody the diversity of human occupation. Even the abstraction of Avenue A, etc., in New York's Lower East Side, is popularly renamed Alphabet City; and in Marvila, a social housing district of Lisbon between its commercial district and the Expo-98 site, zones of concrete blocks allocated letters and numbers in planning were, by political action, transformed into neighborhoods by naming them. Zona J is now Condado. This is not art but—as art can also be—an intervention in a system of classification.

It is quite easy to replace a street name, and public history workshops— as used by The Power of Place in Los Angeles—show the extent to which stories of a place can be recovered from marginalization. But, as the work of The Power of Place also shows in its streetscape designs, the representation of histories in such permanent form can be reductive and exclusive, another aesthetic colonization of spaces hitherto of plural (sometimes contested or incompatible) uses and meanings. Major historical narratives also generate problematic representations. To indicate this I turn briefly to two works of public art by Claes Oldenburg and Coosje van Bruggen: *Mistos*, commissioned in Barcelona in 1992, and *Bottle of Notes*, commissioned for a site outside a new courthouse in Middlesbrough in 1994. *Mistos* is a large-scale, painted steel book of matches. One flames and stands as if heroically above the others, which are bent and spent. A reading of the work, given the history of Barcelona's resistance to fascism in 1937–1939, is that the work commemorates that resistance and the newly reclaimed independence of Catalunya as a semi-autonomous state within Spain after Franco's death. As it happens, the work's red and yellow are the colors of both the Catalan and the Spanish flags. But leaving that aside, is the sculpture adequate to such a history, or is it, thinking of MacAvera's view of Gormley (above), site-general, an adaptation for this site of earlier work in which everyday objects were enlarged for gallery exhibitions? I leave readers to their own conclusions on *Mistos*. Elsewhere in Barcelona, in Fossar de la Pedrera, stone pillars amidst a cypress grove are inscribed with the names of those shot on that site, a disused quarry, by the fascists in 1939. Nearby is the mausoleum of Lluis Companys, president of the Generalitat de Catalunya, shot by the fascists in 1940.[20] Across the road from *Mistos* is a 1992 reconstruction of the Spanish Republican pavilion for the 1937 Paris World Exhibition, by Josep Sert. Nearby street names include Jardins de Rosa Luxemburg and Plaça Salvador Allende.

Middlesbrough is not Barcelona but has a work by Oldenburg and van Bruggen to commemorate Captain Cook, born nearby, whose voyages of "discovery" introduced lethal violence against the person, alcohol, and sexually transmitted diseases to what is now called Australia. The work's

function is to purchase a place for Middlesbrough on an international culture map, emulating more glamorous sites like Barcelona. *Bottle of Notes* consists of a leaning, openwork painted steel bottle, an inner layer in blue composed of van Bruggen's jottings, and an outer in white of extracts from Cook's log. It was celebrated by Richard Cork in the glossy magazine *Modern Painters* under the heading of "Art and Travel."[21] Tracing the work's development in the artists' sketchbooks, Cork notes its first appearance as an image derived from Edgar Poe's story *MS Found in a Bottle*. Poe has no link to Middlesbrough, and the work appears to be an adaptation of a stock image.[22] What is more interesting than Cork's dutiful praise for the city authorities who commissioned the work is that he sets it in a history of modernism in which he illustrates work by Picasso (the use of letter forms in collage), Boccioni (the dynamism of a figure in space), and Tatlin (a model for a revolving tower to house meetings of the Communist International). But is Middlesbrough a communist city? That won't put it on the culture map! So why is Tatlin conscripted to this succession of developments of which *Bottle of Notes* is the supposedly logical culmination? Cork crafts his text immaculately, placing every element within the shell of the previous, and likening the artists to seafarers discovering a world of imagination in their studios. Style predominates over histories to assert the universal value of culture, and in such an aesthetic realm communism ceases to be a plot and becomes a decoration.

Not all public art is like that, of course. Works exist which are questioning and have created a public prepared to engage with them in multivalent ways. Examples are Maya Lin's *Vietnam Veterans Memorial* in Washington, D.C.[23] and the *Harburg Monument against Fascism* in a suburb of Hamburg, by Jochen and Esther Shalev Gerz. The latter is a lead column on which people were invited to write their names or comments with a special pen provided as it was sunk in stages into the ground over a period of years. Its absence stands now for a buried history, the echoes of which it exposed in the racist graffiti applied to it by some people.[24] The artists were not shocked by this but neither do they make claims for it. Conflict exists in cities, and will leave its traces in art. One of my objections to public art is that it tends to deny or mask such conflict.

CRITICAL RECONSIDERATIONS

I want, now, to identify three issues informed by literatures outside that of public art, which I read as triangulating a viable critique of it: the privileging of the visual; the privileging of public spaces as sites for art; and the difficulty of the charisma claimed for modern artists.

Doreen Massey, citing the French writer and psychoanalyst Luce Irigaray, regards a privileging of the visual sense as a form of masculinity.[25] This is to say more than that the statues in Central Park, New York are

mainly representations of men, though they are. It is to say that the primary way in which a city is apprehended is through the visual sense, and that this takes place within a masculinized framework of perception. John Urry notes the effect of tourist posters and brochures when visitors seek out the sites depicted in them to make their own photographic record of the city accordingly.[26] I would argue that public art acts in a similarly affirmative way, adding to the city new visual objects which reframe its spaces as visual sites. The city's visualization—its presentation as vista—begins, possibly, with erection of obelisks as nodes of pilgrimage routes in Rome, by Sixtus V in the 1580s.[27] Its most progressive form is, arguably, Kevin Lynch's theory of good city form in *The Image of the City*,[28] which drew attention to the spaces between buildings which constitute a city's experiential domain. But Lynch retains a visual supremacy through a vocabulary based in nodes, landmarks, and so forth. For Massey, the privileging of visuality, explicit in the god's-eye view of a conventional city plan, is central to, and reason to interrogate, modernity:

> It is now a well-established argument, from feminists but not only from feminists, that modernism both privileged vision over the other senses and established a *way* of seeing from the point of view of an authoritative, privileged, and male position . . . The privileging of vision impoverishes us through deprivation of other forms of sensory perception. . . . But, and more important . . . the reason for the privileging of vision is precisely its supposed detachment. Such detachment, of course, can have its advantages, but it is also necessarily a "detached" view from a particular point of view. Detached does not mean here disinterested.[29]

Massey cites Craig Owens and Hal Foster as well as Irigaray. Her use of the term *disinterested* suggests a Kantian disinterested judgment which she retains to contrast with the interested detachment of the authoritative viewpoint. The viewpoint Massey has in mind is that of a position of power, as in a city plan, the overview or over-sight which allows a sense of continuity. The postcard view of a city reduced to a skyline would be an example of this continuity, or coherence, which eliminates the diversities of the everyday lives that take place in but are not visible in the managed and selective representation of the scene depicted.

But there is an ambivalence in modern literary and visual representations of the city: street life, and the reductive types of street life—the rag-picker, the prostitute, and hobo, to take examples from Baudelaire, Picasso, and the Chicago School of Sociology, respectively—are observed in their everyday activities. To take this a little further before returning to public art: in 1985, sociologist Janet Wolff drew attention to the absence in the literature of modernity of the *flâneuse*, the female equivalent of the male stroller who observes but does not participate in the street life of the metropolis. The stroller, from Baudelaire, and Walter Benjamin writing on Baudelaire, is a

type for the dis-engaged artist. Incidentally, Richard Sennett emulates the stroller in a walk through Manhattan, seeing but not engaging with the city's internal edges.[30] Wolff contrasts the freedom of the stroller to the limits of women's occupation of the city. Anticipating Griselda Pollock's critique of art history (cited below), Wolff writes:

> First, the institutions were run by men, for men ... and they were dominated by men in their operation and hierarchical structure. Second, the development of the factory and, later, the bureaucracy coincides with that process, by now well documented, of the "separation of spheres," and the increasing restriction of women to the "private" sphere of the home and the suburb.[31]

This leads me to the privileging of public spaces as sites for public art. If art intervenes in social formation it needs to do so in the sites in which that formation takes place. These are unlikely to be, except incidentally or during insurrection, the public squares which are sites not of democratic determination but of power's display. Public space is lent an aura of democracy in debates on urban design by a notion that it is where people of different classes, races, and genders mix informally. I understand how it comes to be defended in face of the encroachment of privatized space in the mall, the business park, and the gated apartment compound. But it was never, I suggest, a site of democracy, always a site in which power was performed by those who held it through processions, public executions, and the siting of public monuments which construct historical narratives to lend present regimes an illusion of being a logical culmination of a history.

There was a proliferation of public monuments in Europe and North America from the 1870s onwards. It follows the creation of unified European states such as Italy and Germany, and the defeat of France at Sedan in 1870. In the United States it follows the War between the States, and in Britain statues of Queen Victoria attest an imperialism, undermined by frequent civil unrest at home, which reasserted its dominance through the construction of national myth. Faced with uncertain legitimacy, public monuments deny conflict. Marc Augé writes of the monument as

> an attempt at the tangible expression of permanence or, at the very least, duration. Gods need shrines, as sovereigns need thrones and palaces, to place them above temporal contingencies. They thus enable people to think in terms of continuity through the generations ... The social space bristles with monuments ... which may not be directly functional but give every individual the justified feeling that, for the most part, they pre-existed him [sic] and will survive him. Strangely, it is a set of breaks and discontinuities in space that expresses continuity in time.[32]

It is not accidental that monuments are fabricated in stone or bronze, or more recently in cor-ten steel. If, that is, the role of the monument is to reinforce the categories through which a society is selectively represented to its gaze. Integral to the aesthetic, after all, is transcendence of present actuality.

Transcendence tends to universality, so that the diversity of the everyday is reduced to the homogeneity of the image. Is a veneer of transcendence what is bought when companies or civic authorities commission public art? This would be in stark contrast to the fluidity of city life presented by Georg Simmel in his essay "Metropoles and Mental Life" (1903). The metropolitan life of 1900s Berlin which informs Simmel's account has since given way to the multicultural and cosmopolitan cities produced by migrations,[33] flexible labor markets,[34] and the network society.[35] Simmel has had, nonetheless, a foundational influence on academic readings of urban space. Sociologist David Frisby writes that he sought to demonstrate "that it is social interaction which makes what was previously empty and negative into something meaningful for us. Sociation fills in space."[36] Sociation is ephemeral. In early architectural photography the long exposures required wiped out the figures; this has since become a norm (but the figures were there then as they are now, invisibly).

New kinds of sociation in big cities were liberating, as in women's use of department stores from the late nineteenth century as means to escape suburban domesticity.[37] Oddly, it is in the traditional medium of painting more than in photography that sociation is depicted. Marsha Meskimmon comments that modern art depicts liminal spaces such as the street at night because "Only at certain points could the city provide its maximal transgressive *frisson*."[38] These sites, in which sexual transactions took place, are no less gendered than public spaces yet allow in anonymity some interactions otherwise constrained by codes of normative behavior in domestic and public spaces. Meskimmon sees the experience of urban space as fragmented and dangerous as an overriding theme in modern art, so that the types of representation which emerge "forged links between marginality and art practice while reinforcing the control of the (male) artist over this wild, threatening space."[39] To impose a steel wall to divide an urban space is a form of this fantasy of power on the part of the male artist. But I digress.

There is another side to modern depictions of cities as frenetic spaces. Artists exploit views from a position above the street, on a balcony, and this may reinforce (from Massey's argument) a feeling of being in control, but down below people surge in Impressionist and Futurist cityscapes. Carriages or trams draw past. Light blazes. Figures scurry. It is as if Simmel's characterization of the city was already understood by modern artists before he published it. For Elizabeth Wilson, in *The Sphinx in the City*, women lay claim to this zone of tumult. She cites Sennett as "right to grasp the nettle of disorder, and to recognize that the excitement of city life

cannot be preserved if all conflict is eliminated."[40] Arguing that planning needs to realign itself—away from servicing the requirements of capital in a gendered separation of realms, and towards justice and equality—she writes:

> Cities aren't villages; they aren't machines; they aren't works of art; and they aren't telecommunications stations. They are spaces for face to face contact of amazing variety and richness." [41]

I don't see that in public art. I see spectacles which require a distancing gaze, set in spaces designed to produce disciplined publics, a strategy often extended into the recoding of a whole district as a cultural quarter.

Zukin was initially known for her work on loft living in New York's SoHo, the ex-garment district of artists' studios in the 1970s, then a zone of galleries and boutiques and rising rents which forced out those artists not benefiting from rent control. More recently she has turned to the relation of art and real estate as developers find being a Trustee of a cultural institution provides networking opportunities and can influence the location of cultural insertions which drive up property values. The cultural recoding of neighborhoods is complemented by a clearance of poor people from inner-city streets.[42] Zukin argues that the image of a city conditions its ownership, and that the assumption of control of civic responsibilities by business limits access to the site of that determination:

> The ambiguity of urban forms is a source of the city's tension as well as of a struggle for interpretation. To ask "Whose city?" suggests more than a politics of occupation; it also asks who has a right to inhabit the dominant image of the city . . . At stake are not only real estate fortunes, but also "readings" of hostility or flexibility towards those groups that have historically been absent from the city center or whose presence causes problems: women, racial minorities, immigrants, certain types of workers, and homeless people. Occupation, segregation and exclusion . . . are conceptualized in streets and neighborhoods.[43]

This raises a key question: do we need to gain entry to the site in which the image of the city is determined, or to question the notion that there should be such a site at all? Is it a question of what art to put in public spaces, or of why such sites matter more than any interstitial space in which sociation can occur?

I derive this question from Griselda Pollock's work on women's relation to conventional art history: moving from asking whether women can be admitted to men's art history to asking why, when the rules of that history determine women's subordination, admission to it should be thought desirable, Pollock writes that "we no longer think of a feminist art history but a feminist intervention in histories of art."[44] So, the issue is not to redistribute

admission tickets to the site in question, but to replace the sites to which admission is sought. One of the strongest expressions of this idea is Audre Lorde's: "*For the master's tools will never dismantle the master's house. They may allow us temporarily to beat him at his own game, but they will never enable us to bring about genuine change.*"[45]

Cultural policy is a case of the master's tool, made attractive by offering the arts multiple funding routes (in the United States, after various attacks from the political right). A report from the NEA says, "No longer restricted to the sanctioned arenas of culture, the arts would be literally suffused throughout the civic structure."[46] But Hewitt + Jordan write in context of the project *Futurology* (2004):

> Cultural policy can be divisive. Culture-led regeneration is only repre-
> sentative of a wider constituency and wider culture of the city when it
> is developed alongside a social policy that stems from a vigorous and
> democratic political process. This demands a political system that has
> the confidence to take on and discuss the bigger and longer-term prob-
> lems affecting the city.[47]

Meanwhile, the artist who in the nineteenth century fought the bourgeoi-
sie, then withdrew, now deals with the social exclusion of others.

A possible inference is that artists enjoy some special kind of insight, or can apply their creativity where others, professionals or dwellers, fear to tread. Gormley's metaphor of the poultice fits here, and was reiterated by him in September 2004 at a conference in Stavanger, Norway, where forty solid, cast-iron forms of his body are distributed throughout the city (one in the sea). The work is not uninteresting, each element sited at an exact height so that if they were realigned they would form a continuous vertical axis like a column. Hence the title, *Broken Column*. Yet I worry about the role implied. In Stavanger the sculptures drew out not so much poison as the usual spray-can genitals and tags. Two teachers wrecked their cars by accidentally driving into one sited in a school car park. They said a third person had not come forward but that they found more car parts around the sculpture. Another of the figures, on the stairs to a multistory car park, was painted white to tone in with its setting, then repainted bronze to look like sculpture. People do what they can. Can artists do more? Why should their creativity, rather than professional status, be more interesting than that of anyone else? If Lefebvre is right, and moments of transformation are experienced in everyday lives, then the claim to special insight (which is not the same as professional expertise) fails. In this context, I would argue that the facilitation role of a group such as WochenKlauser differs, as use of a specific expertise to create the conditions in which others imagine alternative futures to those assumed or imposed, from the interpretation of the world for others, or its reduction to an image, in mainstream avant-gardism or public representation in statuary or art.

The claim for special status stems from the indifference experienced by artists cast on the mercies of the market in the Romantic period. The genre of the *Künstlerroman* (artist-novel) in German literature, in which the protagonist undergoes a journey of self-knowledge in adversity, is a form of dealing with the difficulty, producing a status derived from inner struggle to replace that lost in worldly position. A mythicization of the claim is encountered in the work of the first-generation New York School artists. In this already alienated milieu, the abstract artist creates access to primordial depths of human feeling for a public (presumably) unable to gain access to such depths without such introduction. Donald Kuspit, in *The Cult of the Avant-Garde Artist*, reads this as the artist as Promethean adventurer, a Nietzschean "Overman bringing to the more timid world of the herdman . . . a new kind of fire . . . a new vision of what art as well as life can be." He rejects it as a bitter failure to cope with indifference:

> Keeping a secret from the world, creating the effect of knowing something it does not and will never know that is so central to avant-garde art, is not only a paranoid withdrawal from the world's indifference, but also a vicious, however, sublimated, attack on it.[48]

Kuspit ruthlessly but perceptively exposes the flaw in the claims made for modern art. In a more nonchalant vein, I remember the British art critic Peter Fuller commenting that for an art which claimed to be timeless the work of this generation was singularly historically specific, and dated.

Perhaps another way to look at the difficulty is to read the notion of artist as Promethean adventurer as an attempt to reclaim art's seriousness in face of a mass culture of absurdity and deception. But it seems, at root, faced with an unbearable emptiness articulated as work which has nothing to say and no way to say it (as Fuller saw Pollock's later work), the artist's lack of social role is compensated for by a conjuring of charisma, which extends the nineteenth-century Dandy's flouting of bourgeois codes of appearance and behavior to a more formalized justification for existence and high prices. But this is also an extension of the claim made by the nineteenth-century critics, such as Henri de Saint-Simon and Charles Laverdant, who first argued for an artistic avant-garde to lead the way to a new society. The trouble is that if being led is a condition of an unfree subject then being led by artists may be no better than being led by wicked emperors. If this seems a long way from public art, most of its practitioners looking more to the next budget than the depths of psyche, the expedient and the charismatic coincide: the cultural turn in public policy mirrors the artist's oversight of the agency of members of a society to imagine its future for themselves. It is a basic contradiction of avant-gardes and public art is not free from it.

DEMOCRACY, SUBVERSION, AND INTERVENTION

John Tagg argues, reconsidering Marx, that to interrogate classifications opens "an analysis of the articulated levels of representation at which . . . social identities and differences are culturally, politically, and economically produced and precariously fixed."[49] I argue above that public art, as a specialist profession, inherits the category of the public monument, and reproduces in various ways the categories of value which the public monument inscribes in its sites. There are exceptions, as indicated, in which art interrupts the monumental realm. But can the form of the monument be democratized, and/or can it be subverted from within? These are not the same process: to democratize implies a widening of access to sites of representation; subversion is a critique of the construction of such sites in the first place.

Kevin Atherton's *Platforms Piece* at Brixton Station, south London (1986) uses the traditional medium of bronze but re-places it from a realm of privilege to that of the everyday lives of three commuters approached by the artist in the morning peak hour, given money to buy clothes and a bag from the market, and cast using the lost-wax process. They stand permanently on the platforms among the other commuters and, if they still use the station, among themselves. Two are black, one white; two female and one male. The figures do not represent a class but reflect the mix of gender and race of users of the platform. Atherton sees the process of making the work as enabling "a resonance between the figure and the viewer,"[50] its specificity not so much that of its site as that of the publics represented. Without their participation the work could not exist. The limitation is that Atherton admits the noncelebrity commuters of Brixton to a celebrity status which, as a whole, such admission affirms despite the absence of a plinth. But in its time the work constituted a significant step in an incremental shift of public representation.

To take a contrasting case: during a six-year residency in the redevelopment zone of Sunderland in the 1990s, Colin Wilbourne used the discarded red sandstone of a demolition site for *The Red House*, an outdoor sculpture referencing the memories of people living in, or who once lived in or near, the site of the work in a zone initially of housing, cleared to make shipyards in the nineteenth century, then cleared again as the industry was terminated by the Thatcher regime. It is now a site of housing and some light industry. The work is not place-making in the conventional sense, which tended to rely on visual distinctiveness, but a collective effort to give form to memories of the incidentals of domestic interiors. It is used as a meeting place now. On a visit to the site in 1996 I was unable to leave for hours because local people, particularly a woman called Audrey who was cycling there with her daughter, insisted on telling me their experiences in the project at such length. This contrasts with many other visits to see and photograph public art, when contact with bystanders tended to be in the

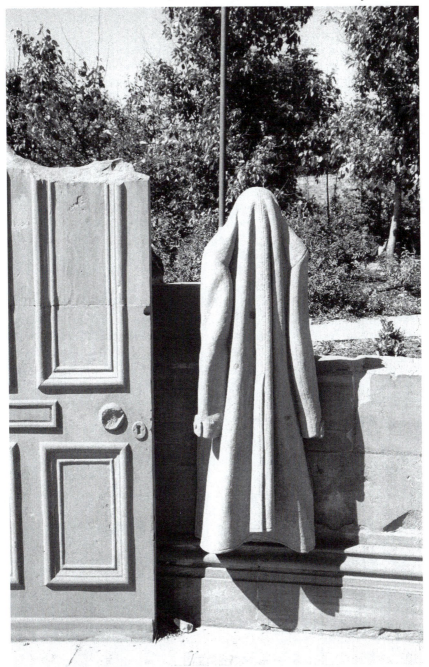

Figure 5.1 "The Red House," Colin Wilbourne. Detail; 1993–1994, Roker, Sunderland. Photo: Malcolm Miles.

form of questions about what the project cost. But then, public art always was a funding category.

Atherton and Wilbourne attempt different kinds of democratization of the form of the public monument, through depiction of others than those in power, and through realization of the memories of place of local people. But does this admission of "ordinary people" to sites hitherto associated with power shift the prevailing power relations of a society? Pollock's argument on women's relation to art history is relevant here, and if it appears that the problem is the site of representation itself, the next question is what else is viable. In using the term *viable* I have in mind a remark by Ernesto Laclau in a footnote to an essay on emancipation: "a democratic society which has become a viable social order will not be a totally free society, but one which has negotiated in a specific way the duality freedom/unfreedom."[51] Perhaps art is a way to pursue the negotiation, through work which occupies an axis between resistance and complicity but does not resolve the tension, but rather makes it evident.

Subversion, as said above, is a matter not of admitting people to monumental status but of interrogating it and, where possible, of inverting the way that status is read from within the genre through which it is normally affirmed. It is useful to be clear about this difference. Work by Atherton, Wilbourne, and others engaging with everyday lives introduces a democratic aspect to the provision of public monuments which, still, represent to members of a society the values to which they are required or invited to make their behavior and attitudes correspond. When the representation is of domesticity or ordinary experience, the sense of requirement may soften into social belonging. To subvert the monument would mean instead using its expected form to counter the concept of monumentality, to make, almost, a spoof monument. An example could be Michael Sandle's *St George* (1989), outside an office block in central London. At a glance it seems a conventional, heraldic monument. Its subject matter is the mythical patron saint of England, an image found in medieval altar paintings and the coats of arms of cities. Sandle re-presents this saint as a soldier carrying out the business for which he has been trained. The dragon can be read as a primeval life form, feminine in contrast to the violent masculinity of George, or as an objectified representation of fear and the unknown, or of the aspects of the wild against which a city is fortification and perhaps rational knowledge also a defense. George becomes Perseus the destroyer. For Sandle he is a thug: "my St George isn't your usual 'officer' type killing dragons with an air of insouciance . . . he's actually working very hard, and is a nasty piece of work."[52] *A Twentieth Century Memorial* depicts a skeletal, large-eared mouse operating a brass machine gun. It is not an explicitly antiwar image but alludes to a militarization and "Americanization" of life. Sandle says, "although it's about war, it's not necessarily antiwar, it's to do with my rather ambiguous thoughts about my own aggression, and war as an historical constant . . . But possibly it's also the sign of a correct,

Figure 5.2 "St. George," Michael Sandle. 1989, London. Photo: Malcolm Miles.

objective estimate of the world as a pretty dangerous place."[53] Sandle has also designed a more conventional war memorial for the island of Malta. But in the cases cited above he uses the form of the monument or memorial to redirect its meaning.

Form, however, is not separate from the meaning; it is more that each inflects the other in an unexpected way. In a conversation with Pierre Bourdieu, Hans Haacke argues that "every time I use this binary terminology [form and content] . . . I get a stomach ache."[54] If content is inscribed in form but the *reception* of art tends to readings of either content evidencing the conditions of a work's production, or of form seen as autonomous and self-contained, then Haacke argues in contrast,

> Artists . . . have usually been quite aware of the sociopolitical determinants of their time. In fact, in the past, they often created works designed to serve specific and prescribed goals. . . . Whether artists like it or not, artworks are always ideological tokens, even if they don't serve identifiable clients by name.[55]

In his own work Haacke exposes the clients: metaphorically setting the Daimler-Benz symbol on a watchtower near Heinrich-Heine checkpoint in Berlin, in *Freedom Is Now Simply Going to Be Sponsored—Out of Petty Cash* (1990); or literally by publishing the details of property holdings in New York, and the intricacy of internal financial dealings in property development, in *Shapolsky et al: Manhattan Real Estate Holdings, a Real-Time Social System, as of May 1, 1971*, an installation of documentary material censored by the Guggenheim Museum as inappropriate to a museum of contemporary art.[56]

Haacke's medium is photographic and textual documentation, and his targets are not public monuments but institutions, in a broad sense. His subversion here is in using a medium taken as transparent to produce a transparency in certain aspects of public life. Haacke followed the Guggenheim's rejection of his installation with *Solomon R Guggenheim Museum Board of Trustees* (1974), which states the names of the Trustees with their corporate affiliations. Deutsch writes,

> A key step in Haacke's development of a type of artwork that interrogates, rather than deflects attention from, the economic and political structure of art institutions, *Guggenheim Trustees* . . . traces the connections among members of the Guggenheim family, other trustees of the museum, and several corporations that frequently shared addresses and offices.[57]

Among the affiliations listed is the Kennecot Copper Corporation, implicated in the murder of Salvador Allende, democratically elected President of Chile, in 1974. In works such as *Freedom Is Now Simply Going to Be*

Sponsored—Out of Petty Cash, or *And You Were Victorious after All*
(Graz, 1988), Haacke adapts existing monuments. The latter consisted of
an obelisk built over the *Mariensäule* (Column of the Virgin Mary) like
that built in 1938 for a public demonstration in favor of union with Ger-
many. The column was obscured by a structure draped in red, with the
Nazi insignia and inscription, as in the title, to commemorate a failed coup
in 1934 during which the Austrian pro-Nazi Chancellor Dollfus was assas-
sinated. On the night of November 2, 1988, the work was fire-bombed.[58]

The intentional ambivalence of Haacke's title—who was victorious, and
when is "after all"?—is a refusal to complete the interpretation of a his-
tory which is many-sided and, as the fire-bombing indicates, continues.
To encounter the work (even, as for me, in documentation) is to take part
in a negotiation of its meaning, and from that the meaning of the histories
referenced. Taking less momentous, more incidental, events as points of
departure, and using satire and irony rather than documentation, Cornford
and Cross seek similarly to retain a tension between different readings of
histories. They write,

> For us, a key function of contemporary art in an open society is to test
> concepts, assumptions and boundaries. One way we do this is through
> making site-specific art works in public places; our projects are often
> satirical or polemic in nature, and involve a degree of risk or uncer-
> tainty . . . As well as the visible artwork, we recognize that the out-
> comes include exchanged attitudes between ourselves, our associates,
> and the people who respond as our audience."[59]

Among a dozen or so unrealized projects exhibited at Nylon, an inde-
pendently curated space in east London, in 2002, was *Avant Garde*, a
rejected proposal for Brighton seafront on the south coast of England: a
life-sized reproduction of a news photograph of fighting which took place
between rival groups of mods and rockers in 1964, to be positioned in the
site depicted. Cornford and Cross note the absence of complexities of class
and gender in media representations of such events, and the repression by
the state of youth violence which is, at the same time, made into spectacle
by the press. They add, "As an official commission that aestheticises youth-
ful rebellion, *Avant Garde* would offer an example of recuperation, the
process by which the social order is maintained."[60] This sets up a tension
between the means of representation of a specific history and what is repre-
sented in it. It proposes what in the circumstances is an impossible monu-
ment, duly declined by the commissioning authority. What is exhibited in
the gallery is that impossibility.

I find myself at the end of this text, as at the beginning, writing on a
work not in public space but in art-space. I recall, too, Wochen Klauser's
use of an aesthetic dimension as an interstitial space, a critical gap in the
dominant society. In the 1970s, after the failure of revolution in Paris, in

face of a move towards total consumption in the affluent society, Marcuse argued that withdrawal to an aesthetic realm was what was viable. This echoes another validation of withdrawal he made in the 1940s, writing on French literature under the German occupation.[61] He cites Baudelaire, Louis Aragon, and Paul Eluard to draw out an idea of a *promesse du bonheur*, a glimpse of joy evident in love stories which, as a realm of intimacy, is beyond the reach of the administered world. That's another story, yet it seems appropriate to end with it. Perhaps it is, as a last resort, in personal encounters (because the political is personal, too) that unfreedom lapses into a condition which at least allows a glimpse of liberation—a glimpse which might not fade away.

NOTES

1. John Beardsley, *Earthworks and Beyond* (New York: Cross River Press, 1989), 155.
2. Patricia Phillips, "Out of Order: the Public Art Machine," *Artforum* (December 1988), 92–96.
3. Brian MacAvera, *Art, Politics and Ireland* (Dublin: Open Air, 1990), 113.
4. Sarah Selwood, *The Benefits of Public Art*, (London: Policy Studies Institute, 1995).
5. Grant Kester, *Conversation Pieces: community + communication in modern art* (Berkeley: University of California Press, 2004), 100–101.
6. Ibid.
7. R. Hylton, "Notes on Documenta," *Engage* 13, (Summer 2003); 43–48.
8. Rosalyn Deutsch, *Evictions* (Cambridge, MA: MIT Press, 1996), 60.
9. Ibid., p.77.
10. Phillips, "Out of Order," 93.
11. A. Broekmann, email to the author, June 10, 2004.
12. Jane Jacobs, *The Death and Life of Great American Cities* (New York: Random House, 1961), 373.
13. Charles Landry and Franco Bianchini, *The Creative City* (London: Demos, 1995), 28.
14. Sharon Zukin, "Cultural Strategies of Economic Development and the Hegemony of Vision," in *The Urbanization of Injustice*, eds. Andy Merrifield and Erik Swyngedouw (London: Lawrence & Wishart, 1996), 227.
15. Michel Foucault, *Surveiller et Punir: Naissance de la Prison* (Paris: Galimard, 1975).
16. Arts Council, *An Urban Renaissance: Sixteen Case Studies Showing the Role of the Arts in Urban Regeneration* (London: Arts Council, 1989).
17. Malcolm Miles, *Urban Avant-Gardes* (London: Routledge, 2004), 166.
18. Lucy Lippard, *The Lure of the Local: Senses of Place in a Multicentered Society* (New York: The New Press, 1997), 48.
19. S. Low, *On the Plaza: The Politics of Public Space and Culture* (Austin, TX: University of Texas Press, 2000), 84–100.
20. A. Gonzalez and R. Lacuesta, *Barcelona: Architecture Guide 1929–2002* (Barcelona: Gustavo Gili, 2002), 125.
21. Richard Cork, "Message in a Bottle," *Modern Painters* (Spring 1995), 76–81.
22. Ibid.

23. C. L. Griswold, "The Vietnam Veterans Memorial and the Washington Mall: Philosophical Thought on Political Iconography," in *Art and the Public Sphere*, ed. W. J. T. Mitchell (Chicago: University of Chicago Press, 1992), 79–112.

24. J. Young, "The German Counter-Monument," in *Art and the Public Sphere*, ed. Mitchell, 49–78.

25. Doreen Massey, *Space, Place and Gender* (Cambridge: Polity, 1994).

26. John Urry, *The Tourist Gaze: Leisure and Travel in Contemporary Societies* (London: Sage, 1990).

27. Richard Sennett, *The Conscience of the Eye*, (New York: Norton, 1990), 153–158.

28. Ken Lynch, *The Image of the City* (Cambridge, MA: MIT Press, 1960).

29. Massey, *Space, Place and Gender*, 232.

30. Sennet, *The Conscience of the Eye*, 163–168.

31. Janet Wolff, "The Invisible Flâneuse: Women and the Literature of Modernity," in *The Problems of Modernity: Adorno and Benjamin*, ed. Andrew Benjamin (London: Routledge, 1989), 141.

32. Marc Augé, *Non-Places, Introduction to an anthroplogy of supermodernity* (London: Verso, 1995), 60.

33. J. Eade, ed., *Living the Global City: Globalisation and Local Process* (London: Routledge, 1997).

34. Sennet, *The Conscience of the Eye*.

35. M. Castells with B. Catterall, *The Making of the Network Society* (London: Institute of Contemporary Art, 2001).

36. David Frisby, *Simmel and Since: Essays on Georg Simmel's Social Theory* (London: Routledge, 1992).

37. R. Bocock, *Consumption* (London: Routledge, 1993).

38. M. Meskimmon, *Engendering the City: Women Artists and Urban Spaces* (London: Scarlet Press, 1997), 9.

39. Ibid., 10.

40. Elizabeth Wilson, *The Sphinx in the City* (Berkeley: University of California Press, 1991), 156.

41. Ibid., 158.

42. Deutsch, Evictions, 93.

43. Sharon Zukin, "Space and Symbols in an Age of Decline" in *Re-Presenting the City: Ethnicity, Capital and Culture in the 21st-Century Metropolis*, ed. A. King (Basingstoke: Macmillan, 1996), 43–59.

44. Griselda Pollock, *Vision and Difference: Femininity, Feminism and the Histories of Art* (London: Routledge, 1988), 17.

45. Jane Rendell , B. Penner, and I. Borden, eds., *Gender Space Architecture: An Interdisciplinary Introduction* (London: Routledge, 2000), 54.

46. G. O. Larson, "American Canvas," in *The Expediency of Culture: Uses of Culture in the Global Era*, ed. G. Yúdice (Durham, NC: Duke University Press, 2003), 11.

47. Hewitt + Jordan, *I Fail to Agree* (Sheffield: Site Gallery, 2004), 29.

48. Donald Kuspit, *The Cult of the Avant-Garde Artist* (Cambridge: Cambridge University Press, 1993), 1.

49. John Tagg, *Grounds of Dispute: Art History, Cultural Politics and the Discursive Field* (Basingstoke: Macmillan, 1992).

50. Serpentine Gallery, *Kevin Atherton, a Body of Work, 1982–1988* (London: Serpentine Gallery, 1988), 13.

51. Ernesto Laclau, *Emancipation(s)*, (London: Verso, 1996), 19.

52. J. Bird "The spectacle of memory," in catalog for Michael Sandle exhibition (London: Whitechapel Art Gallery, 1988).

53. Ibid., p. 35.
54. Pierre Bourdieu and Hans Haacke, *Free Exchange* (Cambridge: Polity, 1995), 88.
55. Ibid., 89.
56. Deutsch, *Evictions*, 159–192.
57. Ibid., 183.
58. Bourdieu and Haacke, *Free Exchange*, 78–81.
59. Draft for future publication supplied to the author, 2004.
60. Ibid.
61. Herbert Marcuse, *Technology, War and Fascism: Collected Papers of Herbert Marcuse*, ed. D. Kellner (London: Routledge, 1998), 199–214.

6 Toward a Celebratory and Liberating System of Teaching Public Art

Stephanie Anne Johnson

Forty students fill the small room at the beginning of the semester. The majority of them are young, but there are also a few returning students whose age range from early twenties to late fifties. There are an equal number of men and women. About a third of the class is Latino/Latina, there are two African-American students and the rest of the students are of European ancestry or mixed heritage. I tell them, "As I stand before you today, I am well aware that I might be the first and last African-American teacher or professor that you will ever have. I am representative not only of my own skills, knowledge, and teaching ability, I also serve as a representative of all people of African descent."

This is a paraphrasing of an opening statement delivered each year to my students who are enrolled in the Visual and Public Art Program at University of California, Monterey. An overwhelming majority of these students have never had an African-American instructor. Constantly aware that I am an embodied trope for "Blackness," this prologue is used to call attention to the seemingly obvious and is a preface to an exploration of experience, position, and race—all of which are integral to the Visual and Public Art Program.

In art history books there has been a lack of adequate representation of African, African-American, Latino, Latina, Asian, Native American, and other artists of colors' work and voices. When the work of these artists and others from socially marginalized groups is included, it has historically been presented as an ethnic aside, an interesting "other" or the source of controversy rather than as an example of a valid artist's practice. In a field that vacillates between reverence and disdain for formalism, the work is positioned in a kind of parallel universe where the evaluation and commentary is generally focused on race-based controversy regardless of the artists' own themes or intentions. It is this pointed lack of fluidity, this intentionally narrowed view of possibilities coupled with a perceived conceptual restriction that situates many artists of color in a position of marginalization and defense. Despite this, public art from those in the "margins" has a unique ability to build bridges and galvanize neighborhoods and communities.

There are those in the field of public art and the academy for whom issues of equity, social justice, and community empowerment are central in life and work. They believe that they can change the art world and the current educational and social systems. They believe that the quality of life and our future depends upon replacing exploitative institutions and practices with life-affirming, inclusive, and sustainable forms of creative expression. I am proud to be one of these artist/educators.

Steven Huss, the Public Art Coordinator for the City of Oakland, California, believes public art can be a vehicle to inform the public about significant societal issues:

> Great art, across the disciplines, is eye-opening. It is revelatory. I think public art can tackle weighty issues that people struggle with or even try to avoid thinking about, like oppression and social inequity, and crystallize them for the viewer. It's not necessarily about making troubling realities more palatable; it's that public art can distill these amorphous or hard-to-grasp concepts into powerful statements, bringing them clearly into focus perhaps for the first time.

The intention of the Visual and Public Art Program (VPA) founders—Judith F. Baca and Suzanne Lacy—was to integrate community arts with seemingly disparate disciplines from the academic world: studio art, art history, critical theory, and multicultural education. It was their belief that the hands, mind, and heart could function together physically and metaphorically to produce projects of reciprocal value to students, professors, the campus, and local communities. An examination of the traditional role of public art and a willingness to incorporate "lessons learned" from national and international social liberation movements provided some of the theoretical cornerstones of the program. At the core of the VPA program's philosophy are critical questions regarding art that has been traditionally celebrated and elevated in public institutions and discussions; art that has been marginalized, missing, or rendered invisible; how positions of power can be used to replace inequity; and how passive viewing can be replaced by engaged collaborative creation.

The program is inclusive of art practices ranging from murals, to three-dimensional projects, to events such as the Day of The Dead celebrations that serve the aesthetic and social needs of diverse communities. Each element in the public art continuum is seen as equivalent, with an ability to serve, heal, and revitalize people, cities, the country, and the world. In a time of increasing economic pressure and social alienation, public art has the ability to make visible the members of society who have been rendered "invisible," to manifest the dreams and hopes of communities in both practical and intangible ways, and to bridge long-standing and often unexamined cultural, racial, and social divisions by providing meaningful

collective experiences. Baca says that inclusion and equity are of primary importance:

> Of greatest interest to me is the invention of "voice giving" for those left without public venues in which to speak. Socially responsible artists from marginalized communities have a particular responsibility to articulate the condition of their people and to provide catalysts for change, since perceptions of us as individuals are tied to the conditions of our communities in a racially unsophisticated society. We cannot escape that responsibility even when we choose to try; we are made of the "blood and dust" of our ancestors in a continuing history. Being a catalyst for change will change us also.[1]

Lacy believes public art should be socially conscious. She says,

> "Whether it operates as symbolic gesture or concrete action, new genre public art must be evaluated in a multifaceted way to account for its impact not only on the action but on consciousness, not only on others but on the artists themselves, and not only on other artists' practices but on the definition of art. Central to this evaluation is a redefinition that may well challenge the nature of art as we know it, art not primarily as a product but as a process of value finding, a set of philosophies, an ethical action, and an aspect of a larger sociocultural agenda."

The ideas advocated by Baca and Lacy, i.e., social responsibility, artists as agents of social change, the redefinition of the terms "public" and "art," and the inclusion of ethical inquiry as an art process, found a forum within the Visual and Public Art Program. Johanna Poethig, a California-based artist with professional experience in creating large-scale murals, and I were hired as faculty. The VPA program has grown from three full-time faculty members in 1995 to four tenure/tenure track and four adjunct faculty members in 2007.

When the program opened it was housed in two former army barrack buildings. One was to be used for a three-dimensional "home-based studio," and the other for a two-dimensional "home-based studio." Initially, the tools and resources required for the program were quite simple: the three-dimensional class had two cordless drills and several hammers and screwdrivers, and the painting class had a few brushes and paint that Poethig brought from her own studio. With these bare essentials and the program structure created by Baca and Lacy, Poethig and I began teaching in the fall of 1994.

The University was originally the site of Fort Ord, an Army base that once welcomed African-American soldiers, multiracial families, and others. Because of its rich historic past, it remains the perfect site for an art program that values cultural diversity and inclusive ways of teaching and learning about public art.

One of the first projects in the VPA program was *The Windows Project*. Initiated by Baca and implemented by Poethig, students painted murals on campus depicting soldiers (both real and imaginary) that may have served at Fort Ord. Using these portraits as a visual metaphor that honored the presence of military personnel, students were able to develop and demonstrate their technical skills. Thirteen years later, many of these portraits are still on the barracks—weathered but poignant reminders of the men and women who lived on this site.

Also early on in the program's development, the Three-Dimensional Home-Based Studio students, Lacy, and I produced a walk-through installation using archival and found materials. It included a timeline on the walls with early and recent history of the Monterey Bay Peninsula. Linda Yamane, a local Native American historian and storyteller, participated in the project along with a former army general, former military officers, and members of the Non-commissioned Officers' Wives Club. They brought scrapbooks, photographs, and stories to share with visitors. The art installation and *The Windows Project* marked the beginning of the Visual and Public Art program's practice of making historical analysis an essential element of the curriculum.

The faculty expanded in 1995 to include Dr. Amalia Mesa-Bains, a nationally and internationally known scholar, installation artist, and MacArthur Fellow. As the founding director of the VPA program she created a curricular model that matched the program's structure with the philosophical criteria set up by the original faculty members. She contextualized the history of the VPA program within the larger campus endeavor:

> The work we have done at VPA really situates itself in our collective commitment to be a utopian and brilliant vision of California State University, Monterey Bay. The underpinning of VPA for me arises out of the ethical, social issues of justice and in a global and environmentally responsible approach to learning. In this sense much of the unique curriculum and pedagogical aspects of VPA have at their source our personal life values and the commitment to this twenty-first-century education for a multicultural society. As a participant in the founding generation of the Chicana/Chicano Movement and the daughter of working-class parents I found my voice within the context of activism. After many years as an artist, scholar, and public-arts administrator, CSUMB was the only place in which such a vision could be created and sustained. Through my relationship with Judy Baca I found my way to VPA and joined my colleagues Stephanie Johnson and Johanna Poethig.

Dr. Mesa-Bains set up goals and course outcomes, the structures for students to develop the technical skills, field experiences, language, and self-knowledge necessary for their role as future public artists, arts

administrators, and teachers. This system of learning also facilitated the growth of less tangible skills such as cross-cultural communication, critical thinking, visual literacy, empathy, and self-reflection. Amalia imagined "the work of the artist as a space of agency and promise toward the well-being of community." In her words this positive and libratory stance "requires a consummate set of skills and practices."

California State University Monterey Bay is a campus that uses an outcome-based educational system. In practical terms this means that each student is presented with a written series of outcomes that describe the expectations of performance as related to the pedagogies and course content. Outcomes presented in the syllabus at the beginning of the course allow the student and instructor to have a shared understanding of expectations and student assessment. By blending the knowledge that students bring into the classroom with new information presented by the instructor, outcome-based education contributes to the development of student higher-order skills such as synthesis and evaluation. This form of education prioritizes a mutual system of accountability from the students and instructors.

With outcome-based education in mind, Dr. Mesa-Bains created six overarching learning goals that guide the VPA program: the capacity for research and analysis, the relational strategies of community building, the values of collaboration, the skills of art production, the understanding of evaluation and revision, and, lastly, the responsibility for distribution. These goals are applied equally to both academic training and the lived experiences of students, faculty, and visiting artists in the program. Additionally, an essential element of the working process within the program has been the formation of reciprocal, collaborative, and long-term relationships between the campus and community as well as among the faculty, staff, and students.

Finally, the ideas, skills, and dedicated work of current and past faculty members (Amalia Mesa-Bains, Johanna Poethig, Lila Staples, Gilbert Neri, Siobhan Arnold, Sophie Touzé, and Patricia Rodriguez) and staff members (Stacey Malone, Vicky Franco, and Todd Kruper) have also been intricately woven into the structure of VPA. In general, the VPA program operates within a "family" model, in which everyone is honored for his or her unique contributions to the well-being and development of the program.

The VPA community of educators has been diverse, including people of Mexican, African, Irish, German, French, and mixed heritages. Faculty and staff have ranged in age from their thirties to their sixties. In crossing the borders of race, culture, gender, sexual orientation, class, and age, the faculty and staff collaboratively contribute to the VPA vision.

Part of the Mission of the VPA program is to "provide students with a life-long set of skills that synthesize studio and community arts approaches to artistic production, exhibition, and education." Both individual and

collaborative art methodologies are used in all of the VPA concentrations: painting and murals; sculpture, installation and performance art; arts education and museum studies; and integrated media studies (photography, digital art). Combining theory with practice, the program pedagogies focus upon historical and contemporary analysis, community collaboration, artistic production, evaluation and distribution of work with an emphasis on applied research, technical competency and self-expression. The program equips students with skills in art making, ethical inquiry, self-reflection, visual literacy, empathy, and reciprocal community engagement to address the critical issues of aesthetics, social justice, and cross-cultural competencies in a multicultural and increasingly interconnected global society.[2]

As a demonstration of the fusion between collaborative work and commitment to social justice, the program has made tangible connections in its structure between the program and local organizations, students and community members, public art and community empowerment. In addition to the studio courses required by each concentration, the curriculum includes six core concept courses:

1. *Major Pro Seminar*, an introduction to the program, the VPA major learning outcomes, and the field of public art;
2. *Ways of Seeing*, a case-based course that critically examines public art projects;
3. *Community Research Service Learning*, a service-learning course combining art activities in the community with personal self-reflection;
4. *Diverse Histories In Contemporary Art*, a critical examination of historical and current artists and movements;
5. *Visiting Artists*, a series bringing local, national, and international public artists to the campus; and
6. *Senior Capstone*, a two-semester course where students propose, create, and exhibit final projects that demonstrate their technical and critical skills in the context of the VPA philosophy and major learning outcomes while preparing to continue with their studies or enter the fields of public art, studio art, community art, arts administration, museum studies, or teaching.

In addition to teaching students technical and professional skills, courses such as *Digital Public Art, Advanced Sculpture, Advanced Painting and Murals, Installation and Performance,* and *Museum Studies* include collaborative and community-based activities that further reflect the curricular goals of the program.

From critical studies of the French Orientalists of the 1800s to case studies of the Black Panther mural at San Francisco State University in the 1960s, from the collaborative creation of digital posters with community partners

to photographic self-portraits, from critical museum studies to hands-on media analysis projects, the VPA program strives to present students with multiple forms of creative expression, firmly grounded in self-reflection, critical thinking, and ethical engagement. All of the VPA courses are conceptually resonant with one another and provide students with the major learning outcomes: research and analysis skills, community and collaborative practices, individual aesthetics development, technical competence, evaluation and revision skills, identification of audience, cross-cultural competencies, and distribution skills for public art projects based upon inclusive, accountable practices.

It is an accepted fact that all students do not learn in the same manner and this is particularly evident in preparing students to work in the field of public art. Evaluation and critique is very complex when applied to art projects in the absence of clear standards where the ongoing debate over "good" work and "bad" work leaves the students confused. Working towards an inclusive system of assessment that contains a place for diverse skills and abilities, the faculty worked with Dr. Amy Driscoll, former Director of the CSUMB Center for Teaching Learning and Assessment, for several years to create a series of criteria for studio and theory classes. This assessment tool has been useful for courses, final senior capstone projects, and departmental awards.

The primary student evaluation criteria and standards for the Visual and Public Art program include:

Community Engagement—The "exemplary" student consistently displays the ability to design reciprocal ways to include community's assets (intellectual, historical or physical) and is able to contextualize their actions in a broad social context. This student consistently integrates other disciplines with their art genre(s) of choice to create something that is greater that the sum of its parts.

Technical Competence—The "exemplary" student consistently applies basic principles of their art genre(s), uses appropriate techniques with skill, understands characteristics of materials, and puts them together in ways that communicate, engage, stimulate, and challenge.

Technical Integrity—The "exemplary" student consistently builds on rich tradition(s) and interprets those traditions with depth and complexity; goes beyond imitation to consistently put their own personal "stamp" on work, their use of materials is unique, out of the ordinary, beyond imitation, and it conserves or restores traditions and techniques.

Reflection—The "exemplary" student consistently connects self and life experiences with work and ideas, thinks critically, takes and implements

feedback, connects to the work of others, examines, challenges, re-thinks their own perspectives and assumptions, and places that per-sonal material in a global context when expressing ideas.

As well as articulating program standards, the faculty work with students towards the development of an internal creative "compass" as a critical tool for the survival of any artist who ventures into the field of public art.

One of the challenges of teaching public art is facilitating awareness of the role of social positioning. In the most often-used, affordable, and easily accessible art history texts, the authoritative norm is still focused upon men of European descent, their work, careers, and the evaluative systems created by and for them. Work by artists of color is mostly acknowledged in ethni-cally specific textbooks, case studies, and articles, as "add-ons," and in texts that scold and critique others while heralding their own radical-ness in the field of public art. The omission of substantive and ongoing diversity within the public museum/public art school system in regards to gender, race, class, sexual orientation, culture, physical ability/mobility, national origin, and language effectively maintains the present systems of power. In this way, the fields of art, public education, and the institutions associated with them share the function of being agents of social hegemony. Fortunately, the internet as an educational tool has shifted this trend, and students can do independent research to present the immense variety of commissioned and "informal" public art from a more inclusive point of view.

The field of public art has progressed since the VPA program was estab-lished. In particular, recent books on public art are doing a better job in the presentation of multicultural, nontraditional artists from a variety of regions and cultures. One of the strategies used in the VPA program to counter the textual and authoritative balance missing in both the fields of art and educa-tion is a series in which visiting public artists of diverse backgrounds give lectures and conduct class and community visits. The physical presence of public artists from diverse backgrounds and their direct interaction with stu-dents has been a powerful experience of modeling the fusion of artistic excel-lence and cultural inclusion.

I teach a course called "Community Research Service Learning," which provides an opportunity for students to bond in an atmosphere of empathy and nonjudgmental exploration. They spend the first weeks of the semester training in cross-cultural competencies, collaborative working methodolo-gies, and skills of self-reflection. During the next six weeks of the semester, students are placed within organizations throughout the community, called CSUMB partners. For the final third of the semester, the class meets together and individually with me to discuss their experiences.

In the fourth week of "Community Research Service Learning" I ask a group of students to pretend they are in a service-learning program, and arrive at their first job at a community center to find a classroom full of Spanish-speaking youth. The students that speak Spanish are asked to play

the role of the youth. As they comfortably talk together, another, English-speaking, student stands up, enters the "scene," and tries to negotiate the language barrier. After several attempts, a different student comes forward and performs. This exercise was based on a workshop I attended and on writings of Augusto Boal.[3] It reverses the position of authority for native English speakers and validates the lived experiences of Spanish-speaking and bilingual students. It is equally as important for the students who speak English (currently the dominant language of the academy in this country) to experience marginalization as it is for the students who speak Spanish (a language commonly spoken in this region) to be in a position of authority and privilege. For the vast majority of the Visual and Public Art students, this is an introduction to the examination of social privilege and the action of building alliances.

Over the past three years, students have always met the challenge of this performance with insight, humor, and camaraderie. Despite attending a university that has approximately twenty-five percent native Spanish-speaking students, this is the first time some of them have thought about the experiences of their Latino/Latina classmates. Many of the students in the California State University system have experienced or will experience discrimination due to their race, age, national origin, gender, class origins, disabilities, language, or sexual orientation at some point in their lives. The VPA students who find themselves in this position professionally will have the tools of empathy, self-reflection, cross-cultural communication, and alliance building to aid them in working with communities and other artists.

Interpersonal skills that provide the ability to work effectively in a variety of regional and cultural settings are essential for today's public artists. Dr. Sonja Manjon, Director of the Center for Art and Public Life at California College of Art, agrees:

> A successful public artist is one that uses their art to make a statement, to galvanize ideas, and to ignite social change. I think public art has the power to transform, change, and save us. I think that the artist carries the soul of the culture and in this environment that we are living in now, that soul is damaged. Many people do not realize that, how damaged it is. And the artists are marginalized in our society. But even within that marginalization they are very powerful because they deal with change and people's lives.

One of the most complex issues in the field of public art is the relationship between representation, ethics, and commerce. This issue is tackled in the VPA museum studies courses where the object, its meaning as interpreted by a curator and interrogated by a viewer, and the relationship between its place of origin and its exhibition are critically examined. Lila Staples, Professor of Museum Studies and Regional Art History, believes threads of equity and social injustice run through all of the courses she teaches. However she

asks students to "identify their own personal biases and how their individual perspectives influence all of their decisions." They then, "consider as a class, what the ethical and social justice issues are around respecting and acknowledging the voice and intent of the maker of an object (as exhibited in a museum setting) and how each visitor's perspective will alter the interpretation of the object."

Johanna Poethig, Professor of Painting, Murals, and Public Art ties together the social and physical environments in her courses:

> Public space belongs to all of us, but increasingly business and corporate interests dominate public space. Public art can be a way to bring more voices to the public arena, to tell the histories and stories of people and communities. It can address social justice issues and bring them to the streets to create dialogue and a more democratic social discussion. I teach them to manifest their ideas and concepts into artistic forms of communication. Without a dedication to individual practice and involvement in the creative social interactions that are essential to our collective growth it is difficult to sustain ourselves as artists and evolve as a culture and society.

Public Art Consultant Regina Almaguer:

> The value of art in our culture is diminishing, replaced by the public's need for vacuous entertainment and cultural learning through media sound bites. I despair at the fact that art has been all but eliminated from our educational system. I don't think that the public understands the repercussions that this will have over the long term relative to how children learn, how they benefit from creative thinking, and how art teaches children to think abstractly in a variety of circumstances. The effect of this deficit is felt not only among youth but also the general public who seem to want a quick and easy understanding of what it is they are looking at, they don't want to be intellectually challenged or be required to think beyond the moment.

With an ever more invasive and monopolized media, social areas that were once considered private are now public. Information about our lives and our economic and personal habits can be retrieved for a fee. Conversely, public information that was once available has now become harder to find despite the lauded internet access, itself an exclusive realm of information retrieval. Media spins a narrative that becomes "truth" through repetition in public places. Iconographic symbols and music once associated with revolutionary ideas have been appropriated for commercial activities. This dissolution of the boundaries between public and private, original and copy, continues the trajectory of conflating art with commerce. Public art has been deeply affected as artists move away from creative expression to marketing as the

primary function of their art. The diminishing resources devoted to both public art and public education have produced the kind of selection process that rewards commercial public art and neglects those who create work that explores or challenges these systems in innovative and experimental ways.

There are those who have created a new synthesis between several fields. Donna Graves, a cultural historian and public-art consultant, has shifted her own focus to "the intersections of art, urban history, urban planning, and explorations about how the histories of urban spaces can be meaningful to people today." She believes that the past "can be a potent lens for understanding where we stand now and where we're going as a society."

"I do cherish the idea that there is room to do great good in this field," she says, "You may not always achieve it, you may only rarely achieve it—but connecting to people through their hearts and minds with what a place means to them and others is what really interests me. And art is one of the most powerful tools we have for making those connections."

So, given the complex definitions of "public" and "art," the diminishment of educational resources for art, and the dominance of media as a purveyor of commerce, how do we teach students about this phenomenon? How do we prepare them to enter a field that has standards that are simultaneously rigid and tectonic? How do we connect the technical, the intangible, and the social in the teaching of public art?

The VPA program uses public-art education as a tool for resistance against the illusory concept of fame, the seduction of money, and elitist, exclusively self-serving art practices. Part of the answer is to be found in our own studios, artistic practices, and experiences. What we create is a manifestation of our beliefs; what and how we teach is often a repetition of what and how we have been taught. We take joy, prejudice, dislike, and failure into the classroom. As instructors, we can make the experience of creativity and learning deeply compelling to our students. Johanna Poethig says,

> I enjoy the collaborative process and the surprises of improvisation. By bringing that into the teaching practice we can all learn something new in the process. If I am engaged and learning then my students will be as well. I teach through modeling my joys and frustrations with my own work and share that with my students.

How we interact with our students has a profound effect upon the way they learn and therefore the ways they will create, teach, and live. We who literally and figuratively hold the keys to the studio can change the learning environment from a contested territory upon which power struggles are reenacted into a wonder-filled space of celebration, connection, and liberation from tyranny and the burden of outmoded ways of being. This is a sustainable resolution for artists as citizens in an increasingly connected global community.

But how do we counter the ways in which "fitting in" and being socially somnambulant are rewarded? How do we get our students to examine individual economic, cultural, gender, and social privileges and inspire them to work collectively both in and out of the field of public art? One of the ways might be to provide students with transferable skills that can directly enrich their lives as well as be applied in the field of public art. With kind, conscious, and helpful interactions with professors; creative activities that are personally rewarding; successful and sustainable experiences in alliance building; and honest, self-reflective, and meaningful collaborations with other students, community members, and professional artists, we can create new generations of public artists who will leave a powerful legacy that will resonate for many generations to come.

In our world where a significant number of people are struggling for liberation, most of us have forgotten what the children still know: that people can be helpful, that creativity takes many forms, that small can be good, and that small, daily celebrations make life fun. I truly believe that public art created from a place of wonder and playful exploration, grounded in timeless values such as respect and reciprocal engagement, has the power to inform, affect, and change vast numbers of people.

Dr. Mesa-Bains says the VPA is an innovative program because

> Our collaborative curricular development, our redefinition of art as a social practice and our pursuit of a community-based program have expanded what I now see as a growing movement in art schools and art departments toward the libratory model of art making. Imagining the work of the artist as a space of agency and promise toward the well being of community is a positive and libratory stance.[4]

The key to the success of the Visual and Public Art program is remembering those without a voice—the many students, artists, and communities who remain unheard—and including them in a long-term sustainable, reciprocal relationship.

NOTES

1. Suzanne Lacy, ed., *Mapping the Terrain* (Seattle: Bay Press, 1995) 46.
2. The Visual and Public Art Mission Statement, Visual and Public Art Department, California State University, Monterey Bay, 2006.
3. Augusto Boal, *Legislative Theatre* (London: Routledge,1998).
4. All quotes are from written and oral interviews done during the months of August through October 2004.

7 A Fine Public Art &
Design Education
Learning and Teaching Public Art

Faye Carey

"New Genre" was not the title, but it was the subject of the Public Art programs—both undergraduate and master's—that came to be taught at Chelsea, in a tradition of contextual arts practice that goes back to the school's complex origins in the late nineteenth century. One of the persistent features that has threaded its way through this evolution, and a key theme of this essay, is the relationship between art and design—whether complementary or competitive—and the corresponding discussion between fine art and public art, both as subject, and as practice.

The immediate predecessor of the Public Art programs at Chelsea was a course whose origins went back more than eighty years, when Hammersmith College of Art and Building—where it lived—merged, in 1975, with Chelsea School of Art, a couple of miles downriver, by which time much water had passed under both bridges. This was a marriage not of love, or even of affection, but of convenience that nonetheless lasted and grew into a curmudgeonly accommodation which prospered probably more as a result of, rather than in spite of, the geographical separation which had them working together but living apart for the next thirty years.

Both of these local art schools started life as trade schools, and each in turn had its own history of shedding and merging, leaving complex and occasionally contested legacies in their wake. Chelsea's origins date back to 1895, as a polytechnic established to provide Londoners with a technical education, at a time when art and design were programmatically, and pragmatically, linked in both teaching and practice. The curriculum offered domestic economy, mathematics, engineering, natural science, music, and an art program emphasizing industry-related design, including product design, graphic design, and a range of techniques linked to the textile industry. Fine Art did not make its appearance as a discrete subject until some time in the 1940s. The establishment became independent in 1957 as Chelsea College of Science and Technology (with still no mention of "art" in its title), and seven years later joined with the corresponding departments of the Regent Street Polytechnic to emerge, penultimately, as Chelsea School of Art. Sited in its modern, purpose-designed building at Manresa Road—but soon annexing further spaces in south London—it

offered a Diploma in Art and Design, Painting, Graphic Design, and Sculpture, with related studies in experimental music, poetry, artists' books, psychoanalysis, philosophy, and anthropology, alongside a new foundation course pioneered by members of staff at the time, including Victor Pasmore and Richard Hamilton. It was in these years following the war that the separation between art and design became most marked, and the school began steadily to shed its association with design and technology, the subjects that had formed the core of its curriculum for most of its existence.[1] As with the other art schools of the time, Chelsea began to transform its diploma courses into honors degree programs in the early 1970s, and by the end of the decade the conversion from industry to academia was more or less complete.

Down the road, a similar—though not precisely parallel—development was taking place at Hammersmith College of Art and Building, founded in 1891, and offering evening classes that would also prepare students for certificates in science and art, but in this case, more closely allied to the building trades. In the early years of the twentieth century the London County Council took over the school and expanded the curriculum. This was much influenced by the Arts and Crafts movement, which was reflected both in the school's purpose-designed building and in an ambitious program that placed architecture at its core, flanked by the allied building trades on the one hand and applied arts on the other. In due course the latter included architecturally related painting, sculpture, ceramics, textiles, interior design, and product design, delivered within five separate programs: Painting, Textile and Fashion, Interior Design, Product Design, and Mural Design. This last—which included painting, stained glass, architectural ceramics and mosaics, printmaking, and photography—provided the patchwork pieces that were eventually stitched together as the Mural Design program, which was the immediate forerunner of the Public Art courses. In 1975, Hammersmith's art, architecture, and building programs split up and went their separate ways, with the art department joining Chelsea, which finally became Chelsea College of Art & Design in 1989, three years after being incorporated as a constituent college of the London Institute (now University of the Arts London).

By the time of the mid-1970s merger, Chelsea had consolidated its identity as a school of fine art, and it was not particularly eager to renew its association with design and technology. But needs—and economics—must, and the marriage duly took place. Broadly speaking, the courses traditionally taught at Chelsea formed the curriculum of the "art school," while the courses traditionally taught at Hammersmith provided the program of the "design school", a split that has remained fairly entrenched—certainly physically (until the move of all the sites to one roof, at Millbank, in 2004), but also ideologically, more or less, ever since.

Up to the time of the amalgamation of the two colleges, the Mural Design course at Hammersmith was attracting students whose ambition

Figure 7.1 Project presentation for Westway Intervention. Designing Public Art BA, Chelsea College of Art & Design, London. Photo: Sue Ridge, 2002.

to study art and design as a single subject was not seen as problematic, and they were making work that was broadly or specifically related to buildings, spaces, and environments: mural painting, architectural glass and ceramics—often ecclesiastic—mosaics, and sculpture. This began to change—certainly in terms of critical positioning—with developments in the field of study itself, in both the United States and the United Kingdom. The relationship between art and design, which was always implicit in the Design School, became both explicit, and central—as both critical theory and practice—to the public art programs, as they began to evolve into what could be recognized as "new genre" public art. At the same time that the debate concerning the relationship between art and design was taking place, a parallel and related dialogue was emerging around the distinctions between fine art and public art, informing much of the debate within both the program specifically, and in the recently merged college generally.

Those structures and methodologies reflecting the values inherent in the creative practices of both art and design shaped the environment of the emerging courses, providing them with both their distinctive energy and their most significant challenges. Engaging with the built environment in the form of architecture had always been part of both the function and the ethos of the department, and this engagement provided the platform for both broadening and deepening the eventual connection to the wider environment: urban, social, economic, ecological, political, and aesthetic.

Against this background, during the late 1970s and early 1980s, the Mural Design course was offering a three-year Diploma in Art and Design that enabled students to develop skills that had evolved broadly in relation to architecture: mural painting, stained glass, modeling, ceramics, photography, mosaic, and three-dimensional design. However, it was also during this period that the relationship of the work to specific architectural sites began to loosen, deriving quite often from noncontextualized, autonomous, independent, and more object-based projects, which were wedded—sometimes subsequently, or arbitrarily—to more or less appropriate sites. The success or otherwise of a piece of work tended to be assessed primarily on the basis of its viability as an autonomous object, albeit one which bore a customary relationship to architecture. This ambivalence is reflected in such material-based aspects of the course as Stained Glass, which throughout the varied history of the program remained a lively and popular area, with students regularly awarded prizes at the annual architectural glass competitions. This reflected the inventiveness and originality of the student body, certainly, but also the energy of a department offering a dynamic mix and juxtaposition of disciplines and ideas.

However, and perhaps paradoxically, this drift towards a more detached and autonomous, object-based work—somewhere between fine art and architectural art—coincided with an increasing engagement with the object as a contextual idea or question, addressing and critiquing the relationship between art and design at precisely the time that issues regarding the boundaries between art and social engagement were gaining currency. Concern was expressed with regard to the student/artist drifting—through inexperience or coercion—into social work or urban repair. It was primarily out of these debates—between art and design on the one hand and "fine" and "contextual" art on the other—that the Public Art courses emerged, with an increasing regard for the correlation of studio practice to art and design theory.

Up until this time, the emphasis in the theory program was on art, design, and architecture histories and movements. With the growing discourse around modernism and postmodernism in the late 1970s and early 1980s, the course found itself poised nicely between three current discussions: first, around art, architecture, and ornament; second, around "thinking" and "making"; and third, around the aesthetic debate concerning the unique, or unassailable, position of art within modern culture. These discussions evolved out of debates initiated by such theoreticians as modernist architect Adolf Loos in 1908 describing "ornament as crime"[2]—equating it with the primitive—and continued much later by Michael Fried in "Art and Objecthood,"[3] critiquing minimalism as inauthentic due to its departure from self-reference and its reliance on environment and audience, thereby blurring the boundaries between art and "nonart"—confusing art with theater, or design. But it was precisely this blurring of the boundaries—if blurring can be precise—that provided a site of divergence from an assumed aesthetic within the art world

which enabled public art to develop as a specific practice with its own freshly developing theoretical, as well as practice-based, position.

Other competing texts reviewed the place of the material within contemporary practice, such as that of Achile Oliva in *The Trans-Avantgarde*, stating, "The dematerialization of the work and the impersonality of execution which characterised the art of the seventies, along strictly Duchampian lines, are being overcome by the reestablishment of manual skill through a pleasure of execution which brings the tradition of painting back into art."[4] And not only paint, but an array of materials, with students exploring ideas and processes through the rich range of workshops—some of which were inherited from the earlier programs—using materials as a means of experimentation, visualization, and expression, as drawing, process and product.

At the same time, the "dematerialization" identified by—amongst others—Lucy Lippard with John Chandler (1968),[5] which defined projects "so expanded" that they were "inseparable from (their) nonart surroundings" (as exemplified by the site-specific or environmental projects and landworks by such US artists as Michael Heizer, Robert Smithson, and Robert Morris), was now indeed further extended to embrace themes and concerns that had hitherto been only obliquely alluded to in art, whether "private"or "public." In that essay, the authors speak about the visual arts hovering "at a crossroad that may well turn out to be two roads to one place, though they appear to have come from two sources: art as idea and art as action." Dematerialization now expanded to incorporate the possibilities of alternative arts practices as forms of social commentary and inquiry, which were developing in response to concerns and anxieties related to social inequalities, anomalies, and models of marginalization (including those practiced within the art world) around a breadth of issues: sexism, racism, health, class, poverty, violence, homelessness, debates around gender and identity, and, most particularly, the environment as subject as well as site—all of which in various forms had begun to be reflected in the interests and practices of both the staff and new generations of students coming on to the course.

A decade later, an equally influential text, "Sculpture in the Expanded Field" by Rosalyn Krauss (1979), speaking mainly but not exclusively about sculpture, continued the exploration of the expanding boundaries of aesthetics, in relation to ideas and processes as well as objects.[6] Here, Krauss identified the need to explore and reconsider terms and meanings in relation to work, such as that by Robert Morris, Nancy Holt, Robert Smithson, Mary Miss, and Bruce Nauman, among others, that appeared to be breaking possibly with (art) history, but certainly with modernism, and defines this rupture within the conditions of postmodernism, primarily with regard to the legitimacy of contingency—including site or "marked site," landscape, architecture, and context—a condition abhorrent to modernism.

Following a parallel, or at any rate comparable, line of development, the ethos of the course evolved whereby engagement with, or regard for,

audience, site, issue, and context as not only a practical but an aesthetic component of the ensuing work became central to process and method-ology, marrying the hitherto apparently competing ambitions of art and design, not now by shotgun, but at least by arrangement through common interest and mutual consent, and at best by respect, and perhaps even love. The principle at work within the course was to invite the students always to identify and pursue their area of creative practice—which was para-mount—and to use the public realm as both site and as testing ground for ideas. Interdisciplinarity of art and design practices, often regarded at the time with suspicion as potentially undermining the principle of autonomy sacred to fine art, was approached positively within the Public Art pro-gram, and what began to excite students about the course was this very strategy which encouraged them to test personal interests, ideas, and pro-cesses in such a way as to furnish them with models of practice that were underpinned by an ability to exercise artistic freedom, sustained and sup-ported by rigorous and reliable design frameworks and disciplines.

Shortly before, or simultaneous with, these developments, a number of initiatives, events, and critiques were beginning to have an impact on the arts agenda—"public," "fine," and educational—both in and beyond Lon-don. In 1977, the Arts Council of Great Britain initiated its "Art in Public Places" scheme, which encouraged interest and investment in public art projects, as did the "Art into Landscape" initiative set up in the mid-1970s jointly by the Serpentine Gallery, the Royal Institute of British Architects, and the Landscape Institute.

Then, notably, in 1982, and in the light of these developments, the Insti-tute for Contemporary Art hosted the Art and Architecture Conference, a formative event with respect to the future growth and development of art in the public realm in the United Kingdom. Deanna Petherbridge, who played a key role in its organization, states that it arose out of "the growing need for a forum for debate between artists and architects" at which "the proph-ets—and critics—of the New Collaboration assembled to try and establish a critical base for the movement" out of which emerged "a reflection of the complex issues surrounding the whole subject . . . "[7]

With contributions from architects such as Theo Crosby, Charles Jencks, and Will Alsop, this seminal conference provided new models for practice and was followed by a series of exhibitions, events, and discussions seeking to establish a critical base for the "New Collaboration," while at the same time acknowledging the difficulties of doing so "in an age of sophisticated pluralism."[8] The Public Art course engaged with the exhibitions that fol-lowed from this event to bring students together with architectural proj-ects, thereby promoting the notion of active participation from the outset. Teachers from diverse practices including architecture, sculpture, paint-ing, photography, model making, architectural glass, and textiles formed fantasy design teams with students in the college studios to explore the creative potential of collaborative practice. Gradually, the emphasis within

the program was shifting towards an approach that placed critical consideration for context and audience at the center of its design ethos, with practice-based research—visual, environmental, and social—at the heart of its design methodology, alongside an ongoing reconsideration of what constitutes aesthetics in the public realm.

One of the outcomes of the debates arising from the 1982 conference was the initiation of a discussion on the merits or otherwise of Percent-for-Art policies, along the lines of the long-standing American model. This federal and state-sponsored program, initiated in Philadelphia in 1959 and gradually proliferating across the United States, was visibly successful in terms of urban regeneration, most notably in cities such as Seattle. Here, in the United Kingdom, the advisability of such a policy emerged in 1983, with the recommendation by the House of Commons Select Committee on Public and Private Funding of the Arts that businesses, local authorities, and government departments consider dedicating a proportion of the full cost of the project to commissioning new works of art—a policy considered and nominally adopted but very unevenly sustained or implemented over the years by the relevant bodies empowered so to do. Nonetheless, the government initiative served to draw the attention of local authorities, planning departments, and other agencies to the potential opportunities for addressing aspects of urban decay and regeneration, *inter alia*, through such a program. The prospect was therefore now more firmly embedded, at least nominally, in the arts agenda, at the levels of planning, funding, education, and practice.

A further legacy of the 1982 conference and related exhibitions was the establishment that year of the Art and Architecture Society, launched to strengthen the connection between the two professions, and to continue developing the dialogue in relation to both promoting and critiquing collaborative practice. From the outset, staff on the Public Art course—followed soon after by successive years of students—were involved with the new organization, for a time cosponsoring the visiting speaker program, which included artists, architects, and designers from across the formal and political spectrum, enabling and continuing an often uncomfortable dialogue which has nonetheless contributed to the public art discourse for over twenty years.

Two years later, and energized by the same momentum, 1984 saw the establishment, under Lesley Greene,[9] of the Public Art Development Trust, the first of the organizations founded to advance awareness and promote the generation of art in the public realm in the United Kingdom. The Trust arose out of discussions between members of the then Greater London Arts Visual Arts Panel, the Arts Council, and the Gulbenkian Foundation, which offered three years of funding. The initiative was launched at the Air Gallery by Lord Gowrie, then Minister for the Arts, with an exhibition of artists working in public places. Supported initially by a mix of public and private funding, PADT provided the first model for all subsequent public

art agencies in the United Kingdom, such as the Public Art Commissions Agency working out of Birmingham and other regional programs. Soon after, in 1985–1986, these agencies came together to form the "agency of agencies," the Public Art Forum (or PAF, recently re-formed as ixia) to share information, monitor projects, and promote good practice in the field, which included a commitment to championing education—for both artists and audiences—about art in public places. The Public Art course was associated with a number of the member organizations, including PAF itself, from their earliest days, and the artists, events, and projects they initiated. These associations helped to provide the experience for students in understanding and addressing, as artists and designers, the often conflictual concerns of both the commissioning bodies on the one hand, and the audiences affected by or involved in such projects on the other. Learning to incorporate these concerns, as well as the numerous pragmatic issues and responsibilities, came to be embedded as standard practice within the creative design process involved in student projects. When in 1987 Deanna Petherbridge reviewed the state of collaborative practice in her book *Art for Architecture*—a project which arose out of the work undertaken by a research team from the recently formed Art and Architecture organization—official interest in the subject had developed significantly, as evidenced by the foreword, authored by both the Minister of State for Housing and Planning and the Minister of State for the Arts at the time.

New organizations with complementary agendas began to add to the climate of diversity, further evidence of the growing trend for carrying creative practice away from what was increasingly perceived as the hygienic, or at least predictable, environment of the gallery—and the system within which, and to which, it was bound—to breathe the oxygen of risk and uncertainty beyond the format the security of the white cube. Artangel, for example—which provided regular contributors to the visiting speaker program of the Public Art courses at Chelsea—was established in 1985, and functioned somewhere between an entrepreneurial management team and fairy godmother. Its focus was to enable the individual artist or artists to invent new and largely experimental forms of work for specific sites and audiences, rather than to manage particular projects, as was the case with the newly forming public art agencies, who tended to mediate between client—or site—and potential artists, via open or limited competition. Entirely different in function but contributing equally to the shifting cultural climate were such groups as Common Ground, Sustrans, Platform, and others, whose remit was very specifically related to sustainable environments, both urban and rural. All of these had an impact on the changes taking place within the program: its processes and materials, the teaching that was taking place in both the studio and the lecture theater, the teachers, the visiting speakers, and the students who applied specifically to learn how to work artistically within a social or environmental context through the application of design disciplines to imaginative, creative, artistic

practice. Students began to work mainly off site, and in due course both the research and the testing of ideas in the "field" became a requirement of every project. This form of action research had a significant impact on students and on the nature of the work carried out on the course. As the program developed, taking risks, relinquishing a measure of control, and being uncertain of outcomes became the exciting norm, reflected in the changing curriculum, teaching practice, student experience, presentations, peer assessment, and evaluation processes, and in the evolving artistic practice evident in the program.

A further factor contributing to the debate and the consequent developments taking place within the course arose out of two opposing trends in practice that were emerging around this time: the growth of corporate arts policies and agendas, and the maturing of the community arts movement, manifested in the increase in commissioning of large-scale, often site- or issue-specific works such as paintings, sculpture, textile wall hangings, architectural glass, and installations in corporate headquarters and industrial parks on the one hand and, on the other, the proliferation of murals—paintings, mosaics, and ceramics—within inner-city neighbourhoods throughout the United Kingdom. Students in the course became involved in live projects in both instances, in response to the numerous invitations to participate in competitions or to propose, and sometimes to execute, designs for commissions that had begun to arrive at the department from a variety of sources. A strategy for responding to such initiatives was constructed, based on a balance between the educational value derived from working on a "live" site with a client, and the professional and ethical position of the student working in the "marketplace." These opportunities and initiatives led to the construction within the program, central to all projects, of a professional practice component and related handbook, which addressed all aspects of working effectively—professionally, legally and ethically—in the public realm.

The course used these opportunities to look beyond merely tolerating the constraints placed on a project by the practicalities, and exploited them to strengthen and emphasize many aspects of collaborative practice, thereby introducing students to the numerous creative possibilities inherent in the challenging processes of negotiation, beginning with the design brief, which would be constructed within the academic requirements of the course as a project. The client would agree to participate with the educational aims of the project, through a managed partnership, by co-presenting the brief to the student group, making the site available for analysis and research, taking part in discussions, and participating in the design selection process. The course required that the students fulfill the requirements of the curriculum by responding to, analyzing, and critiquing the brief; undertaking the necessary research; participating in discussions; and devising a response in the form of detailed designs, models and (where appropriate and realizable within the course structure) material execution

of aspects of the project. Students were then free and encouraged—indeed, required—to interpret the brief as they saw fit, including, if they chose, to critique its aims and objectives, provided they could construct a viable argument for their proposals. The partner organization, as well, was then often involved in aspects of the critical process, responding as client, and engaged in constructing a shortlist of students who would be invited to take their proposals a stage further. Course involvement in such live projects usually ended at this point, and, where opportune, students were free to negotiate independently any further arrangements with the client, with the course acting, if at all, in an advisory or facilitating capacity. The pressures emanating from funding bodies for projects—particularly, in the 1990s, those connected to millennium and lottery proposals—to show evidence of an educational component added impetus to this process, with the initiative for the proposed collaboration with the course most often instigated by the partner organization. Once students had been introduced to this method in the early stages of the course they were free to devise their own projects, using this process of action research and design development as a model of practice.

The core of the "didactic" component of the teaching took place within this model, whereas the learning in relation to the students' artistic development came about in the same way it did everywhere in art and design education: through conversations, affinities, clashes, longueurs, unexpected encounters, desperation, inspiration, neglect, delayed reactions, in studios, corridors, bedsits, parks, pubs, study trips, books, films, poems, dreams.

By contrast, research undertaken in 1988 for a Churchill traveling fellowship inquiring into the nature of collaborative practice in the United States was striking with regard to teaching through design discipline, or professional practice, within fine-art programs. The study coincided with a major exhibition, "Architectural Art: Affirming the Design Relationship," taking place in New York. It was generated significantly by the recent growth of public art in the United States and included work by numerous artists and architects showing and discussing recent collaborative projects and debating the merits and concerns around this burgeoning practice. It was growing—in both quantity and scale—primarily as a result of the incentives provided by the Percent-for-Art program, introduced in the mid-1960s and adopted by that time in twenty-four states, alongside a fairly vigorous federal policy which encouraged, or required, the incorporation of art within national projects. Thus, an increasing number of artists and craftspeople across the country had become focused on architectural and related opportunities, rather than exclusively on the studio and gallery systems, to support their work, with vast sums of state and federal money going into building projects and providing them with a considerable living. Yet, of over 40 colleges identified and contacted in pursuit of this research on the basis of their course descriptions, not one—at the time—was offering a program, or even a unit within a course, that would specifically provide students with

experience or expertise that would enable them to explore the extraordinary opportunities afforded them through Percent-for-Art policies. Indeed, the research indicated that there was considerable resistance to initiating such a program, apparently due to the concern within art schools—and within the art community generally—with regard to sustaining (the fantasy of) purity of autonomy, and a distinct anxiety around what was perceived as the "compromise" that such collaborations would be bound to entail. From the architect's position there was a parallel concern. For example, S.I.T.E. partner James Wines[10] commented that, "In most collaborations between artists and architects, what you see is that there is no content to the reason to get together" and without this, the so-called collaboration could be gratuitous, "conceptually shallow and superfluously ornamental." Many architects rejected, and frequently resented, this legal requirement, which they often regarded as not only burdensome but, worse, disruptive of the integrity of the architectural process and project, where the art was regarded as inherent within the design, and not adjunctive to it. This was a principle, and a position, with which the Public Art course was entirely in agreement, but it was precisely this misalliance that it sought to address through a program that included and explored these very issues arising from the debates around materiality, art, architecture and design, fine art, and public art. To sustain the artificial dichotomy between creativity and professionalism—between art practice and design process—would surely be to deprive students of the very development that would enable them to collaborate effectively, and creatively, on the exciting initiatives that were arising from the new policies.

The debate was further energized by a number of publications and events that followed close upon each other, and which impacted on and contributed to both the theoretical discourse, as well as the studio practice, of first the M.A., and soon after the new B.A. Public Art programs at Chelsea. Amongst these were essays by writers such as Patricia Phillips,[11] and books such as Arlene Raven's (1989) *Art in the Public Interest* and W.J.T. Mitchell's (1990) *Art in the Public Sphere*, which included some of the first articles by both established and emerging authors critiquing the social and political dimensions of contemporary art, mainly in America—although often applicable in the United Kingdom—addressing a breadth of issues including diverse publics, shared spaces, commodification, consumerism, ownership, authorship, local histories and industries, poverty, homelessness, unemployment, addiction, AIDS, racism, sexism, social exclusion, gender, neighbourhood and domestic violence, and the shifting place and function of art within a social and urban context.

In Rosalyn Deutsch's (1991) seminal essay on the politics of collusion that harnessed public art in a local government drive to remove the inconvenient and unsightly homeless from the streets of New York, she brings the argument full circle, and into bleak and stark relief. This essay had an impact on the debate in the United Kingdom, and was heatedly discussed

at the "New Voices in the City: Art and the Urban Environment" conference held in Manchester in 1993, organized by Ian Hunter and Celia Larner of Projects Environment with Manchester City Art Galleries: an event attended by staff and students of both the undergraduate and postgraduate public art courses at Chelsea. An event of this scale and breadth could not, and would not, have happened without the financial and political support of such sponsors as Manchester City Council and the city's Development Corporation, amongst others, who were at the time energetically bidding for the 2000 Olympic games, and who would be awaiting a report of the conference's findings, as a contribution to that ambition. The week-long program included an international array of scores of artists, designers, planners, agents, educators, writers, critics, and politicians all discussing the city as a site of cultural generation, and public art was represented and debated in all its nuances, both current and historic. Amongst the many notable contributions was that of Patricia Phillips, who commented that

> To produce public projects one has to be engaged in a critical and speculative practice. It is the character and nature of public art to explore all the significant questions of contemporary cultural production, to lead the discourse that we are all involved in as artists, as administrators, as critics, and to investigate in the most enthusiastic and intense and emphatic way ideas about the nature of community and the instrumentality of art. [12]

Mary Jane Jacob, American curator of a radical public art project in Chicago, noted that "Once we have got past the idea of community as a deficiency model . . . and come rather to the position that the community can contribute to art, and can contribute to a new kind of public art, we have been able to work with some fairly radical forms that change our notions of what the audience can handle."[13]

Jochen Gerz spoke about political projects undertaken in Germany, which had far-reaching and sometimes unexpected and at times unhappy repercussions. He was later invited as artist-in-residence to the Public Art program at Chelsea, where students worked with him on the research phase of the Phoenix project for Coventry, reinforcing the recognition that imaginative approaches to research and management contribute substantively to the creative content and outcome—that is, to the aesthetic impact—of a project. British-born, American-based artist Andrew Leicester, who also came to work with students at Chelsea, spoke about the significant impact on his own practice of the process of research and engagement with the public that would provide the primary audience for the work. It was clear that far from compromising the project, the work was substantively enhanced—for both artist and audience alike—precisely as a result of, rather than in spite of, the friction of social engagement.

As well as hearing and discussing the controversial findings of the first major assessment of permanently-sited art in public places in the United Kingdom, Sara Selwood's *The Benefits of Public Art*,[14] the conference learned of the immeasurable benefits to the proliferation of public art attendant upon a bid to host the Olympic Games, as evidenced by the phenomenal regeneration of Barcelona's urban infrastructure.

The following year, in 1994, a second, follow-on conference, "Littoral: New Zones for Critical Practice in Art," was held in nearby Salford, also organized by Projects Environment, which continued and expanded on many of the themes and issues introduced at the Manchester conference, with some of the same contributors returning to engage in discussion with new speakers from numerous countries. One of these was Suzanne Lacy, (then) Dean at California College of Arts and Crafts in Oakland who was in the process of completing *Mapping the Terrain: New Genre Public Art* (1995), which gathered together accounts by artists and critics of new work in this field, drawing attention to issues and methodologies that had risen from unremarked obscurity to a place in both public consciousness and critical awareness. The collection included essays by writers whose work had become familiar to students through the theory program and elsewhere, such as Patricia Phillips, Mary Jane Jacob, Lucy Lippard, Jeff Kelly, Allan Kaprow, and Arlene Raven, as well as Suzi Gablik, whose book, *The Re-enchantment of Art*, was influential in fostering debate on the spiritual dimension of art in the late twentieth century. Lacy's book came out in 1995, the same year that Nina Felshin's *But Is It Art? The Spirit of Art as Activism* was produced by the same publishers, and which included some of the same contributors. Critical writing and interest in public art, for years virtually ignored, was now in full and exhilarating spate.

The course at Chelsea had for some years benefited from the endeavours of a trainee librarian whose chosen area of study was public art, providing our students with a regularly updated compilation of the most comprehensive bibliography of subject-related material probably then available. It is noteworthy that for years the reading lists that contributed to the theory program of the public art courses were comprised mainly of extracts and articles on the subject, and now within the space of less than two years, we had for the first time a substantial, and growing, collection of books to recommend to students in their chosen field of study.

Much of the writing drew attention to the nature of the relationship between artist and audience, and this development became prominent in both the structure and the assessment process of course projects which encouraged students to consider and articulate on whose behalf they believed they were working, and who would benefit, while at the same time questioning the illusion of "altruism." The final project was regularly prefaced by these comments by social activist artist Hans Haacke[15] (1974), which students were asked to consider:

[No"artists"] are immune to being affected and influenced by the socio-political value-system of the society in which they live and of which all cultural agencies are a part, no matter if they are ignorant of these constraints or not ("artist" like "work of art" are put in quotation marks because they are predicates with evaluative connotations deriving their currency from the relative ideological frame of a given cultural power group). So-called "avant-garde art" is at best working close to the limitations set by its cultural/political environment, but it always operates within that allowance.

"Artists" as much as their supporters and their enemies, no matter of what ideological coloration, are unwitting partners in the art-syndrome and relate to each other dialectically. They participate jointly in the maintenance and/or development of the ideological make-up of their society. They work within that frame, set the frame and are being framed.

By the mid-1990s many of the practice and theory issues concerning art and design, fine art and public art, and artist as activist had consolidated towards a research program embodied within the broad theme of "Public and Private," and in the spring of 1999 the Public Art department—staff, students, and invited speakers—held a one-day conference at the Institute of Contemporary Arts in London entitled "Public/Private: Subjects and Spaces." Artists, architects, and designers from the United Kingdom, Europe, and the United States spoke about their work, expanding on the theme to include such complementary polarities as "personal/political," "individual/collective," "secret/open," "exclusive/inclusive," and the necessarily private and public character of all works of art, whatever the content or context, reflecting the internal dialogue that takes place both within the artist, and between artist and audience. It was clear from the work that was shown and discussed that the relationship between private and public is one that is being continually negotiated, and that the boundaries between the two—within the artist, the work, the audience, and between all of these—are fluid and negotiable. These are the very issues that had become central to the development of the Public Art curriculum at Chelsea and that have defined its particular character within the college over the years.

The premise of the conference held that contrary to the critical observation that too little is held in common any longer to make public art viable, both imaginatively and factually there is much that is shared: aside from such fundamental human commonalities as biology, ecology, psychology, the laws of the material world, and occasionally even humor, we also hold in common uncertainty, conflict, ambiguity, and fragmented identification: all relevant to making and experiencing public art. We considered how our understanding of what is private relates to such concepts as narcissism

and exhibitionism, or, conversely, how our sense of either communicating or withholding may be expressed within a given work and whether there is a place for exchanging experiences of privacy or intimacy—joy, grief, triumph, loss—in the common, public realm. The event coincided with the White House Clinton–Lewinsky scandal, and there was little in the art world, public or private, at the time that could compete with either the sensationalism or the surrealism of newsreaders' straightlaced and outrageously public broadcasts of cigars, sex, and stained satin.

The conference also provided the opportunity to discuss the other term conventionally paired and contrasted with *public,* which was not *private,* but *fine,* as in *fine art,* a term perceived as having greater autonomy and authenticity, having internal satisfaction as its ultimate goal, whereas *public,* as in *public art*—a term often described derisively as an oxymoron—was perceived as negotiable, contingent, and compromised by external demands and constraints.

Yet, as we know, neither of these positions is unmediated. "Fine" artists have always operated within the conditions of a system which is socially, economically, and culturally constructed and determined, just as artists working in the public realm—and they are often the same people—must negotiate the conflicts which arise out of the equally competing demands of poetics and pragmatics. Both the challenge and the allure of public art—either by necessity or by choice—has to do with the more conscientiously mediated involvement with audience. For some artists, this may be as much to engage others in the creative process, as to engage with the creative processes of others.

At the ICA event, Polish-American artist Krysztof Wodiczko's presentation forcefully illustrated the impact of projecting the deeply private—domestic, sectarian or racial violence, and grief—into the public realm, through the appropriation of habitually "invisible" public spaces and monuments, revitalized and reincorporated into collective consciousness as screen "giants." He described the extensive process of research and discussion, as he encouraged participants—bereaved families, brutalized women—to address their communities through the medium of film in a public arena. The resulting speaking images, massively enlarged and moving in every sense, thereby transformed habitually unremarked, paradoxically invisible, public sites into the activated spaces of living, moving monuments.

Jochen Gerz, who was at the time artist-in-residence on the Public Art course at Chelsea, also reconsidered the place and meaning of the monument as a potential site of collective self-awareness and spoke of his engagement with specific audiences as central to the process of making work concerned with human conflict—internal and external—and strategies for surviving, and living with, uncomfortable truths as a community.

Other speakers addressed the relationship between art, architecture, and urbanism, and how such terms as *private* and *public* may be constructed and understood as ways of negotiating the relationships between personal

and political, self and site, subject and city, power, gender, and fantasy. They also discussed how such ideas may be communicated through visual and spatial language and form; these are often developed through collaborative architectural practices, including directly engaging with local audiences through art and popular culture to communicate complex and critical ideas—another example of the potential for public art as process, to engender and to underpin communal reflection and social change.

Also under discussion were the debates that take place within design teams, professional bodies, and local communities, where mutual or conflicting desires and fantasies come to light, alongside practical considerations such as budgets, funding, and fundraising, and how all of these potentially frustrating obstacles can often contribute—and occasionally become central—to the creative process, content, impact, and ultimate effectiveness of a project.

Much of the discussion of that day rehearsed the issues being debated within the course, as it had evolved from a broadly materials-based applied arts program to one concerned equally with ideas and processes around the relationship between art, design, architecture, and urban and rural environments, alongside concerns around autonomy, authenticity, authorship, partnership, collaboration, audience, identity, functionality, quality of life, and the capacity for all of these to effect change. Prioritizing process and incorporating audience engagement within learning and teaching methodologies had been developing over time, and arose equally out of the practices of the teachers involved in the program, the shifting interests of the students enrolling on the course, and the events within and beyond the spheres of art and art education.

In the decade that has passed since the publication of *Mapping the Terrain*, the distinction between fine art and public art has blurred both in contemporary practice and in the colleges where the two subjects have been taught traditionally as discrete courses. Much of the ethos of fine art has become firmly embedded in public art, and many of the sites and practices long associated with pubic art have slipped into fine art, to the point where maintaining two distinct programs has become unsustainable. The Public Art courses at Chelsea came to an end as discrete programs in 2004, but the discipline continues through the work of those teachers whose passion is engagement with public sites, spaces, issues, and audiences. Undoubtedly, some of the processes specific to public art will be diluted and may be lost, but equally the opportunity is now there both for creative collaboration and for more constructive debates to take place concerning the imaginative practices of art and design, finally, after a century, under one roof.

NOTES

1. Historical information compiled from "AIM25: Archives in London and the M25 area," compiled by Julie Tancell as part of the RSLP AIM25 project. See website http://www.aim25.ac.uk.

2. Adolf Loos and Adolf Opel, *Ornament and Crime: Selected Essays* (Riverside, CA: Ariadne Press, 1998).

3. M. Fried, "Art & Objecthood," *Art Forum*, June 1967, 10.

4. A.B. Oliva in *La Transavangardia Internazionale*, Milan. 1982, quoted in Michael Archer, *Art Since 1960* (London: Thames and Hudson, 1997).

5. Lucy Lippard and John Chandler, "The Dematerialization of Art," in *Art International* 12, no. 2 (February, 1968) and reprinted in L. Lippard, *Changing: essays in art criticism* Dutton, 1971).

6. Rosalyn Krauss, "Sculpture in the Expanded Field" *October* 8 (Spring 1979) and reprinted in R. Krauss, *The Originality of the Avant-Garde and other Modernist Myths* (Cambridge, MA: MIT Press, 1985).

7. Deanna Petherbridge, *Art for Architecture* (London: HMSO, 1987).

8. Ibid.

9. Private communication, 2004.

10. Founding member of SITE architects; director of the Center for Environmental Design at Parsons School of Design, NewYork. Parts of the text are excerpts from his book, *De-architecture* (New York Rizzoli International, 1987).

11. For example, see Patricia Phillips, "Out of Order: The Public Art Machine," *Artforum*, (December 1988), 27.

12. Professor Patricia Phillips, page 33 of the Report from the conference, "New Voices in the City," held in Manchester Town Hall, March 1993.

13. M. J. Jacob, M. Brensen, E. M. Olson (eds), *Culture in Action: A Public Art Program of Sculpture Chicago* (Bay Press: Seattle, 1995), 2.

14. Sara Selwood, *The Benefits of Public Art* (London: Policy Studies Institute, 1995).

15. Hans Haacke in *Art into Society, Society into Art* (London: ICA , 1974), 63.

8　Teaching Public Art in the Twenty-first Century
An Interview with Harrell Fletcher

Shelly Willis

Harrell Fletcher has worked collaboratively and individually on a variety of socially engaged, interdisciplinary projects for more than a decade. The elements of his practice of fifteen years are the origin of a new graduate program called Art and Social Practice Art, launched in the fall of 2007 at Portland State University. The program at Portland State is one of three public-art education programs that have been recently initiated, marking a new area of study and discourse for public-art education.

The work Fletcher and Jon Rubin, Fletcher's collaborator from 1993 to 1999, made in graduate school was cited as one of the sources of the Social Practices graduate program in the Fine Arts Department at the California College of Arts, San Francisco, California. Lydia Matthews and Ted Purvis, who borrowed the term *social practices* from sociology, founded the program in 2004. Purvis says the program curriculum was developed "to think about what social space means and then use art strategies to alter relations in that space."

Jon Rubin, now a professor at Carnegie Mellon, is teaching classes in the Art-in-Context program—a hybrid of public, relational, and social art practices. As part of the program, each semester he rents a storefront in a different Pittsburgh neighborhood and uses it as a center for research and action with his students.

Fletcher has managed to bounce seamlessly between museums and the public art realm throughout his career. His work has been shown at the San Francisco Museum of Modern Art; the de Young Museum; the Drawing Center; the Sculpture Center; the Seattle Art Museum; Signal in Malmo, Sweden; Domain de Kerguehennec in France; and the Royal College of Art in London. In 2002 Fletcher started *Learning to Love You More*, an ongoing participatory Web site with Miranda July. Prestel published a book version of the project in 2007. He is the 2005 recipient of the Alpert Award in Visual Arts. His current traveling exhibition *The American War* has traveled across the United States.

Fletcher was interviewed in the summer of 2007 about social practice art, the development of his work, and why he is starting a graduate program at Portland State.

SHELLY WILLIS: WHAT AND HOW DID YOU DECIDE TO NAME THE NEW PROGRAM YOU ARE STARTED AT PORTLAND STATE UNIVERSITY?

Harrell Fletcher: Well, that's slightly complicated. Trying to figure out what I do or have been doing for the last fifteen years or so has been difficult. I never really had a term for it and was usually frustrated when people applied one to my work or me. The applications would usually be wildly off—like installation artist, relational aesthetics, or socially engaged community artist. Then the term *social practice* emerged. The California College of Arts in San Francisco started a program in 2005 that used the term and in the description of the program cited the work Jon (Rubin) and I did when we were graduate students. I kept getting asked to participate in symposiums and lectures that were about social practice, so it very quickly became a term applied to my work and one I was identified with.

SW: Why start a graduate program based on Social Practice Art?

HF: Everything that students are learning in art school is based on a studio practice model. The idea is that you go to your studio, have your genius moment, come up with a painting, sculpture, or whatever it is and then the way that it is presented—if it is ever presented—is in a commercial gallery and then in a museum. Hopefully.

The reality is only a tiny fraction of artists working in their studios ever show their work in a commercial gallery. So, it feels to me like a con almost, especially in a school context. We are leading students through a sequence, teaching them how to be artists, with a model that doesn't work. Once they've graduated, even if we just look at M.F.A. students, the numbers are bleak. Only five percent of the students that graduate with M.F.A.s are working as artists two years after graduation. If that were another kind of program—medical school, for example—it would simply disintegrate. People need the prospect of a job or they usually won't pay to go through school. How you get discovered and who discovers you never gets discussed in school. So for me, I've always felt like I'm a con man if I'm participating in that system. I feel like I'm tricking people.

SW: A con-man as an artist or as a teacher?

HF: There's the con-man artist aspect too, but (I'm speaking) as a teacher—making my students believe that a studio practice can be a reality. They are following a carrot and, along the way, we take their money. They graduate and then we train a new set of students in the same way. We sort of cover our tracks too, because ninety-five percent of the artists, good and bad, just disappear.

When I started graduate school, I rejected that model pretty quickly. I decided I'd do work that is designed for a specific place and a specific audience and cut out that whole "waiting for someone to discover me" part. It doesn't matter if I wind up in a commercial gallery or museum, because the cycle is complete if I make work that gets shown. Those are the crucial elements. Of course, I want the work to be good too.

SW: But what about the money part of the equation? How do you make a living as a social practice artist? Where is the market?

HF: During school, I realized that the money part was probably not going to happen. The writing was on the wall. It was the early 1990s and the market had fallen out. The numbers just weren't there and so I thought, "Well, I'll just do what I want to do and not worry about the money part." Jon and I started Gallery Here and made other work using what we now call the social practice model, and the cycle was complete. We invested in the participants. We cared about the audience because we were making the work for them and with them.

SW: You were making your work primarily for a nonart audience. But weren't you also still making it for gallery directors and curators?

HF: Definitely, but that was secondary. It was on our minds. We were in art school. We were aware of the art market. We hoped art critics and curators would like the work too. But, eventually what happened was that I was able to support myself.

It occurred to me when I began teaching that I didn't want to perpetuate the studio practice myth. I wanted to create a program designed to teach artists ways to become functional within society and sustain them financially. I believe our society sees artists as useful and important. I did eventually make a living as an artist, but it happened to me in a sort of haphazard way. Now I can take that experience and apply it to a program that illustrates possibilities that aren't normally discussed within the art context—academic contexts, especially.

SW: What are the tools, methods, and curriculum for your new program? How is it set up?

HF: There are eight graduate students enrolled in the Art and Social Art Practice program. They don't get a studio. That's a big deal for most graduate students. They can't be in their studio clocking in hours like a good art student. That means they've got to do something else. I've developed requirements that force them out into the world and into the public realm. For example, the work cannot be made in a vacuum. It has to be shown. They are required to create a blog and a Web site, so they

can catalog their work and make it public. They can do a project that takes place in a day and disappears, and make a record of it by taking a digital photo and writing it up and putting it on their blog. They are required to do a final project, not an exhibition, which evolves during the two-year program and doesn't need to be conclusive.

If you aren't making art for a gallery, it won't look like paintings that would be attached to a white wall. You make something else. My understanding of what an artist is, especially at this point in the game, is someone who gets to do anything they want—anything within monetary and legal limits, and even those can be pushed. So, if that's the case, then why do ninety percent of the artists out there want to make paintings and sculptures? If you are telling them, "Hey, you get to do anything you want from now on," are ninety percent of them going to make paintings? If artists really understood that they can do anything they want, then they would be doing a lot of other things besides making paintings, and a lot of it would take place outside of a gallery context in an alleyway, park, a public building. The site changes the form of the work. It doesn't need a form that fits into the context of a gallery anymore.

SW: Is a public art practice different from social art practice?

HF: No, we could call the program "public art practice." The reason social art practice is slightly preferable to me is because the word *public* has been used so much it is stigmatized to a certain extent. People don't really know what a social artist is, so it is pretty open-ended. Most people think that public art or public artists means making permanent, large-scale, outdoor sculpture. When you ask the general public, "What is a public artist?" They say, "Oh, it is somebody that makes murals or somebody that makes sculptures that are permanent." Why not community art instead of social practice art? *Community art* is a great term, but unfortunately it was used in the 1980s to describe making bad murals with kids. The term got overused, so it is difficult to use the term any more without people automatically assuming that's what you mean. So it is nice to have a semiclean slate with this other term. Ultimately, it doesn't really matter, it's just words—they will all probably get stigmatized, eventually.

SW: You've got dozens and dozens of ideas for social art listed on your Web site.

HF: The ideas on the Web site were generated in my travels. They are kind of like insurance, like backup in case a situation doesn't occur, or I am exhausted, or want to be expedient. They are ideas I can use, so I don't need to devote myself to a place for months. I've got a whole new set of ideas.

SW: What comes first—the site, which includes the audience, or the idea? Because in the context of public art practice, it is usually perceived by curators, critics, and administrators, that artists consider the site and audience first before coming up with the idea.

HF: *Site-specific* was another one of those terms that I was once really excited about, but then I realized it, too, had this loaded meaning, which ultimately has more to do with the way an architect works then the way that I wanted to work. I think there are interesting ways that architects work but, ultimately, I wasn't concerned with the physical elements of the site. Even early on, Jon and I were talking about a new term that never really caught on—*situation-specific*. We encountered situations which included physical environments, but also had to do with social dynamics. These situations could be incredibly transient. We could bump into somebody on a street corner, and that could lead to a project. I like the term because it is looser. You can walk into any situation and there is potentially a project there to work out.

SW: Does public art or social practice art need to accomplish something? In the spirit of new genre public art does it need to be meaningful?

HF: You can be an evil social-practice artist. It's art and social practice—it's not social work. There isn't an agenda. You do not need to be out there helping people. If you do, great. My own tendency is to try to do some good, so I imagine I might inadvertently encourage it in my teaching practice.

In graduate school I was trying to reject the sense that I was doing good. I thought the idea of new genre public art was pretentious. I just didn't feel comfortable with the idea of artist as society fixer. Instead of going out and finding something I can offer a community, I search for the things I can get *from* a community. I believe a community has something to offer me. I'm not going to teach them—they are going to teach me. In that sense, I've always thought of my practice as selfish. I'm getting to go out and learn things from people who know things that I don't know. I have this minimal thing to offer, which is art. I never have a predetermined sense of what the content should be and because of that I end up working on projects whose subjects have nothing to do with my personal interests. What I really have is an interest in people who have (an interest of their own), and then I find a forum for that content.

SW: Does a public art practice also have its own set of rules and is it as separate from social-art practice as studio-based practice?

HF: I think there are plenty of crossovers because we are bedfellows. If my "Social Art Practice" had come out of sociology or anthropology or journalism then those would be the things we would be relating to and there

probably wouldn't be any real connection to a studio-based commercial art practice. But, because it is within an art department there is going to be crossover. For example, there is usually a gallery component to my projects and that's OK. I like galleries. I like art museums. I'm not saying that they are bad. I'm just saying that they are dominant and I want to offer another possibility for myself, for audiences, and especially for my students.

SW: You wrote in an essay that to help combat your shyness you forced yourself to talk and interact with people socially as part of your practice. Do you still feel like you are doing that?

HF: It's been integrated into my process, but I do it less. I tried it out. I realized it could work. It is interesting. But it requires so much energy that I think I'm retreating back. I'm cutting myself off more and more which is where I was before and that's OK. I don't ask people so many questions anymore.

SW: One of the threads through your work is creating exhibition spaces. Early on in graduate school you and Jon made Gallery Here. In 2004 you created the Museum of the School of Social Work, an interactive museum in the University of Minnesota School of Social Work, and recently *The American War*. The latter stands out because it doesn't seem "situational." It's not about an individual you met in a neighborhood or someone you came across in a residency. It's about a historic event.

HF: This project is different in many ways from my past work because I'm not as interested in individual interactions or asking as many questions. I realize I can be interested in a subject, create a structure for it and there will still be all kinds of unknowns and individuals that are still teaching me things. I'm more interested now in doing work that has political content and may have some sort of societal impact.

SW: In *The American War* you had an idea and then found the structure for it.

HF: That's my fear. I never want to start with an idea and then illustrate the idea. I want it to be the other way around—this is the place, these are the people, whatever they want to say is what we talk about. I let the participants determine content.

The American War was different in that it wasn't about people I met, it was a whole museum. It didn't make sense to recreate it in Vietnam, so I recreated it photographically back in the United States. But I still did public programs that allowed local people at the exhibition locations to have a voice.

I (once) created a series of programs called "Come Together" events. The first ones had no thematic direction. Participants talked about anything they wanted—scuba diving, furniture polishing, skateboarding. I did one in New York with twenty-eight people that was eight hours long. There were food-cooking demonstrations, a talk about the history of chocolate, and tango lessons. That was very interesting and I liked doing it, but now I'm more specific. There is a subject and a framework. It has become more interesting to devise a structure, set things in motion, and see what happens.

SW: Well, then it is site-specific. There is someone in the community, who knows the community, who lives in the community making the project about the place.

HF: When I am invited to a community by an art institution, the curator or administrator has a dinner for me and usually invites the local artists, art patrons, people interested in art. The conversation is the same each time regardless of where I go. So I created the "Come Together" program and invited the artists to ask nonarts people to come give a talk. You realize there is this whole other world, right next to us, and it's interesting to the audience and even the speakers because they normally don't have entrance into art spaces. The goal is for the public to become more comfortable and invested in the art space and the artists to become more invested in the outside world. It showed me things that I wouldn't see normally when I'm brought into a place and am just introduced to the artists or art community.

SW: Have you ever responded to a Request for Qualifications? Done a mass mailing of your slides to public-art programs across the country?

HF: Early on Jon and I tried and it usually didn't work. We spent hours and hours writing applications. We kept applying, but it didn't work. Once you're turned down from doing something a certain way, you either give up entirely, or you find a way around it. The way around it was just doing it ourselves, with our own money, which there wasn't much of, with whatever resources we could find.

We did a couple of public art pieces in downtown San Francisco in a parking garage and another on muni. I did a couple of projects here in Portland. The bureaucracy killed me. I just couldn't deal with it, so that was another reason I gave up.

SW: What was inhibiting about the process?

HF: There's a lot of paperwork and investment in something that you typically don't get. You don't get these projects unless you are totally dialed in and if you do get commissioned then you are left dealing with all these other things.

SW: Like what?

HF: Managing a budget, dealing with a contractor, with insurance, dealing with things architects are trained to do, not artists. An artist has, once again, no training or knowledge about the process, no secretary. People tell you, "No you can't do it that way," and you aren't used to that either. Because, you've been trained to be a studio artist and if you want to turn something red, nobody is going to stop you. In the public art realm there are people stopping you at every turn. No, it can't be done that way. It has to be permanent. Permanent means fifty years. You must make it out of these materials. It can't be dangerous.

SW: Will the Social Practice Program include instruction on how to navigate those processes?

HF: Yes, students will go through the process of applying for Percent-for-Art projects. They will do it as a team. Different members of the team will take on different facets of the process. I am setting the process up that way because I think making these kinds of projects are more appropriate for a studio, not an individual artist. That's why architects are really better at making this kind of work.

SW: How can a Percent-for-Art program support individual artists (not teams or studios or architects) in the public realm?

HF: I think some European models that pool percent funds work. Funds are applied to particular areas of the community that are in need, and then the project is developed in a similar way that a curator would work with an artist. It is the curator's job to deal with the bureaucracy and it is the artist's job to make the art. It is also important to get rid of the necessity for permanent work. The ideal is to say an artist, we've got $50,000, decide what you want to do with it.

I'm including the City of Portland in the planning stages of the program at Portland State and we are creating opportunities for students in the program to work in the City in artist-in-residence-like situations. But, I guess I'm hoping that maybe those established institutional public art systems will eventually change. Maybe cities will create different models so that artists can work more usefully within the system. But, I'm cynical.

SW: What is different about consciously making work for a nonart audience?

HF: It's usually assumed that we need to dumb the work down. But that isn't the case. There are many layers in the work and ways people can approach it. In the same sort of way I could, say, go for a hike in the woods by myself and appreciate the trees and the birds. But, I could do the same thing with

my friend, a botanist, who explains the scientific names of plants and their medicinal functions and have a completely different experience. Both experiences are valid and wonderful. It is the same way with my work. I don't want to make-work so only the expert can understand. I want everyone to be able to walk through that forest and have an interesting experience.

SW: How do artist and architecture practices differ?

HF: I think Vito Acconci has it right. Create a studio, with a lead artist, in the same way you would in an architect's office. The lead artist gets to practice the creative aspects of the project and other members support that process.

I recently read about a Minnesota artist (Siah Armajani) who did a project in Spain. He created a model, gave it to a curator, who dealt with fabricators, the public, and site-related issues. I thought, "Wow, if someone can just make a model and it just gets fabricated, then do you really need to be an artist?" We want people to think we are rare and qualified to make things the rest of the public is not qualified to make. It's egotistical. But my sense was probably anyone can make a model, have it fabricated and it could be interesting, even more interesting than the work most artists are doing. So I decided to try it out.

I was asked to do a public sculpture at a sculpture park in France. The park is on an old estate that includes a lake and a chateau that has been turned into galleries. The sculpture park includes mostly plop art from the 1980s and 1990s. It is thirty minutes from the nearest small city and three hours from Paris. People really use the park, not as a place to experience art, but a place where they can walk their dog, go fishing or running, and have a picnic. I started the project by asking people in the park what they thought of the sculpture. The general consensus was that they rather it wasn't there at all. So, I asked people to propose a sculpture for the park. I would choose the project and get it fabricated. I had them make drawings and write down the specifics—size, shape, where it would be sited.

An eight-year-old boy named Corentine proposed making a turtle sculpture. He wanted to keep it realistic. He is a realist artist. He likes turtles. So why not make a turtle sculpture? Sensible. Then given the opportunity to make it out of any material. He decided to make it out of the best material—gold. But then he wanted to keep it real, so he wanted to paint it green. This kind of decision is the complication you hope for in an art project. This is the antilogic that generally gets cut out of a rational person's thinking. If you make something out of gold, you don't paint it green. That would ruin it.

Once I decided his was the project I wanted to work with, I became Corentine's assistant. We set up a studio, made drawings and clay models, and I carved out a turtle in foam to his specifications. He met with the administrator of the project, who told him it couldn't be made out of real

gold (the cost was over 3 million dollars). So, instead he picked a very gold-looking bronze and had the foundry add one ounce of gold to the sculpture during the fabrication process. We went around with the administrator and argued about the site for the sculpture. The administrator won out in the end. Which is, you know, typical. We made a model, the foundry cast it in bronze, and we installed the sculpture and a plaque, and had an unveiling. The process took two years. A permanent sculpture completely conceived and executed, in the same way as any artist, by a ten-year-old boy, is now part of the sculpture park collection.

People are always saying, "Oh, my kid could do that" and I say, "Yeah, your kid could probably do that, and it would probably be really amazing, so let's do it and see what happens." Normally kids are only given clay, crayons, pens, and paper—what happens if you give them a bronze foundry? What are they going to make? Of course they need assistants, but so does any artist. What I've realized is that I have certain skills, if I just lend them to someone then a project can be made that I would never make. The result is a sculpture that people actually like.

SW: How do you deal with ownership issues?

HF: I don't worry about my own ownership. I'm more concerned that the people I work with feel invested. I'm pushing for their ownership and the audience's ownership of the work. I visited the museums and became invested in art from a very young age. But I realize that the general public usually doesn't go to museums, and those are the people I want to make art for. I don't want to make things that people aren't invested in, aren't connected to, don't have an emotional tie to.

SW: What are the ideas you are working on now?

HF: The thing that I'm leaning towards now is making larger-scale work that isn't commissioned. I want to use the same process I used early on in my work, but at a larger scale. I want to find funding for it and make it happen through a different sort of process.

My wife Wendy Red Star is Crow Indian and she grew up on the Crow reservation in Montana. We went there to visit and one of the things we realized was that there are a lot of deep-fried foods served at restaurants and consumed by residents. People also drive big, diesel trucks. We wondered, what if we combined these two things and made a bio-diesel station on the reservation that collected all the grease that is getting thrown away and then turned it into fuel for the diesel trucks that everyone is driving? We want to make a bio-diesel station and a bio-diesel vehicle. The station would function as a place to get relatively cheap fuel and as a multi-use community center, a library, and a gallery, maybe a day-care center.

We are also thinking about doing a project about a rug my dad bought us. We have hardwood floors and a new baby, and my dad thought we should get a rug. Initially we tried to buy a fair-trade rug from Afghanistan, Pakistan, or India, but prices were in the $7,000 range and we couldn't do that to my dad. So after months and months of looking we settled on a rug that isn't fair-trade. It was purchased through a home-furnishing company in the United States and it was much cheaper, so he ordered it, but it didn't come. My dad checked it out and somehow they had canceled the order, so we re-ordered it and we eventually got two rugs in the mail. We've decided to sell the second rug to a collector or a museum and use the money to research where it was made in India, and travel to that place and give the money to the people who actually made the rug.

These are the kind of ideas and processes that I now find interesting.

Part II

Into Practice

9 The Millennium Park Effect
A Tale of Two Cities

Regina M. Flanagan

Over lunch one day in the mid-1980s, I asked Erwin Noll, editor of *The Progressive* why the arts were a low government funding priority in Wisconsin. I was a young administrator charged with the state's Percent-for-art program and seeking counsel from a range of political advisors. The governor chaired the State Building Commission, which funded percent projects and approved artists' proposals, and in his office he prominently displayed a portrait of Robert LaFollette, who founded the state's Progressive Party in the 1920s. If the grassroots populism of that period inspired the governor, why he did not enthusiastically endorse public art, which by its intention and the process of its creation directly encourages public discourse? I hoped that Noll, editor of the magazine that has carried on the Progressive movement's legacy since 1929, could enlighten me. Noll replied that while the founders of the party were committed to citizen participation and accessible government, their priorities were the health and welfare of the populace and addressing issues of social and economic justice. Then he said something that still reverberates—that Progressives believed the arts became important only after other needs were met and that the affluent classes should fund them.

Political culture and public art are intertwined. The political traditions of a place influence the public's perception of what is appropriate and also their expectations of what is possible when it comes to government funding for the arts and especially public art. Even when they do not directly pay for it, federal, state and municipal units of government enact laws that proscribe our civic landscape and influence public art. From a city's comprehensive plan, which defines patterns for land use and future growth and preserves areas for plazas, parks, and open space to federal laws requiring that public spaces meet codes for public safety and comply with the accessibility standards set forth in the Americans with Disabilities Act, government affects the context if not the form, of public spaces and public art.

Madison, Wisconsin has a unique political culture. Seat of government and home to the state's leading university, Madison has a reputation as a liberal town. Many of the school's graduates settle close-by, starting businesses that are spin-offs of university research or that cater to the highly educated populace. They frequently become involved in local politics. Paul

Soglin, student leader of anti-war activities in the 1960s, first became a city council member and then went on to serve as mayor for six terms, beginning in 1973, (just before his twenty-eighth birthday) off and on until 1997. Politics is a favorite pastime in Madison and everyone is invited, indeed expects, to play.

Recognizing that grassroots participation would be the key to public art planning for the city, the Placemaking Collaborative, including me, Christine Podas-Larson, and Cliff Garten, in 2001 authored *The Public Art Framework and Field Guide for Madison, Wisconsin*, a do-it-yourself guide. But change was afoot; while we were devising this planning tool, the Overture Center was under construction. Designed by architect Cesar Pelli and completed in 2004, the Center occupies one entire block of State Street, the city's downtown commercial corridor connecting the State Capitol and the University of Wisconsin, and houses theaters, galleries and facilities for nine cultural organizations, including the Madison Symphony Orchestra and the Madison Museum of Contemporary Art. The Overture Center was funded entirely by private philanthropy—at $207 million it is the largest private gift in Madison's history. The sole funders are W. Jerome Frautschi, founder of Webcrafters, the manufacturer of books for the country's largest educational publishers, and his spouse, Pleasant Rowland Frautschi, the woman behind Pleasant Company and the creator of the American Girl doll empire, which had recently been sold to Mattel for $700 million. Since the early 1980s the Frautschis, who believe in the potential of the cultural arts and entertainment to revitalize downtown, have spent freely to make their vision a reality. Jerome Frautschi chairs the Overture Foundation, which oversees the disbursement of their donations, and shepherded the construction of the center that is now the core of the Madison Cultural Arts District. [1]

Private generosity made possible the most significant cultural gift Madison has ever seen. The individual arts institutions and organizations would not have dreamed of nor been able to mount such an ambitious capital campaign. In less than a decade, wealthy patrons with a bold vision and the funds to execute it changed the entire ecology of Madison's arts community. Andrew Taylor who directs the University of Wisconsin's Bolz Center, in 1969 the first business school program in the nation set up to train arts administrators, sees the arts as part of the urban ecosystem. He says they generate economic and social benefit by creating the street life and creative experiences that grow energized citizens. For an arts establishment to thrive, he believes it needs to show the ways it contributes to a community's overall health. [2] Arts organizations that are residents of the Overture Center now feel the added pressure of their status as economic generators.

Concurrent with the construction of the Overture Center, a second major urban design effort was underway, instigated by several downtown neighborhoods. They engaged the Urban Open Land Foundation (UOLF)—a private, non-profit organization whose mission is to create and revitalize public places and help communities retain quality open space networks, to lead the

planning process for a linear eighteen-acre parcel in a former rail corridor. The result was the Madison Central Park Concept Plan, which proposes a public plaza and farmer's market; gardens with native plants; a performance stage and open lawn; and a bicycle plaza that would serve as a hub for trails in southern Wisconsin. Public art punctuates entry points and the junction of paths along the park's five-block-length.

To further explore the potential for this new "central park," on March 13, 2007 the Wisconsin Academy of Sciences, Arts and Letters' public policy program sponsored "The Triumph of Millennium Park, and its Lessons for Public–Private Partnerships" at the Overture Center.[3] Edward Uhlir, the director of design, architecture and landscape for Chicago's fabulously successful park was invited to speak along with Madison Mayor David Cieslewicz. Uhlir told the audience of around 150 people that Millennium Park has changed the way Chicagoans feel about each other and has elevated the city's self-esteem. Uhlir's PowerPoint presentation emphasized that the park became a reality through the vision of Mayor Richard M. Daley and forward-thinking donors who partnered with the city. He described the evolution of the park and its performance venues, gardens and public art. In conclusion, he cited economic statistics touting the park's beneficial effects on surrounding real-estate values and tourism revenues. But Uhlir was unaware of the occasion's agenda until the Mayor spoke.[4] Cieslewicz recognized that every great city has a great park and talked about the possibility of creating a new "central park" along an abandoned rail corridor downtown. He expressed the hope that "someday we may have something that rivals Millennium Park—at least in our own scale."[5]

What did Madison, with its participatory political culture and tradition of grass-roots involvement in public projects, hope to learn from the example of Millennium Park—a park largely designed and funded by private interests?

Situated just north of the Art Institute of Chicago and west of Grant Park and bounded by Michigan Avenue, Randolph Street, Columbus Drive and Monroe Street, Millennium Park is actually one of the world's largest green roofs and part of Mayor Richard Daley's incentives to turn Chicago into one of the most environmentally friendly cities in the United States. The 24.5-acre park is built over a railroad corridor and a 2,200-space parking garage. The park is a series of outdoor rooms that are filled with public art and cultural venues, including the Jay Pritzker Music Pavilion, the Harris Theater and the Lurie Garden but also a Bike Station to encourage bicycle commuting and a Welcome Center powered by solar energy.

I first experience the park on a ninety-five-degree Friday afternoon in June 2005, almost one year after its dedication.[6] The Windy City feels like a blast furnace. The curvy glittering proscenium of Frank Gehry's Pritzker Music Pavilion hovers above the trees, announcing the park. I enter the northwest corner at Washington Avenue and walk up an ornate staircase past the Millennium Monument in Wrigley Square, a classical Beaux-Arts peristyle incised with the roll call of donors. A distracting, shiny object visible through

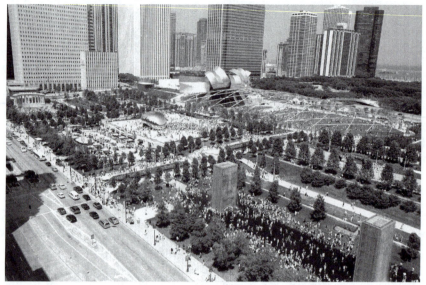

Figure 9.1 Millennium Park, Chicago, Illinois. Credit: City of Chicago/Peter J. Schulz.

the trees on my right—Kapoor's *Cloud Gate* affectionately called "the bean" by Chicagoans—is a magnetically attractive work. The elliptical form rests upon two points and appears weightless, as if it just alighted on AT&T Plaza. But today the sculpture looks like a dirigible in a hangar; it is completely surrounded by a tent and inside metalworkers are sanding its seams. When I visit again in April 2007, the entire work is revealed, reflecting the sky and the horizon in a great arc on its mirror-like surface. People appear like ants as they hurry toward it and handprints smudge its pristine surface because touching the sculpture is irresistible.

I continue to ascend the stairs and arrive at an expanse of cool green lawn in front of the Pritzker Music Pavilion that is framed overhead by the latticework of the pavilion's sound system. The Great Lawn measures six hundred feet long by three hundred feet wide and can accommodate over seven thousand concertgoers on folding chairs and blankets and four thousand in the auditorium's fixed seats. Security personnel in bright yellow t-shirts stand out as they eye to see people reclining on the lawn.

Behind the undulating curves of the pavilion's façade, a cantilevered web of tubular steel supports the ribbon-like steel panels of the proscenium. I learn later that engineers that design amusement park roller coasters fabricated Gehry's structure.[7] East of the pavilion, Gehry's 925-foot-long BP Pedestrian Bridge clad in shiny stainless steel panels snakes from the park over Columbus Drive and lands near a bedraggled rose garden in Grant Park. On the return trip, the bridge provides changing views of the downtown skyline, the park, and especially the pavilion. I feel as though I am within a sculptural space; movement through this functional form brings it to life.

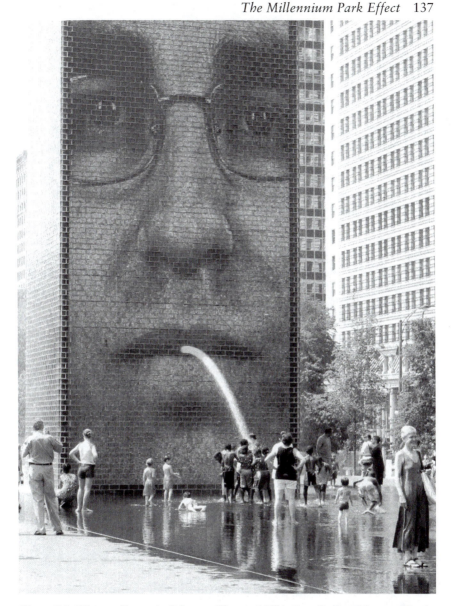

Figure 9.2 "Crown Fountain," Jauma Plensa. Millennium Park, Chicago, Illinois. Credit: Regina M. Flanagan, 2005.

South of the Great Lawn, surrounded by a tall hedge, is the Lurie Garden by Kathryn Gustafson. Two-and-a-half acres in extent and constructed over a thin layer of soil only thirty inches to four feet deep, the garden draws its layout from the origins of the site. It is composed of two portions, the Light Plate and the Dark Plate, which are separated by the diagonal cut of the

Seam, a boardwalk along a shallow channel of moving water that follows the original line of the railroad's trestle. When I visit the park two days late, on Sunday afternoon, crowds of people are seated on the wooden steps leading down to the water, cooling their feet in the stream. I follow the watercourse to the south end of the garden and looking back, the hedge forms a horizon line anchoring the gleaming crown of the music pavilion visible just beyond. The Light Plate west of the Seam is carpeted with blooming drifts of over 130 varieties of native prairie and ornamental plants selected by Piet Oudolf. Across the Seam and up several steps between tawny limestone retaining walls, the wooded landscape of the Dark Plate features shady outdoor rooms. From this highpoint, the architectural tableau of downtown Chicago unfolds.

When I exit the garden's southwest corner, I hear splashing water and waves of laughter. Past an allée of trees, a terrace overlooks the spectacle of the Crown Fountain by artist Jaume Plensa. Two fifty-foot-tall glass block towers each containing 147 LED screens project a pair of gigantic faces across a 230-foot-long reflecting pool. Their eyebrows and facial muscles twitch, they blink and wet their lips, and after precisely five minutes they smile broadly and slowly purse their lips—and a torrent of water arcs out into the pool. Shrieking children in bathing suits elbow each other below. When the spigot is turned off, the children rush to line up against the walls of the towers and begin a countdown . . . three, two, one . . . and a waterfall from the top of the towers nearly knocks them off their feet. Then the cycle begins again with a new pair of faces. Adults and children mill about, cooling themselves in the shallow pool. The Crown Fountain is the most popular place in the park on this scorching day.

The wide, shadeless Chase Promenade and Boeing Galleries run north and south through the center of the park. These ramped connections provide unimpeded access to all levels of the park, unlike the ornate staircases that traverse the site from east to west. I avoid these areas on Friday but when I visit the park on Sunday when the weather is cooler I return to view an exhibition by local photographer Terry Evans, featuring images of Chicago from the air. I overhear many languages spoken among the groups examining Evan's work, including Russian, Spanish, French and Japanese.

I observe the passing parade—an extended African-American family including grandmother, mother, father, two teenaged girls, and a young boy sits down to rest on a nearby bench. They are carefully dressed in their Sunday best and it is clear that this is a special outing. Two Indian women wearing vivid, sparkly saris chat amiably as their husbands trail behind. A security person on a Segway scooter zooms up to a pair of bicyclists peddling through the crowd and informs them that no bikes are allowed within the park. They are directed to the Bike Station at the park's northeast corner to secure their bicycles. This building includes a multi-tier parking ramp for the storage of up to three hundred bikes as well as locker rooms with showers.

Solar panels power the building and it has other energy-saving innovations such as toilets that conserve water.

Situated on the wide sidewalk at Michigan Avenue and Monroe Street, I discover the only seemingly improvised activity—tables covered with checkerboard cloth and festooned with attention-getting whirligigs. On either side of the table, players of many ages and ethnicities are quietly absorbed in games of checkers or chess, oblivious to passersby. Also on this corner, a New Orleans–style brass band has set up, lending a festive air to my evening stroll. Street performers display special permits indicating their entertainment has been sanctioned by the city.

I visit for the second time in April, 2007, and the gleaming steel works by Kapoor and Gehry dominate the park through the leafless trees. The faces on the Crown Fountain, which is active twenty-four hours a day year-round, appear somber with the water turned off rather than gleeful or mischievous. But the colossal visages lend a benevolent human presence to the dull cityscape. The nearby chess tables are gone. Rules now prohibit ad-hoc vendors and performers in the park and they have had to relocate down the street. The Department of Cultural Affairs controls programming and hires musicians and other performers to circulate in the park and to entertain children in the free Family Tent.

The park's final permanent public artwork, and the only piece by Chicago artists has been installed in the atrium of the Welcome Center on Randolph Street. *Heliosphere, Biosphere, Technosphere* by Patrick McGee and Adelheid Mers is composed of three nine-foot-diameter two-way mirrors mounted at right angles to each other overhead, on two walls and the ceiling in the building's atrium. They reflect each other and the view of the sky out the window; the imagery etched on the mirrors overlaps with the changing, real-time atmospheric conditions. Solar energy is the subject of the artwork, and the building itself is clad with photovoltaic cells and generates most of its own energy.

Millennium Park with its innovative architecture and public art and technological marvels may be a park for the twenty-first century, but its social intentions are more like the great parks of the nineteenth century such as New York's Central Park (1858–1880s) and Chicago's South Parks including Jackson Park and Washington Park (1871 and 1894), all designed by Frederick Law Olmsted. These parks emphasized naturalistic design, passive recreation and genteel social interactions. With the exception of the boisterous activity around the Crown Fountain, Millennium Park is a place for strolling and quiet pursuits like a picnic on the Great Lawn, resting tired feet in the Lurie Garden's stream or reclining under the shade trees edging the Chase Promenade and Boeing Galleries. I encountered few distressed children (or parents) during my visits. The park's newness and cleanliness sets it apart as a special place and fosters an atmosphere of regard for others, even though a fleet of security personnel enforces it. This subdued setting presents ideal conditions for experiencing the park's public art.

Mayor Daley conceived the idea for Millennium Park in 1997 while visiting his dentist whose office overlooks the unsightly garage deck, surface parking lots, and railroad cut between Michigan Avenue and Grant Park that would become the park.[8] The parcel had remained substantially unimproved since 1836, when the Board of Canal Commissioners designated a soggy strip of land between the growing city center and Lake Michigan to be "Public Ground—A Common to Remain Open, Clear and Free of Any Buildings, or Other Obstruction, whatever" in order to avoid commercial development along the lake.[9] Control of the undeveloped space was transferred to the city in 1844 and it was known as Lake Park or Lake Front Park for the next fifty years. But in 1852 the state gave the Illinois Central Railroad the right to use the land as a corridor to their freight terminal serving downtown industries in exchange for building a protective breakwater and a raised trestle to prevent Lake Michigan from flooding the land at the mouth of the Chicago River. The site was significantly enlarged in 1871 with charred fill from the Great Chicago Fire to include the railroad's Grand Central Depot, and by 1890 the rail corridor's right-of-way was thirteen hundred feet wide at Randolph Street, where Millennium Park is now located.

Legal rulings at the turn of the twentieth century set the course for the subsequent development of the site. In 1892 the United States Supreme Court ruled that the state of Illinois did not have the authority to grant lakefront water rights or control to the Illinois Central—this power belonged to the city "in trust for public use." Under this decision, the city owned all of the filled land east of Michigan Avenue between Eleventh and Randolph streets, including the railroad right-of-way. Later, this ruling would be referenced to gain control of the land for Millennium Park that the railroad had been using for many years as surface parking lots. Attorney Randall Mehrberg, general counsel for the Chicago Park District, recognized the railroad was powerless to build anything on the site because they did not own air rights above the property, and, since they had abandoned rail operations, sued to terminate their easement. In December 1997, the railroad donated its rights, title, and interest in the property extending from McCormick Place to Randolph Street in exchange for a tax deduction and to boost their earnings and increase their sale price during a takeover bid by Canadian National Railway (Gilfoyle, 82). The railroad finally relinquished control of the lakefront after almost 150 years.

A series of lawsuits between 1890 and 1909 by mail-order magnate and Michigan Avenue property-owner Aaron Montgomery Ward invoked the edict to keep the park free of buildings. As Chicago began planning to host the 1893 World's Columbian Exposition, the garbage and ugly wooden shanties occupying the lakefront offended Ward. While he and other adjacent property-owners did approve construction of the World's Congresses Building that was used during the fair and later became the Art Institute of Chicago, the Illinois Supreme Court upheld Ward's opposition to erecting the Field Museum of Natural History in the park. The Montgomery Ward

ruling established height restrictions effectively curtailing any sizable park structures over 40-feet-tall except band shells (two were constructed 1935–1970 and 1976–present) and a Beaux-Arts peristyle (1928–1953), and was referenced on several occasions during the design process for Millennium Park's architecture and public art.

Another historical precedent influences Chicago architecture, city planning and park design to this day—the City Beautiful movement that grew out of the 1893 World's Columbian Exposition. Daniel Burnham, of the Chicago firm Burnham and Root, was the Director of Works and led the fair's ambitious architectural program. Although largely self-taught, Burnham promoted historical European models of architecture by commissioning McKim, Mead and White, and other architects who had trained at the École des Beaux Arts in Paris. The legacy of the fair includes Jackson and Washington Parks, the Museum of Science and Industry, and City Beautiful-inspired proposals for lakefront development, including the Municipal Improvement League Plan (1895) and Daniel Burnham and Edward Bennett's utopian *Plan of Chicago* (1909). The City Beautiful movement appealed to Chicago's civic elite because they believed the institutions of government, literature, art, and culture could serve as the common ground for harmonizing individual and class interests, and the neoclassical style associated with the movement visibility emphasized order and control (Gilfoyle, 25). The *Plan of Chicago* advocated the creation of a viable civic center for the city, and between 1917 and 1929, Burnham and his partners oversaw the design of Grant Park, a key component of the plan, in the style of the French Renaissance and constructed the park's centerpiece, Buckingham Fountain.

After his illuminating experience at the dentist's office, Mayor Daley put plans in motion for the park. Since assuming office in 1989 his administration had made arts, culture, and entertainment a centerpiece of development and tourism and had encouraged and subsidized a downtown cultural renaissance, including the renovation of Navy Pier; the redesign of Soldier Field and an integrated Museum Campus connecting attractions in Grant Park, including the Shedd Aquarium, the Field Museum, and Adler Planetarium. An empowered Department of Cultural Affairs, housed in the Chicago Cultural Center across Michigan Avenue from Millennium Park, has become one of the city's most popular agencies, and mounts exhibitions and events in their building and throughout the city; sponsors and coordinates music festivals in the parks; and administers the Chicago Percent-for-Art Program.

On March 30, 1998, Daley launched the Lakefront Millennium Project as a public-private partnership with John Bryan, the retired CEO of the Sara Lee Corporation, as chief fundraiser. Daley asked Bryan to raise $30 million from the private sector. A passionate long-term arts supporter, Bryan had served on the board of trustees of the Chicago Symphony and the Art Institute of Chicago, and during his tenure at Sara Lee the corporation was awarded the National Medal of Arts for its altruistic corporate policies. But most important, Bryan had an incomparable knowledge of why rich people—such

as himself—actually want to give money to things and also understood that people asked to give money want and expect to get involved in the details of initial planning.[10]

Bryan at first adopted Burnham and Bennett's early-twentieth-century City Beautiful ideas for the lakefront as an artistic composition set forth in the *Plan of Chicago*. The venerable Chicago firm Skidmore, Owings, Merrill LLC (SOM) was hired to produce a master plan, which was later altered because it slavishly adhered to Burnham and Bennett's model and wasn't forward-looking enough for the donors. With its series of staircases, the design also presented serious accessibility issues. Although SOM's master plan was extensively reworked, it established the general scheme for the park as a series of outdoor rooms that extended Grant Park's gridded parterres. SOM conceived the entrances and exits, the promenade, the skating rink, the location of the fountains, the peristyle, the Great Lawn, the garden, and the music pavilion as a unit. The parking garage was a key component of their plan. Requiring a public investment of $120 million in municipal bonds, it would be both the financial and structural support for the park—at conception, the Lakefront Millennium Project was as much a transportation project as it was a new park space (Gilfoyle, 88).

But how would the park amenities, including public art atop this structure, be funded? Bryan formed the Millennium Park Board of Directors with Donna LaPietra of Kurtis Productions as his cochair and included corporate officials such as Marshal Field V who had experience in civic and cultural affairs. Then Bryan devised a strategy to identify individuals, families, and corporations with historic attachments to Chicago and to ask them to each contribute a gift in excess of $5 million to develop a space in the park to which they would have naming rights. He convinced Marshall Field V to lead a drive for smaller gifts of $1-million, and these donors' names would be inscribed on a peristyle in the northwest corner of the park—a roll call of Chicago's "modern-day Medicis," according to Donna LaPietra (Gilfoyle, 104). But to attract donors Millennium Park had to be original and unique, and Bryan decided that significant works of public art, historically an important component in downtown Chicago's urban design, would be the answer. Beginning in 1978 Chicago's Percent-for-Art ordinance incorporated public art into municipal building programs, and by the 1990s the Loop featured over one hundred works of public art in corporate plazas and lobbies as well as in city-owned spaces and buildings, and included the famous Chicago Picasso.

On July 10, 1998, Bryan convened the Millennium Park Art Committee, including art collector Lew Manilow, Michael Lash (director of the city's public art program), and gallery director of the city's public art program, and gallery director Richard Gray, among others. Gray relates that the art selection process soon reached an impasse because the committee members had conflicting aesthetic interests, and he suggested empowering officials from the Art Institute to make recommendations. They asked Jeremy Strick, Curator of Modern Art, to assemble a list of world-renowned artists and he

brought slides of their work to the committee (Gilfoyle, 112). The committee had considered and rejected the idea of a competition because they felt there should not be a public process on art and did not want the public voting on it, although later they did bring their selections to the city's Public Art Committee for review and comment.[11] They also decided to commission two sculptures rather multiple pieces of art, one to be located in the garden across from the Art Institute and another for the central plaza near the skating rink, and invited proposals from artists Jeff Koons and Anish Kapoor.

Bryan also formed an architecture committee to determine the design and purpose of the park's music pavilion, and a group to address the creation of the garden south of it. In August, 1998, Edward Uhlir, former Parks District architect, engineer, and planner, and member of the Mayor's Public Art Committee, was lured out of retirement by the Mayor to be Millennium Park's design director and project manager. Uhlir joined the architecture committee, which was debating how to make an artistic statement with a band shell, when they hit upon the idea of commissioning Frank Gehry to design it. Committee member Cindy Pritzker, whose family owns the Hyatt Hotel chain and the Marmon Group and endows the annual Pritzker Prize in Architecture, was particularly enthusiastic about Gehry's work and pledged $15 million for the music pavilion. Uhlir and committee member James Feldstein were dispatched to Los Angeles to convince Gehry to design it. Gehry listened patiently as Uhlir described the unique possibilities of the site but became more interested when he talked about the pedestrian bridge connecting Millennium Park to Grant Park over Columbus Avenue. Gehry, who had never designed a pedestrian bridge, was intrigued and when Feldstein said that they were approaching him with the Pritzker family's blessing, Gehry agreed to design the pavilion and the bridge. Securing Gehry was a defining moment for the project—the integrated ensemble of the music pavilion and its Great Lawn and the pedestrian bridge are the most significant elements of the park—and transformed it from a transportation and infrastructure project into a "world-class cultural attraction that no other city has" in the words of Mayor Daley (Gilfoyle, 118).

Meanwhile, Koons proposed a 150-foot tower for the central plaza with a kitschy motif of children's toys. Built of a variety of materials, it featured a spiraling water slide that could be used by the public. Kapoor presented a model in December, 1998 for a gleaming, 150-ton, 60-foot-long and 30-foot-high elliptical metal sculpture for the garden, which would reflect the sky and its surroundings. Park visitors would be able to walk under it. Committee member Cindy Pritzker objected to Koons's proposal, as did Mayor Daley. Uhlir remarks that the artist's design was ill-conceived and impossible to build, and the tower would have been taller than anything in the park and most buildings on Michigan Avenue.[12] Kapoor's magical sculpture was favorably received. However, garden committee members questioned the relationship between Kapoor's work and the traditional garden by landscape designer Deborah Nevins, which conformed to SOM's Beaux-Arts master plan. The

sculpture also would have been in close proximity with Gehry's pavilion. "It just didn't work," said Michael Lash, because it conflicted with Gehry's pavilion, which was seen by some committee members as "a giant piece of sculpture"(Gilfoyle, 121). The situation grew messy when Gehry expressed reservations about the Nevins-designed garden, and its donors also grew disenchanted and withdrew their financial commitment in April, 2000.

Bryan suggested starting over with the garden design and then his art committee boldly decided against Koons's proposal and moved Kapoor's work from the garden to the central plaza facing Michigan Avenue. Outside the garden and off-axis from the pavilion was the logical place for Kapoor's sculpture, where it could have some breathing room and reflect the city's architectural gems across the street. Kapoor agreed the open plaza was a better site and requested no lighting in proximity to the work and minimal landscaping around it.[13] However, the engineers had to redesign the parking garage to support its weight in this location.

The garden would now have its own identity but was in need of a designer. Its committee decided to conduct a two-stage international competition, the most open competition for any of the park's enhancements. Bryan composed an eleven-member jury including La Pietra, Lash, James N. Wood, (President, the Art Institute of Chicago), directors of Boston's Morton Arboretum and the Chicago Botanic Gardens, and several architects. Uhlir wrote the prospectus, which was issued on July 17, 2000, inviting eighteen landscape architects, garden designers, and planning firms to prepare initial designs for a forward-looking garden that would provide a contrast and complement to the scale and character of Grant Park, and a year-long floral display unique to the region and different from other Chicago venues.[14] From eleven responses, three projects were chosen for further development—*Millennium* Garden by the office of Dan Kiley, who had designed the Chicago Art Institute South Garden in 1962; Urban Riff Garden by Jeff Mendoza Gardens; and The Shoulder Garden by the team of Kathryn Gustafson Partners with master plantsman Piet Oudolf and theatrical lighting designer Robert Israel.

The Shoulder Garden was unanimously endorsed by the jury, which found it "bold, intellectual, daring, and cutting-edge" and the only entry enhanced by the presence of visitors because it invites them to occupy its spaces in a series of staged theatrical relationships.[15] But Bryan and his committee had difficulty locating a donor for the garden because a gift twice the original estimate of $5 million was now required to build the winning design. Finally, in May 2003, a new sponsor was secured—Ann Lurie, who directs a foundation established with her late husband Robert Lurie's fortune from Equity Group Investments—agreed to the $10-million endowment necessary for the garden. Bryan now had sponsors for all of the park's major enhancements.

While conflicts and escalating costs grabbed the attention of media, planners and city officials, one of the most important events in the evolution of the park slipped under the radar. On December 9, 1999, project manager Ed Uhlir presented the design for Gehry's music pavilion to the City's Public

Art Committee. The committee was authorized to evaluate publicly funded Percent-for-Art projects, but the art in Millennium Park technically did not fall under their purview because it was funded completely by private donors. Only Uhlir recognized the gravity of the meeting—the pavilion's prominent metal ribbons that cantilevered out over the audience and extended upward to a height of 130 feet violated the Montgomery Ward height restrictions for buildings in Grant Park (Gilfoyle, 178). Uhlir claimed the pavilion was really a piece of sculpture, and if the Public Art Committee recognized it as art then he would have a useful argument should the Plan Commission question its appropriateness. "We were just getting unofficial endorsement," Uhlir said afterward. No minutes document this meeting but Uhlir says that the committee loved the design and supported it unanimously, agreeing that the decorative elements above the proscenium were not "structures" but "art" (Gilfoyle, 181). The SOM master plan had gone through a lengthy review process including public debate and input leading to final approval by the Plan Commission in May, 1998, but no official ever requested another hearing. Instead, administrative staff reviewed the addition of Gehry's pavilion and concurred that the design was consistent with the original (SOM) plan (Gilfoyle, 180).

The fountain in the park funded by the Lester Crown family is the only work of public art that was not chosen and designed through Millennium Park officials and committees. The family, who are the largest shareholders of General Dynamics, gave their funding commitment early, in December 1999, and were involved through all phases of the project. They solicited artists through an informal competition, and because they are active in real estate development and familiar with all aspects of construction, they also participated in the design and engineering of the artwork. First, the Crowns asked Bob Wislow of U.S. Equities Realty (who later managed the construction of the fountain, music pavilion, bridge, and Anish Kapoor's sculpture) to compile a list of artists and architects. Plensa was not on this list but was recommended to Wislow by attorney and art collector Jack Guthman. Wislow showed Susan Crown almost a thousand images of public art from around the world, and the family selected Plensa, Maya Lin, and architect Robert Venturi and invited them to present concepts. The Crown family wanted a work that would appeal to families and children and were most impressed with Plensa's proposal.

Plensa has remarked that good art challenges the viewer to interact with it, to question tradition and preconceptions, and generates "an exchange of energy" (Gilfoyle, 282). His design for the Crown Fountain accomplishes these aims using twenty-first century technology. The towers project video close-ups of one thousand Chicago residents, who were filmed for Plensa by students from the School of the Art Institute of Chicago. According to Plensa, the changing images will enable the fountain to evolve and become a visual archive of the city. Chicago Tribune architecture critic Blair Kamin remarks that "Plensa's democratic move of glorifying not the leader but the common person inverts

the convention of rulers and gods being divine and makes the human beings divine—on the LED screens and on the plaza itself."[16]

Although the Crown Fountain is arguably the work most beloved by the public—children flock to it in the steamy summer months and crowds gather to observe the ongoing spectacle—when Plensa initially presented the scale model in 2002, it was met with criticism and opposition. Art Institute president James Wood felt the glass towers were too tall and others worried the digital technology would become outmoded. Mayor Daley was concerned the spectacular lighting would "Disneyfy" that part of the park, giving it a glitzy Times Square feel (Gilfoyle, 290). In a letter to John Bryan, Michael Lash was most critical, objecting to the height and scale of the project and contending that it intended to "one-up" Kapoor's work (Gilfoyle, 291). Kamin has observed the work over several seasons and disagrees. He says, "the towers are perfectly scaled in their verticality to the 'cliff' of buildings on Michigan Avenue and the LED light endows the sculpture with color and a sense of warmth that are absent from the classical pieces in the park and even *Cloud Gate*, especially in winter."[17]

At Millennium Park's dedication on July 16, 2004, Mayor Daley was able to proclaim that the park was built and would be maintained at no cost to regular taxpayers because the income from the parking garage under it and the northern portion of Grant Park was anticipated to cover the city's investment in its construction. This point was significant because from a master plan by SOM in 1998 for a 16.5-acre park anticipated to cost $150 million, design and construction expenses had escalated to $475 million with an increase in the total area of the park to 24.5 acres and the addition of stellar architecture and public art. Gehry's pavilion, trellis and bridge came in at $75.8 million; Plensa's Crown Fountain cost $17 million; Kapoor's *Cloud Gate* was $23 million including the structural reinforcement for the plaza; and the Lurie Garden cost $10 million including its endowment for upkeep.[18] Of the final $475 million price tag, the city's commitment to infrastructure was kept within the $270 million budgeted including $95 million from the special property tax assessed in the Central Loop Tax Increment Financing District and $175 million in limited tax bonds issued by the City of Chicago. In December 2006, this debt was retired early when the city negotiated a lucrative 99-year lease with a private garage operator and investment company for the garages under Grant and Millennium Parks.[19] Private gifts that continue to come in presently amount to $240 million, including more than $1 million each from 115 individuals, corporations and foundations. A gala event for donors before the public opening of the park netted an additional $3 million toward the park's endowment for ongoing maintenance.[20]

Despite the cost overruns and delays, Uhlir declares that the park was worth the wait and effort because it has become an economic dynamo for the central business district. Writing for the *Economic Development Journal* in Spring, 2005, he states that, "the 'Bilbao effect' is causing local and regional governments everywhere to look at innovative and unusual architecture to lure

the tourist dollar. We now consider our new park to have a similar impact—the "Millennium effect"—although Chicago has much more to offer than Bilbao."[21] Seven new condominium projects attribute their successful sales to their proximity to the park and a study released in April 2005 calculates that the economic impact over the next ten years on the adjacent real estate market that is directly attributable to Millennium Park will total $1.4 billion. South Michigan Avenue has lacked the cachet of North Michigan Avenue's "Magnificent Mile," but the "Cultural Mile" created by the park and the nearby theater district is expected to generate from $428.5 million to $586.6 million for hotels, from $672.1 million to $867.1 million for restaurants, and between $529.6 million and $711.1 million for retailers over the next ten years. In the first six months after Millennium Park opened, over two million people visited. Yearly visitation is expected to be in excess of three million and total visitor spending from 2005 to 2015 is anticipated to range between $1.9 billion and $2.6 billion.[22] Priceline.com handles internet reservations for hotel rooms, and they report that of the top fifty destinations for Summer 2006, Chicago's Millennium Park was the most requested destination.[23]

The Millennium Park project energized a trend of public–private partnerships that has increasingly impacted the direction of the city's public art program. While primarily charged with administering the Percent-for-Art ordinance that sets aside 1.33% of municipal construction and renovation costs for public art, the program also facilitates collaborations between government agencies, the private sector and other sponsors. In 2006, Cindy Pritzker approached the program after she had raised $1.2 million to bring to Chicago thirty indoor and outdoor pieces by Niki de Saint Phalle that she had seen in Atlanta. The Chicago Public Art Program worked with Pritzker and the parks and tourism departments to install the temporary exhibition at the Garfield Park Conservatory. The program also coordinates outdoor exhibitions for the Boeing Galleries, a linear north-south promenade in Millennium Park, and is working with Mark di Suvero on an exhibition of his sculptures for this space. But Gregory Knight, Deputy Commissioner/Visual Arts at the Department of Cultural Affairs says that since Millennium Park, "it has become more difficult to introduce indigenous ideas and projects that are 'Chicago focused' and to avoid (the pressure of) taking on projects that have been done by other cities."[24]

Civic projects with the scope and ambition of Millennium Park need champions and it is unlikely that a government body could have taken the bold action necessary to enable the creation of the park and its public art. Knight points out that the city's funding for the Public Art Program does not even come close and that, "the deep pockets of (Millennium Park's) donors buried the cost overruns . . . if the public art program were run this way, it would be a scandal."[25] As the scope of the park and the quality of its landscape, art and architecture grew, so did its cost and John Bryan was uniquely positioned to motivate the private donors to increase their financial commitments.

The park began with a master plan which was approved by the city's Plan Commission but which changed as the donors' demands influenced it. John Bryan marshaled the many committees that controlled the selection of architects and artists and the park's design flexed to accommodate the donors' ideas. Stakeholder status was conferred upon donors by virtue of their monetary investment. The Mayor remained closely involved in the process, and several presentations were made to the city's Public Art Committee as plans for the art and architecture evolved, but the revised plans were not resubmitted to the Plan Commission. The Millennium Park Board of Directors operated with an unusual degree of autonomy that was often questioned by the local media.[26]

Madison's Central Park differs from Millennium Park in many respects but most notably because its conceptual plan was developed through the exhaustive public process that characterizes the city's political culture. A park for that location had been talked about since the 1970s and finally, in 2005, a preliminary plan was endorsed by the Common Council. A few days after Uhlir's presentation at the Overture Center in Spring, 2007, Mayor Cieslewicz announced twelve community leaders would comprise the Central Park Design and Implementation Task Force. The committee will work with the preliminary plan and includes former Madison Mayor Joe Sensenbrenner and Nancy Ragland, the retired director of the Olbrich Botanical Gardens, a popular private institution that has a partnership with the city. Politicians, business leaders, directors of nonprofits, and neighborhood representatives round out the group. Sensenbrenner, who is also board president of the UOLF, said that "one aim of the committee will be achieving the correct balance between public support and private inspiration." The public-private partnership was critical to the success of Millennium Park in Chicago, he added.[27] Absent are representatives from the arts community.

The Task Force is grappling with whether their park is a local or a regional park and whom it should serve. Mark Olinger, Director of the Department of Planning and Development, staffs the committee for the city and remarks that "the park is in need of a compelling vision. I'm not sure that there is common agreement about what the park is and (as a consequence) the project has not gained traction with the local philanthropic community."[28] Olinger believes that the arts community will eventually become involved because public art is prominently featured in the park's conceptual scheme.[29] Millennium Park never had such an identity crisis—from the beginning, the Board recognized that their site was the finest piece of undeveloped real estate left in Chicago and that they did not want to put an ordinary park on that piece of land (Gilfoyle, 105). They aimed to attract an international roster of the most creative artists and architects in the world at the time of the millennium to design different elements of the park.

Before the Overture Center, Madison's major civic projects developed over time, in phases, not only because of the sporadic availability of funds but also as befits the grassroots model, which requires widespread public support for

a project to gain momentum. The ongoing redesign of the Capitol Square and State Street passing in front of the Overture Center exemplifies this process. The Public Art Framework and Field Guide of 2001 called for teams applying to the Department of Planning and Development for the project to include an artist. Wallace, Roberts, Todd LLC, of Philadelphia, and artist Brad Goldberg of Dallas, were chosen to develop the master plan for the eight-block-long street. In working sessions with government officials, business stakeholders, and concerned members of the public including many local artists, the design team produced ideas for public art at three pocket parks and granite paving along the street's length with incised quotes from Wisconsin literary luminaries such as conservationist Aldo Leopold.

After the master plan, the project went through another phase with a series of open competitions. A team of local designers including sculptor Jill Sebastian of Milwaukee detailed the overall plan for the streetscape, and others were chosen to design specific elements such as bus shelters and fountains. In 2004 Sebastian created *The Philosopher's Grove* in the first block near the Capitol Square, featuring a human-scaled ensemble of cylindrical granite forms that erupt from the pavement at dynamic angles. The forms comprise seats and tables and are situated in a grove of trees. Sebastian often collaborates with writers, and she laid out a process to select literary quotes to etch on the granite forms, but this component of her design remains to be fully funded through the city's modest public art allowance. As construction proceeds down the street, additional granite seating ensembles have been replicated under her supervision. When funding is secured, Sebastian will complete the work by handling the writing for the entire length of the street like an anthology.[30] State Street is being constructed as funding becomes available through Tax Incremental Financing, federal funds and property assessments; but with many designers and a twelve-year timeframe for completion, there is also the danger of compromise and loss of focus. Some portions of the design may never be completed. In contrast, Millennium Park emerged full-blown after a six-year period of concentrated fundraising, design and construction.

Ed Uhlir, who has stayed on to become the executive director of Millennium Park, Inc., has spoken with civic groups from San Francisco to Boston, which, like Madison, have been impressed with the park's effects upon economic development and tourism. These cities see the park as part of an urban planning trend that believes arts and culture are critical to attracting the "creative class"[31] that makes regions economic winners. With the Overture Center, Madison joined this trend. But the city appears interested in the Millennium Park model for Central Park primarily because of its public–private funding mechanism (its means) rather than its ends (a focus upon cultural venues and public art). Central Park was initiated by the neighborhoods through UOLF, a private nonprofit organization, and like Millennium Park, it will only happen if it is mostly privately funded. If it is built, the city will consider taking it on only if it has an operating endowment. Olinger muses, "What management, ownership, and maintenance model will make it go? The example of Olbrich

Botanical Gardens (a public–private partnership) presents one possibility. But Central Park will be different than our other city parks. It may have its own board, executive director, and city employees assigned to it—and it will need other sources of revenue."[32]

Taxpayer resistance to government spending has become a problem for American cities. After two decades of federal disinvestment and local budget cutting, many cities have difficulty maintaining what they have and mayors are left with few choices for funding ambitious new projects. It is increasingly clear that municipal governments lack the financial resources and the power to govern without the support of private groups. Millennium Park fundraiser John Bryan has said that in the past, he's been in favor of government support for the arts but he has never made a crusade of it. Now he believes that, "our cultural organizations and facilities are better off managed by the private sector than the public sector."[33] Ed Uhlir admits that, "Millennium Park wouldn't have happened if it wasn't for the private sector really wanting to create something for the public." (Gilfoyle, 350.)

How important is the process or the means that led to the creation of Millennium Park? The result is a park that is open to the public without fee, whose programming and maintenance have been endowed at little cost to taxpayers—and a park that, by many accounts, people love. In a democracy, history and process matter. But what if there is no political will to maintain the public domain? Millennium Park poses a conundrum not only because it is outside of the practice of public art that endeavors to involve the public in aesthetic decision making and to create work through an interaction with them, but also because the donors' largesse bought widespread influence. The true Millennium Park effect will be revealed as our nation's public realm becomes increasingly privately funded.

NOTES

1. John Allen, "Madison's Magnum Opus, With the opening of the $205 million Overture Center, downtown looks to stage a creative comeback," *WISCONSIN* 15 no. 3 (Fall 2004), 24.
2. Ibid., 27.
3. Recorded by Madison City Channel 12, viewed online at www.ci.madison. wi.us/mcc12/adhocMarch.html 16 May 2007; Samara Kalk Derby, "Mayor Has 'Great Park' in Mind," The Capital Times, March 14, 2007.
4. Edward Uhlir, interviewed by the author, Chicago, Illinois, April 6, 2007.
5. Derby, "Mayor Has 'Great Park' In Mind."
6. My observational analysis of the park is indebted to the techniques Setha M. Low used in *On the Plaza, The Politics of Public Space and Culture* (Austin: University of Texas Press, 2000).
7. Tour of Millennium Park, Nancy Karen, Chicago Architectural Foundation, June 26, 2005.
8. Timothy J. Gilfoyle, *Millennium Park, Creating a Chicago Landmark.* (Chicago and London: University of Chicago Press, 2006), 81.

9. This brief history of the site is drawn from Gilfoyle's excellent book and also an architectural tour of the site led by docent Nancy Karen of the Chicago Architectural Foundation, June 26, 2005.

10. Chris Jones, *"A one-man fundraising machine, John H. Bryan is an idealist with the right names at his fingertips,"* Chicago Tribune, July 15, 2004. Section 7.

11. Edward Uhlir, interviewed by the author in Chicago, April 6, 2007.

12. Uhlir interview, April 6, 2007.

13. Uhlir interview, April 6, 2007.

14. Charles Waldheim, *Constructed Ground, The Millennium Park Garden Design Competition.* (Urbana and Chicago: University of Illinois Press for Chicago Department of Cultural Affairs, 2001), 12.

15. Ibid, 15.

16. Kamin Blair, interview by the author, Chicago, April 6, 2007.

17. Kamin interview, April 6, 2007.

18. Edward Uhlir, telephone interview by the author, August 16, 2007.

19. Edward Uhlir, "The Millennium Park Effect, Creating a Cultural Venue with an Economic Impact." *Economic Development Journal,* (vol. 4, No. 2, Spring 2005) and interview, August 16, 2007.

20. Uhlir interview, August 16, 2007.

21. Op. cit., Uhlir.

22. Millennium Park Economic Impact Study. Goodman Williams Group, URS Corporation. April 21, 2005.

23. "Priceline.com Releases Top 50 Destinations List for Summer 2006; Chicago's Millennium Park is #1 Most Requested Summer Destination." On-line report, http://www.priceline.com/. Visited June 28, 2006.

24. Gregory Knight, interview by the author, Chicago, April 5, 2007.

25. Knight interview, April 5, 2007.

26. The Chicago Tribune was particularly critical of Millennium Park. See Ford, Liam. *"How a budget tripled in six years, Design changes, construction problems resulted in $475 million cost,"* Chicago Tribune, July 15, 2004. Section 7, Special Section, Millennium Park.

27. Samara Kalk Derby, "Powerhouse Park Panel Picked," *The Capital Times,* March 16, 2007.

28. Mark Olinger, telephone interview by the author, June 22, 2007.

29. Mark Olinger, telephone interview by the author, August 22, 2007.

30. Jill Sebastian, telephone interview by the author, June 23, 2007.

31. Richard Florida, *The Rise of the Creative Class and how it's transforming work, leisure, community and everyday life.* (New York: Basic Books, 2002). Florida argues that regional economic growth is driven by the locational choices of creative people and they prefer places that are diverse, tolerant and open to new ideas. He devised a "Creativity Index" that mixes four equally weighted factors: the share of the workforce in the creative class based upon census data; innovation as measured as patents per capita; high-tech industry using the Milken Institute's Tech Pole Index; and diversity as measured by the Gay Index. Of the 268 regions sampled in Florida's Creativity Index, Madison ranked 20th overall, ahead of Chicago at 29th.

32. Olinger interview, June 22, 2007.

33. Chris Jones, *"A one-man fundraising machine."*

10 Investigating the Public Art Commissioning System
The Challenges of Making Art in Public

Shelly Willis

INTRODUCTION

In the spring of 2007 more than one hundred artists, curators, contractors, fabricators, family members, and friends gathered at private art collector Steve Oliver's ranch in Gyserville, California, to celebrate the opening of *Tower* by artist Ann Hamilton. Hamilton stood to make her remarks and began by saying, "I'd like to thank Steve Oliver. He only gave me permission. He never said, 'no'."

Oliver, a private collector in Northern California, had invited Hamilton eighteen years earlier to make a work at his 120-acre ranch, which also houses work by Bruce Nauman, Richard Serra, Martin Puryear, and Ursula von Rydingsvard. In that time, Hamilton won the MacArthur Foundation's Genius award and represented the United States in the Venice Biennale. She also experienced the disappointment of the abandonment of the largest public art commission in the 150-year history of the University of Minnesota's Public Art Program.

Oliver's invitation to Hamilton resulted in an eighty-foot concrete tower, nestled into one of the most beautiful valleys in Northern California. Rimmed with oak trees, the tower almost disappears in the dry golden grass that sweeps across rolling hills. A concrete, double-helical staircase arises from a pool of black water and circles up the interior of the tower to an open sky. The steps provide a place for an audience and a stage for site-specific performances. Hamilton envisions the tower as "the voice" of Oliver's private collection and will work with Oliver to commission site-specific performances in the space over the next five years.

Private sources—individual artists, nonprofit organizations, private and corporate collectors and public–private partnerships—have partially or fully developed and funded some of the most important public artworks of the past forty years. Steve Oliver, Spoleto Festival, InSite San Diego, Public Art Fund, Christo, Robert Smithson, Southern Exposure, the Dia Foundation, and the extraordinary public–private partnership that resulted in Chicago's Millennium Park have all been responsible for the production of significant public artworks. By contrast, governmental public art programs proliferate, but the artworks they generate often fall short of expectations and potential. For a

Figure 10.1 "Tower," Ann Hamilton. 2007, Oliver Ranch, Guernville, California.
Photo: Laurence Campling.

variety of reasons, many publicly commissioned artworks devolve into design
elements, disappearing into the cityscape without a whisper from the public.
Newspapers and art publications rarely offer features or criticism of public art
and only a few American universities offer degree programs in public art.

What happens between the public funding for an artwork and its installa-
tion? Are artists, designers, and the public compromised by the process? What
are the responsibilities of the artist and commissioning agency? Are public art
processes working? Is it more practical to adopt the curatorial and education
process of museums to commission public artworks or is public art better
served by the procedures used in architecture and urban design? Is there a way
of creating a system that says, "yes" more often than it says "no"?

None of these questions found easy answers when Hamilton won her com-
mission to create a piece for the University of Minnesota's Molecular and
Cellular Biology Building. Her vast, internationally acclaimed experience as
an artist couldn't prepare her for the challenges that lay ahead.

THE SELECTION PROCESS

From the start, public art processes are shackled by time constraints and
systems that inhibit both the artist and the commissioning agency. Worse,

these processes are often unfaithful to the public they serve. From art-ist selection to design development, to fabrication and installation of the artwork, committees are unequipped to deal with their enormous respon-sibilities, and project managers don't have the autonomy and authority to do their job. Competitions are unwieldy, and unrealistic expectations are placed on project applicants and selected artists.

Since America's first Percent-for-Art program was established by Phila-delphia in 1959, committees have been formed around specific projects to select public artists and the works they'll create. The architect, a few art professionals and a grab bag of people who "represent the community" come together to look over artists' proposals via slides or digital images, interview the finalists about their intent and, with varying degrees of debate and dissent, in a few short meetings select a project they deem right for their wants. Yet it is nearly impossible to really understand an artist's work by reviewing it under these circumstances.

Take the work of the filmmaker, artist, and architect Alfredo Jaar. He doesn't work in one particular medium or format, and his work has dealt with such diverse subjects such as Rwandan genocide, homelessness in Montreal, the restrictiveness of Finnish nationalism, and the cultural iden-tity of a small town in Sweden. How does one understand what a given project would look like in Jaar's hands by looking at ten projected images of his work? Even for a practiced and sophisticated curator, it isn't enough visual information.

This prospect is all the more intimidating for people invited onto selec-tion committees with little to no experience in public art or the language of design. These neophytes are often asked to go beyond artist selection into the realm of ad hoc public art master planners charged with choosing design and site "opportunities" for artists. Public art administrators rarely, if ever, have the time to offer even the most basic of primers before these committees begin their work.

Of course, the very process often dissuades someone like Jaar or Ham-ilton from applying for a given project. Indeed, Hamilton had to be con-vinced to apply for the Molecular and Cellular Biology Building project and only reluctantly agreed after several conversations with public art program staff. Not only does the bureaucracy put off many emerging and established artists, but also so does design and build systems that don't fit the way they work.

Design and open competitions are expensive. Artists are asked to sub-mit budgets, written statements about their qualifications and past work, images of past work, and a conceptual design for the pending project—all this with little or no compensation or the time and ability to research or visit the site. Meanwhile, the commissioning agency and committee already have strong, predetermined ideas about the form and site for the coming art-work, already envisioning a sculpture, a garden, a floor, a tile mural, light-ing, a fence, or what have you. This doesn't stop public art administrators

from spending countless hours marketing the competitions and processing the applications that follow. Little wonder, then, that these processes yield designs that are ultimately unsatisfying to both the artist and commissioning agency.

More than five hundred artists applied through an open competition to create public art for the University of Minnesota's Molecular and Cellular Biology Building. Even after university staff whittled the field to 65, the committee was ill-prepared to handle the crush of information about the artists. By the time Hamilton was selected, the building had already broken ground, presenting the artist insurmountable problems for coming up with a design everyone involved could embrace, in the time available.

After a jury of art and design experts selected an artist and proposal for the World Trade Center Tower memorial, the New York Times art critic Michael Kimmelman reacted critically to the committee's design selection. "Good art, like science, is not democratic," he wrote. "An open competition can produce a Maya Lin Vietnam memorial once in a generation, maybe, but mostly it results in the generic monuments that are now the universal standard: stereotyped images plagiarizing superficial aspects of serious art, mostly minimalism, for watered-down symbols of mourning and loss."[1]

Kimmelman is right—art isn't democratic—but public art also doesn't come from a monarchy. Not one city, state, county, or federal public art program in the country gives direct decision-making power to a single person. Doing so would be elitist and against some of the core principles of public art. The nature of public institutions is that they are accountable, transparent, and inclusive. The solution, instead, is redefining the roles, responsibilities and qualifications of selection committees and the administrators who put them together.

Committees and public art program staff should be anchored by arts professionals including curators—experts in contemporary art, familiar with looking at and talking about artists' concepts and processes. They should work together to understand the potential social, practical, and aesthetic functions of the artwork. Then, they not only should have the knowledge, but also the authority, to fulfill that potential by looking outside the pool of applicants and the commissioning agency's slide bank to find the right artist for the project. Public art is not separate from, but is embedded in, the discourse of contemporary art.

Committee members and public art program administrators need this knowledge and context to consider, for instance, whether they want an artist such as Siah Armajani, who wants to make useful gathering spaces for community and believes art should have an integral connection to society but isn't inclined to collaborate, or someone such as Stuart Allen, whose work deals with fundamental elements of perception such as light, gravity, and space. Do they want to commission someone like Mark di Suvero, whose work is rooted in modernism, or is Wing Young Huie a better choice

because of his interest in exploring what is plainly visible but often goes unnoticed in American life? What about Harrell Fletcher, who creates his ideas from spontaneous exchanges with individuals? Or is Mildred Howard better suited for the project because of her interest in memory, history, and family? Does the committee want an artist who makes work about discovery, or someone interested in social and political change? None of these questions deal with whether the given public artwork should be sculpture, mural, or etched window.

It is critical that public art programs include curatorial staff with time and expertise to research and find the right artists for a project, and who are granted the authority to select artists and designs, and make recommendations to committees. These adjustments will save time and money by giving artists a better way of determining whether or not they want to apply for a project, committees a better way of working together, public art administrators and curators the authority to apply what they know, and will open up opportunities for artists like Alfredo Jaar to work within public art commissioning systems.

DESIGN, FABRICATION, AND INSTALLATION

Artists often face the daunting task of coming up with an idea upon demand for a community that can't be defined. Even after the selection of an artist, committees, administrators, and artists navigate an obstacle course of systems ready to say "no" at every turn—business operations, contract negotiation, artwork conservation and maintenance, engineering, the many technicalities of artwork fabrication, and, of course, the particular public ostensibly being served by a given project. "Artists tend to approach things differently than designers," says New York artist Janet Zweig. "Designers have a circumscribed problem to solve and they have to do it quickly, with functional solutions restricted by the very specific needs of a commercial client. Artists need time to develop broader, open-ended inquiries, and can often redefine the terms of the problem."

In public art, artists bear responsibilities beyond conceiving and creating the work. Time isn't only their own—countless others have deadlines to meet when the artwork is connected to construction of a building or public space—and artists need to know when and what to compromise, and to have a sincere desire to work in the public realm. Concepts of time worked against Ann Hamilton for her commission at the University of Minnesota.

Hamilton immediately determined the conceptual foundation, envisioning the Molecular and Cellular Biology Building as an organic cell, but she took another two years to come up with a form for the artwork that would work within the budget and the schedule for building construction. Meanwhile, there was an expectation by the people who were associated with the building, including one of the highest-ranking officials at the University,

that the artist should be able to come up with an idea and deliver it quickly, while working within a construction process that was beyond her control.

Hamilton wanted to replace hundreds of the bricks planned for the building's façade with custom-made glass bricks that would light up in response to motion inside the building. Despite construction that was already underway, the building contractor believed there was still time for Hamilton to fabricate and install the artwork. The committee unanimously approved Hamilton's design proposal but, that same day, the building project manager told Hamilton construction was ahead of schedule and the bricking of the building was to begin in mere weeks. Delaying the construction to allow Hamilton time to prepare and install her bricks would cost the university thousands of dollars for every lost day. With no other way to make this proposal happen, Hamilton abandoned it.

Hamilton's follow-up email to the project manager illustrates the helplessness and frustration artists often feel when merging their processes with systems ill-equipped to deal with artists. She wrote,

> At the moment, I have been up all night "processing," so to speak . . . restless hours going through a bazillion scenarios in my mind . . . more like hitting my head against a brick wall than finding the muse . . . but hours and hours of work, and long before anything tangible is seen . . . it can't be bidden or forced . . . the right thing has to offer itself up . . . I keep thinking that if I stand on my head, I will be able to see it or imagine it differently.

Moving forward, Hamilton kept to her initial idea, born from imagining the Molecular and Cellular Biology Building as an organic cell, but conceived a new way to make it happen. Her second formal design consisted of horizontal bands of tubular LED lights across the six floors of the façade. Again, movement in the building would filter into the brain of a computer and translate it into light. Hamilton's intent was using light to express the body's (in this case, the building's) process of responsive amplification.

Hamilton envisioned using green fluorescent light crawling across the building. In order to make the light appear organic, she had to create a computer program that would translate motion inside the building into unique light patterns. She hired Ben Rubin and David Small, both artists and technical designers, to collaborate with her. In her proposal, Hamilton wrote,

> Advances in imaging technology now make it possible to witness the "dance" of millions of neurons firing in unison—a kaleidoscope of constantly changing cellular activity responding to incoming sensations and amplifying or synchronizing electrical activity within the brain. These chemical triggers producing extra-cellular and intra-cellular linkage provide points of inspiration and departure for this project.

> Just as the touch of finger to surface might reverberate up one's spine, so the amplification of sensory input on a cellular level spreads out to engage the communal intelligence.

The design review committee approved the proposal on the condition Hamilton secure a building permit before moving forward with the fabrication. This condition worked against the university's budgeting and permitting requirements and also the terms of Hamilton's contract—still in the design phase, Hamilton wouldn't be paid until she began fabricating the computer program.

Four years after Hamilton's selection, the building not only was complete but staff had been working inside it for more than a year. The momentum for Hamilton's project was unraveling.

EXPLORING A NEW SYSTEM

Artists such as Vito Acconci, Cliff Garten, and the collaborators Helmick + Schechter are established and successful enough to employ staff experienced in navigating the financial, legal, and technical sides of a major public art project. This isn't typical. Most artists slog along alone, unable to compete against the machinelike operations they encounter or within the rigid systems they're entering.

It's critical, then, to re-examine the process from front to back and shift and expand the responsibilities of the artist, commissioning agency, and project manager. There is no template for the flawless public art project, just as there is no set formula for an artist's creative method, but the process runs best when artist selection happens during or before the selection of an architect, or early on in a renovation process. But, more importantly, since some projects don't involve the building of an entire new structure, there should be much more time for developing an idea, not a few months, so the artist can be brought in very early and given access to all the architects and designers involved. This leaves room for the artist to envision an open space and work with the architect to integrate artwork into it. The project manager needs to work with the artist at every stage as a guide, an informational and institutional resource, and a liaison between the artist and the public. Far too often, once an artist is selected the project manager leaves the artist to navigate the complicated processes alone, providing little support. Typically, the design review committee diminishes or completely disappears after approving a design, existing in name only and playing no active role in a project. This leaves an underfunded public art program manager or staff alone to handle the advocacy and other critical stages of seeing a project through to completion and to ensure its care long afterward.

It is standard for museums to spend twenty to thirty percent of an exhibition's installation budget (in addition to already-funded education program

staff) on education programs for the public. Yet for most public art programs, anything budgeted for education rarely covers the printing and mailing of postcards announcing the artwork. There are almost never "openings" for a public art piece; it usually just appears. Ongoing community education involving the initial artist selection and design review committees helps eliminate communication problems and eases the public's involvement throughout the life of a project.

Hamilton's design for the Molecular and Cellular Biology Building was beautiful, intelligent, and inventive, and it had a strong relationship to the building and programs inside. There are many "ifs" that would have changed the fate of this project: if Hamilton had been commissioned when the architect was selected, if the public art administrator had had the authority to approve designs and make recommendations to the committee, if a committee of mostly public art experts had selected and guided Hamilton through the process, if that same committee had been involved in the final decisions to move forward or not, if there had been funding for education throughout the process, the outcome may have been different.[2]

Temporary or permanent, from plop art to new genre public art, guerilla architecture to social sculpture, social practice art to street performance, artists drive the development of art in the public realm. For art to continue serving the community, public art administration systems must evolve to make room for the possibilities.

NOTES

1. Michael Kimmelman, "Architecture; Ground Zero's Only Hope: Elitism," *New York Times*, December 7, 2003.
2. Shelly Willis managed the Molecular and Cellular Biology public art project at the University of Minnesota until she left the University in October, 2004.

11 Here and Gone
Making It Happen

Kristin Calhoun and Peggy Kendellen

INTRODUCTION

The Percent-for-Art Program in Portland, Oregon, had its beginnings like many others in the United States, with a focus on acquiring artworks for public facilities. When the program reached its ten-year anniversary in 1990, the Regional Arts & Culture Council (RACC) engaged the arts community in a series of informal conversations about the state of public art in Portland—what worked, what didn't, and what was needed. Feedback was gathered from artists, the general public, and former public art selection panelists. It came as no surprise that there was strong support for continuing to commission permanent works. However, both mature and emerging artists were eager for opportunities that would allow them to explore socially relevant ideas, experiment with new materials, and extend their studio investigations into the public realm. The general consensus was that adding a component of temporary works would enrich the program and provide touchstones for conversations about art and other issues in the community.

From this initial idea, navigating the bureaucracies followed. The City Attorney reported that while there was nothing in writing to prohibit such works, there also was nothing to specifically support them. To quell any potential controversy about using public funds for nonpermanent works, it was suggested that temporary public art be referred to as "artworks of specific duration." RACC amended its Percent-for-Art Guidelines to qualify temporary works for Percent-for-Art funds, with the stipulation that the only permanent record of these projects would be image documentation and written commentary (both from the artists and, in some cases, from the public, e.g., comment books).

Since this plan was set into motion, RACC has explored three discrete temporary public art programs: outdoor temporary works (*in situ*PORTLAND), an indoor temporary installation series in one of the City's primary municipal buildings (*Installation Space*), and an artist-in-residence program (*intersections*). All of the programs in their various guises share a similar goal of promoting creative growth for the artists,

the creative community, and the community at large. All have had their share of successes, failures, and controversies, and each is distinctive in the ways artists can approach working within a program's parameters—be they geographic, contextual, or formal.

Through these programs artists are able to work within conceptual frameworks that are of the moment, with materials that do not need to survive. The challenges of creating work for this particular site are similar to most site-specific permanent installations—lighting, accessibility, public safety issues, and the size of the space itself. Selected artists must be open to changing the physical nature of their installation to meet public safety requirements. Individuals have proposed ambitious projects without a clear understanding of how the installation would physically or aesthetically fit the space. At times there have been dramatic changes for the better; at other times, there have been unfortunate results.

The success of a specific project ultimately depends on three things: the selection panel's willingness to take risks, an artist's idea, and the artist's ability to carry out that idea, including interacting with the community in which it's placed. When installations succeed, the artist typically has a deep knowledge of the possibilities and limitations of materials used, and is willing to submit himself or herself to the challenges of public scrutiny. Some artists have struggled due to an inability to carry out an idea materially, or because of developing negative relationships with the community or of not comprehending the physical limitations of a site.

The seed for RACC's outdoor temporary program, *in situPORT-LAND*, began in 1993 with two temporary installations funded with Percent-for-Art dollars from the renovation of a series of park blocks. Following the initial installations (examined below), RACC wanted to build on those achievements and launch a temporary outdoor program. It took some time to find a funding source, but in 1998 *in situ*PORTLAND was launched with a pool of funds that was generated from the City's Floor-Area-Ratio Bonus Program, which allows developers more floor space in exchange for certain amenities, public art being one of them. It was a pool of funds with no restrictions other than that it be used for public art within the Central City district and was the first time RACC had unrestricted public art funds that could easily be committed to temporary works.

Installation Space began in 1994 and is RACC's longest-running continuous temporary program funded by public dollars. Located in a small recessed area in the lobby of a public building, installations rotate monthly. At its inception it was one of the few interior sites in the city that promoted the installation genre that also had a broad cross section of viewers. The initial funds ($3,000) for the program were Percent-for-Art dollars generated from the renovation of the building's lobby, and provided support for two years. Artists were paid a $250 honorarium that covered time and materials for restoring the space to its original condition at the close of the

installation. The program is now funded through the general Public Art Trust Fund and artists are paid a $1,000 honorarium.

The third temporary program administered through RACC and funded by Percent-for-Art dollars can also result in permanent works, depending on how the project evolves. *Intersections,* a public art residency program, began in 2000 and offers artists the opportunity to spend time within a city or county agency developing ideas in collaboration with clients and/or staff. The resources for this Percent-for-Art funded program were generated from the purchase and renovation of an existing building that was to serve as the headquarters for Multnomah County.

GETTING STARTED

The first temporary *outdoor* projects were commissioned when a string of five park blocks (North Park Blocks) in Northwest Portland underwent renovation. The neighborhood was located in an area experiencing the growing pains of gentrification and evolving from low-rent artists' studios, light blue-collar industry, and transient hangouts to upscale condos and high-end retail outlets. Percent-for-Art funds generated from the park's renovation amounted to only $15,000, not enough to commission a permanent piece with the typical public art expectation that it "last forever." A selection panel of neighbors, artists, and parks personnel was eager to try temporary public art, and divided the money into two $5,000 site-specific opportunities that would have a one-year maximum duration. The remaining $5,000 would be set aside to create a "pad" for the future placement of temporary work, an idea that was then abandoned a few years later in favor of adding the money to a temporary program (*in situ*PORTLAND).

Through an open call the panel chose two artists, Kristy Edmunds from Portland and Steven Siegel from Red Hook, New York, who created remarkably distinct temporary pieces just blocks apart. It was Edmunds's first experience working and performing in the public realm, while for Siegel the project continued his exploration of relationships between recycled materials and the environment.

Perusal (August 5, 1993) by Edmunds was a performance/installation sited on a basketball court in the North Park Blocks. The piece was based on the tension between gentrification and displacement within urban projects. Over five hundred (three-foot by two-foot by six-inch) blocks of ice, many with objects frozen inside (e.g., a fan, a basketball, a gift certificate to a bookstore, a CD), were arranged in a series of passageways. Edmunds worked with a local ice manufacturer to create a "hide-and-seek" method of embedding the objects and creating varying levels of clarity in the blocks. She wanted the ice to melt over the course of several days, depositing the frozen objects onto the ground, free for the taking. Spectators were invited to "peruse" the installation and collect any objects of interest once the blocks had melted.

Figure 11.1 "Perusal," Kristy Edmunds. 1993, a performance/installation of 500 blocks of ice, many with objects frozen inside, Portland, Oregon.

However, that process unfolded in a radically different way once the spectators became active participants. The installation and performance took place on a hot and steamy August evening and coincided with the First Thursday gallery openings in the area. While promotional media were solicited, the ensuing coverage was far different than imagined. A local weatherman gave his evening weather report in the midst of the ice blocks as a way to highlight the contrast in temperatures between the installation and the ninety-plus-degree weather. He encouraged viewers to come enjoy the cool environment and take what they wanted. The cameraman focused on a five-dollar bill and an electric fan imbedded in two different ice blocks. No mention was made of the "perusal" idea. While the weather was an enticement, a newspaper columnist strongly hinted at the opportunity for a lucky citizen to find a one-hundred-dollar bill frozen inside one of the ice blocks. Who knows what the bigger attraction was—to cool off or to get something free, be it a fan or one hundred dollars. The First Thursday arts crowd came out in force, as did members from the broader community, heeding the weatherman's advice and the possibility of finding one hundred dollars.

For the performance to begin as scheduled at twilight, members of the crowd literally held back others who had staked their claim at a particular block of ice. The performers' slow and subtle movements, based on common everyday gestures and actions, confused many people who did not

understand they were to be an audience observing something rather than freely wandering through the ice passageways during the performance. At its conclusion, spectators quickly descended upon the ice blocks to claim the goods, some by trying to smash the blocks apart to retrieve their prizes. When that proved difficult, some people retrieved tire irons or crowbars from their cars to liberate their booty. The artist and her crew of performers looked on in shock.

This unchoreographed performance by the general public was not the quiet, thoughtful revelation that Edmunds had sought or expected. There came a point where all involved had to step back and simply observe the evolving sociology of the moment, with the understanding that audience reaction is an uncontrollable element of putting work in the public realm. At the end of the evening, an older woman, who throughout the day had been observing the installation and chatting with the crew, came up to the artist holding a little coin purse she had eyed earlier near the surface of an ice block and then retrieved as the ice melted away. She thanked Edmunds for the childhood reminder of a favorite aunt that the coin purse had given her. She said that when she'd opened it she discovered the one-hundred-dollar bill and insisted that Edmunds take it, saying that the coin purse and the memory were more than enough for her.

Two blocks from Edmund's installation, *Hood* by Steven Siegel, had been completed earlier that day. The ten-foot-tall conical sculpture, constructed from recycled newspapers and plant materials, was a statement on the enormous amount of disposable materials and the "new geology" of waste in the environment. The title further linked the work to Portland, as Mount Hood is the closest mountain to the city. The installation had begun a week earlier with the delivery of a dumpster full of recycled newspapers obtained from the city's recycling program. Siegel worked with student assistants, laboriously layering the discarded paper around a wooden frame. Over seven days, his "new geology" began to emerge and ultimately topped out at thirteeen feet with a planter box built into the top, in which he planted shrubs donated by Portland Parks and Recreation (PP&R).

Hood remained in the park for one year, during which it acquired a rich, moss-covered, slightly charred and yellowed patina. At one point someone attempted to set fire to the piece but failed because the paper had been so thoroughly soaked that it wouldn't burn. In the end the work was dismantled, the paper reclaimed by the recycling program, the plants donated, and the lumber recycled. Months later there was no evidence that the piece had existed.

RACC learned two important lessons from these projects. First, there is an appreciative and receptive audience for temporary works both within the artist community and general public. Second, partnering with city bureaus clearly added depth to the projects and helped remove barriers that might otherwise derail such nontraditional installations. The administrators of the recycling program were quick to offer their support of the

project, thrilled to be part of the artists' commentary and to highlight the artful reuse of the "waste." They have since sponsored other "trash-into-art" projects. The collaborative approach RACC took to working with PP&R has led to a strong ongoing relationship and greatly streamlined the permission of subsequent projects in parks.

INSTALLATION SPACE: TAKING IT INDOORS

Following the success of the outdoor temporary projects, in 1994 the *Installation Space*, an indoor program, was launched in the Portland Building, a notable postmodern fourteen-story structure designed by Michael Graves. About ten years after the building opened, the City remodeled the highly criticized and dimly lit main lobby. A space originally devoted to a small newsstand was converted into a site for "the arts council to put art"— a challenging programming surprise given the site's physical limitations (11'8" x 13'6" x 7'5"). Nonetheless, the visibility of the space couldn't be more ideal. Employees and visitors can't miss the space when passing through the lobby on the way to various destinations. The space is just a mere six feet from the building's directory; the information desk is situated directly opposite; an ATM machine is just a few feet away; a stairway leading to a second floor Public Art Gallery is adjacent to the space; and a convenience store is right down the hall.

The program's principal goal is to present provocative, challenging, and diverse works that inspire discussions about the public's expectations and definitions of art. The project comfortably fits into the goals of RACC's Public Art Program and is funded with public dollars. Because of the very public location, the program has promoted dialogue and stimulated debate between devotees and antagonists.

To launch the program, a selection panel invited a short list of artists to submit proposals. Following that initial selection, an open call to regional artists is now posted annually. The program started with a $1,500 annual budget, paying artists a small $250 honorarium for a six-week installation. The following year, the length of the installations was reduced to four weeks (feedback indicated the general public wanted more variety and got bored with six-week installations). A student component, added in 2000, provides a $500 honorarium, while the professional artists are now paid $1,000.

Following selections, artists are required to meet with RACC staff to review their plans for the installation. Since this program is intended to encourage emerging artists to test their "mettle" in a public space, many artists submit ambitious proposals that need some fine-tuning before final installation. To that end, RACC staff functions as consultants to assist artists in accomplishing their intended goals. Other city staff are consulted (e.g., the building manager) when safety issues are of concern. The program

is a valuable learning experience for artists to understand the complexities of working in a public space.

Since its beginnings in 1994, over one hundred established and emerging regional artists have invigorated the space with challenging, sobering, witty, and interactive installations. The general audience ranges from schoolchildren to citizens conducting business with the City of Portland and Multnomah County—populations who may not be habitual gallery or art museum visitors. If longevity is any indication, this program is a resounding success with the building's tenants and the region's arts community.

Artists are selected based on past work and strength of proposal—there are no interviews. Selection criteria include artistic merit, conceptual approach, potential to spark dialogue, and ability to challenge the general public's expectations and definitions of art, and adhere to public safety. However, every selection panel grapples with the definition of "installation art," as do the artists who apply. The Call for Artists has assumed applicants understand what installation art is, and currently reads:

> The selection panel is seeking artists to create temporary installation pieces/environments of one-month duration. Proposals to use the space to exhibit individual artworks will not be considered as the space is intended to showcase the genre of installation art.

As the program grows, so does the knowledge of what can be accomplished in the space—from sound to water to performance to visitors contributing art or posing as the art. Nonetheless, the concept of altering the experience of a space does not always play into an artist's proposal. Some artists have big ideas and not necessarily the wherewithal to carry them out.

Taking risks with new artists and new approaches is part of the working formula for the program. At times, the applicant pool yields fewer compelling proposals than available time slots, leading the panel to invite specific artists to submit proposals. To keep some continuity in thinking and approach to the space from year to year, panelists typically serve two-year terms. Over the years, a comment book has become the avenue for viewers to react to an artist's idea, its execution, or to others' comments. It's also an evaluation tool for artists to appraise their success and for RACC to assess the general response/learning curve of the viewers. Some artists, in fact, express their enthusiasm to show at the space because of the comment book's reputation for honesty and open dialogue (if not often blatant, and containing both informed and uninformed criticism). Comments sometimes recall previous installations that compare more favorably to the one they're looking at, while other more banal comments remark that this is their favorite installation ever. And, in the spirit of free speech, the book is also a forum for individuals to voice

their homophobic, gymnophobic, or politicophobic viewpoints sparked by viewing the artwork and, at other times, not even directly related to the installation.

Not surprisingly, cultivating productive relationships with city personnel is critical for RACC's work to be appreciated and supported in this small space. A Portland artist created a stunning parklike environment using huge amounts of natural materials gathered from the region's forests. During the weekend installation, a somewhat tense relationship developed between the artist and the security guard. He ultimately chose to report her installation as a fire hazard to a fire inspector, who then was required to conduct a formal inspection, ultimately deeming the installation unfit for a public space because of its high flammability potential. The artist deinstalled the piece, leaving one lonely stump in place—a homage to the previous lush installation and a commentary on city rules and regulations. One person remarked in the comment book that if we had just let the installation remain for a month, it would have taken that long for the complaint to wend its way through the city bureaucracy and everyone could have enjoyed this beautiful greenspace.

Interactive installations have become popular in the space since the audience seems to be ready, willing, and eager to participate. Artists have interpreted "interactive" in many ways—one artist invited viewers to contribute to a drawing; another asked viewers to write their wishes and drop them into a wishing well, which the artist then compiled and taped so that when you leaned over the well you could hear the wishes being read. Artist Christy Nyboer moved her studio into the space with the intention of focusing on the artist at work and the value of the artistic process. She created a completely enclosed and secured space with walls across the two exposed sides and a lockable entrance—and moved in the contents of her studio. Exterior display cases were for work in progress and video monitors featured documentation of her at work in the space. Nyboer used a time clock installed next to the studio entrance to record her workday. If people wanted to interact with her, they had to pass notes or images through a drop slot in the door.

Another installation, *Be Portlandia* by Amos Latteier, gave viewers the chance to pose as *Portlandia*, the monumental hammered copper sculpture by Raymond Kaskey that hovers over the building's entry and is an icon of Portland. Latteier wanted participants to consider the meaning behind a figurehead and how a city, a monument, or a photograph represents someone. According to the artist,

> People who work in and pass through the Portland Building [could] try on the role of representing Portland for themselves, rather than leaving this duty to a statue. A city is not a single entity, but a collection of unique people. I want to demonstrate this fact by bringing the symbol of Portland within reach of the citizens.

At the same time, he urged people to have fun by posing as *Portlandia*, have their picture taken, and end up with a souvenir of themselves. Over one hundred people participated in this installation.

OUTDOOR TEMPORARY WORKS: *in situ*PORTLAND

By 1998, through the private developer's bonus program noted earlier, RACC gained a pool of funds that it earmarked for an ongoing outdoor temporary program. Enlisting a panel of artists, curators, and citizens from the community, RACC established the *in situ*PORTLAND program "to place challenging work in the public to serve as a catalyst for dialogue about art and/or community issues," and to provide artists with an expansive opportunity. Artists responded to an open call that listed potential sites for consideration, while also allowing artists to propose other sites. In the first year there were three $7,500 commissions, and in subsequent years the commission was increased to $10,000.

Tax Lot #1S1E4ODD, the program's first project, was a one-year urban garden that explored the temporary resuscitation of a historically underutilized downtown lot for the purpose of growing food. Conceived and performed by contemporary dance artist Linda K. Johnson as a time-based performance piece, *Tax Lot #1S1E4ODD* addressed how we prioritize our use of undeveloped space in the downtown core, and ultimately how these choices reflect our values and desires as a city. In her proposal Johnson wrote:

> At a time when both the presence of the growing of food has all but disappeared from our urban centers and we as a culture seem almost hopelessly detached from the labor, vulnerability and patience required to create, maintain, and harvest a garden, Tax Lot 1S1E4ODD hopes to be a reminder of the value of that process. Harvested food will be donated to hospices and shelters upon collection and any hardy plant materials will be donated at de-installation of the garden.

Sited at the triangular confluence of three major arterials, the work inhabited land a little over one-tenth of an acre in size that had seen no significant use for years other than to separate traffic. It had been merely a grassy patch until the Portland Department of Transportation seeded it with wildflowers two years prior to this installation. In an effort at once absurd and provocative, the artist transformed the space from a sea of grass and wildflowers to a beautiful organic garden, then back to its former state, in one growing season (March 2000 to April 2001). Designed, installed, planted, maintained, and harvested by Johnson in collaboration with a group of volunteers she assembled, the fenced and gated garden also contained a small "casita" which made the garden enjoyable during rain or shine. By August

the garden was bursting with sunflowers, artichokes, and cardoons. With each change of season a new scarecrow arrived, made by fellow artists who had been invited by Johnson (in summer 2000, Paul Arensmeyer and Gregg Bielemeier; in fall 2000, M.K.Guth; in winter 2001, Elizabeth Mead; in spring 2001, Brian Borello).

The public embraced the garden, with the notable exception of a group of neighborhood ladies who "greatly preferred the wildflowers." There was a small movement by neighbors to make it a permanent community garden, but the PP&R Community Garden program decided that the site did not meet its criteria for safe pedestrian access and ample nearby parking. At the end of the project, Johnson donated the casita to PP&R and it was re-sited in another community garden.

As part of the *in situ*PORTLAND program RACC formed a partnership with the Portland Institute for Contemporary Art (PICA) to curate an annual project that could augment either its artist-in-residency program or visual arts exhibition program. In 2002–2003 Visual Arts Curator Stuart Horodner curated *a LOT*, a series of three temporary art installations utilizing a ten-thousand-square-foot vacant lot located in the downtown retail core. The lot was flanked by old brick buildings on two sides and had heavy pedestrian and vehicular traffic. The goal was to animate the empty space prior to its impending development by the Portland Development Commission, another project partner.

The first installation, *Golems Waiting*, featured sculptures by artist Daniel Duford. On September 21, 2002, Duford fired on site four large, raw, red clay hulking figures that he had built in his studio, using the hollow figures as their own low-fire kiln. The public was invited to watch. The inspiration for the figures drew from two sources, the story of the golem from Yiddish folklore and the comic-book adventures of the Incredible Hulk and The Thing. Three of the figures were haunched on their knees leaning forward with their heads down; the fourth was kneeling upright facing one of the adjacent brick walls.

The sculptures were intended to remain for several months, during which they would begin to disintegrate, intentionally left vulnerable to the elements. As with *Perusal*, public intervention sped the process. Within days, two of the golems had been shattered and the remaining two partially damaged. Several days later, in an attempt to focus attention on the use of public space for artistic actions and ideas rather than the vandalism, Duford presented a creative response to the destroyed sculptures by making large shadow/ghost drawings of golems on the brick wall that the kneeling figure had been facing, using the same ceramic slip he had used for the sculptures. Two days later he gave a public talk at the site about the work, its original intent, and its evolution, or rather devolution. The golem drawings stood watch over the site for the next couple of months until all the shards were removed and the drawings were wiped away. Reflecting on the experience in an article he wrote for *The Organ*, a local arts paper, Duford wrote:

The truth is, after the initial shock of seeing the work so brutally ru-
ined, I realized that a profound event had transpired—something I
could never have planned. I put something in an unprotected lot that I
had lovingly made with my hands. I put my trust in the public. Do I still
have that trust? Absolutely. Would I do it again? Yes, and hopefully
soon. I received such a moving reaction, such empathy to my work.
That excitement and affection for the golems only magnified in re-
sponse to the damage. The real enemies are the fear, thoughtlessness,
and ignorance that motivated the vandals in the first place. We are a
balkanized and constantly shifting public. Art for that public should
be temporary; it should provoke. The story of Golems Waiting is now
more important than the physical thing itself. Like all golems, it is big-
ger than its creator. The story, the idea, is unbreakable.[1]

Nearly a year later, in conjunction with his exhibition *eRacism* at PICA,
Maine artist William Pope.L created/performed *CANDY MOUNTAIN* at
a LOT for two consecutive nights. On a large angled stage floor painted
with an image of the American flag, and dressed in an old-fashioned milk-
man's outfit, he danced with anyone who signed up to the Burl Ives ver-
sion of the 1930s hit song "Big Rock Candy Mountain," by the legendary
Harry "Haywire Mac" McClintock. As with many of the artist's most
well-known performances involving great feats of endurance and risk, this
one also challenged Pope.L's stamina and, in this case, his pocketbook. For
each dance partner Pope.L donated ten dollars of his own money to OUT-
SIDE IN, a Portland-based nonprofit agency that provides safety, food, and
transitional housing for homeless youth and low-income adults. OUTSIDE
IN then used Pope.L's donations to encourage matching funds from poten-
tial dance partners.

Over two evenings, in temperatures over 100 degrees, he danced two
full eight-hour shifts up and down the angled stage, beginning at 6:00 p.m.
and ending at 2:00 a.m. Every hour on the hour he doused himself with a
pail of chocolate syrup, which, he said, "lubricates the relationship between
citizens who fight for liberty but live in a country with a long history of rac-
ism." Pope.L chatted with each of his dance partners about homelessness,
love of country, and the future of democracy.

Members of the public waited in line, some for more than an hour, to
receive a dance card and then for their moment to waltz with Pope.L, as the
Burl Ives' recording played again and again. As they waited, many talked
about the dilemma of wanting to dance yet realizing that it would cost
the artist money. That dichotomy, so central to many of Pope.L's other
performance pieces, didn't seem to stop anyone from actually dancing.
As the evenings wore on and he became more and more covered with
chocolate, as the conflict between the pursuit of liberty and justice and
the history of racism became more visually prominent, the line of dance
partners did not wane. By 2:00 a.m. the second night, William had danced

Figure 11.2 "Candy Mountain," William Pope. L. 2003, performance, Portland, Oregon.

with 143 partners and given $1,430 of his money to OUTSIDE IN, who in turn raised an additional $1,644. For weeks afterward, RACC and PICA received thank-you's from community members who had observed or participated in the piece, noting how engaging, sweet (no pun intended), and poignant their encounter had been.

There have been other projects as well with *in situ*, some performance-based, others as visual arts installations. To date, while there have been challenges to specific projects, none have been deemed "failures," as all have generated some level of public dialogue and all have provided growth opportunities for the artists. For this program, a failure would be a project that seemingly went unnoticed or that did not meaningfully expand an artist's oeuvre.

INTERSECTIONS: PUBLIC ART RESIDENCIES

Another opportunity for artwork of specific duration originated in 1999, when the top executive official of Multnomah County, a creative thinker and aspiring artist, voiced interest in mining the creativity of her employees. She proposed using a portion of the Percent-for-Art funds from the renovation of the new county headquarters to start an artist-in-residence program. One viable avenue, she felt, was to bring artists into the workplace. The initial selection panel, of which she was a member, was adamant, though, about not creating a residency that served as a "find-your-artist-within" exercise. Rather, the goal was to encourage artists to

use the county's facilities and employees' expertise to facilitate their ideas, explore new working methods, and develop socially engaging, interactive art experiences in community settings.

The program was broadly defined as intending "to give participating artists the opportunity to push boundaries of art in nonart settings and explore new possibilities, new venues, and new ideas for engaging the community. Multnomah County is the artists' studio, and its citizens, partners, and employees are the artists' resources." The budget was $8,000 and the duration of the residency was dependent upon the goals of the artist. In retrospect, rather than defining the program at the outset, we listened to the feedback from and observed the experiences and outcomes of selected artists which helped define its parameters and goals.

Artist Harrell Fletcher argued to define his "intersection" with the county as working with the citizens, and chose to develop several neighborhood-based and context-specific projects. Ultimately, he produced provocative works that were impressive additions to his portfolio, but limited in their involvement and outreach to Multnomah County employees or clients of their services. That raised the question of the importance of direct interaction and outcomes related to county services and employees.

Fletcher's residency spanned multiple projects and multiple years. First, he completed a project idea already underway as part of a residency with the Portland Institute of Contemporary Art. In *Everyday Sunshine* Fletcher completed work on a family of privately owned lawn sculptures he had discovered while walking through his Northeast Portland neighborhood. The original sculptures had been vandalized and taken into the owner's house for safekeeping. Fletcher devised a way of fixing them and proposed to the owner that an entirely new set of lawn sculptures be created, based on the owners and people in the neighborhood. Collaborating with other local artists, Fletcher completed the project. The new lawn sculptures now stand in the owner's front yard.

In *More Everyday Sunshine* Fletcher continued to focus on exposing the creativity of county residents—"artists-in-residence" in their own right, as he put it. He worked with the owner of Jay's Quik Gas Garage to implement Jay's long-held idea of creating and screening a video at his shop, which he considered to be the "center of the universe." He wanted the video to evolve in a similar manner to James Joyce's literary classic *Ulysses*. Over a period of about two weeks, and using passages from *Ulysses* as script material, Fletcher and fellow artist Steve MacDougall videotaped six employees and numerous customers reading excerpts Fletcher had culled from the book and written on cue cards. The twenty-two-minute video became a loose conversational performance of a day-in-the-life of Jay's Quik Gas Garage. "Blot Out the Sun" was screened on a warm August evening with over one hundred people attending. Jay commented that the entire experience had been "a dream come true."

Much of Fletcher's work explores the dynamics of social spaces and communities. His final project started with convincing the staff at the County's Department of Community Justice to endorse his project of photographing employees' and clients' scars, writing down their stories, and exhibiting the work in the building's waiting room. The impetus for the project came from Fletcher's desire to work in the Community Justice system "because it is such a big part of our society but is generally represented in fairly sensational ways." The documentation of stories and photographing the scars took place over the course of two days in the lobby of the Mead Building, a destination for offenders to meet with their parole officers. The artist framed fourteen of these photos and they were displayed for three months in the waiting room.

Continuing his efforts to harvest ideas from others, Fletcher attempted to engage county employees in a Web-site project that featured a description of something they had always wanted to do, accompanied by their picture. Unfortunately, this effort to engage employees in a Web-based project was met with reluctance and challenged by how to get the word out to thousands of employees. Fletcher posed the question, "blah, blah, blah" and, as it turned out, no one wanted to share. Or, from a different perspective, we didn't do the outreach necessary to adequately inform the employees what this project was about. Attending a handful of employee meetings and sending out various emails turned out not to be enough.

While Fletcher was stretching the definition of county "client," another artist-in-residence, Linda Wysong, embarked on an ambitious undertaking of working directly with county employees from seven different agencies. During her residency she focused on and collaborated with county employees who regularly needed to travel as part of their jobs—employees from the Survey Crew, Tax Assessment, Road Maintenance, Health/Nuisance, Sign Shop, Animal Control, and Library Outreach Services. The project depended on the willingness of participating agencies to share their mission and practices. To accomplish this, she arranged for "ride-alongs" with county employees. She observed that the travel patterns of a tax assessor, a transportation planner, or an animal control worker can reflect their own narratives and the larger sociopolitical structure.

Her research involved observation, conversation, note taking, and recording parts of the workday with a camera or tape recorder. She followed all department policies and never interfered with the work at hand. Work-related materials and images of individual employees were gathered and used with their permission. She created a Web site that included interviews, photos, and other information about her residency (www.co.multnomah.or.us/arts/linda). She also produced seven fine-art prints based on her experiences, each representing the movement (mapping), physical work, processes, and people specific to an agency, which became part of the City/County Portable Works Collection.

The culmination of her residency—a bus tour of county operations from the workers' perspective—offered a unique opportunity for the general public to view county services in action. The tour covered nearly seventy-five miles, stopping at county job sites and workplaces, and hearing from employees who served as "local briefers." Agencies collaborated with the artist in the planning and implementation of the tour.

Evaluating the success of these residencies is largely dependent on feedback from the artists and the employees with whom they've partnered. Hearing the owner of Jay's Quik Gas saying "this was a dream come true," it's hard to say that the project was a failure because it didn't interact with county employees or facilities. The inability to engage county employees in a Web-site project was disappointing for the artist but informative as far as gauging the willingness and interest of employees to participate in a more conceptually based project. Wysong's ability to engage the employees was dependent on recognizing and honoring the importance of their work, which most of the public is unaware of—and took over six months to set up.

During a time when county budget issues were being bandied about in the press and employees were being laid off and social service programs cut, it appeared that if the project was funded by the county it should more directly interact with county services and employees. Ultimately the program's focus has become the intersection of the "art of work" and the "work of art." The preferred outcome is to have an artist at the helm of a project interacting with employees and/or clients. The end result could be a temporary or permanent object or event authored by the artist and inspired by the "art of work."

The program has evolved with each successive year—providing more focused goals and more specific locales for the residencies. At first it was left up to the artists to define what the residencies were and where they would work. This met with mixed success. How was the public to know that a street performance was a public art residency or that it was interacting with employees and clients of the county? Did it matter? Was a tangible art object necessary to define success? Was the ephemeral aspect of Fletcher's Web-based project premature? After all, it was 2001 and the awareness of the potential impact of the Web and how it could be used was not pervasive.

THE TEST OF TIME

In each of these temporary programs public art staff are the key components for weaving together a strong coalition of supporters to shepherd through the system, and productive working relationships are fostered with other public agencies. By working with the various government agencies,

new and innovative ways to create fresh opportunities for artists can be found.

The individual programs remain flexible to the needs of artists, communities, and government agencies. There is no fixed formula that works for every situation or program. A key to the afterlife of these programs is an insistence on first-rate documentation that continues to tell the stories after their physical presence and short-term collective memory have vanished.

The temporary programming, originally instigated by artists, has proven to be invaluable in terms of allowing them to make creative, material, or scale leaps in their own work as well as to hone their skills at working in the public realm. The individual projects can promote discussion of local and global community issues, and by incorporating public interaction into some of the programming, a deeper understanding of the work behind a work of art—the concept development and fabrication process—can also be achieved.

With the peaks and valleys of public construction dollars dependent on the state of the economy, RACC continues to seek alternative ways to offer artists new challenges to create work in the public sector, and, ultimately, expand the definition of "public art."

NOTES

1. Daniel Duford, *The Organ: Review of the Arts* 3, (February 2003).

12 As Rich as Getting Lost in Venice
Sustaining a Career as an Artist in the Public Realm

Terri Cohn

Seen in this way, the storyteller joins the ranks of the teachers and
sages. He has counsel—not for a few situations, as the proverb does,
but for many, like the sage.

Walter Benjamin[1]

Our short life spans are the problem in the sense that we hand a torch
over to the next and the next and the next generation. That's why it's
so important that this torch is burning as bright and as brilliantly as
possible for that short little lifespan. Things like political ins and outs
and ups and downs, I try not to think about that.

Agnes Denes[2]

Artists who have dedicated their careers to working in public places are
inevitably philosophers and storytellers. The worldview this implies is
an imperative, as the process they must undergo to realize their work is
long, strenuous, and often filled with unanticipated disruptions. Though
this is one facet of the creative process in general, artists who are com-
mitted to working in the public realm have numerous populations they
must intrigue, court, and satisfy in order to attain the opportunity to
realize their artistic vision. Despite the gauntlet of city planning, design,
and community meetings, public artists must endure—in tandem with
the potential that their projects can be rejected at any stage—artists who
have sustained long careers in the public sector remain devoted to excit-
ing in their audiences the desire to embark on a journey of discovery.

Extensive conversations with Agnes Denes, Andrew Leicester, John
Roloff, and Buster Simpson, who have created art in public places for
more than twenty years, revealed how their expertise and raison d'etre
is in uncovering and providing insights into the history of a place—its
voice, natural resources, chronicles, residents, activities, and especially
its stories—and embodying these site elements in the work in ways that
inspire individuals to want to discover more. As each artist expressed

in their individual way, there must be latitude in such work to wander, to get lost, and to find the path of meaning the work provides; it must afford the visitor a chance to be a flâneur, intrigued to wander and engage in decoding the paradoxes of a place, and to internalize a greater understanding of it. The most resonant public art can be viewed like a map, which, once understood, allows viewers to find their own way. It shows but doesn't tell. As Buster Simpson so artfully describes, "it's as rich as getting lost in Venice and no want for direction."[3]

Simpson's metaphor is expansively expressed by Agnes Denes in a statement she made about the "new role of the artist." In it she distills the essence of how and why some public artists are inspired to maintain their careers over a lifetime, despite the numerous drawbacks and challenges they face. Her statement provides a worldview that can also be used as a meaningful way to consider and resolve these perpetual enigmas:

> I believe that the new role of the artist is to create an art that is more than decoration, commodity or political tool. This art questions the status quo and the direction life has taken, the endless contradictions we accept and approve. It elicits and initiates thinking processes and suggests intelligent alternatives.
>
> In a time when meaningful global communication and intelligent restructuring of our environment is imperative, art can assume an important role. It can affect intelligent collaboration and the integration of disciplines, and it can offer skillful and benign problem solving. A well-conceived work can motivate people, unite communities and affect the future.
>
> Artistic vision, image and metaphor are powerful tools of communication that can become expressions of human values with profound impact on our consciousness and collective destiny. The artists' vocabulary is limited only by the depth and clarity of their vision and their ability to create true syntheses well expressed.[4]

The system of sentient connections that Denes, Simpson, Leicester, and Roloff create with their work can be effective in drawing viewers' attention to the deeper meaning of a place—its history, inherent ecology, and stories. Their holistic interest in creating such alliances is essential for public art created in an age and society such as our own that is fragmented and heterogeneous, in need of means to link disparate experiences and memories. Writer Marianne Doezema elucidates it as follows: "The public monument has a responsibility apart from its qualities as a work of art. It is not only the private expression of an individual artist; it is also a work of art created for the public, and therefore can and should be evaluated in terms of its capacity to generate human reactions."[5] This essential perspective extends the emotive potential of art in

public places, and the responsibility of the artist, raising broad questions concerning to what social ends people have been moved, and what historical conclusions, understanding, and actions such work has enabled in their own lives. [6]

These questions were expressed as pivotal concerns by the four artists whose ideas and public art works are considered in this essay. Although there are various inroads to discussing their art in the public realm, a sense of exigency concerning the nature and preservation of public memories and the need to engender ties between people, places, collective and individual histories, and value systems emerged as an essential facet of their individual commitment and methodologies. In distinctive and remarkably expansive ways, Denes, Simpson, Leicester, and Roloff have been motivated by and have dedicated a vital portion of their artistic careers to realizing these contingent relationships. The desire to engender ties between people, places, and the contingent nature of their collective, embodied histories, is a central motivation for each of them. The significance of this is epitomized in Agnes Denes' belief that the shift from the "inner space of the artist's psyche to the exterior space of public convention dissolves the old opposition between artist and audience."[7]

MONUMENTS TO MEMORY

One of the most consistent long-term motivations expressed by these artists has been their desire to create works that create tangible links between people and places, and their historic and legendary pasts. Andrew Leicester's first major public art work was his *Prospect V-III*, Coal Miners' Memorial, which was built at Frostburg State College in Maryland in 1982. The commission came in response to some of Leicester's early *Hillside Images* (1974), huge markings (that he defines as Earthworks) that played with topography and perception, created on farmland along the edge of a thirty-mile section of US Highway 52 in Minnesota. Although *Prospect V-III* was not initially intended to be a memorial, when Leicester saw how coal mining had shaped and molded the hills and the communities in the area he was inspired to "create something based on the industry or the archaeology of it."[8] Mining has personal meaning for Leicester, because during his student years in England he lived for a time in an area with a history of various sorts of iron and steel and coal mining, "vestiges of the Industrial Age."

Leicester recounts having rich and pivotal experiences while creating *Prospect V-III* (also known as *5–3*). He met a number of miners and mining families, who showed him small quarries on their property and shared their collections of implements. As their dialogue evolved and stories surfaced, *Prospect V-III* emerged as a metaphor for mining. The form was excavated out of a hillside, and allows visitors to walk through coal-hued houses, across a wooden bridge, and into the mine shaft, and from its interior

to have a panoramic view of the Georges Creek coal basin. The "lovely, poetic" nature of the work provides a great and positive contradiction to the stripped landscape that remained when the coal industry abandoned that place. Leicester epitomizes the issue as follows:

> You've got this so-called reclamation of the landscape, taking out all of the coal and all of the metal rails, but what's left? There's no visible link to the past that all these existing communities still feel and have memories of. So in a way, this work performs as a form of social reclamation, concretizing a link to the past before everything is totally removed.[9]

Leicester's long engagement with communities and their histories has deeply informed his numerous realized public projects since that time. The challenges they offer remained as one facet of his interest in working in public places, evident in more recent projects like *Phantom Furnace Columns* (2002), created in Youngstown, Ohio, which allegorically suggests its industrial past; and *Seven Seas* (2003), sited adjacent to the domed stadium in Minneapolis. *Seven Seas* is a particularly strong example of Leicester's dexterity in aesthetically connoting and mapping past and present histories of places. For this project, he designed seven arches and various brick patterns to allude to the disparate populations that settled in Minneapolis during the twentieth century. Lines radiate from the center of the plaza, creating a circle that was designed to feature a fifty-five-foot tower. Because the plaza was historically populated with boarding houses, mostly inhabited by Swedes and Germans (who couldn't communicate with each other), and the city is now home to immigrants from around the world, the column, if built, will represent this Babel-like history. Unfortunately, the recent decision to rebuild the stadium has indicated that the future of the column remains in abeyance.

Buster Simpson also speaks of how the layering of time and collective memory too often gets abraded in public projects, which is incongruous with his belief in the need to "enrich the aesthetic, the history, the ecology, the sociology of the place."[10] Simpson embraces the stratification and interweaving of past and present in a place, and consistently realizes this in unexpected ways. For his *Seattle George Monument* (1989), Simpson created a "self-trimming topiary assimilating the profiles of Chief Seattle and George Washington, as the overgrowth on Seattle becomes George."[11] The way in which Simpson manipulated the profiles of Washington and Seattle—symbols of two facets of American society—implies the complex assimilation or domination of one culture over another. The artificially simulated interdependence of the two social entities symbolized by Washington and Seattle (and, not incidentally, the names of the state and city in which the monument stands) also speaks to the political realities of this relationship. These ideas are emphasized by the use of invasive English ivy

Figure 12.1 "Phantom Furnace," Andrew Leicester. 2002, steel and lighting, 4'6" × 19', Federal building, Youngstown, Ohio. Credit: courtesy of Andrew Leicester.

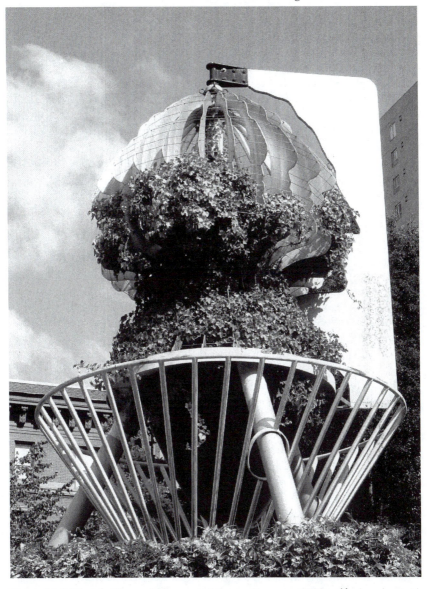

Figure 12.2 "Seattle George Monument," Buster Simpson. 1989, self-trimming topiary, 28' × 12', Seattle, Washington.

growing out of a Boeing 707 nose cone to create this topiary monument, serving as a reminder of the long history of colonization, as well as the implications of our attempts to manipulate nature.[12]

The balance between aesthetics and polemics in this monument demonstrates Simpson's goal to enhance and insure the layered experience of places, as well as his role as a provocateur. These aims are also evident in

Simpson's proposed monument *Embark* (1999), which was chosen for the San Francisco Embarcadero project. The idea for the monument—which Simpson envisioned as an eighteen-foot-tall stainless-steel sculpture of a foot—emerged as Simpson discovered that the only memento of the dismantled Embarcadero freeway was the footings that had supported its columns. The monument had been selected by the San Francisco Art Commission for the site, but was subsequently rejected by the city's board of supervisors.[13] Although Simpson was unhappy with the outcome of this somewhat contentious process, he was especially disturbed that the designers "were scraping away any kind of semblance of the layering of time on that waterfront, the actual record of a city's accretion process was erased and replaced with memory markers of an earlier account of history; it was all sanitized."[14] Simpson (and the Art Commission) believed that the form of *Embark* was replete with local meaning; that it related to the idea of footings and to the recreational uses of the space; and in a broader conceptual and historical context, to manifest destiny, as well as the scale of and technology used to create the foot of the Statue of Liberty.

The commitment to revealing and preserving the vertical layering of time in a place are fundamental concerns for Agnes Denes and John Roloff in their considerations of art in the public domain. Both artists visualize their projects on global as well as local levels, and tend to consider historical time on an epic scale. Roloff is particularly interested in geologic time and *anthroturbation*, a term that refers to the idea of "humanity, rather than wind or gravity or another natural force, as the agent of transformation."[15] He describes how he considers a site for a public project to be "from at least ground level all the way to the mantle, and then one hundred miles in diameter," and how his research is aimed at the stories hidden at that level.[16]

Naturally paired with Roloff's geologic preoccupations is his deep concern for the archaeology of places, and the process of initiating systems that, once activated, are allowed to proceed according to the passage of time, and natural (or human) forces that determine their evolution or outcome. Roloff explored this idea between 1980 and 1992 with his *Kiln/Furnace Projects*, a remarkable series in which he "took sculpture materials and processes that involved fire, fusion and an interdisciplinary synthesis out of the studio and into the landscape on a scale never before attempted."[17] The metamorphosis of these pieces, from monumental sculptures in the landscape—comprised of ceramic fiber blankets or refractory cement suspended from steel frames—to ignited furnaces that transformed their surface silicates and carbonates to their original, unrefined states, had parallels with the igneous processes inherent in nature. What was left were either traces of the work on the landscape that disappeared over time, or—as with Roloff's later steel-reinforced pieces—fossilized, memorial relics. Roloff has often used the form of the ship as the structure for these works, metaphorically reiterating the nautical sense of transformational passage of materials, fuel, and metabolic energy.[18]

Roloff's extended interest in the monument/memorial nature of such elemental processes, on one level embodied in the *Kiln/Furnace* pieces, is naturally reiterated in his series *The Lahontan Group I–III* (1985–1987). These latter projects were conceived as an homage to Lake Lahontan, an Ice-Age inland sea that once covered eight thousand square miles of northern Nevada. The series was especially important because it metaphorically represented a shift from the fiery beginnings of the earth to the more recent Holocene Epoch, and tangibly demonstrated a transition in Roloff's work. *Ancient Shoreline/Island for Lake Lahontan* (1985), a *Kiln/Furnace* piece, was the first of these monumental works. For the second piece, *Talking Tree/Glacial Epoch* (1987), Roloff created a sense of evolution by reconstructing *Ancient Shoreline*, reusing the steel structure that remained after its ceramic "skin" was burned off, giving it the appearance of a fish fossil. *Talking Tree/Glacial Epoch* served as a kind of trellis for three alder trees which engaged with its framework, intended to symbolically represent a dialogue between the Ice Ages of northern Nevada and the climate of the modern era. For the third work, *Vanishing Ship (Greenhouse for Lake Lahontan*; 1987), Roloff transformed the structure into a more explicit boat form and positioned the ship at an oblique angle, making it appear to sink into the earth. Roloff's extended his marked interest in palingenesis by facing the structure with glass, thus converting its function to a greenhouse.

This third state of *The Lahontan Group* is the richest, serving as an elegy for the vanishing of Lake Lahontan and the Ice Age. Inside it were natural materials gathered from Pyramid Lake near Reno, Nevada—water, sediment, rocks, a gull feather—which Roloff used to refer to its ancient beginning. The duality between the sense of loss implied by the sinking vessel, and the generative function of its earthbound greenhouse, was a reminder that "though the earth, with its interconnections, may be the center of everything that is our actuality, we tend to misremember actuality and concentrate instead on the culture that overlays it."[19] By creating an enclosed system for *Vanishing Ship (Greenhouse for Lake Lahontan)*, Roloff structured conditions that allowed him to position himself as an observer, creating another link between the *Kiln/Furnace* pieces and *The Lahontan Group*, and reiterating his interest in initiating systems that can be sustained without him.

Roloff carried the metaphor of *Vanishing Ship* into an urban context with *Deep Gradient/Suspect Terrain* (1993) by reusing the sinking ship/ greenhouse as a place-specific monument in San Francisco's Yerba Buena Gardens. *Deep Gradient/Suspect Terrain* suggests parallels with the sedimentary relationship between the land and adjacent sea floor of the coastal United States, and the actual tectonic relationship between the ship's hull visible in the street-level plaza with the vast convention space of Moscone Center below.[20] To strengthen the holism of his intended geographic references—the site was originally underwater—Roloff also configured the

Figure 12.3 "Deep Gradient/Suspect Terrain," John Roloff. *Seasons of the Sea Adrift*; 1983, painted steel, tinted laminated glass, sediment and plant growth from the Pacific Ocean floor, water, misting system, pavement level glass view port units, altitude markers, Yerba Buena Gardens, San Francisco, California. Credit: courtesy of Gallery Paule Anglim, San Francisco.

work to serve as a conservatory for plants, germinated from seeds embedded in the sedimentary material that was gathered from the sea floor off the California coast that once covered the area that is now San Francisco.

In Roloff's recent works, such as *The Seventh Climate (Paradise Reconsidered*; 2006), he has extended his consistent interest in the site-based conversation between the present and the past, as well as his desire to unleash processes that are out of his control. Created as part of I-5 Colonnade Park in Seattle, for *The Seventh Climate (Paradise Considered)* Roloff wanted to create a dialogue between the existing local ecology of the site—its weeds and blackberries—and the larger time frame of species that historically grew in that place. To achieve this, he chose species from four climates of the same latitude that represent terrains, and planted them close together so they would have to "interact and negotiate their interactivity." This process is reminiscent of his *Furnace/Kiln* pieces, and his belief that "the artist

is organizer of the forces, but then the work interacts according to its own conversation."[21].

Although Roloff's ongoing interest in the vastness of geologic time has affinities with Agnes Denes' in terms of immense time frame and heroic scale, Roloff's focus tends toward the distant past, while Denes tends to project her thinking far into the future. A monumental example is *Tree Mountain—A Living Time Capsule—11,000 Trees, 11,000 People, 400 Years* (1992–1996). Denes speaks of the need to work in epic scale in order for the work to have impact. She explains that this has always been central to her work in public places; how "when I do a large project and use fifty acres or one hundred acres it's because it has to be that big to make a difference . . . when you create a project that's on a monumental scale, you take people's breath away. You stop them in their tracks and they begin to think."[22] Initially conceived in 1982, *Tree Mountain* was not commissioned until 1992, when Finland's Ministry of the Environment selected it at the Earth summit in Rio de Janeiro, as part of Finland's commitment to alleviating the world's ecological stress. *Tree Mountain*, quite literally, is a huge manmade mountain, created in Ylojarvi, Finland, and planted with 11,000 trees by the same number of people. One of the largest reclamation sites in the world, *Tree Mountain* has been declared by Finland as a national monument to serve future generations with a meaningful legacy. Ironically, although the Finnish government sponsored this project because its citizens were becoming increasingly concerned about environmental damage, Denes points out their country is one of the few that doesn't yet actually share this global issue.

To establish a palpable relationship between the individuals who planted *Tree Mountain* and future generations, Denes designed and awarded certificates that designate them as "custodians of the trees."[23] Fundamental to Denes' vision with such a project—which is intended to reach twenty or twenty-four generations into the future—is her belief that our short life spans create a myopia concerning the fate of the planet, and, therefore, the problem of creating a human sense of timeless accountability. Denes reiterates her eloquent belief that "we hand a torch over to the next and the next and the next generation. That's why it's so important that the torch is burning as bright and as brilliantly as possible."[24] In this way, the tree affidavit, which is intended as an inheritable legacy from one generation to the next, is the first ecological art undertaking of this proportion in the world. It is a fine example of how an artist can realize the aesthetic expression of activated value systems, and simultaneously provide a legacy of optimism for the future. Its brilliance is underscored by the tangibility of the certificates that each generation can pass onto the next, assuring that the lore of the place and its inhabitants will be remembered over time.

From the beginning of her career, Denes' public projects have manifested her commitment to the relationship between environmental issues and human concerns, and have prolonged her unremitting interest in working

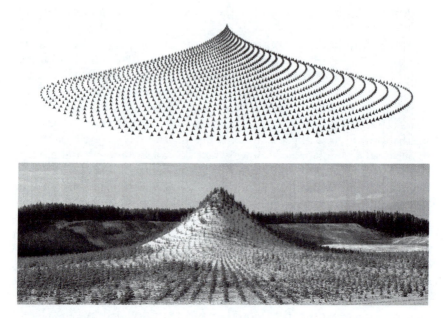

Fiugre 12.4 "Tree Mountain—A Living Time Capsule—11,000 People, 11,000 Trees, 400 Years," Agnes Denes. 1992–1996, 420 × 270 × 28 meters, Ylöjärvi, Finland. Eleven thousand trees were planted in a complex mathematical pattern by 11,000 people from around the world, to be maintained for 400 years. Photo: courtesy of the artist.

in public places. She ceremonially declared this commitment in 1968 with *Rice/Tree/Burial*, her first public art work. For this process-based piece, Denes planted rice to represent life and sustenance; chained trees to symbolize interference with natural ecologies and connections; and buried a unique copy of her haiku poetry to symbolize these connective ideas by relinquishing something personal to the earth. Denes explains this triangulation as, "represent(ing) thesis, antithesis, synthesis, which always goes through my art; the philosophical aspect, the philosophy, and then the act."[25] Of particular importance to her is "the relationships and the time capsules we place in the ground to communicate with the future," an act that is consistent throughout her projects.[26] In 1977 she was invited to reenact *Rice/Tree/Burial* on a larger scale at Art Park in Lewiston, New York. To create this version of the project, she lived and worked for seven days and nights on the edge of Niagara Falls while planting a half-acre rice field. The experience was life-changing for Denes. She describes the sublime nature of the experience: how "the power of nature and our insignificance was incredible." Coincidentally, the work became an intervention when the rice she planted grew up as "red rice," a mutant strain that was an unforeseen consequence of Art Park having been a dump site near Love Canal.[27]

Rice/Tree/Burial was a venerable beginning to Denes' career as a public artist for numerous reasons. It enabled her to establish the philosophical base and methodologies for her art, which she has sustained to the present. Today it is considered to be very important because it was also "the first exercise in Eco-logic."[28] The inherently political nature of the work has, by intention or circumstance, been central to Denes' experiences and visionary public art projects. For *Wheatfield—A Confrontation* (1982), which is probably the artist's best-known piece, Denes planted and harvested two acres of wheat on a landfill in Manhattan's financial district, a block from Wall Street and the site of the World Trade Center. This work stated her prodigious desire to "call attention to our misplaced priorities and deteriorating human values."[29] Along with the unique experience of farming land in Manhattan worth $4.5 billion and producing $158 worth of wheat on the New York Stock Exchange, *Wheatfield* posed acute contradictions between great technological achievements and their interference with the world's ecosystem. The fact that the four-acre site faced New York harbor and the Statue of Liberty underscored the deep contradictions inherent in the work, especially with questions concerning the meaning of freedom.

PEOPLE, PLACES, TEMPORALITY, AND MEMORY

Internationally recognized as an artist of extraordinary vision, Denes has spent her career committed to monumental projects with vast human implications, yet doesn't feel that their long-term effect is necessarily predicated on their physical permanence. She cites *Wheatfield* as a good example, stating that it "is very highly respected. It was so beautiful. When you see the Statue of Liberty and the wheat in front of it, then it looks like all of Manhattan has been turned into a wheat field, and it does make an impact on people."[30] Her perspective reiterates the shared belief among these artists that memory plays an essential role in the long-term meaning of place-specific works.

Of far greater concern for Denes is the disparity between the selection process that is inherent in receiving commissions and their material realization. She expressed her dislike of competing against other artists for commissions, in part because she believes that public art competitions sanction those in charge to maintain control of achieving the necessary demographics demanded by municipal art commissions. She specifies the persistent cycle of selection as the biggest problem attendant to art in public places, along with fundamental concerns of daily life. She believes that

> (the artist's) long-term vision must be strong enough and your commitment to what you're doing must be strong enough so that this egoless art form (I consider this an egoless art form) perpetuates itself and continues in spite of all these things . . . the most gratifying thing is when

> I give a talk and a person comes over and says, "Thank you for what
> you do . . . you make me so hopeful about life."[31]

For equally valid reasons, Andrew Leicester's feelings about the longevity
of his public art projects shifted early in his career. In 1983 he was invited
to create another coal-mining memorial in Rapid City, South Dakota.
Although *Toth*, the Black Hills Memorial he created there, was intended to
be a temporary work, Leicester realized that since as much time, research,
thought, and energy went into a temporary work as into a permanent one,
it made more sense to create the latter. The community supported this idea
and the outcome of this experience initiated Leicester's commitment to cre-
ating only permanent public artworks.

Leicester's thinking is antithetical to a widely held contemporary belief
that "we cannot separate the monument from its public life, that the social
function of such art *is* its aesthetic performance," suggesting that time may
be the catalyst for such engagement. This belief asserts that memory is sus-
tained rather than denied by the temporality of transitory public projects.
As James E. Young describes it, "(the counter-monument) recognizes and
affirms that the life of memory exists primarily in historical time: in the
activity that brings moments into being, in the ongoing exchange between
people and their historical markers, and finally in the concrete actions we
take in light of a memorialized past."[32]

This assertion frames Leicester's thinking as contrary to those artists and
theorists who have favored the growth of temporary public art projects, and
the fact that the intention to create ongoing exchange between people and
the public artworks he creates is of central concern. As Leicester, Denes,
Simpson, and Roloff each pointed out, their generally diminished interest
in temporary public projects is apropos to the amount of time, resources,
and scale inherent in creating all art in the public sphere. Ultimately, their
philosophical attitudes toward working in public places—regardless of the
duration of their projects—has been essential to their sustained careers.

Buster Simpson's experiences provide some particularly poignant exam-
ples of this. One of the great values he sees in creating permanent public
art projects is that, in the best of circumstances, a determined destination
is secured. For instance, during the fall of 2004 Simpson was one of seven
artists short-listed for a project on the Independence Mall in Philadelphia.
His proposal responded to the fact that in that place it was difficult for
individuals to casually meet or socialize. Simpson blended this local need
with the broader history of the site, and proposed to cast thirteen bronze
Windsor chairs to represent the original colonies. He chose the Windsor
chair, in part, because "(it) is a very democratic chair, the one used for the
signing (of the Declaration of Independence) and a place that people could
actually sit and have their lunch or play act or whatever."[33]

However, the *Independence Mall* project was not realized in its outdoor
location, so Simpson reconfigured it as an exhibition for the Temple Gallery

in Philadelphia. For the exhibition he built his own eccentric versions of Windsor chairs—emerging out of wooden pallets and inscribed with quotes pulled from the Declaration of Independence—on one level making a contemporary statement about democracy.[34] Conceptually related to his *Seattle George Monument*, for the Temple Gallery project Simpson had a local wood-turning lathe shop that has been in operation since the 1870s turn legs for his chairs, which were shaped as profiles of the 2004 presidential contenders. Simpson describes the gallery show, which was very popular (about two thousand people came to the opening), as "a really wonderful break for me; it was a holiday to just be able to be focused and direct and immediate . . . it was like painting for a week."[35]

The downside of this project was Simpson's concern with the disposition of these objects when the exhibition ended, a constant issue for studio-based artists, and one which also plagues artists who create allegedly permanent public artworks. Simpson spoke of this issue in relationship to *Host Analog* (1991–2006), which was originally sited adjacent to the Oregon Convention Center in Portland. After an old-growth Douglas fir nursing log eight feet in diameter was moved to this spot from the Bull Run watershed, and reestablished itself as a host for new growth in that place over a ten-year period, subsequent modifications to the Convention Center dictated that the work needed to be relocated. Ever rational in outlook, Simpson recognized that "*Host Analog* is a piece about dynamic displacement, art as entropy, rather than commodity."[36] He continues, "cities are dynamic. They're always being modified. Every convention center has to grow, and it had to grow in the direction of my nursing log . . . so we respectfully moved it and everything growing on the carcass survived . . . It's in a much better location now. These things happen, and you just have to be flexible."[37] This attitude is supported by his experience, as "the new location offers better prospects for the *Host Analog* to be "completed." Meanwhile, we are the gatekeeper to all the variables working for and against the climax of the nursing-log phenomenon."[38]

Simpson's sensitive insights restate the benefits of adaptability for artists working in public places. On another level, the unanticipated organic variables of sites, along with their political volatility, dictates a constant need for artists to resolve the precarious balance between the design needs of public projects and the conceptual consideration of their materials. John Roloff discusses this issue in relationship to his recently completed *Site Index* (begun 2001), a complex, multiphase commission based on geologic and biologic concepts created for the College of Architecture and Landscape Architecture at the University of Minnesota, Minneapolis, in collaboration with Rebecca Krinke, Associate Professor of Landscape Architecture at UMN. For *Site Index*, Roloff continued his investigation of the primordial marine origins of the site, and its subsequent existence as land eroded by glaciers. His desire was to use rock and other materials for the project that would reveal the actuality of the location "as a feeder dike from a protozoic

rift system . . . essentially the same rock as what's directly below . . . The idea of revealing the system that's way hidden, both in terms of time and distance, was interesting to me . . . It's like a river underneath."[39]

Although Roloff admits that there is a kind of romanticism connected to this deep probing into the past, he also believes that this research and disclosure component of the work is germane to the educational function of the project location, as well as to his long-term artistic and philosophical interests. Roloff's concern with the geologic material source for *Site Index* prompted him to visit the quarries where the aggregate from the concrete and the clay used to make the bricks originated. He revealed those stories with text inscribed onto those materials on the buildings, creating additional strata of interpretation, conceptual points of entry, and catalysts for memory. Yet, consistent with considerations Roloff had in creating *The Seventh Climate (Paradise Considered)*, he expressed less interest in the issues of temporality or permanence and greater concern with the issue of "the human time frame."[40] In this context, Roloff's consideration of the duration of a material or a public art piece is balanced by broader considerations of the relationship of the work to other site elements, such as the Steven Holl building adjacent to *Site Index*, or the relationship between the local ecology and structural elements of *The Seventh Climate (Paradise Considered)*. Roloff's long understanding that his work is "a story of materials, a story of a process besides the building of it" epitomizes the shared belief among these artists that it is the role of art to say things that can't be said.[41]

OUTCOMES AND PERSPECTIVES

During the three-year interlude since I began conversations with these four artists about temporality and duration, intention, and realization in their art in public places, a striking group of younger artists working in the public realm has emerged. The questions that long plagued discussions of public art, concerning permanent versus temporal modes and shifting nomenclature, have been replaced by an intensive focus on the interventionist potential of publicly realized artworks. Such work has surfaced from a variety of artistic sources that reflect the globalized circumstances of this historical moment.

It is significant to acknowledge how these emerging methodologies are in some ways contingent on the expansive and sustained vision and realized public projects of Agnes Denes, Andrew Leicester, John Roloff, and Buster Simpson, and how their thinking and philosophies helped open the space for artists to redefine their roles, the places in which their work could be realized, and what value they wish to assign to them. Carrying forth the torch Agnes Denes so poetically describes, what remains most important to artists working in the public sphere is the continued desire for a sustained

conversation between what currently exists in a place, what was there in the past, and how the public can be encouraged to consider its palimpsest of stories for the future.

NOTES

1. From Walter Benjamin, "The Storyteller: Reflections on the Works of Nikolai Leskov," first published in *Orient und Okzident*, October 1936. This story is included in Dorothy J. Hale, ed., *The Novel: An Anthology of Criticism and Theory 1900–2000* (Malden, MA: Blackwell Publishing, Ltd., 2006), 378.
2. Interview with Agnes Denes, October 11, 2004.
3. Interview with Buster Simpson, October 31, 2004.
4. Agnes Denes, "Some Words on My Art," provided to me by the artist, extracted from "Notes on Eco-Logic: Environmental Artwork, Visual Philosophy and Global Perspective," Leonardo, 26 no. 5 (1993), 387–395.
5. Mariane Dozema, "The Public Monument in Tradition and Transition," *The Public Monument and its Audience* (Cleveland, OH: Cleveland Museum of Art, 1977), 9.
6. These questions are raised by James E. Young in his essay "Memory/Monument," in Robert S. Nelson and Richard Shiff, eds., *Critical Terms for Art History* (Chicago and London, University of Chicago Press, 2003), 246. This perspective also references feminist criticism, which established that it is the private realm that helps to restate the public, rather than the other way around.
7. Denes interview.
8. Interview with Andrew Leicester, September 27, 2004.
9. Such intent has affinities with the thinking and work of Joseph Beuys and Hans Haacke, whose early tree planting and gray water reclamation projects provided models to encourage beneficial relationships between humans and nature. For instance, with *7000 Oaks*, created in 1982—the same year as Leicester's *Prospect V-III*— Beuys used the symbolic potential of oak trees to refer to life's fragility, a metaphor that introduced an element of hope through the act of enabling an engaged dynamic between the two. Leicester's work here forges links with environmentally-based art practices and socially engaged Conceptual art practices of the period.
10. Simpson interview.
11. Ibid.
12. In" The Storyteller," Walter Benjamin writes of the significance of the proverb as an ideogram of a story, and how "a proverb, one might say, is a ruin which stands on the site of an old story and in which a moral twines about a happening like ivy around a wall," (Hale, 377). This metaphor is consistent with Simpson's dedication to embodying the layered history of public places, and the organic expression of it in his *Seattle George Monument*.
13. The piece chosen and built for the San Francisco Embarcadero project is Claes Oldenburg and Coosje van Bruggen's *Cupid's Span*. The visual compatibility of Oldenburg and van Bruggen's sculpture with the Bay Bridge span in the near distance exemplifies the seduction of more superficial site characteristics, and the name recognition of the artist with the process of public commission awards.
14. Simpson interview.
15. The term *anthroturbation* was developed by Roloff in conversation with the geophysicist Paul Sprudich.

16. Interview with John Roloff, August 30, 2004.

17. Constance Lewallan essay, at www.johnroloff.com.

18. As part of his interest in analogous systems, Roloff talks about the relationship between ecology and metabolism. He explains, "there's two parts to metabolism—you have to destroy to make and then you have to build to make . . . it's just the breakdown of things in order for something to be reconstructed as part of a cycle," (from interview of August 30, 2004).

19. Bill Berkson, "John Roloff, University Art Museum," *Artforum*, November 1987 (as posted on johnroloff.com). The framework from this third state of *The Lahontan Group* is now installed on the grounds of the Djerassi Resident Artists Program in Woodside, California. The works that comprised the original series are no longer extant.

20. Roloff discussed the significance of his consistent site-related structural interests, and how they relate to this work. For *Deep Gradient/Suspect Terrain*, this includes his awareness that although the foundation of the piece is contained in boxes in Moscone Center, below the surface of the plaza and out of sight, it remains of significance to his concept and intentions.

21. Interview with John Roloff, June 23, 2007.

22. Denes interview.

23. Aira Kalela, "Tree Mountain—A Living Time Capsule—11,000 Trees, 11,000 People, 400 Years, Ylojarvi, Finland, 1992–96," in *Agnes Denes: Projects for Public Spaces, A Retrospective*, ed. Dan Mills (Pennsylvania: Samek Art Gallery, Bucknell University, 2003), 31.

24. Denes interview.

25. Denes has written extensively of this philosophy, and explains in her writings in the book *Agnes Denes* (published by the Herbert F. Johnson Museum of Art, Cornell University, in conjunction with her 1992 retrospective), that these three acts constituted "the first transitional triangulation and formed the Event. According to evolutionary theories, the Event is the only reality, while the reality we perceive is forever changing and transforming in an expanding evolutionary universe . . . "

26. Denes interview.

27. Ibid.

28. Denes, "Rice/Tree/Burial" loc. cit.

29. Ibid., 118.

30. Denes interview.

31. Ibid.

32. Young, "Memory/Monument."

33. Simpson interview.

34. The quotes Simpson pulled from the Declaration of Independence make accusations against King George that Simpson feels are applicable to today's George (in the White House).

35. Simpson interview.

36. *Host Analog* Document on Saw Blade, 2006, from www.bustersimpson.net.

37. Simpson interview.

38. Interview with Buster Simpson, June 24, 2007.

39. Roloff interview.

40. Ibid.

41. Quote, Roloff interview; closing statement based on conversations with the artist, 2004 and 2007.

Note: All quoted statements in the text that are not cited are from the interviews with the artist being discussed.

13 From Margin to Mainstream
Dyke Action Machine! Public Art and a Recent History of Lesbian Representation

Carrie Moyer

In 1969, the Stonewall Inn, a gay bar on Christopher Street in New York City, was raided by the New York City Police Department. A mass of gay men and drag queens openly fought back, and this riot marked the birth of the modern gay civil rights movement. Yet, unlike the Black Power movement and the Women's movement, there are no enduring images of the Stonewall Rebellion embedded within the collective American consciousness. The 1955 image of Rosa Parks seated on a bus, in front of a white man, speaks volumes about the direct correlation between public awareness of political movements and the indelible memory created by repeated viewing of a single, compelling image. Even if we don't remember their names, who can forget the photograph of American athletes Tommie Smith and John Carlos raising the Black Power salute on the dais of the 1968 Mexico City Olympics, or Billie Jean King beating the pants off Bobby Riggs in 1973? Visual representation is power. Outside of the usual collection of stereotypes assigned to gay men and lesbians, the first grand-scale appearance of homosexual marginalization in the popular imagination was the 1981 photograph of an emaciated AIDS patient—hardly an empowering icon. And yet the urgency of the AIDS crisis made it unseemly to point out the complete absence of lesbian representation.

What an enormous difference twenty-five years have made. The media frenzy in 1997 caused by Ellen DeGeneres' coming out as both a lesbian sitcom character *and* a real, live lesbian seems today like ancient history. In the past decade, the mainstream's embrace of gays has gone from a tentative air kiss to a full-on bear hug. The summer of 2004 saw the airwaves flooded with footage of earnest lesbian and gay couples seeking legal recognition for their unions. Stereotypes have been freshened up. Fey, neurotic hairdressers and interior designers have given way to *Queer Eye for the Straight Guy*'s Fab Five, a gang of lovable, utterly normal, user-friendly gay men whose *raison d'être* is to civilize and soften up heterosexual men, much to the delight of their exasperated wives and families. Still the ratio of lesbian to gay representation remains skewed.

This cultural shift in image from tragic AIDS victimization to well-scrubbed homosexual normalcy was in great part due to the efforts of

lesbian and gay artists and activists of the past decade. Coming of age as a gay person in the 1970s and 1980s meant being fluent in the coded, homo-erotic undercurrents buried in the mainstream media, codes that were fully exploited by advertisers who could always bank on gay consumers' exper-tise at "reading between the lines." At the same time vibrant lesbian and gay visual cultures were developing in step with the burgeoning civil rights movement.

For the queer artists, designers, copywriters, marketers, and media con-sultants of my generation, professionally engaged as we were in the con-struction of the mediated world, this lack of recognizably lesbian and gay visual representation in the mainstream just didn't compute. Having grown up being both emboldened by and resentful of our own marginality, we worked hard to increase straight culture's tolerance level for our difference and to build all manner of social support systems for ourselves. And yet we were still not seeing ourselves represented on the streets, in magazines, or on the television and movie screens. Enter Dyke Action Machine!

DAM!

Dyke Action Machine! was a two-person public art project that I founded in 1991 with photographer Sue Schaffner. From 1991 until 2004 Dyke Action Machine! (DAM!) blitzed the streets of New York City with pub-lic art projects that combined Madison Avenue–savvy with Situationist tactics. The project evolved into a kind of advertising agency for lesbian identity. DAM!'s street-based campaigns dissected mainstream media by inserting lesbian images into recognizably commercial contexts, revealing how lesbians are and are not depicted in American popular culture. DAM! performed the role of the advertiser. We promised the lesbian viewer all the things she'd been denied by mainstream visual culture: power, inclusion, and the public recognition of identity.

Sue Schaffner and I met in Queer Nation and were drawn together by a desire to subvert and create counternarratives to the advertisements that we were producing at our day jobs. Sue is an artist and commercial photog-rapher whose work has been published on the editorial pages of countless mainstream publications. I came to activism as an outraged painter and graphic designer looking to contribute my commercial skills to my own liberation, enamored of the media-driven, appropriation art of the early 1990s. Acting as the unofficial Minister of Propaganda for various New York City activist groups including the Lesbian Avengers and the Irish Les-bian and Gay Organization, I was interested in producing agitprop that placed our concerns within the larger frame of mainstream visual culture.

DAM! began as a program of Queer Nation, an activist organization that was founded in 1990 in New York City by four ACT UP members to address homophobia and violence against gays and lesbians, as well as to

increase queer visibility. The organization is often credited with reclaming the word *queer* from its former pejorative connotations. Although Queer Nation was comprised of both men and women, a group of approximately twenty lesbians (Sue and myself included) wanted to do work that directly addressed lesbian issues. We formed Dyke Action Machine! and carried out numerous actions for one year before disbanding.

Sue and I later decided to continue our collaboration using the name Dyke Action Machine! Modeled on other earlier political/art collaborations such as General Idea, Gran Fury and the Guerrilla Girls, the individual artistic identities of DAM! members were screened and subsumed by the anonymity implied by our name. Research for DAM! campaigns began by thoroughly scanning the current mainstream and alternative press, by polling lesbian friends and colleagues, and by forming casual "focus groups" to find out what was on the minds of our friends and colleagues.

An early DAM! campaign from 1993, *Do You Love the Dyke in Your Life?*, showed a row of five tough-looking butches dressed in tight t-shirts and briefs, posed with arms crossed and with wry expressions on their faces. The poster was a reaction to a Calvin Klein underwear advertisement featuring actor Mark Wahlberg (known at the time as rapper Marky Mark), who had gone on record as a homophobe. The poster simultaneously acknowledged the popularity of Calvin Klein underwear amongst lesbian and gay consumers, and put lesbians who adhere to a queer aesthetic of attractiveness into a homoerotic frame that used a white, muscle-bound body to covertly appeal to gay male consumers. The poster illustrated the "transference" that lesbian consumers are often required to make.

Projects were produced quickly, seemingly overnight, in response to commercial ad campaigns. With the advent of high-end computers production became streamlined, making it easier for DAM! projects to be covertly created on the job. Designing on the computer allowed for an immediacy. The streets of Manhattan were quickly converted into sites for "call and response" between mainstream advertising visuals and activist interventions, foreshadowing the way the internet is used today.

All DAM! projects were produced on a shoestring budget, and their realization required a certain amount of ingenuity. Sue and I traded design and photography services for access to our employers' state-of-the-art photo and digital equipment. Free printing was donated by HX Magazine (a gay bar rag) in return for logo placement on our posters. Canvassed from gay activist meetings, models volunteered to be photographed in return for having their images plastered all over the street. Fellow artists built props. In an effort to combat the consumerist impulse to buy, which is enabled by advertising, DAM! campaigns never sold anything (except, on occasion, a bit of visibility for gay magazines). Posters were given away for free whenever possible.

DAM! projects were inherently ephemeral and transitory and always conceived in reaction to current events. However, many of the projects

are as relevant today as when they first appeared. In 1997, *Gay Marriage: You Might As Well Be Straight* combined the aesthetic of the heterosexual wedding industry with the mainstream gay movement's call to legalize gay marriage. It took the glossy Martha Stewart fantasy to its psychotic limits by showing one ecstatic bride dragging her unwilling mate through a landscape of matrimonial booty.

The earnest tone and formal elements of the 1940s war-effort posters was combined with the opportunistic use of patriotism by marketing campaigns for companies like Tommy Hilfiger and Ralph Lauren in the poster *Lesbian Americans: Don't Sell Out!* (1998). The poster positioned the butch lesbian as the embodiment of the truly revolutionary, independent American Spirit. It featured a photograph of an archetypal trio of red-blooded butches looking as sweet and tender as James Dean and Sal Mineo, and was meant to represent an indigenous American queer culture that was steadily being eroded by the homogenizing forces of assimilation. Originally the poster was created as a reaction to a recently released survey heralding the above-average incomes of gays as well as their potential to become "brand-loyal" consumers. *Lesbian Americans: Don't Sell Out* could today be a call to arms against the war in Iraq and against the marketing of the gay lifestyle as seen in *Queer Eye for the Straight Guy.*

DAM!'s main conceptual and aesthetic interests were to mine the history of advertising and marketing in the public realm. From action movie posters to bridal magazines, educational Web sites to Works Progress Administration (WPA) posters, all forms of communication became fair game. Therefore, deciphering the meaning of the posters took a certain degree of visual sophistication and agility on the part of the audience. The sheer volume and speed with which information, both civic and commercial, is disseminated produces a visually literate public and allows for an insider sense of humor that is uniquely New York.

DAM! projects created a hybrid form of public address and civic issues. They were packaged to fit seamlessly into the only common space New Yorkers share, the commercialized streetscape. Of the thirteen public art projects produced since 1991, eight were located on the streets of New York City. Typically, a DAM! campaign was comprised of five thousand posters wheat pasted in the city over a one-month period. Target neighborhoods were in lower Manhattan, between the East River and the Hudson, and in downtown Brooklyn. These geographical areas overflow with daily pedestrian traffic and have long been prized sites for wheat pasting. They carry histories of graphic interventions. The long-standing gay neighborhoods of the East and West Village as well as Chelsea were chosen to make sure to reach our core constituency.

During the 1990s, locations used for guerilla posting—abandoned buildings, construction sites, bus kiosks, mailboxes—were subject to a constant push–pull of city intervention and gentrification. The conversion of less-than-desirable neighborhoods into upscale shopping and residential districts

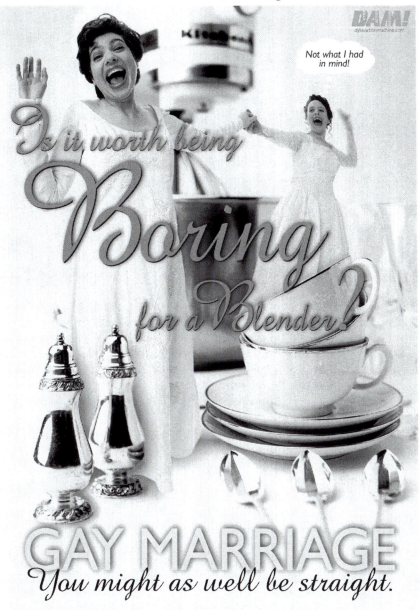

Figure 13.1 "Gay Marriage: You Might as Well Be Straight," Dyke Action Machine! 1977, offset poster, 18" x 24". Credit: Copyright © Dyke Action Machine! (Carrie Moyer and Sue Schaffner).

precipitated an explosion of outdoor advertising. As a part of Rudolf Giuliani's quality-of-life campaigns, instigated during his two terms as mayor

(1993–2001), heavy fines were levied on wheat pasting or "sniping," which was characterized as vandalism. However, due to the large revenue generated by outdoor advertising, law enforcement turned a blind eye to wheat pasting on designated sites.

Because of limited public space, two professional sniping companies, hired by corporate interests, eventually controlled wheat pasting. Too small to compete with such professional outfits, independent snipers ran the risk of having their noncommercial posters and handbills covered over nightly. Locations traditionally used by activists and other marginalized groups to communicate with each other became battlegrounds for public recognition. To ensure the life span of a campaign while minimizing vandalism, DAM!'s largest expense was the fee paid to professional snipers. As long as the fee was paid, commercial snipers were indifferent to the message, thereby inadvertently enabling an interesting cacophony of communication on the streets.

In 1994, the poster *Straight to Hell* took advantage of the newly professionalized streetscape. *Straight to Hell* highlighted Clinton's first debacle in the White House, the "don't ask don't tell" policy which required gay and lesbian soldiers to stay in the closet for the duration of their service. If a queer soldier's sexual orientation became known, she was subject to expulsion. The poster exposed the true victims of the policy, lesbians of color. During that time, lesbians of color were being kicked out of the American military at a much higher rate than white enlisted men, yet the mainstream media focused on the latter. In response, DAM! created a poster depicting a trio of vengeful butches in a backdrop typical of action genre posters. This fictitious film was one that we imagined lesbians would love to see, but would likely never be produced.

By the late 1990s, commercial outdoor advertising and culture-jamming interventions all fell victim to diminishing public space in New York City. Scaffolding and construction sites were torn down as new buildings were completed. The quality-of-life police still did their rounds until gentrified neighborhoods were devoid of places suitable for wheat pasting. Corporations and activists alike had to find new locations for getting out their message. Then the internet came along.

Unlike the random audience for street-based campaigns, the internet provided curious viewers looking for queer content an opportunity to participate. DAM! produced three Web-based projects. The first, *The Girlie Network* (1996), presented listings, promotions, and teasers for a fantasy television channel. In 1996 network television was beginning to introduce secondary lesbian characters into mainstream storylines (i.e. Sandra Bernhardt's character, Nancy, on the *Roseanne* show). In America, with the debuts of gay cable channels *Logo* and *Here*, the concept of a 24–7 lesbian television network could be seen as prescient. DAM!'s first website received four thousand hits a day, including desperate queries from isolated lesbians and gay men looking for support as well as the occasional homophobic diatribe and death threat.

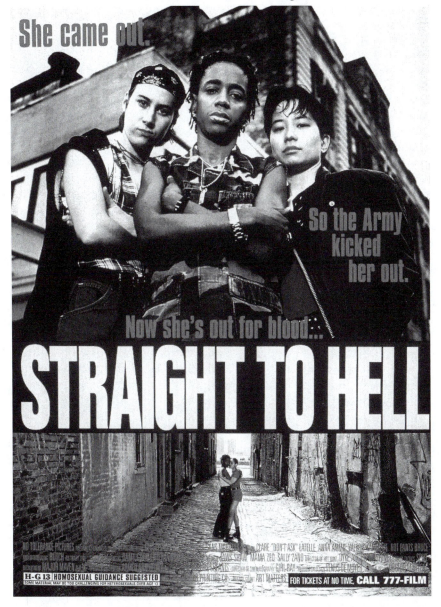

Figure 13.2 "Straight to Hell," Dyke Action Machine! 1994, offset poster, 19" x 25". Credit: Copyright © Dyke Action Machine! (Carrie Moyer and Sue Schaffner).

The second Web site, *DAM! FAQ: Dyke Action Machine! Answers Your Frequently Asked Questions About Lesbians* (1999), was created in response to a number of Web sites that seek to "educate" viewers on the evils of homosexuality. It took a light-hearted approach to the constant burden of

always needing to explain one's sexuality. The Web site *Gynadome* grafted a moment from the Women's Land movement of the 1970s to the present time. The Women's Land movement was established to allow women to disconnect from the establishment and men by creating women-only separatist communities in rural parts of the United States. The DAM! project poster featured the tagline "No Electricity. No Computers. No Men." and depicted a scrappy band of female techno-resisters in a postapocalyptic Earth. *Gynadome* wryly posits lesbian separatists in a neo-Luddite utopia and a place in which Mother Nature has literally grown over mankind's environmental abuses.

The diminishing number of wheat pasting sites created an opportunity to promulgate new hybrids of art, propaganda, and marketing ephemera. D.A.M. S.C.U.M. (Dike Action Machine Society for Cutting Up Men) was created in 1995 to reexamine the concept of separatism by imagining a lesbian-only militia movement. It was created in reaction to the growth of the far-right Christian militias in the United States. For inspiration we looked to *Soldier of Fortune* magazine and Valerie Solanas' *S.C.U.M. Manifesto* (The Society for Cutting Up Men). We created and distributed matchbooks and wallet cards that advertised a phone line offering listeners a list of self-defense products for the working girl or a dramatic reading of the *S.C.U.M. Manifesto*. In 2004 we created a campaign button with the text "Run Bush Run. The Lesbians Are Coming." The retro design was based on classic campaign buttons from the 1960s and reintroduced the younger generation to a revered symbol of lesbian separatism and Amazon autonomy, the labrys or double-axe.

The Möbius strip of influence between mainstream commodity visuals, gallery-based art, and fringe or activist graphics has been repeatedly demonstrated in the work of political artists of the past decade. Nationally renowned artist Barbara Kruger's career began as an art director for *Mademoiselle* magazine. Members of the SILENCE = DEATH Project, the collective behind ACT UP's classic logo, were employed by major corporations such as Avon and Vidal Sassoon while pursuing their individual studio practices. The very same organizations responsible for the proliferation of advertisement in the environment also incited us to make art on the streets and for galleries. The boundaries between high and low, fine art and popular culture, rendered porous by postmodern art practice, seemed particularly vulnerable given the passionate sense of injustice felt by many queer artists during the 1990s.

In 1984, the term *culture-jamming* was first coined by the art-rock group Negativland to describe their "rearrangement" of corporate mass media into new works of art that undermined the original source material. While the term had not yet become part of common parlance, queer interventionist projects from the early 1990s were nonetheless actively engaged in the practice and the disruption of the corporate encroachments into public space. The rich mix of sensibilities created when artists, activists,

and media professionals work together produced actions and graphics that were well crafted, visually sophisticated, campy, and about as far from the earnestness of 1960s activism as you could get. "Give peace a chance," the gentle, heartfelt rallying cry for the Vietnam era by John Lennon, gave way to tongue-in-cheek slogans such as "We're here. We're queer. And we've come for your children," or "Absolute Queer." These slogans were an implicit acknowledgement of how deeply entwined notions of personal identity have become with consumerist branding.

DAM!'s intended audience grew and evolved considerably. Initially the impetus was to speak *to* and *for* the lesbian who was rarely portrayed in mainstream visual culture. Tangential audiences were both random (passersby, Web surfers) and specific (lesbians, gay men, and members of the media industry who were provided with a press kit each time a campaign debuted). The widespread distribution of DAM! posters and ephemera to the queer community and the press produced a vast accumulation of anecdotal responses, reviews, interviews, and feature articles. Gradually, through inclusion in exhibitions and catalogs, DAM! gained a place in the art world and academia, a particularly valuable arena, as teaching is one of the most important means of extending the influence of temporary work.

DAM! is often asked to "measure" the political efficacy of its work, highlighting the awkward position these projects staked out between the art world and the arena of social advocacy. The location of the campaign was always an essential determinant of its political efficacy. In New York City, DAM! posters fit into the barrage of visual stimuli and were only occasionally subject to random antilesbian scrawl. Yet, in Knoxville, Tennessee, the *Lesbian Americans: Don't Sell Out* poster elicited outright vandalism. On over fifty posters, the word *lesbian* was carefully cut away from the image, which was otherwise left intact. Because this defacement happened at a university, one would like to believe that the spoiler was trying to broaden the message to include all viewers. However, it was not hard to read the gesture as homophobic on a campus that prided itself on its all-American image and its legendary football team. Other projects were created after receiving an institutional stamp of approval. In Munich, Germany, a government agency commissioned a German-language version of the *Gay Marriage* campaign for the subway system, concurrent with the 2000 national debate on same-sex unions. In San Francisco, the Yerba Buena Center for the Arts sponsored twenty-five light boxes throughout the city to coincide with the opening of Dyke Action Machine!'s retrospective exhibition *Straight To Hell: 10 Years of Dyke Action Machine!*

With its streets papered in an indiscriminate mix of politics, art, and commerce, it was New York City where DAM!'s public art campaigns read most clearly as both art and politics. The multivalent, humorous references to design, lesbian and gay vernacular, contemporary advertising, political events, and social trends embedded into each campaign fit into conceptual art rubric. Americans are inured to corporate and political doublespeak,

with the advertising industry often drolly playing on this knowledge with great success. A public art project that coopts the look and feel of commerce will inevitably come off as both sexy and suspect. Initially meant to leaven an earnest plea for visibility and tolerance, humor became a sign of awareness and an admission of ambivalence.

The most bittersweet rewards for queer activists and artists are borne from observing the cultural shifts within the media landscape over the past decade. These changes bring with them a number of questions: Was our job to introduce society to new ideas? Was it to educate marketers? Did the projects ultimately only serve consumers?

Based in the media capital of the world, the New York City advertising establishment is especially adept at foraging at the fringe, looking for and finding fresh ideas in unexpected places. This is best illustrated by the print advertising campaigns for the long-running gay soap opera, *Queer as Folk*. The characters in the series are hip, fashionable, androgynous urban professionals, mirroring the population depicted by much of the queer agit-prop of the 1990s. These images were selected at the time to both reflect us and disrupt long-standing stereotypes of lesbian and gay representation. As lesbians and gays become visual "place-holders" for people of all sexualities who don't fit into the normative definition of family promulgated by the Christian Right (particularly unmarried heterosexual couples), the language of gay pornography and radicalism has seeped into the mainstream ad copy. *Get Folked*, the playful, sexually ambiguous headline for *Queer as Folk* as well as the subtle transformation of the rainbow flag into a running design element functions in the same straight–gay binary pitch that DAM! has so long relied upon.

Gay Marriage: You Might As Well Be Straight was one DAM! campaign that offered two such simultaneous readings. On the one hand, in 1997 gay marriage was not yet on the straight viewer's radar and the poster functioned simply as a visible sign that two women might consider marriage as an option. On the other hand, seen by a gay audience who was already cognizant of a desire to marry, the campaign reminded viewers of the feminist critique of marriage that predates the national push for legalizing gay unions. "You might as well be straight," a rather nasty indictment to any lesbian, was a community call for a more radical analysis of what the mainstream gay movement was actually fighting for in our name.

Clearly DAM! changed over thirteen years. More to the point, the culture that DAM! borrowed from and aimed its campaigns at have changed, marked in the mainstream by the increasing appearance of lesbians and gays on the American cultural radar. Given the generational gap among supporters of gay marriage, young people have already proven themselves to be much more accepting of same-sex relationships than their parents and grandparents. One could argue that it was in part due to its own efforts that DAM! became obsolete as a political venture within a media-savvy urban center like New York City. Such obsolescence is an admirable goal

for any truly political venture. Yet, outside of an art-savvy urban center, DAM! continues to resonate politically, buttressing other, more mainstream, voices of visibility. In these cases, thirteen years of activity are collapsed into the contemporary media landscape, creating a kind of time warp of lesbian visibility.

The next generation of lesbian and gay art directors, designers, copywriters, marketers, and media consultants are graduating into positions of power. To them, activist groups such as ACT UP, Queer Nation, and the Lesbian Avengers are simply the points on the gay liberation continuum that begins with Oscar Wilde's trial and includes 1950s butch–femme bar culture, 1970s gay bathhouses, and the Stonewall Rebellion. The fluidity with which these histories are being repurposed by the mainstream media as a means of developing new audiences and consumers is both horrifying and breathtaking. When Viacom was developing *Logo*, their 24–7 gay television channel, they tapped into the "pink tank" of 1990s queer activist artists, including Dyke Action Machine! and other members of prominent art collaborations. We were hired to "brainstorm" with *Logo's* creative department and help them come up with ideas for future programming. Were we delighted that the media had finally acknowledged our contribution to making lesbians and their concerns visible? Hell, yes. We always knew Dyke Action Machine! would make a great advertising agency.

14 In the Storms of the World
Building Communities to Assist Social and Ecological Justice

James Marriott

PREAMBLE

PLATFORM brings together the arts and activism to create projects which address issues of social and ecological justice. Founded in 1983, we have worked consistently in this manner, mainly in London and the Tidal Thames Valley, our home. Deep and radical political shifts often require long time scales in order to be even partially realized, but to sustain engagement in challenging issues individuals need the support and encouragement that comes from community. The driving force behind many social practice artists and arts groups such as PLATFORM is the desire to pursue and realize radical political change. Building communities around these intents is, in our experience, key to maintaining the input of energy necessary for achieving—and indeed pursuing—these goals. However, building communities is difficult and full of pitfalls.

Over the past weeks and months I seem to be living in a parallel imagination, conducting my daily affairs but all the time ruminating on the Vikings. I am possessed by their ship-bound life. I mull over those boats, fifty-foot wooden hulls powered by twenty-six oarsmen, a draught of only eighteen inches, cutting across the North Sea and far up the valleys of the Seine, the Rhine, and the Thames. Perfectly calibrated craft.

The Viking Era is conventionally said to have opened with the Norwegian attack on the monastery of Lindisfarne, off the Northumbrian coast of England, in 793: "On the 8th of June, the harrying of the heathen miserably destroyed God`s church on Lindisfarne by rapine and slaughter" (Anglo-Saxon Chronicle, Laud MS)

Forty-two years later in 835, Danish ships mounted the first raids in our valley—"the heathen devastated Sheppey"—at the mouth of the Thames. In this attack they pillaged the monastery at Minster.

I think of the clash of these two groups, one rapidly mobile, carried in wood across water, the other devotedly sedentary, settled in stone on land—about twenty or thirty each, sheltering from the storms of the world. Communities bound together through belief, through activity, dedicated to each other—in spiritual struggle and in physical struggle. Bound together,

conducting their labor over time, one in the vehicle of the ship, the other in the vehicle of the cloister.

When I can, I return to visit a monastery that I have stayed in several times over the past decade. One of the many things that draw me to it is its constancy. Each time I visit, it is essentially exactly the same as when I last left. Thirty or so brothers sing the hours, a weekly cycle of narrating the Psalms that has continued—perhaps unbroken—since the founding of the Rule of St. Benedict, fifteen centuries ago. At home I can wake in the night at 5:00 a.m. and know, as sure as the bed I lie on, that the brothers have begun to sing Matins. That same pattern of singing, of a constant round of prayer, continued in hundreds of abbeys, nunneries, priories, and chantries up and down our valley for the better part of nine hundred years until the Reformation.

What a deep contrast to the whirlwind of contemporary London, the maelstrom of this metropolis and its valley, in which the new is constantly demanded, constantly lauded with a howling insistence on production rather than being.

In 2005 PLATFORM had its twenty-first anniversary. For over two decades we have worked to bring together the arts and the social sciences, focusing them on issues of social and ecological justice. From its inception, PLATFORM was an interdisciplinary group, bringing together those with a background in artistic practice and those with a background in political practice. We have remained interdisciplinary, brought together by our common intent—to work for social and ecological change—and a common place. For since 1985 we have been based in London and the valley of the tidal Thames that it is built within. It is our home, our common ground, our jumping-off point, our subject matter.

The number of people working as part of PLATFORM has varied over time. Currently there are effectively twelve of us, not all working full time. Twelve[1] individuals form the dialogue at the heart of the endeavor, but sit within a wider group of people who make the work possible. This wider group comprises, firstly, the five Trustees of PLATFORM,[2] and, secondly, the approximately eighty individuals with whom we are in pretty constant dialogue and upon whom we depend for support, guidance, and encouragement. The range of people is diverse—at a PLATFORM annual party you might meet a Jesuit priest, a direct action Anarchist, a youth worker, or an oil geologist. This field of perhaps one hundred people could be thought of as a community.

It is hard to quantify the sense of community that PLATFORM gives people, and difficult to write of such things without sounding self-satisfied. But this community—like other things in the city—provides a kind of battery, a current of solidarity for those who are close to it. A way of illustrating this is the importance we attach to creating events around key political moments, for example, a feast on the evening of a public demonstration against the war on Afghanistan, or a party on the night of the

2004 United States presidential elections. The inverse is easier to see. A gap would be left in part of the civic fabric if PLATFORM did not exist. Perhaps this is what helps us focus on the long term, to think of PLAT-FORM over the next thirty years, and design projects with a twenty-year imagination frame.

Maintaining cohesion within the core of PLATFORM through many lean financial years and exhausting challenges has required constant effort and creativity. To do this, we have drawn on a number of sources of inspiration, including the work of the artist Joseph Beuys. Beuys said that the forming of the social body is in itself a sculptural process or a "Social Sculpture." Creating an organization is an artistic activity that demands great skill and concentration. Beuys, adapting the ideas of Rudolf Steiner, believed there is a threefold balance in the social organism:

1. Liberty in the sphere of creativity: the Spiritual Sphere
2. Equality in the sphere of decision making: the Rights Sphere
3. Solidarity in the sphere of material needs: the Economic Sphere

These ideas, refracted through the pragmatism of the English mind, provide us with guidance.

LIBERTY IN THE SPHERE OF CREATIVITY

Sometimes people (and we ourselves), are puzzled by the question of whether PLATFORM is a collective. The term *collective* generally implies that the output of the group is jointly created and owned, and no one person has any greater claim than any other on the ideas embodied in the work. From 1983 to 1991 PLATFORM conformed to this notion, creating its productions through a process of workshopping with two to five participants. The output was utterly coauthored and co-owned. This model is prevalent in small-scale theater companies.

However, in 1991 when we planned the project *Still Waters* the limitations of this method were revealed. While trying to facilitate the collaboration of individuals from diverse disciplines (a clinical psychotherapist, two performance artists, a publicist, an environmental economist, a writer, a sculptor, and a teacher) we found it more productive to work on the greater project in smaller units. Nine people working in four pairs, with one administrator, created *Still Waters*.

For the past sixteen years, the structures of our collaborations have been much more fluid. Currently we are working on a number of concurrent projects. For example, five people effectively drive the *Remember Saro-Wiwa* project, whilst one person will author the book *The Desk Killer*, and *Unraveling the Carbon Web* engages five people. We value the liberty of individuals within the collective to work alone on a particular

strand of work. Perhaps we recognize that solitary and collective work has different qualities of risk and intensity, and all these qualities need to be encompassed. At the same time we are constantly trying to find ways of working collaboratively and integrating the creative impulses of those within the group as a whole.

Each person in PLATFORM labors away in his or her own sphere, with a great deal of freedom to take it in whichever direction the work needs to go. However, each person is required to talk about, show, and argue the case for his or her work to the others. Thus, the group functions as a sounding board and a source of questioning and inspiration. We try to find the crossovers between our projects, the cohesiveness of different strands, and mutual opportunities. There is a kind of continual dance between the individual and the collective.

This essay, for example, is written by me and reflects my sensibilities and biases. An essay on this subject by another person in PLATFORM would be different in its emphases. However, it is read in draft and commented on by others in the group and thereby comes to express a more shared representation of the understandings we have jointly evolved.

The key to our success is trust. Anyone at the heart of PLATFORM trusts the others to speak on behalf of the whole, to represent the whole (and indeed projects which they are not directly working upon), and this trust takes time to build. Past experience has shown that it may take five years of engagement for a person to become committed to the group. This period is a process of slowly learning about each other, and developing shared political, emotional, ethical, and aesthetic understandings. From this trust comes the presumption that each participant will develop confidence, and be given support, to develop projects within PLATFORM. However, sometimes we'll begin a collaboration that does not lead to the collaborators becoming engaged with PLATFORM.

Occasionally outsiders ask, "Is PLATFORM really a collective anymore?" They say, "You all seem to be doing your own separate things." But what this question does not recognize that we are all cocreating our collective enterprise, which is the social sculpture of PLATFORM. We are all involved in the conceptual unfolding of every project undertaken by the group. It isn't uncommon for us to reconfigure the collaborations within PLATFORM. For example, five individuals, three of whom are working on other projects within PLATFORM, are currently driving *Remember Saro-Wiwa*.

Returning to the image of the ship, we see that each person pulls a different oar. The differing skills and abilities of each person are recognized, yet everyone involved is engaged in the same endeavor. Sometimes, however, we have moved out of sync, once so badly that one person left PLATFORM after ten years. Differences in methodology, and to some extent politics, became too great. It was a very difficult period, but last year that person began working with PLATFORM again on a specific project.

EQUALITY IN THE SPHERE OF DECISION MAKING

To act, to think, to behave democratically is a constant challenge. I was brought up and educated in a culture that was oligarchic. It is a struggle for me to learn to listen to others and to respect another's voice as if it were my own. PLATFORM is surrounded by a culture that is far from democratic and rarely encourages democratic behavior. Thus to try and run ourselves democratically is a struggle, Even so, we try to evolve patterns and systems of behavior that encourage democracy.

From the beginning, taking our inspiration from early 1980s feminism, agit-prop arts, and the green movement, the key decisions in the group have been made by consensus discussion. We have not gone to a vote in over twenty years. We try to give discussion enough time to unfold in a manner that is inclusive, holding as hard as we can to the belief that Democracy is More Important than Speed.

Meetings are formal, minuted, timed, and regularly dispersed across the calendar. This isn't a novel process in the world of civic society groups or business, but rare in activist circles and arts collectives. We try to borrow from different disciplines. In the late 1990s PLATFORM existed, for a while, as just three core directors, with four trustees overseeing work from a distance. Now there are eight of us involved in the work, two others engaged more intermittently, and one of us on sabbatical. In the last two years the trustees (now five) have become far more centrally involved as vital guides and the ultimate decision makers. Like in all British charities, the Board of Trustees is the top-level decision-making structure. What's different is that the PLATFORM trustees have chosen to delegate a large share of creative and strategic thinking to the staff. Nevertheless, counting the trustees, the number of those directly involved in PLATFORM is now seventeen. Consequently we needed to shift and redefine the way in which decisions are made. This is because for all of us to meet and make decisions, as the three core directors had done in the past, would grind democracy to a halt. We discovered— through difficult experiences—that some degree of division of responsibility is necessary.

As the profile of the organization grows, and as the number and scale of the projects being undertaken increases, it definitely becomes harder to maintain the flowing discussion that is at the heart of PLATFORM. We see our current size as being close to an upper limit. We found that decisions need to be made within smaller subgroups, and hierarchies tend to evolve out of practical necessity. Is it possible that certain democratic methods, such as consensus, break down after a certain number? We are a consciously small organization, and happy if all those involved can sit around a table face to face and feel they are cocreating an organization, a social sculpture. We are resistant to growing in number to the point where meeting regularly becomes difficult.

SOLIDARITY IN THE MATERIAL SPHERE

Different levels of personal finance can so easily undermine collectivity. Viewed from a distance all of us in PLATFORM have similar economic circumstances. We are all from the global bourgeoisie, inhabitants of a "First World City," people of the "Rich World." However, viewed more closely there is a great deal of difference in our financial backgrounds and our own senses of personal security. Hence we have slowly created a structure of waging—which we call the "social justice waging system"—within which all the salaried staff are paid the same wage, adjusted according to need. For example, those who have inherited savings are paid less than those without and there are extra salary increases available to those with children or dependents, such as aging or sick relatives.

It seems to us that this system helps provide equal opportunities, because in our city, within some smaller radical environmental groups and arts groups, there can be a bias towards participants from wealthier backgrounds, or the expectation on people to make huge personal sacrifices. They are part of a culture of "volunteerism," in which participants are expected to donate their labor. Such donations are regarded as being virtuous as well as necessary, yet they favor those who can afford to volunteer their work. From time to time PLATFORM has fallen into this same trap, and we see our waging scheme as a means of changing that culture.

Our system ensures that the burden of wage cuts and other sources of insecurity impact us equally. Making an assessment of each person's needs is a delicate process. It requires that each individual reveal his or her personal matters including financial status. But it's a way of assisting equity, defusing jealousy, and, most importantly, of building community.

Working through these three spheres—creative freedom, decision making, and material equity—takes time and can be seen as unproductive or even self-indulgent. Indeed the labor involved in these processes, because they can appear to be unproductive, is hard to finance. But fundamentally these processes create trust and friendship. They enable us to develop ideas together and create a community that can carry us over time through the storms of the world.

On the morning of June 2, 1989, after a night sleeping out in Devilsden Woods, two of us from PLATFORM walked down into the Wandle valley. We'd been following a straight line from the coast at Brighton headed for the Thames in London—sea to tidal valley. At the headwaters of the Wandle we left the line and followed the river down to its mouth at Wandsworth, where this tributary flows into the Thames.

As we walked along the river we passed through Croydon, Beddington, Mitcham, Merton, Wimbledon, Wandsworth. Each place bares the name of a settlement created by Saxon or Jutish peoples who arrived in the valley in the fifth and sixth centuries. Peoples from across the North Sea, from what is now Germany and Denmark, traveled by ship up the Thames

and into the Wandle valley. Wandsworth derives from "Wendles-worp," the village of Wendle, after whom the river itself is named.

All of these settlements depended upon the river and its tributaries for their livelihoods. The river was used for drinking, washing, cooking; for water to help crops grow; as a place to fish and hunt; and to wash the new-born infant and the dead. From the seventh century to the nineteenth century, the river provided a source of local renewable energy. The Wandle was a great milling river: each village had one or two mills to grind corn, to full cloth, beat copper, and print textiles. The river was the center of these communities—communities of place.

But the valley that we walked through in 1989 was swathed in concrete, brick, and the tarmac of South London—a suburb to inner city. The river is polluted, litter-strewn, and seemingly ignored. Our walk was part of PLATFORM's project titled *The Tree of Life—The City of Life*, and this was our first engagement with the Wandle.

Our work in the Lower Wandle Valley (the eight-and-a-half square miles of cityscape that lie around the river's final reaches) has had a number of phases:

1989–1991: *The Tree of Life—The City of Life*, a ten-week "residency" tent project in which artists lived, ate, and slept in five locations along the southern inner London's Thames River.

1991–1992: *The Power of the Wandle* (part of the project called *Still Waters*); an environmental economist and a sculptor created events and exhibitions proposing the installation of a new mill on the river.

1993–1995: *Delta*, the installation of a micro-hydro turbine, combined with a large bell rung by the tides, a stone carved arch, and a music event to celebrate the river's tidal mouth. This was followed by a residency at St. Joseph's Primary School, which received electricity generated from the river's flow to light its music room. The residency concluded with a music performance by the pupils that, together with the music from the riverside event, was published as a cassette tape.

1994–1999: Years of maintaining the micro-hydro and helping to create a local civic group called the *Wandle Delta Network*—which struggled to ensure that the development of the area at the mouth of the river took place in an ecological and socially inclusive manner.

1994–2002: *RENUE (Renewable Energy in the Urban Environment)*, a charity established with other local groups to carry out renewable energy and ecological education projects in the Wandle Valley. This was also a time in which we struggled to raise funds and obtain the land to create further projects.

2002: We combined RENUE with another sustainable energy initiative called SEA (Sustainable Energy Action) to create better renewable energy and energy efficiency projects in the Wandle Valley and across London. PLATFORM continues today in an advisory capacity to RENUE/SEA.

Each of these phases was largely unplanned but grew organically and from its predecessor, and essentially worked on by creating community around ideas situated in place. Ultimately we were trying to build a "community of place."

At times this attempt to create community was more structured. The *Wandle Delta Network* held regular monthly meetings and had a newsletter and a membership. RENUE was legally formed into a charity with five trustees, staff, and a field of supporters who engaged in the work. At times the community around the work was less structured. In the first phase, for example, we gathered contacts and friends from just being in the locality, walking the streets, and clearing rubbish from the river.

The challenge has always been to retain the engagement of disparate individuals and groups in the ideas that we are exploring. Despite the fact that this work is focused within a geographic area that takes less than an hour to walk across, with an area the size of an average English parish, it is a place that has a constantly shifting population.

When we first began in earnest to make connections in the locality—by going to the meetings of local civic and environmental groups, by searching out the local government officers, and so on—we had the sense that we were newcomers in a stable community. We feared being seen as interlopers and occasionally stepped on toes. A decade later, many of those with whom we began our dialogue had moved. Meanwhile the fabric of the place has undergone rapid transformation. New blocks of flats have been built, new residents have arrived, and it is essentially a whole new neighborhood. Our first impressions were wrong. It is not stable. Over time this locality has become a new community, a new place. There's a sense of multiple communities forming and reforming and thereby altering the nature of the place.

This reality poses practical and conceptual issues. On the practical level it takes a huge effort to keep in contact with our long-running allies and friends, while trying to make contact with newcomers. Undoubtedly the circle of those with who we were in dialogue was most extensive up until 1999. This circle has narrowed in the past eight years.

Conceptually, what does "a community of place" mean when that place is not some mythic village, but a place through which a tide of humanity is constantly flowing, where the size of the population remains constant but its make-up is always changing? What does long-term commitment mean in a place like this—a place that is typical of London and the satellite towns and villages of its valley?

In 1998 PLATFORM, as part of the *Wandle Delta Network*, participated in the community response to a public inquiry into the plans for the development of a key area in the delta, known as the Shell Oil Depot. For eighty years the oil corporations BP and Shell had run an oil depot at the mouth of the Wandle. Established in 1910s, it ceased to operate in 1996, and the land of the depot was sold to a commercial developer, Persimmon Homes. Persimmon proposed to build luxury flats on the land, renaming it the Riverside Quarter.

Back in 1998 it seemed that the local authority, Wandsworth Borough Council, was the biggest obstacle to the evolution of the delta in a manner that was ecologically and socially sustainable. However, the real power lay with Shell and the conditions they gave to Persimmon on the nature and capital return of any future development. Shell was not present at the public inquiry and was hardly visible on the local stage. The heartfelt desires of citizens for their locality counted for little and sapped much of the strength from the *Wandle Delta Network*.

British Petroleum and Shell are two of the United Kingdom's largest capital companies. Over the last decade they have been continually among the world's ten largest corporations. In 2003 their turnover, of $233 billion and $269 billion respectively, was greater than the gross domestic product of a great number of the countries in which they work. In the same year they each employed approximately 100,000 people and three times this number was directly outsourced. They are everywhere and yet nowhere.

Corporations such as Shell and BP have a vast impact on communities or "places" throughout the world, including Colombia, Georgia, Nigeria, and Venezuela. At the same time they are effectively "placeless." Part of the raison d'etre of corporations is their capacity to create economies of scale. Thus the inner drive of BP is to make these economies by creating globally standardized products—whether that be in the branding of petrol stations, the labeling of a lubricant, the text of the in-house magazine, or the guidelines for managing staff or controlling capital. They are arguably "counter place." They are forces that work to eradicate the distinctiveness of place, not by malicious design, but just by the inertia of their own logic.

"Place" is the land and the stories that lie over the top of that land. Like a protective covering, industrial development projects such as mining, oil exploration, or deforestation destroy places ecologically. Equally importantly, they also destroy the stories, which are lost as inhabitants are dispersed.

PLATFORM's *Homeland* project (1992–1993) was a traveling installation in the back of a truck that explored issues surrounding London's ecological footprint and transnational trade. The project used a lightbulb factory in Hungary, a copper mine in Portugal, and a coal mine in Wales to show the transcontinental links that are necessary to bring light to London.

At the heart of the project was a space that was created for discussion with those who visited the installation. The discussions were carefully structured. We requested that each visitor take a small piece of paper and make a drawing depicting their idea of "home." Then we talked with the visitor about the drawing. "What does home mean to you?" "Where do you feel you stop belonging?" or "How often do you think of the future of the place where you live?" The drawings and conversations were multiple and varied, some lasting ten minutes, some over an hour. Many people had a multiple sense of "home"—the home they had as child, the home they lived in at the time, the home they hoped to live in. One of the drawings that particularly stood out, depicted a neatly drawn planet Earth with a red heart hanging beside it. An American working in Hammersmith, a senior marketing executive in the GE corporation, made it. That drawing illustrates exactly a sense of corporate "placelessness."

Yet transnational corporations are themselves communities—not communities of place, but communities of intent or action. What are these communities—several hundred thousand strong—like? Who are they? Can we work with them? Can they be encouraged in one direction or another similar to more "traditional" communities of place?

In 1996 PLATFORM began the initiative *90% Crude*, which continues to grow. *Still Waters*, *Delta,* and RENUE evolved around a concern for the biosphere of the Thames Valley, the role of water in London and the possibility of locally generated renewable energy. In contrast, *90% Crude* focuses on the question of corporations, their place in our city, and their impact on the world. It focuses on the effects these companies, primarily the oil and gas industries, have on the environment, democracy, and human rights. These companies are the contemporary manifestation of our city's imperial history.

"Crude" refers to oil and "90%" to the scale of the reduction in CO_2 emissions that our city needs to make over the next two decades in order to reach a sustainable level of greenhouse gases in the atmosphere.

At the heart of London is "The City," or the financial quarter. It is often referred to as The Square Mile, which refers to the land area defined by the Roman walls that used to surround this area of London. The City was founded the Romans, but after four hundred years it was abandoned and left in ruins by the Saxon settlers. The pattern of the Roman streets was almost totally eradicated by scrubland and farming. In the ninth century, in response to the threat of the Vikings raiding up the Thames, the city walls were erected again and London was reborn. From this fortified seed the great metropolis grew to five hundred square miles in area, with a population of eight million.

Each day approximately 360,000 people work in The City, two thousand of whom actually live there. Workers flood in from Greater London and the hinterland counties of Essex, Sussex, Middlesex, Kent, Surrey, Hertfordshire, Berkshire, and Suffolk. The square mile is a place of itinerant labor,

like an industrial business park, but quite phenomenally powerful with arguably the largest concentration of corporate headquarters in the world. PLATFORM's office/studio is just on the edge of The Square Mile. The Square Mile is our "local community." How are we to address it? As we reflected upon this question we considered a number of factors:

1. PLATFORM is critical of this community, which is different from the way we feel about, for example, the community of the Wandle valley. Despite their power, The City and the corporations seem to inspire little cultural representation—very few films, novels, plays, or artworks have been created about them.
2. The balance of power between PLATFORM and The City poses new problems because it is immensely powerful and demands deference or fear.
3. When we started the project, despite the fact that we knew very few people in The City, most of them were probably like us—largely white, middle-class, graduates, normally with a grounding in the humanities or the social sciences, sharing similar tastes in film, literature, theater, and the visual arts.

Since 1996, PLATFORM has created a series of projects through which we have tried to build a collective understanding of The City and its corporations, and a connection, and an interaction with those that work there and make up its "community."

Killing Us Softly, a lecture–performance that evolved between 1996 and 2003, was designed for small audiences. Nine people were invited to each of the seven day-long events. The performance mixed factual and autobiographical stories and combined video and slides with live music. We searched out individuals for the audience who were either engaged in corporations, or critical of corporations; we recognized that both these facets formed part of a "community." The lecture–performance explored the psychology of people who work in large corporations and how individuals can distance themselves from the impacts of their actions. It explored how "compartmentalization" enables office workers to be blind to (or turn a blind eye to) the occasionally devastating impacts of their labor. It also showed how we might imagine ways out of this kind of corporate psychology. Sixty people participated in the experience over a two-and-a-half-year period, attending the performance and engaging in an extended discussion process after it. The work is currently in production as a book entitled *The Desk Killer*.

The Museum of the Corporation is in development. It is a proposal for an open space where people can debate the social and ecological justice of transnational corporations. To test the waters, *PLATFORM* launched *Loot!* In this guided walking tour, ten to fifteen attendees explored the vanished history and contemporary parallels of The City's first corporation—the East India Company (1600–1858). The Museum of the Corporation asks why no

such cultural space exists where the activities and impacts of transnational corporations can be examined.

In the project *Unraveling the Carbon Web* PLATFORM is analyzing the network of institutions that surround the two major oil corporations, BP and Shell. These giant corporations do not operate in isolation, but are part of a web, "The Carbon Web," of banks, advertising agencies, government institutions, pension funds, legal firms, and museums that collectively drive forward the oil business. For example, the Tate Britain is sponsored by BP and thereby helps the creation of the public acceptability of BP's core activity, the creation of a "social license to operate" that is vital if it is to continue to make money from the extraction and sale of hydrocarbons.

Additionally, PLATFORM is producing (or coproducing) analytical reports that are sent to financial analysts, members of Parliament, and the press, making public demonstrations with other NGOs (Non-Governmental Organizations), and regularly producing performance and workshop events about the Carbon Web. The event called *Gog & Magog*, named after the two giants who mythically founded The City, is a guided walking tour. Ten to twelve participants meet at 8:30 a.m., as the financial markets begin to open, and spend the morning exploring and visiting banks and advertising agencies, government ministries, and law firms, or "actors" in the Carbon Web. At each stop they hear fables by PLATFORM and between stops listen to a soundtrack. The exploration enables them to experience the physical presence of the Web in their city, which is normally hidden. The guided tours take place on Quarterly Results Day, or when BP and Shell present their financial performance. On these days the entire Web community listens intently for signals that will determine the future direction of their companies. The second half of each day is spent reflecting and discussing what participants have seen—coming to hear each other's views and building up some kind of camaraderie.

Slowly but surely we have built our presence in this community—presence as a respected source of advice to NGOs, investment managers and journalists. Presence as those who create unique and safe spaces in which big questions can be asked by people in the Carbon Web who have doubts. Presence as those who provide critics of the corporations with information and inspiration. Now we find ourselves known in this community with perhaps two hundred individuals interested in our work or actively seeking our engagement. And we find ourselves with a series of challenges: how are we to deal with this interest? How are we to cater for those requests for engagement? What is the right form, or forms, to maintain this community of interest? To help shift it into a community built around the intent of working to change the corporations?

Difficult though it is to maintain working in a community of place over the long term, this work suggests some fairly standard forms, most clearly represented by the *Wandle Delta Network* with its monthly meetings, its newsletter, and so on. Are such things really appropriate as forms around

which to gather individuals from this disparate "community" of The City and its corporations? A community made up of people who are fundamentally "busy," who constitute a community in their workplaces rather than in their leisure time. Perhaps we need to explore new forms—such as Web-based chat rooms, or Web sites that use open-source Wiki software. Or does this take us away from the concrete nature of community and into the standardized format of the IT world?

Maybe the solution is to create events that bring wider groupings of that community together. For example, the quarterly cycles of *Gog & Magog* are intended to culminate in large annual events—an Annual Gathering—at which all the attendees will be brought together.

On November 10, 1995 the Nigerian government, because of his long-running protest against Shell, murdered the writer and activist Ken Saro-Wiwa. November 2005 was the tenth anniversary of this event, and PLATFORM initiated and coordinated a coalition to create a living memorial to Ken Saro-Wiwa. The *Remember Saro-Wiwa* project in many ways ties together the different strands of PLATFORM's recent work. It addresses the corporations and the Carbon Web in our city; it explores London's ecological footprint and each citizen's personal responsibility; and it is an intervention in the social and ethical debate of our metropolis.

The first living memorial was launched in November, 2006, and is a life-size representation of a typical Nigerian bus, fabricated in steel by the Nigerian-British artist, Sokari Douglas-Camp. The words of Ken Saro-Wiwa, "I accuse the oil companies of practicing genocide in Ogoni," are inscribed on the bus. Perhaps it is in the creation of objects and events such as these that a community can help define itself? And through the creation of such a memorial we can alter the physical fabric of our city—a city littered with monuments to imperial heroes. This might become a memorial to those with a tradition of struggling against our imperial city—joining the existing statue of Gandhi and the planned statue of Mandela. It might even be a location on future guided walks in the *Gog & Mogog* quarterly events.

A text of seminal importance on the thinking of PLATFORM is the essay by John Berger, the "Historical Afterward" in *Pig Earth*. Berger writes,

> Modern history begins—at different moments in different places—with the principle of progress as both the aim and motor of history. This principle was born with the bourgeoisie as an ascendant class, and has been taken over by all modern theories of revolution. The twentieth-century struggle between capitalism and socialism is, at an ideological level, a fight about the content of progress . . . Cultures of progress envisage future expansion. They are forward-looking because the future offers ever-larger hopes . . . A culture of survival (a peasant culture) envisages the future as a sequence of repeated acts for survival. Each act pushes a thread through the eye of a needle and the thread is tradition. No overall increase is envisaged.[3]

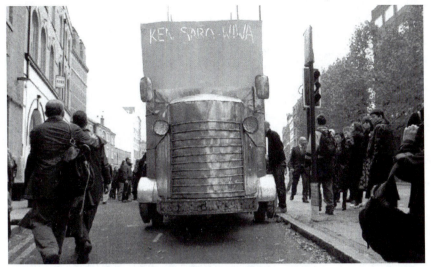

Figure 14.1 "Remember Saro-Wiwa," PLATFORM. Living memorial bus sculpture at its launch, November, 2006, London. Credit: PLATFORM.

The ship has its direction. Parties of Vikings—who were in the main peasants turned temporary warriors and adventurers— set out in their ships with clear intent. We know that Vikings reached Vinland, in what is now Newfoundland, after a journey across the vastness of the North Atlantic. Yet this journey was not a giant leap, but a series of steps, from Norway to Shetland, from Shetland to the Faroes, to Iceland, to Greenland, to Vinland. Each step was intended to be never more than three days' sail. To lose sense of direction, to be lost at sea, to drift for weeks without modern navigation systems, was a kind of cold hell—Old Norse has a word for this horror, hafilla.

Perhaps the intent, the direction of travel, is the key to community. In the work in the Wandle valley the intent was to create a place, a settlement, whose ecological impact (upon its own biosphere and that of elsewhere) is increasingly limited. It is intriguing that when the intent was strongest, most clearly articulated, then the community of place had its largest number of participants, and was most committed and optimistic. The period between 1992 and 1999 was definitely the strongest yet; perhaps with luck—and the redefinition of the intent— the wave will rise again.

And with the work on 90% Crude it becomes increasingly clear that we need to delineate the intent around which we are gathering a community. The era of the oil and gas is ending; its demise will come in maybe fifteen years, twenty-five years, fifty years, but its end is not in debate. Many within the industry, from senior directors to contracted geologists, recognize this. The question is how to limit its social and ecological impact in the present, and how to hasten its overall demise? How to shift beyond our city's fossil

fuel economy—beyond our corporate and imperial economy and beyond our corporate and imperial psychology?

In the Benedictine monastery the cycle of prayer marks out a cycle of time, a wheel of time. But this wheel is not directionless; it too looks back to the time of the life of Christ, and forward to the Second Coming, the end of time. The goal is not to reach this end of time—like the Rapture of the Evangelicals. The goal is to maintain the process, to mark out the days, to survive. To survive in the shadow of a vision that provides direction.

NOTES

1. Those currently employed by PLATFORM and their primary disciplines include the following: Ben Amunwa, campaigner; Ben Diss, activist; David A. Bailey, curator; Chris Fremantle, fundraiser/arts project manager; Dan Gretton, writer/teacher; Ewa Jasiewicz, campaigner; Sarah Legge, administrator; James Marriott, artist/writer; Mika Minio, campaigner/researcher; Greg Muttitt, researcher; Mark Roberts, finance manager; Jane Trowell, musician/teacher.
2. Trustees, roles, and professions: Wallace Heim, writer; Rosey Hurst (chair), business director; Charlotte Leonard (treasurer), finance; Rodney Mace (secretary), historian; Anna Wright, communications director.
3. J. Berger, *Pig Earth* (New York: Pantheon Books, 1979), 203–204.

15 The Art of the Question
Thinking like a Public Artist

Anonymous

The following list of questions was developed anonymously by a public artist in response to a research project at Chelsea School of Art & Design. The artist approached the development of the questions with the same method he would use in developing an art project. The artist's personal philosophy is that all questioning must begin with the self, and then, in order to address how one might carry on a conversation over time and space, expand from that core point—similar to the concentric circles a drop of water makes on the surface of a still pond, moving outward and expanding in scope. These questions can serve as a practicum for engagement and reflection when approaching a place-specific public art project and have been used in public art curriculum.

- When/why should I ask questions?
- What do I hope to achieve with my questions?
- Where should I start? What questions should I ask?
- How should I ask my questions?
- What question should I ask first, since everything is so intricately interconnected?
- What question can I ask that would go beyond the surface appearance of any problem and expose the inner multilayered complexity?
- Where should I start my questions from, since the social system outside of me, my role as a human being, and the entire practice of academic/"intellectual" learning, education, and even questioning are questionable in and of themselves?
- What system can I follow that would question my questions?
- Are my questions genuine, or only an expression of some intellectual trend, and/or current cultural fashion?
- How can I ask questions, so that they do not get coopted and simply become part of the status quo/larger trends?
- What question can I ask that is beyond the current fashions, tastes, and trends?
- How are my questions affected by my time, location, culture, language, etc.?

- How can I ask questions that challenge prior assumptions?
- Who is going to answer these questions, if the system at large is questionable?
- How am I going to even think and search for answers, since I don't even know the correct/real way of thinking?
- How can I look for a correct answer, since I haven't been taught how to find and discover truth?
- What is true thinking anyway, since I'm pretty sure it's not about deciding what to eat for dinner, what movie to see, or what clothes to wear?
- How can I even use my mind beyond its constructed/established parameters?
- Shouldn't my questions first and foremost concern me?
- Should I just ignore questions like who am I? Why am I here? Where did I come from? Where am I going to? Can I assume that answering these questions doesn't affect my other questions?
- What do I believe in? What is the basic foundation that informs my actions, thoughts, behavior, likes, dislikes, etc.?
- What informs my direction and sets my destination?
- How does all this relate to the arts?
- Is there a definition for the arts beyond the imposed limitations of cultural boundaries and social class structures?
- What does it exactly mean to say that I am an artist?
- How does art define my being?
- Is my being, in some way, limited by my "identity" as an artist?
- How does my culture define being?
- Does the current art system support my development as a being?
- What is my identity in the larger life continuum?
- What is this thing we call "I"? Who am I beyond the parameters set by any family, social, and cultural identities?
- Why is there so much emphasis in the arts on constantly trying to come up with something "New"?
- Does this "newness" have any depth/meaning, or is it sufficient simply as icing?
- Are we currently teaching our art students the complexity of reality, and how to use the arts as a means to come closer to the discovery of our own uniqueness?
- Are we teaching students the ways of scientists and explorers; discovering new realties and uncharted territories?
- Why haven't we experienced similar "isms" such as; "avant-garde," "modernism," "minimalism," "conceptualism," "postmodernism," etc. in the field of science?
- Why is it that we have forgotten about meaning/content, and instead use words and vocabulary that only appear profound and meaningful?
- What is the relationship between meaning and language/naming?

- Do definitions and the process of defining brings us closer to the truth and meaning of a thing?
- What is the role, function and meaning of the arts?
- Whom am I doing my art for?
- How is public art different from the other arts?
- Is there a separate role and vision for public art? What is this role?
- What is a community? Why do we have societies? What is our common unity?
- Should I understand the current state of the arts as representative of our current cultural qualities and intellectual standards?
- How did we ever get here? After all these years of so called human progress, is this where we have ended up where, aside from more technologically advanced tools, we fundamentally behave the same as cave people?
- Have we given up pursuing the larger questions of life? Are we truly striving towards being human?
- Can art ever step outside of the influence of money/power?
- Who/what has determined this direction and state of affairs?
- Has anything really changed in our societies, since the days that we gathered around the fire to keep warm?
- Why am I interested in doing public art?
- What makes an artwork public?
- Can an artwork in a museum be considered public art? What about one that is part of a private collection?
- Is the notion of public art a new concept?
- Does the public/viewer influence the making of the artwork? How?
- How does our consumer based society inform the creation, presentation, viewing, etc. of pubic art and art in general?
- How do we measure the success of an artwork?
- Does the public's and/or private collectors' taste measure an artwork's success?
- Should we have a different system for measuring the success of public art?
- Is it good art because it's political, social, environmental, multicultural, conceptual, sensational, minimal, etc.?
- What does it mean to create artworks that are available and accessible to the public at large?
- Does the process of public art sacrifice the artist's vision?
- What is an artist's vision and so what if it needs to be changed?
- What is the role of an artist when creating public art?
- What makes a work in/with/for/by the public into a public art piece? Is it public art if it appears in public?
- What makes me a (public) artist; education, training, experience, passion, my white coat, etc.?
- Should there be a distinction between art and life?

- If so, what separates public art/art from life?
- What would happen to the art market, if art became life?
- What is art then, if art is life? and then what is life?
- If art and life become one, how can we understand art? What can it be compared with?
- Can art be compared to law, philosophy, business, science, manufacturing, etc.?
- What does it mean to be cultured? How does art provide culture?
- What constitutes high or low "culture"?
- What is high and low culture?
- What is it to be cultured?
- How does art connect cultures?
- How do we view and understand the art from another culture? What tools/means do/should we use to approach these art forms?
- Does being cultured make me a better human being?
- How do we evaluate/understand the art from this culture? Do/should we apply the same value system to the arts from other cultures?
- How does consumer culture view/influence the arts?
- What "culture" should I choose; high/low, American/European, Eskimo, etc.?
- How does "being cultured" differ from gaining social status?
- Is there such a thing as art that is beyond the costumes and clothes that it has put on at different times, and for various places?
- What does it mean to communicate?
- What is the purpose of communication?
- What are the conditions for having communication?
- What are the differences and similarities between communication and expression?
- Is it necessary for an expression to be understood by others?
- Is there a difference between expression and self-expression?
- What is self-expression?
- What is the definition of self? Is it the ego? How do we separate the two?
- How do we distinguish between a self/ego-expression, and a self-expression that is an extension of an essential humanness?
- How do we evaluate communication through the arts?
- How do we feel about an artwork that communicates very clearly and precisely, versus one that we cannot relate to in any way?
- When does a work of art become graphic/didactic/ literal?
- Why do we think? How do we think? What is thinking?
- Is thinking simply the processing of gathered information?
- What is the difference between my thinking about what to have for lunch and thinking about the meaning of life?
- Is thinking related to the process of understanding, and gaining knowledge?

- Does my thinking bring me closer to knowing?
- Is knowledge truth? What is the Truth? Does truth depend on time and space?
- What is knowing/ knowledge? How do we gain knowledge?
- Is understanding something the same as knowing it?
- What is the relationship between knowledge and information?
- What is the difference between thinking and the processing of information?
- Does knowing mean having information, or having knowledge?
- How much of what we "know" is simply information?
- How does language relate to the process of gaining knowledge?
- What is the relationship between meaning and words/language?
- How do we, or can we, understand the meaning of more abstract concepts, such as pain, joy, death, god, etc. through words?
- What is the relationship between definition and meaning?
- What is visual literacy?
- Is our culture a visual culture? Is it visually literate?
- What is the relationship between message and meaning? Is getting the message the same as understanding the meaning?
- So what if we don't understand the meaning and only get the message?
- How does a culture that focuses more on the message than the meaning, influence the making and viewing of the arts?
- What role do advertising and politics play with this concept of "message"?
- What is the relationship between message, image, and meaning?
- Why do we accept something as good, simply because it looks good? —Is a written word Asian, if it looks Asian? Is a spoken word English, if it sounds like English? Is it art, if it looks like art?
- Are these discrepancies (between the look, and the content, the message, and the meaning) natural or cultural?
- How does the cultural context influence the making/viewing of the arts?
- How does our culture view and value the arts?
- What influences the making of cultural values and how does this affect the arts?
- Who decides/chooses the cultural values?
- How does our culture define art?
- Is art culturally specific?
- Can art reach viewers beyond its cultural context?
- What informs the making of culture?
- How do we define culture?
- How does art inform culture?
- What is the relationship between culture and class?
- What is the definition of a subculture? How does/can a subculture emerge to become the (main) culture?

- Why should we be concerned with intercultural communication?
- Is consumerism a new development in human history, or is it a natural human tendency?
- Is art about making connections?
- Why do we want to connect with others?
- Is there a human need to be able to connect with others?
- Why do I do art?
- Is art about discovering? Isn't my art ultimately about me, and therefore about discovering who I am?
- What do I hope that my art could do in/for/with others?
- Does art have a personal/private side and a separate public side?
- What is a personal/private art, and what is public art?
- When does personal becomes universal/public?
- How do we define individuality (individual voice) in the arts?
- Why is there so much focus on the individuality/ego of the artist in our culture?
- How do/could we identify self, amidst all the cultural, educational, social, and family influences?
- When is an artwork an individual/egotistical expression and when is it an expression of a human being, who is essentially unique ?
- What is the relationship between my creative self and my being, i.e., is my creative self, my heart, my mind, my body etc.?
- What is the relationship between my self and existence?
- How can an artwork connect with a diverse audience?
- How do we read an artwork?
- How is an artwork reflective of its culture, audience, maker, etc.?
- What informs our (creative) decision-making process?
- What values do we follow in composing/selecting and editing an artwork?
- Is an artwork complete without its viewer?
- How do we choose our medium of expression?
- How does the public inform the making of an artwork?
- What is imagination?
- What is creativity?
- What is inspiration?
- What inspires creativity in us?
- How is a creative space, idea, person, movie, store, etc. different than a noncreative one?
- Is something creative also inspirational, and vice versa?
- How does a work/an idea inspire/motivate us?
- What does it mean to be inspired/motivated?
- How do we recognize creativity?
- What answers are we looking for while creating or during the act of creation?
- What is creativity the vehicle for?

- Is creativity cultured or nurtured? When does creativity start in a child?
- Is creativity imperative to communication? Is it imperative to development? Why?
- What is the relationship between emotions and creativity? That is, is something that evokes emotions creative, and vice versa?
- What makes art compelling? Or when is art compelling?
- When is a space, an object, etc. emotionally charged?
- What is beauty? Is "beauty in the eye of beholder"?
- Are there any common definitions of beauty that are beyond personal, social, historical, and cultural contexts?
- How can something personal be/become universal?
- When do we consider a work/an idea complete?
- How do we value/evaluate a work/an idea? What is aesthetic value?
- Why should we ask questions?
- Why is it important to constantly search for who, why, what, where I am, and what it means to be human? How does art help in this process?
- What is meant by inclusive, accessible, and approachable artwork? How can an artwork accommodate all these qualities, i.e., in its process of making, visual composition, conceptual structure, etc.?
- What is meaning? Does everything have meaning? How do we access it?
- How does the process of naming/defining influence our view of the particular thing that is being named? How does this process contribute to reality as a whole?
- Can we simultaneously be aware of the overall unity, and the arbitrary separation that is caused by the process of naming/defining?
- Is reality unified, or a collection of separate entities?
- Where do we choose to draw the line between two items, in order to separate/name them? In a rainbow where does yellow becomes red?
- Why do we have this process of naming anyway?
- Do we have names in order to be able to identify?
- What is the relationship between an identity and a name? That is, is an artwork's identity summarized in the name? Is "political art" political, and "aesthetic art" not political? Where do we draw the line between the two?
- What is "political art"? Does it include the landscape painting on the wall?
- How do we determine that a work of art is political, social, ethnic, classical, contemporary, modern, folk, craft, outsider, visionary, etc.?
- What is expressing oneself? When do we say that a rosebush is expressing itself? When it grows leaves, develops roots, produces branches, buds and flowers, and/or when the flower fades and the leaves turn yellow?

- What is the intention for being exposed to the arts from different cultures? Is it to expand my understanding of that culture? Why? What do I hope to achieve/gain with this understanding? How can this exposure/understanding help me as the unique individual that I am (beyond my social, political, and cultural form/norm) move towards my own set of goals and destinations?
- Is this understanding/exposure supposed to increase my "tolerance" of our differences? Is it to practice an open mind? What is the view of my social/political/cultural/educational systems on this matter?
- Do we naturally tend to reject differences, or is it a learned/cultured process?
- Is prejudice, racism, nationalism, etc. nurtured or cultured?
- Am I indifferent towards how others talk, behave, dress, eat, etc.? Do I want to control others? Do I want to influence others? Do I want to teach others? How does all this influence my art making? That is, do I want to control, influence, and/or teach others through my artwork?
- How can I teach anything since just about everything that I've been taught has been superficial information without any fundamental substance?
- How does my art reflect my specific personal, social, political, and cultural background and context?
- How do we identify a cultural expression? How can we know all the complex intricacies that make up a culture, in order to be able to identify its expression?
- Why do we often simplify the complexity of a cultural expression into a superficial, stereotypical image of that culture? Is this an attitude that is nurtured in us, or is it the by-product of a consumer mentality?
- Given the current global cultural context, with its diverse sociocultural communities, how do we identify and exhibit a specific cultural expression?
- As curators and/or educators, do we choose/ identify a cultural expression based on the artist's place of birth? The (cultural) name of the artist? The recognizable cultural themes, forms and/or symbols, etc. within the artwork?
- Why do we need to designate a separate category for "others"?
- How do we feel if an artist from culture A uses themes/forms/symbols, etc. from culture B? For example; how do we feel about a white artist painting African-American portraits in the style of a self-taught artist? How do we feel about an African-American artist painting portraits of white figures in an academic, traditionally "Western" style?
- How does our idea/definition of "self" influence our making, viewing, expectations, and understanding of the arts?

- How does our current popular perception of reality, or our notion of separation, fragmentation, and discontinuity in life, shape our view and understanding of the arts and their role?
- How will this perception of wholeness and continuity alter our understanding of the arts, their roles and functions?
- Considering that language by its nature separates and divides in order to define, how can we ever hope to reach knowledge through words?
- Considering this perspective of existence as a unified whole, how do we need to redefine self? What is self-expression? What is personal (art) and public (art)?
- What has been the expected role of the arts, and how is it changing, or how will it need to be changed?
- Considering our current materialistically focused perspective, how do we define the function of the arts? Where, and how, do we look for the influence of the arts on/in our lives?
- Again, based on this same materialistic view, how do we define quality? What is the quality of life? What is the quality of time? What is the quality of art?
- What value system do I use to measure quality, i.e., is it "good" because it is expensive, it is large, it has prestige/class, it is fashionable, or perhaps because it is political, or social, etc.?
- Being part of a culture that is completely drenched in physical sensations, where do we look for the influence of the arts in our lives? How can we even begin to see the more subtle realms of life, and search for the invisible?
- Assuming that we come to recognize a need for change, how can we then shift our prior way of life? For example, if we have been wearing a pair of yellow contact lenses for our entire life, have never taken them off, and have even forgotten that we even have these lenses on, now where and how could we look for the actual/real colors that are not filtered through our lenses?
- How do we redefine art to reflect our newly discovered worldview?
- What is the role, function/responsibility of an artist? Is it to watch over the flame of creativity, like a Zoroastrian priest who is vigilant about keeping the fire burning at all times hoping for everyone to discover their own burning flame inside?
- What does it mean to do something artfully?
- What is the difference between a baker who does his job out of mere financial necessity, for instance, and one who bakes with passion? What about a mechanic? Or, a scientist, or an artist?
- What does it mean when we say that someone does her work so artistically?
- How does one gets passionate about her work? Why do we get passionate and attracted toward something? What is it that draws me to flowers? Why am I fascinated with butterflies? Why am I mesmerized

by the stars? What calls me to flying airplanes? Am I curious? Am I curious to know, learn, discover, etc.?

- Is the force that is now pulling me towards various objects, themes, and concepts similar to that which drew me towards almost everything when I was a kid? Is it curiosity for discovery? What is this force?
- Is this force of discovery the raw fuel that feeds my passion and attraction to pursue the things that I love to do?
- Is a baker searching after discovery? A scientist? A mechanic? A lawyer? A carpenter?
- What is discovery? Is it to know, understand, and cognize the true nature of something (anything: tangible, nontangible, physical, metaphysical, etc.)?
- What would/could be the ultimate discovery/knowledge? Is there an end to knowledge? Is discovery an end to itself, or is it a means for accumulating more wealth, power, and fame?
- How can I discover the more subtle and hidden dimensions of life?
- How can I become more sensitive/in tune with the law/order that shapes and governs all of life?
- How can I practice becoming more sensitive? How can I refine my sensitivity? Is art about this process of refining?

Part III

Mapping the Lineage

A Timeline for the History of Public Art

The United Kingdom and the United States of America, 1900–2005

Cameron Cartiere, Rosemary Shirley, and Shelly Willis

The following timelines represent the establishment of significant public art policy and programs, artworks, and events, the United Kingdom and the United States. It includes groundbreaking works that represent the beginning of important movements in public art such as works by artists participating in design teams or new genre public art. For the purposes of the timeline the definition of public art primarily relates to funding, access, and intention. It is not a definitive timeline. There is no way we could possibly list the many important works of public art that both countries are privileged to claim. We purposefully omitted publications and sculpture parks -- the latter because it typically operates with different funding and commissioning mechanisms. This is just a beginning and we hope it serves as a starting point for further conversation, research, and dissemination.

Special thanks to Jack Becker, Public Art Review; Jeremy Hunt, Art & Architecture Journal; Jonathan Banks, IXIA; Vivian Lovell, Modus Operandi; Louise Trodden, Art in the Open; David Allen, David Harding, Kristine Miller, Maggie Henton, Pallas Lombardi, and B+B for their contributions.

UK USA

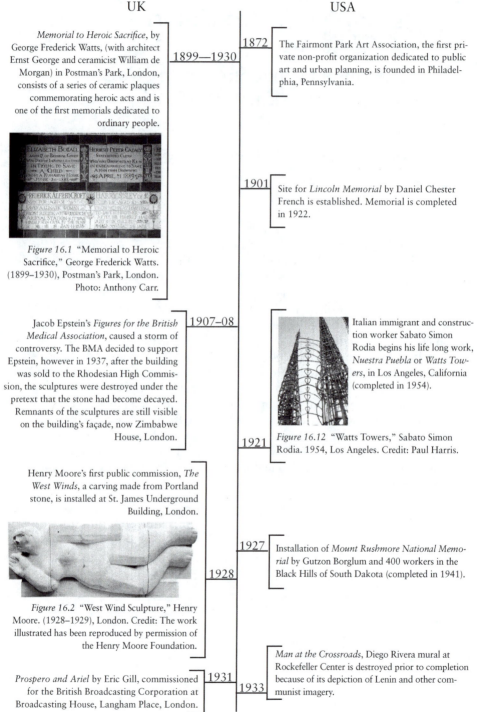

Memorial to Heroic Sacrifice, by George Frederick Watts, (with architect Ernst George and ceramicist William de Morgan) in Postman's Park, London, consists of a series of ceramic plaques commemorating heroic acts and is one of the first memorials dedicated to ordinary people.

1899—1930

1872 The Fairmont Park Art Association, the first private non-profit organization dedicated to public art and urban planning, is founded in Philadelphia, Pennsylvania.

Figure 16.1 "Memorial to Heroic Sacrifice," George Frederick Watts. (1899–1930), Postman's Park, London. Photo: Anthony Carr.

1901 Site for *Lincoln Memorial* by Daniel Chester French is established. Memorial is completed in 1922.

Jacob Epstein's *Figures for the British Medical Association*, caused a storm of controversy. The BMA decided to support Epstein, however in 1937, after the building was sold to the Rhodesian High Commission, the sculptures were destroyed under the pretext that the stone had become decayed. Remnants of the sculptures are still visible on the building's façade, now Zimbabwe House, London.

1907–08

Italian immigrant and construction worker Sabato Simon Rodia begins his life long work, *Nuestra Puebla* or *Watts Towers*, in Los Angeles, California (completed in 1954).

1921 *Figure 16.12* "Watts Towers," Sabato Simon Rodia. 1954, Los Angeles. Credit: Paul Harris.

Henry Moore's first public commission, *The West Winds*, a carving made from Portland stone, is installed at St. James Underground Building, London.

1927 Installation of *Mount Rushmore National Memorial* by Gutzon Borglum and 400 workers in the Black Hills of South Dakota (completed in 1941).

1928

Figure 16.2 "West Wind Sculpture," Henry Moore. (1928–1929), London. Credit: The work illustrated has been reproduced by permission of the Henry Moore Foundation.

Man at the Crossroads, Diego Rivera mural at Rockefeller Center is destroyed prior to completion because of its depiction of Lenin and other communist imagery.

Prospero and Ariel by Eric Gill, commissioned for the British Broadcasting Corporation at Broadcasting House, Langham Place, London.

1931

1933

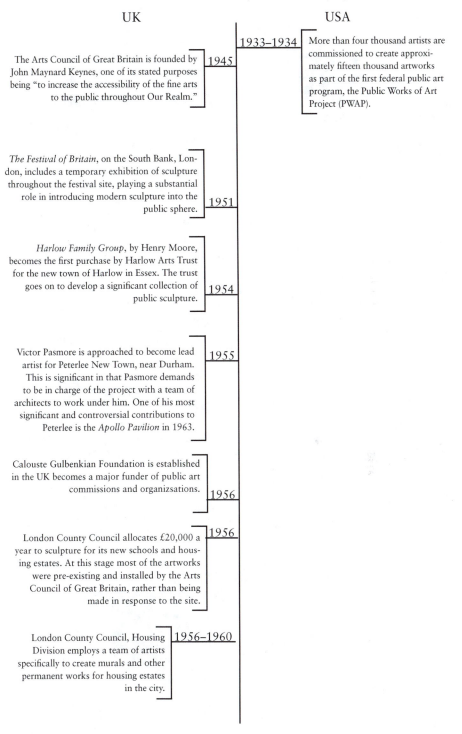

UK

USA

1933–1934

1945
The Arts Council of Great Britain is founded by John Maynard Keynes, one of its stated purposes being "to increase the accessibility of the fine arts to the public throughout Our Realm."

More than four thousand artists are commissioned to create approximately fifteen thousand artworks as part of the first federal public art program, the Public Works of Art Project (PWAP).

The Festival of Britain, on the South Bank, London, includes a temporary exhibition of sculpture throughout the festival site, playing a substantial role in introducing modern sculpture into the public sphere.
1951

Harlow Family Group, by Henry Moore, becomes the first purchase by Harlow Arts Trust for the new town of Harlow in Essex. The trust goes on to develop a significant collection of public sculpture.
1954

1955
Victor Pasmore is approached to become lead artist for Peterlee New Town, near Durham. This is significant in that Pasmore demands to be in charge of the project with a team of architects to work under him. One of his most significant and controversial contributions to Peterlee is the *Apollo Pavilion* in 1963.

Calouste Gulbenkian Foundation is established in the UK becomes a major funder of public art commissions and organizsations.
1956

1956
London County Council allocates £20,000 a year to sculpture for its new schools and housing estates. At this stage most of the artworks were pre-existing and installed by the Arts Council of Great Britain, rather than being made in response to the site.

1956–1960
London County Council, Housing Division employs a team of artists specifically to create murals and other permanent works for housing estates in the city.

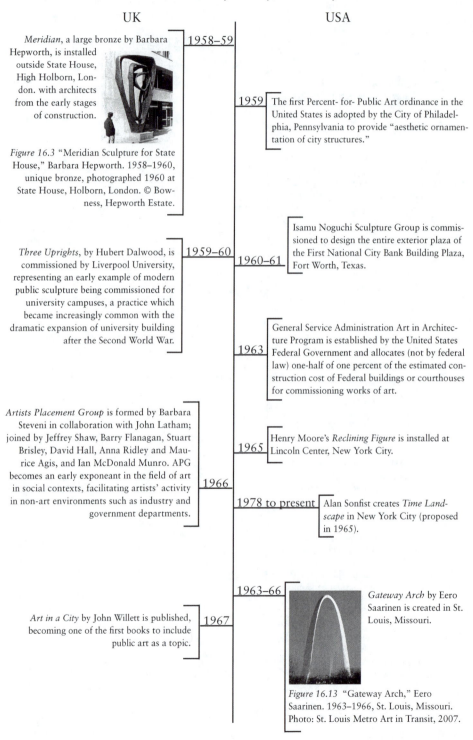

UK

USA

Meridian, a large bronze by Barbara Hepworth, is installed outside State House, High Holborn, London. with architects from the early stages of construction.

1958–59

1959 The first Percent- for- Public Art ordinance in the United States is adopted by the City of Philadelphia, Pennsylvania to provide "aesthetic ornamentation of city structures."

Figure 16.3 "Meridian Sculpture for State House," Barbara Hepworth. 1958–1960, unique bronze, photographed 1960 at State House, Holborn, London. © Bowness, Hepworth Estate.

Three Uprights, by Hubert Dalwood, is commissioned by Liverpool University, representing an early example of modern public sculpture being commissioned for university campuses, a practice which became increasingly common with the dramatic expansion of university building after the Second World War.

1959–60

1960–61 Isamu Noguchi Sculpture Group is commissioned to design the entire exterior plaza of the First National City Bank Building Plaza, Fort Worth, Texas.

1963 General Service Administration Art in Architecture Program is established by the United States Federal Government and allocates (not by federal law) one-half of one percent of the estimated construction cost of Federal buildings or courthouses for commissioning works of art.

Artists Placement Group is formed by Barbara Steveni in collaboration with John Latham; joined by Jeffrey Shaw, Barry Flanagan, Stuart Brisley, David Hall, Anna Ridley and Maurice Agis, and Ian McDonald Munro. APG becomes an early exponeant in the field of art in social contexts, facilitating artists' activity in non-art environments such as industry and government departments.

1966

1965 Henry Moore's *Reclining Figure* is installed at Lincoln Center, New York City.

1978 to present Alan Sonfist creates *Time Landscape* in New York City (proposed in 1965).

1963–66

Art in a City by John Willett is published, becoming one of the first books to include public art as a topic.

1967

Gateway Arch by Eero Saarinen is created in St. Louis, Missouri.

Figure 16.13 "Gateway Arch," Eero Saarinen. 1963–1966, St. Louis, Missouri. Photo: St. Louis Metro Art in Transit, 2007.

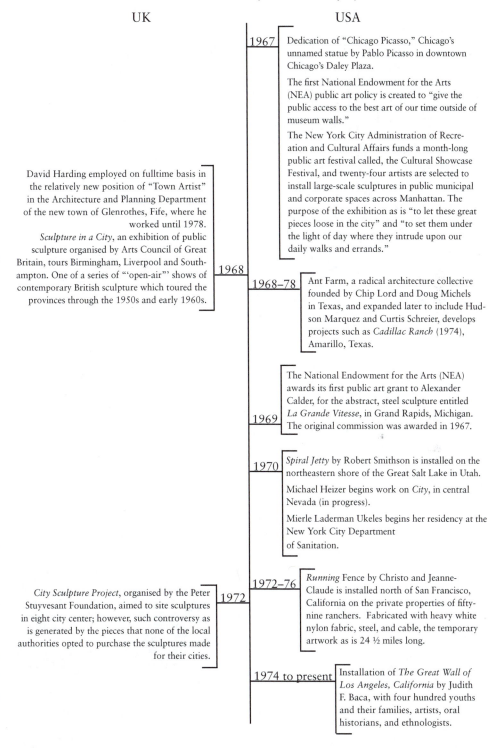

UK **USA**

1967

Dedication of "Chicago Picasso," Chicago's unnamed statue by Pablo Picasso in downtown Chicago's Daley Plaza.

The first National Endowment for the Arts (NEA) public art policy is created to "give the public access to the best art of our time outside of museum walls."

The New York City Administration of Recreation and Cultural Affairs funds a month-long public art festival called, the Cultural Showcase Festival, and twenty-four artists are selected to install large-scale sculptures in public municipal and corporate spaces across Manhattan. The purpose of the exhibition as is "to let these great pieces loose in the city" and "to set them under the light of day where they intrude upon our daily walks and errands."

David Harding employed on fulltime basis in the relatively new position of "Town Artist" in the Architecture and Planning Department of the new town of Glenrothes, Fife, where he worked until 1978.
Sculpture in a City, an exhibition of public sculpture organised by Arts Council of Great Britain, tours Birmingham, Liverpool and Southampton. One of a series of "'open-air'" shows of contemporary British sculpture which toured the provinces through the 1950s and early 1960s.

1968

1968–78

Ant Farm, a radical architecture collective founded by Chip Lord and Doug Michels in Texas, and expanded later to include Hudson Marquez and Curtis Schreier, develops projects such as *Cadillac Ranch* (1974), Amarillo, Texas.

1969

The National Endowment for the Arts (NEA) awards its first public art grant to Alexander Calder, for the abstract, steel sculpture entitled *La Grande Vitesse*, in Grand Rapids, Michigan. The original commission was awarded in 1967.

1970

Spiral Jetty by Robert Smithson is installed on the northeastern shore of the Great Salt Lake in Utah.

Michael Heizer begins work on *City*, in central Nevada (in progress).

Mierle Laderman Ukeles begins her residency at the New York City Department of Sanitation.

City Sculpture Project, organised by the Peter Stuyvesant Foundation, aimed to site sculptures in eight city center; however, such controversy as is generated by the pieces that none of the local authorities opted to purchase the sculptures made for their cities.

1972

1972–76

Running Fence by Christo and Jeanne-Claude is installed north of San Francisco, California on the private properties of fifty-nine ranchers. Fabricated with heavy white nylon fabric, steel, and cable, the temporary artwork as is 24 ½ miles long.

1974 to present

Installation of *The Great Wall of Los Angeles, California* by Judith F. Baca, with four hundred youths and their families, artists, oral historians, and ethnologists.

UK

USA

1974 (1977, 1980)

Art into Landscape competitions take place, to design public art works for sites identified by local authorities all over the United Kingdom. The competitions were open to professionals, laymen, schools, and children; selected entries were displayed at the Serpentine Gallery, London, with a number being realised by various local authorities. Organizsed and funded in part by Arts Council of Great Britain.

1975

Anne Knight is commissioned by the Seattle Art Commission to produce nineteen hatch covers (man hole covers) for the City. One of the first projects of this type.

1976

Claes Oldenburg's sculpture titled *Clothespin* is installed in Philadelphia.

First public art design team is commissioned by Seattle City Lights, Seattle, Washington to create a public artwork at *Viewland/Hoffman Electrical Substation* in Seattle. The team includes Andrew Keating, Sherry Markovitz, Buster Simpson, and Viva and Emil Gehrke.

Social and Public Art Resource Center (SPARC) is founded by Judith F. Baca, Christina Schlesinger, and Donna Deitch, in Venice, California, to produce, preserve, and conduct educational programs about community-based public artworks.

1977

Art in Social Contexts course begun by Paul Oliver at Dartington College of Arts. The first art course in which students make works for public sites in which the context is a key element of the works.

1977

Lightning Field by Walter De Maria is installed in southwestern New Mexico. The earthwork is made with four hundred polished stainless steel poles installed in a grid, one mile by one mile in size and is funded and maintained by the Dia Art Foundation.

The US Department of Transportation's Design, Art and Architecture Program is established, giving official sanction for the expenditure of federal funds for permanent art in new and renovated transit facilities funded by the federal government and for development and administration of the program.

Three Weeks in May, by Suzanne Lacy, is installed at the City Hall Shopping Mall, Los Angeles, California.

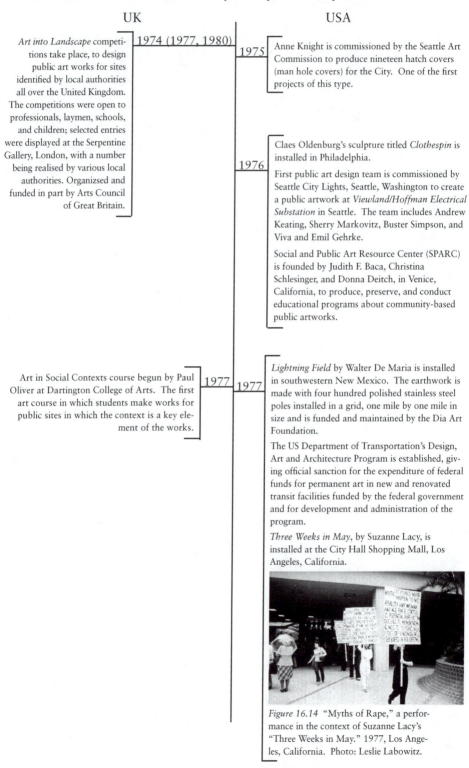

Figure 16.14 "Myths of Rape," a performance in the context of Suzanne Lacy's "Three Weeks in May." 1977, Los Angeles, California. Photo: Leslie Labowitz.

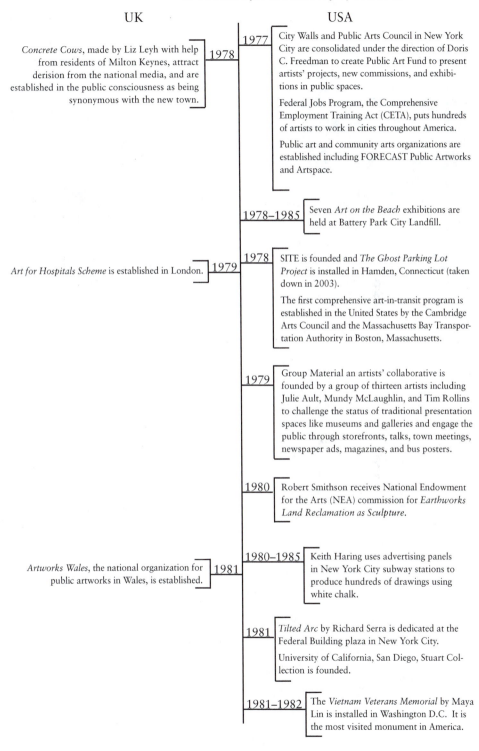

UK

USA

1977 — City Walls and Public Arts Council in New York City are consolidated under the direction of Doris C. Freedman to create Public Art Fund to present artists' projects, new commissions, and exhibitions in public spaces.

Federal Jobs Program, the Comprehensive Employment Training Act (CETA), puts hundreds of artists to work in cities throughout America.

Public art and community arts organizations are established including FORECAST Public Artworks and Artspace.

1978 — *Concrete Cows*, made by Liz Leyh with help from residents of Milton Keynes, attract derision from the national media, and are established in the public consciousness as being synonymous with the new town.

1978–1985 — Seven *Art on the Beach* exhibitions are held at Battery Park City Landfill.

1978 — SITE is founded and *The Ghost Parking Lot Project* is installed in Hamden, Connecticut (taken down in 2003).

The first comprehensive art-in-transit program is established in the United States by the Cambridge Arts Council and the Massachusetts Bay Transportation Authority in Boston, Massachusetts.

1979 — *Art for Hospitals Scheme* is established in London.

1979 — Group Material an artists' collaborative is founded by a group of thirteen artists including Julie Ault, Mundy McLaughlin, and Tim Rollins to challenge the status of traditional presentation spaces like museums and galleries and engage the public through storefronts, talks, town meetings, newspaper ads, magazines, and bus posters.

1980 — Robert Smithson receives National Endowment for the Arts (NEA) commission for *Earthworks Land Reclamation as Sculpture.*

1980–1985 — Keith Haring uses advertising panels in New York City subway stations to produce hundreds of drawings using white chalk.

1981 — *Artworks Wales*, the national organization for public artworks in Wales, is established.

1981 — *Tilted Arc* by Richard Serra is dedicated at the Federal Building plaza in New York City.

University of California, San Diego, Stuart Collection is founded.

1981–1982 — The *Vietnam Veterans Memorial* by Maya Lin is installed in Washington D.C. It is the most visited monument in America.

UK | USA

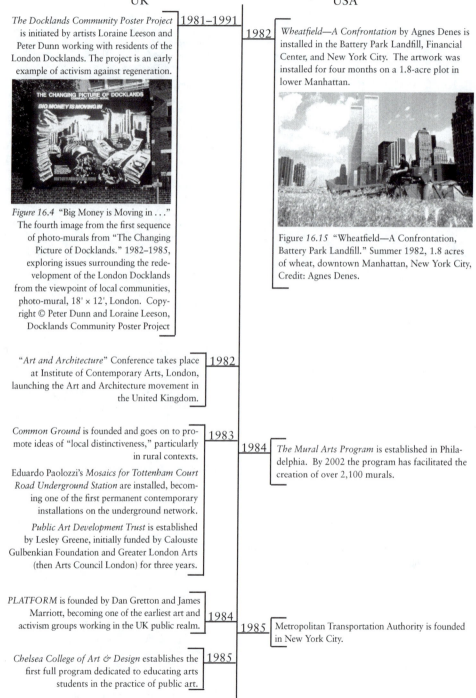

1981–1991 *The Docklands Community Poster Project* is initiated by artists Loraine Leeson and Peter Dunn working with residents of the London Docklands. The project is an early example of activism against regeneration.

Figure 16.4 "Big Money is Moving in . . ." The fourth image from the first sequence of photo-murals from "The Changing Picture of Docklands." 1982–1985, exploring issues surrounding the redevelopment of the London Docklands from the viewpoint of local communities, photo-mural, 18' × 12', London. Copyright © Peter Dunn and Loraine Leeson, Docklands Community Poster Project

1982 *Wheatfield—A Confrontation* by Agnes Denes is installed in the Battery Park Landfill, Financial Center, and New York City. The artwork was installed for four months on a 1.8-acre plot in lower Manhattan.

Figure *16.15* "Wheatfield—A Confrontation, Battery Park Landfill." Summer 1982, 1.8 acres of wheat, downtown Manhattan, New York City, Credit: Agnes Denes.

1982 "*Art and Architecture*" Conference takes place at Institute of Contemporary Arts, London, launching the Art and Architecture movement in the United Kingdom.

1983 *Common Ground* is founded and goes on to promote ideas of "local distinctiveness," particularly in rural contexts.

1984 *The Mural Arts Program* is established in Philadelphia. By 2002 the program has facilitated the creation of over 2,100 murals.

Eduardo Paolozzi's *Mosaics for Tottenham Court Road Underground Station* are installed, becoming one of the first permanent contemporary installations on the underground network.

Public Art Development Trust is established by Lesley Greene, initially funded by Calouste Gulbenkian Foundation and Greater London Arts (then Arts Council London) for three years.

1984 *PLATFORM* is founded by Dan Gretton and James Marriott, becoming one of the earliest art and activism groups working in the UK public realm.

1985 Metropolitan Transportation Authority is founded in New York City.

1985 *Chelsea College of Art & Design* establishes the first full program dedicated to educating arts students in the practice of public art.

UK

USA

Artangel is established by Roger Took and becomes one of the first not-for-profit agencies focusing primarily on the commissioning of temporary public artworks. (James Lingwood and Michael Morris are appointed Co-Directors in 1991).

Art in Partnership is established in Edinburgh, becoming the first public art commissioning agency in Scotland.

1985

1986

Silence = Death Campaign, by Gran Fury, images placed on posters, t-shirts, stickers, buttons, and at bus stops.

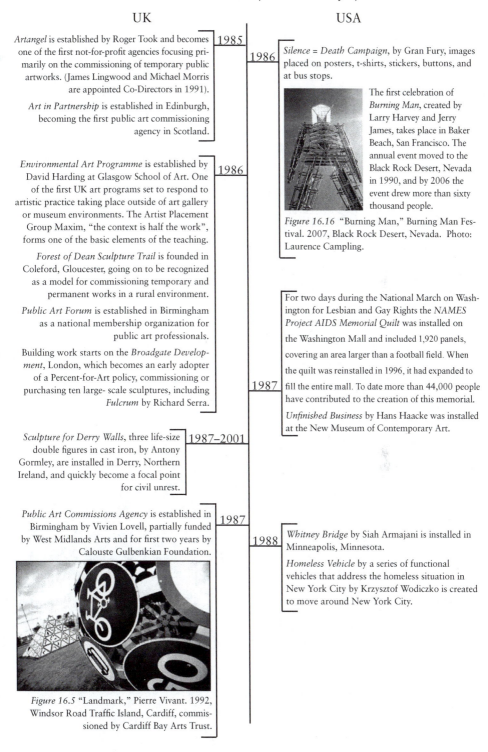

The first celebration of *Burning Man*, created by Larry Harvey and Jerry James, takes place in Baker Beach, San Francisco. The annual event moved to the Black Rock Desert, Nevada in 1990, and by 2006 the event drew more than sixty thousand people.

Figure 16.16 "Burning Man," Burning Man Festival. 2007, Black Rock Desert, Nevada. Photo: Laurence Campling.

Environmental Art Programme is established by David Harding at Glasgow School of Art. One of the first UK art programs set to respond to artistic practice taking place outside of art gallery or museum environments. The Artist Placement Group Maxim, "the context is half the work", forms one of the basic elements of the teaching.

Forest of Dean Sculpture Trail is founded in Coleford, Gloucester, going on to be recognized as a model for commissioning temporary and permanent works in a rural environment.

Public Art Forum is established in Birmingham as a national membership organization for public art professionals.

Building work starts on the *Broadgate Development*, London, which becomes an early adopter of a Percent-for-Art policy, commissioning or purchasing ten large-scale sculptures, including *Fulcrum* by Richard Serra.

1986

For two days during the National March on Washington for Lesbian and Gay Rights the *NAMES Project AIDS Memorial Quilt* was installed on the Washington Mall and included 1,920 panels, covering an area larger than a football field. When the quilt was reinstalled in 1996, it had expanded to fill the entire mall. To date more than 44,000 people have contributed to the creation of this memorial.

Unfinished Business by Hans Haacke was installed at the New Museum of Contemporary Art.

1987

Sculpture for Derry Walls, three life-size double figures in cast iron, by Antony Gormley, are installed in Derry, Northern Ireland, and quickly become a focal point for civil unrest.

1987–2001

Public Art Commissions Agency is established in Birmingham by Vivien Lovell, partially funded by West Midlands Arts and for first two years by Calouste Gulbenkian Foundation.

1987

1988

Whitney Bridge by Siah Armajani is installed in Minneapolis, Minnesota.

Homeless Vehicle by a series of functional vehicles that address the homeless situation in New York City by Krzysztof Wodiczko is created to move around New York City.

Figure 16.5 "Landmark," Pierre Vivant. 1992, Windsor Road Traffic Island, Cardiff, commissioned by Cardiff Bay Arts Trust.

UK | USA

1988

Action for Cities Programme, authored by the Department for National Heritage, links public art and urban regeneration together for the first time in UK policy.

First phase of building at *Canary Wharf* in London's Docklands begins, including the development of a public art program which continues to commission new works, growing to comprise over forty pieces of art.

Percent-for-Art is proposed as a National Scheme by the Arts Council of Great Britain, stating that its expected principle benefits would be (a) visible improvements to the built environment in towns and the countryside; (b) an increase in the patronage of artists; and (c) new money identified and injected into the arts economy.

1989

Tilted Arc by Richard Serra is removed.

SOS! (Save Outdoor Sculpture!) is founded to catalog and access thirty thousand publicly accessible sculptures utilizing volunteers and state and local organizations. Fifty-four percent of the works are determined to be in critical or urgent need of conservation.

The first issue of *Public Art Review* is published by FORECAST Public Artworks in St. Paul, Minnesota.

Michael Singer and Linnea Glatt are hired by the Phoenix Arts Commission and the Department of Public Works to provide architectural concept design for the Solid Waste Transfer and Recycling Center.

1989–1991

Public Art Strategy for Cardiff Bay, Wales, authored by Public Art Commissioning Agency and Cardiff Bay Development Corporation, becoming one of the first Public Art Strategies designed for community regeneration.

1989–1992

National Health Service funds national demonstration projects for Art in Acute Hospitals. The national profile of the demonstration projects establishes art as an integral aspect of hospital design.

1990

Mel Chin begins *Revival Field* in the Pig's Eye Landfill in St. Paul, Minnesota.

1990

Report by Arts Council Percent-for-Art teering Group states that "Percent-for-Art is the method of making sure that art and craft of high quality is part of the environmental heritage we leave behind."

Public Art Report is published by Public Art Forum, featuring the results of a comprehensive survey carried out in 1988 among the existing local authorities in England, Scotland, and Wales. The survey finds that less than six percent of local authorities have policies pertaining to the commissioning of public art.

Edge 90, one of the first multicity site-specific biennales in the United Kingdom, curated by Tracey Warr, Rob La Frenais, and Jon Bewley, takes place in London, Newcastle, and Glasgow.

Section 106 Agreement is established, acting as the main instrument for placing restrictions on developers, often requiring them to carry out tasks which will provide community benefits such as public art provision in new developments.

1991

First they want to take away a woman's right to choose. Now they're censoring art, by the Guerrilla Girls, is installed in New York City.

Figure 16.17 "First they want to take away a woman's right to choose. Now they're censoring art," Guerrilla Girls. Copyright © 1991 Guerrilla Girls. Courtesy of www.guerrillagirls.com.

Places With a Past, a series of projects that explore the identity of the City of Charleston, North Carolina, and curated by Mary Jane Jacob, is held in conjunction with the Spoleto Festival.

UK

1991

RSA (Royal Society for the encouragement of Arts, Manufactures & Commerce) *Art for Architecture* scheme is established to award grants for collaborative ventures between artists and architects, landscape architects, engineers, and designers (closed in 2004).

Over 50 local authorities in the United Kingdom adopt Percent-for-Art strategies, rising to over 150 in the following years, initiating the creation of public art officer posts within councils.

1992

Commissions East established in Cambridge, in order to promote best practice in commissioning works of art for public spaces in eastern region of England, funded by Arts Council England.

M8 Art Project, begins on the motorway between Glasgow and Edinburgh, with a series of roadside artists' commissions which are highly significant in both scale and ambition. Commissioned by Art in Partnership with public and private funding.

Figure 16.6 "The Horn," Dalziel + Scullion. 1997, M8 motorway between Glasgow and Edinburgh, commissioned by Art in Partnership for West Lothian Council. Photo: Michael Wolchover.

Royal College of Art establishes its M.A. in Curating, which includes a course on curating art in the public realm, led by Isabel Vasseur.

1993

House by Rachel Whiteread is completed. This concrete cast of a Victorian terraced house on Grove Road, London contributed to her Turner Prize win of the same year. Generating much controversy, it was demolished just months after its completion.

Figure 16.7 "House," Rachel Whiteread. 1993, London, commissioned and produced by Artangel. Photo: Stephen White.

National Lottery is established, becoming major arts funding stream.

Locus + is established (preceded by the Basement Group, 1979 to 1983, and Projects UK, 1983 to 1992) in Newcastle-upon-Tyne, funded by the arts council, focusing on the presentation of socially engaged, collaborative and temporary projects, primarily for nongallery locations.

USA

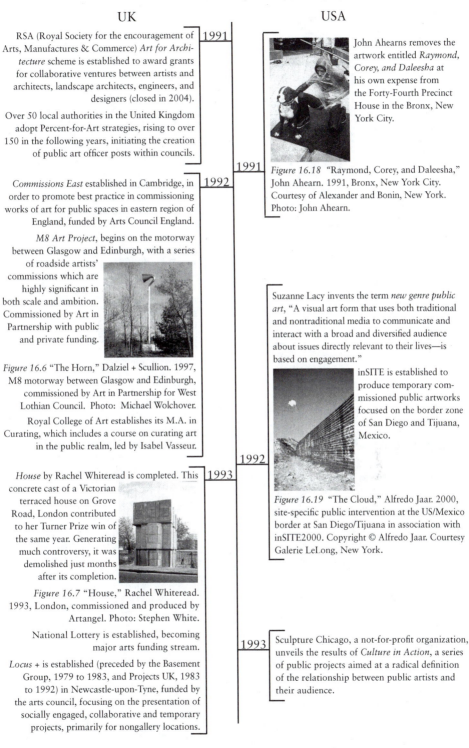

John Ahearns removes the artwork entitled *Raymond, Corey, and Daleesha* at his own expense from the Forty-Fourth Precinct House in the Bronx, New York City.

1991

Figure 16.18 "Raymond, Corey, and Daleesha," John Ahearn. 1991, Bronx, New York City. Courtesy of Alexander and Bonin, New York. Photo: John Ahearn.

Suzanne Lacy invents the term *new genre public art*, "A visual art form that uses both traditional and nontraditional media to communicate and interact with a broad and diversified audience about issues directly relevant to their lives—is based on engagement."

inSITE is established to produce temporary commissioned public artworks focused on the border zone of San Diego and Tijuana, Mexico.

1992

Figure 16.19 "The Cloud," Alfredo Jaar. 2000, site-specific public intervention at the US/Mexico border at San Diego/Tijuana in association with inSITE2000. Copyright © Alfredo Jaar. Courtesy Galerie LeLong, New York.

1993

Sculpture Chicago, a not-for-profit organization, unveils the results of *Culture in Action*, a series of public projects aimed at a radical definition of the relationship between public artists and their audience.

UK | USA

1993 — *Adsite* by FAT (Fashion Architecture Taste), an exhibition of artworks shown in bus shelters across central London, explores the connection between art, the public realm, and the everyday.

1994 — The first degree program for public art in the United States is established: Visual and Public Art Program, University of California, Monterey Bay.

1994 — *muf architectureart*, an all female artist/architect collective, embark on their first collaboration, going on to establish as a practice in 1996.

Heatherwick Studio is established by Thomas Heatherwick, becoming a model for combining architecture, design, and sculpture.

"Where is Fairfield?" by Seyed Alavi is launched in Fairfield, California, a typical American suburb to explore the city's sense of identity and inspire community pride. Thousands of members from the community collaborate to present the question "Where Is Fairfield?" for one day (April 7) using dozens of different mediums and locations: bookmarks, buttons, engraved bricks, grocery store bags, jelly beans, in movie theaters and newspapers, on the radio, air plane banner, a post office cancellation stamp, on a wine label, toothpick flags placed in food at local restaurants, projections on buildings, and t-shirts designed for babies born on the day of the project. The answer to the question is also explored and presented back to the community at large over the next three months at a Chamber of Commerce breakfast, in exhibitions, City Council meeting, on hand painted banners, video and postcards made by thousands of students.

The Benefits of Public Art are defined in research by the Policy Studies Institute as (a) contributing to local distinctiveness; (b) attracting companies and investment; (c) having a role in cultural tourism; (d) adding to land values; (e) creating employment; (f) increasing the use of open spaces; and (g) reducing wear and tear on buildings and lowering levels of vandalism.

PLACE artists' collective organize campaign protesting against the barrage development which is part of regeneration scheme for Cardiff Bay.

1995

1995 — *Kielder Water and Forest Park*, established in Northumberland Becomes a model for commissioning highbred art and architectural works in a natural or rural environment.

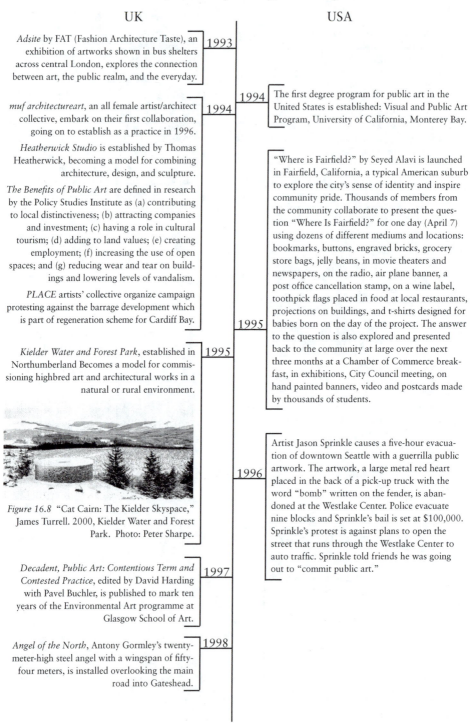

Figure 16.8 "Cat Cairn: The Kielder Skyspace," James Turrell. 2000, Kielder Water and Forest Park. Photo: Peter Sharpe.

1996 — Artist Jason Sprinkle causes a five-hour evacuation of downtown Seattle with a guerrilla public artwork. The artwork, a large metal red heart placed in the back of a pick-up truck with the word "bomb" written on the fender, is abandoned at the Westlake Center. Police evacuate nine blocks and Sprinkle's bail is set at $100,000. Sprinkle's protest is against plans to open the street that runs through the Westlake Center to auto traffic. Sprinkle told friends he was going out to "commit public art."

1997 — *Decadent, Public Art: Contentious Term and Contested Practice*, edited by David Harding with Pavel Buchler, is published to mark ten years of the Environmental Art programme at Glasgow School of Art.

1998 — *Angel of the North*, Antony Gormley's twenty-meter-high steel angel with a wingspan of fifty-four meters, is installed overlooking the main road into Gateshead.

UK

USA

1998

artranspennine98 is organized by Tate Liverpool and Henry Moore Foundation, Leeds. Featuring 40 new projects, this massive exhibition of public works stretched across the Pennine region, from Liverpool in the west to Hull in the East.

1998

Project Row Houses is established in Houston, Texas, on a site of twenty-two abandoned shot gun houses to connect the work of artists with the revitalization of community.

1999

Ecce Homo by Mark Wallinger is the first in a series of sculptures commissioned to fill the empty fourth plinth in Trafalgar Square, London. Initially organized by Fourth Plinth Commissions, becoming the Fourth Plinth Project in 2005.

North London Link, a two-year program of off-site projects working with groups and communities in Camden, is organized by Camden Arts Centre and includes work by Anna Best, Adam Chodzko, and Orla Barry.

Over Easy by Richard Wilson is installed at The Arc, Stockton-on-Tees; its position as integral to the structure of the building rather than being a decorative element makes it a model of fusing art into architecture.

Liverpool Biennial is established becoming a major international contemporary art event, going on to commission many temporary works of art for various locations in the city.

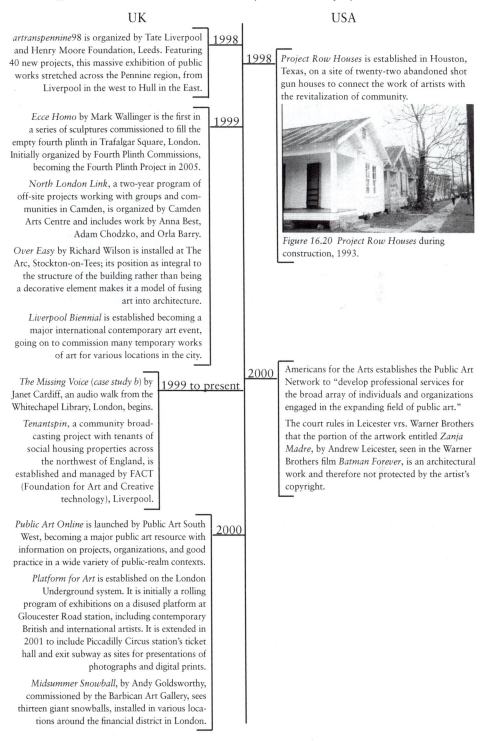

Figure 16.20 Project Row Houses during construction, 1993.

1999 to present

The Missing Voice (*case study b*) by Janet Cardiff, an audio walk from the Whitechapel Library, London, begins.

Tenantspin, a community broadcasting project with tenants of social housing properties across the northwest of England, is established and managed by FACT (Foundation for Art and Creative technology), Liverpool.

2000

Americans for the Arts establishes the Public Art Network to "develop professional services for the broad array of individuals and organizations engaged in the expanding field of public art."

The court rules in Leicester vrs. Warner Brothers that the portion of the artwork entitled *Zanja Madre*, by Andrew Leicester, seen in the Warner Brothers film *Batman Forever*, is an architectural work and therefore not protected by the artist's copyright.

2000

Public Art Online is launched by Public Art South West, becoming a major public art resource with information on projects, organizations, and good practice in a wide variety of public-realm contexts.

Platform for Art is established on the London Underground system. It is initially a rolling program of exhibitions on a disused platform at Gloucester Road station, including contemporary British and international artists. It is extended in 2001 to include Piccadilly Circus station's ticket hall and exit subway as sites for presentations of photographs and digital prints.

Midsummer Snowball, by Andy Goldsworthy, commissioned by the Barbican Art Gallery, sees thirteen giant snowballs, installed in various locations around the financial district in London.

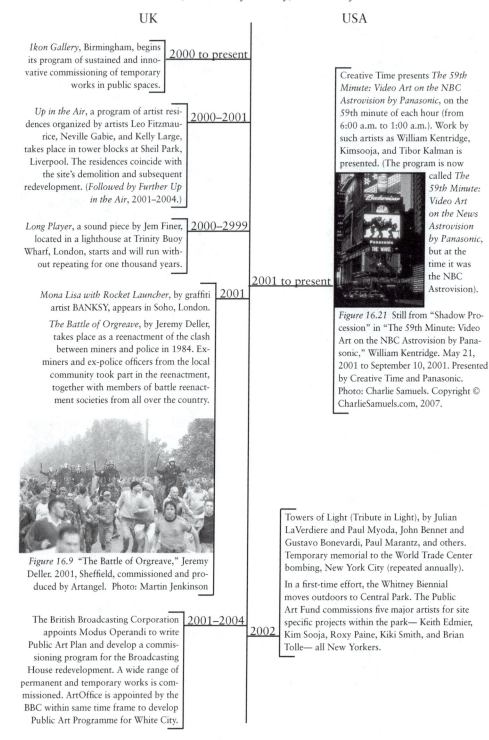

UK | USA

2000 to present

Ikon Gallery, Birmingham, begins its program of sustained and innovative commissioning of temporary works in public spaces.

2000–2001

Up in the Air, a program of artist residences organized by artists Leo Fitzmaurice, Neville Gabie, and Kelly Large, takes place in tower blocks at Sheil Park, Liverpool. The residences coincide with the site's demolition and subsequent redevelopment. (*Followed by Further Up in the Air, 2001–2004.*)

2000–2999

Long Player, a sound piece by Jem Finer, located in a lighthouse at Trinity Buoy Wharf, London, starts and will run without repeating for one thousand years.

2001 to present

Creative Time presents *The 59th Minute: Video Art on the NBC Astrovision by Panasonic*, on the 59th minute of each hour (from 6:00 a.m. to 1:00 a.m.). Work by such artists as William Kentridge, Kimsooja, and Tibor Kalman is presented. (The program is now called *The 59th Minute: Video Art on the News Astrovision by Panasonic*, but at the time it was the NBC Astrovision).

Figure 16.21 Still from "Shadow Procession" in "The 59th Minute: Video Art on the NBC Astrovision by Panasonic," William Kentridge. May 21, 2001 to September 10, 2001. Presented by Creative Time and Panasonic. Photo: Charlie Samuels. Copyright © CharlieSamuels.com, 2007.

2001

Mona Lisa with Rocket Launcher, by graffiti artist BANKSY, appears in Soho, London.

The Battle of Orgreave, by Jeremy Deller, takes place as a reenactment of the clash between miners and police in 1984. Ex-miners and ex-police officers from the local community took part in the reenactment, together with members of battle reenactment societies from all over the country.

Figure 16.9 "The Battle of Orgreave," Jeremy Deller. 2001, Sheffield, commissioned and produced by Artangel. Photo: Martin Jenkinson

2001–2004

The British Broadcasting Corporation appoints Modus Operandi to write Public Art Plan and develop a commissioning program for the Broadcasting House redevelopment. A wide range of permanent and temporary works is commissioned. ArtOffice is appointed by the BBC within same time frame to develop Public Art Programme for White City.

2002

Towers of Light (Tribute in Light), by Julian LaVerdiere and Paul Myoda, John Bennet and Gustavo Bonevardi, Paul Marantz, and others. Temporary memorial to the World Trade Center bombing, New York City (repeated annually).

In a first-time effort, the Whitney Biennial moves outdoors to Central Park. The Public Art Fund commissions five major artists for site specific projects within the park— Keith Edmier, Kim Sooja, Roxy Paine, Kiki Smith, and Brian Tolle— all New Yorkers.

UK

USA

Sustainable Communities Plan is launched by the Blair government, recommending that "the key requirements of sustainable communities include a sense of place," listing public art among the factors which can contribute to local distinctiveness. | **2003**

artstranspennine03, curated by Nick Crowe and Ian Rawlison, hijacks the *artstanspennine98* brand and invites artists to create a trail of public art across the Pennines, operating on a budget of £503 as opposed to the reported £3 million budget of the original event.

European City of Culture for 2008 awarded to Liverpool.

Poole Streetscape Manual is devised to provide a detailed design strategy for the spaces between buildings, pavements, roads, and public spaces within the town's regeneration area; artists on the design team include Vong Phaophanit and Claire Oboussier. | **2003–2004**

ixia (formerly Public Art Forum) is established in Birmingham, as a think tank and research organization for Public Art, funded by Arts Council. | **2004**

2005 | *Cloud Gate* (often referred to as "The Bean"), by Anish Kapoor, is installed at Millennium Park, Chicago.

My Mummy was Beautiful, Yoko Ono's contribution to the Liverpool Biennial, sees the city flooded with photographic images of a naked breast and vulva, causing widespread controversy. One banner at St. Luke's church is removed, but organizers insist that this is to replace a damaged banner elsewhere and is not in reaction to calls for its removal.

Gates, by Christo and Jeanne-Claude, is installed in Central Park, New York City. Development of the project began in 1979; permission for the project was received in 2003. From February 12 to 27, fabric panels measuring 7 feet in length hung from 7,500 gates creating a saffron-colored "river" throughout the park.

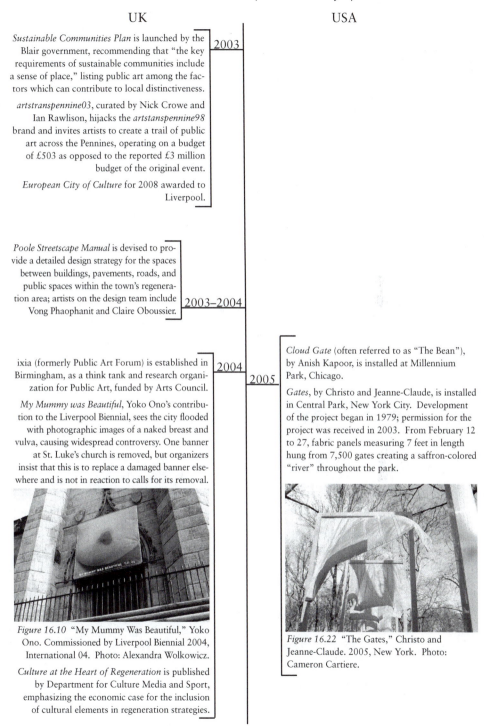

Figure 16.10 "My Mummy Was Beautiful," Yoko Ono. Commissioned by Liverpool Biennial 2004, International 04. Photo: Alexandra Wolkowicz.

Culture at the Heart of Regeneration is published by Department for Culture Media and Sport, emphasizing the economic case for the inclusion of cultural elements in regeneration strategies.

Figure 16.22 "The Gates," Christo and Jeanne-Claude. 2005, New York. Photo: Cameron Cartiere.

UK USA

2005

Research for Arts Council England, London by Bridget Sawyer Ltd., on London local authority Public Art Strategies including Percent-for-Art policies, indicates only twelve out of thirty-two London Boroughs have Percent-for-Art policies.

Remember Ken Saro-Wiwa Living Memorial, taking the form of a steel bus made by Sokari Douglas Camp, tours various locations around the United Kingdom, becoming Britain's first mobile memorial.

Alison Lapper Pregnant, Marc Quinn's eleven-foot, six-inch white marble carving of a disabled woman, eight months pregnant, is installed on the fourth plinth in Trafalgar Square, London, in contrast to the military heroes on the other plinths. This temporary work is used as one of the sculptures bookending *The Sculpture 100*, a film which surveys one hundred years of public sculpture in England.

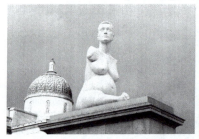

Figure 16.11 "Alison Lapper Pregnant," Marc Quinn. (2005), Trafalgar Square, London. Photo: Anthony Carr.

Bibliography

Bachelard, G. *The Poetics of Space*. Boston: Beacon Press, 1994.

Beardsley, J. *Earthworks and Beyond: Contemporary Art in the Landscape*. New York: Abbeyville Press, 1989.

Bennett, S., and J. Butler, eds. *Locality, Regeneration & Divers[c]ities*. Bristol: Intellect Books, 2000.

Clifford, S., and A. King,. eds. *From Place to PLACE: Maps and Parish Maps*. London: Common Ground, 1996.

Clifford, S., and A. King, eds. *Local Distinctiveness: Place, Particularity and Identity*. London: Common Ground, 1993.

Coles, A. . *Site-Specificity: The Ethnographic Turn*. London: Black Dog, 1999.

Cork, R. *A Place for Art*. London: Cornerhouse Publications, 1993.

Crabtree, A. *Public Art, Art and Design*, Art and Design Profile, Jan/Feb, 1996.

Dee, J., *A Place for Art*. Sunderland: AN Publications, 1988.

Deutsch, Rosalyn. *Evictions: At and Spatial Politics*. Cambridge, MA: Graham Foundation, MIT Press, 1996.

Doss, E. *Spirit Poles and Flying Pigs: Public Art and Cultural Democracy in America*. Washington: Smithsonian Institute Press, 1995.

Easterling, K. *Organization Space: Landscapes, Highways, and Houses in America*. Cambridge, MA: MIT Press, 1999.

Felshin, N., ed. *But is it Art? The Spirit of Art as Activism*. Seattle: Bay Press, 1995.

Finkelpearl, T. *Dialogues in Public Art*. Cambridge, MA: MIT Press, 2000.

Fleming, R.L., and R. von Tscharner. *Placemakers: Creating Public Art That Tells You Where You Are*. Boston: Harcourt Brace Jovanovich, 1987.

Foster, H. *RECODINGS: Art, Spectacle, Cultural Politics*. New York: The New Press, 1985.

Gablik, S. *Conversations Before the End of Time*. New York: Thames and Hudson, 1995.

Harding, D., ed. *Decadent Public Art: Contentious Term and Contested Practice*. Glasgow: Foulis Press, 1997.

Harris, S.P. , ed. *Insights / On sites: Perspectives on Art in Public Places*. Washington: Partners for Liveable Places, 1984.

Heath, J., ed. *The Furnished Landscape: Applied Art in Public Places*. London: Bellow, 1992.

inSITE94. *A Binational Exhibition of Installation and Site-Specific Art*. San Diego/Tijuana, 1994.

Jacob, M.J., curator. *Places with a Past: New Site Specific Art at Charleston's Spoleto Festival*. New York, 1991.

Jacob, M.J., organiser. *Culture in Action*. Seattle: Bay Press, 1995.

Jacob, M.J., and M. Brenson, eds, *Conversations at the Castle: Changing Audiences and Contemporary Art*. Cambridge, MA: MIT Press, 1998.

Jones, S. , ed. *Art in Public*. Sunderland: AN Publications, 1992.

Kaster, J., ed. *Land and Environmental Art*. London: Phaidon, 1998.

Knabb, K., ed. *Situationist International Anthology*. Berkeley, CA: Bureau of Public Secrets, 1989.

Kwon, M. *One Place After Another: Site Specific Art and Locational Identity*. Cambridge, MA: MIT Press, 2002.

Lacy, S., ed. *Mapping the Terrain: New Genre Public Art*. Seattle: Bay Press, 1995.

Levinson, Sanford. *Written in Stone: Public Monuments in Changing Societies*. Durham, NC and London: Duke University Press, 1998.

Lippard, L.R. *Lure of the Local: Senses of Place in a Multicentered Society*. New York: The New Press, 1997.

Lippard, L.R. *Overlay: Contemporary Art and the Art of Prehistory*. New York: Pantheon Books, 1983.

Malpas, W. *Land Art in Close-up*. New York: Crescent Moon, 2000.

Matilsky, B. *Fragile Ecologies: Contemporary Artists' Interpretations and Solutions*. New York: Rizzoli, 1992.

Matzner, F., ed. *Public Art: A Reader*. Ostfildern-Ruit: Hatje Cantz, 2001.

Miles, M. *Art, Space and the City: Public Art and Urban Futures*. London: Routledge, 1997.

Miles, M., and T. Hall, eds. *Interventions: Advances in Art and Urban Futures, Volume 4.*, Bristol: Intellect Books, 2005.

Miles, M., and N. Kirkham, eds. *Cultures and Settlements*. Bristol: Intellect Books, 2003.

Mitchell, W.J.T., ed. *Art and the Public Sphere*. Chicago: University of Chicago Press, 1992.

Oakes, B., ed. *Sculpting with the Environment—A Natural Dialogue*. New York: Van Nostrand Reinhold, 1995.

Peltson, Ruth A., ed. *Creative Time: The Book, 33 Years of Public Art in NYC*. New York: Princeton Architecture Press, 2007.

Public Arts Commissions Agency. *Public:Art:Space*. London: Merrell Holberton, 1998.

Raven, A. *Art in the Public Interest*. New York: Da Capo Press, 1993.

Rogoff, I. *Terra Infirma: Geography's Visual Culture*. London: Routledge, 2000.

Rugg, J., and D. Hinchcliffe, eds. *Advances in Art and Urban Futures, Volume 2: Recoveries and Reclamations*. Bristol: Intellect Books, 2003.

Selwood, S. *The Benefits of Public Art: The Polemics of Permanent Art in Pubic Places*. London: Policy Studies Institute, 1995.

Senie, H.F., and S. Webster, eds. *Critical Issues in Public Art: Content, Context and Controversy*. New York: Harper Collins, 1992.

Senie, H.F. *Contemporary Public Sculpture: Tradition, Transformation, and Controversy*. Oxford: Oxford University Press, 1992.

Sonfist, A., ed. *Art in the Land: A Critical Anthology of Environmental Art*. New York: Dutton, 1983.

Suderburg, E., ed. *Space, Site, Intervention: Situating Installation Art*. Minneapolis: University of Minnesota Press, 2000.

Yngvason, H., ed. *Conservation and Maintenance of Contemporary Public Art*. Cambridge, MA: Archetype Publications Ltd, 2002.

Contributors

Margaret Adamek serves as the Special Projects Director at the Center for Urban and Regional Affairs, University of Minnesota. She co-directs the Northern Lights Leadership for Institutional Change initiative and a national research initiative on higher education reform in the land grant university system. Her interests include systems and social change; integration of multicultural philosophies as the basis for institutional transformation; and linkages between food, behavior, and the environment. She is the co-editor of *Engaging Campus and Communities: The Practice of Public Scholarship in the American Land Grant University System.*

Faye Carey was a principle lecturer at Chelsea College of Art and Design in London. She was the course director for the B.A. program in design for the environment and for the M.A. program in the same department. Faye has written extensively on public art issues, particularly in relation to public art and education. She is also a practicing psychotherapist.

Cameron Cartiere is a lecturer at Birkbeck College, University of London and is the M.A. course director for the department of Arts Policy & Management. She has lectured extensively on public art issues and contemporary art practice and is the co-author of *The Manifesto of Possibilities*, a guide for the commissioning of public art in urban environments. She developed the project "Building Cultures: Art and OUR City"—a series of discussions examining the role of public art in community engagement and regeneration, and activism in public art. Current research includes the project "Art in Transit: Public Art on the Move," investigating the development and impact of public art in areas of transportation.

Kristin Calhoun has been managing public art projects in Portland, Oregon, for over 15 years. Most recently, her work has focused on libraries, youth facilities, and a large correctional facility. Temporary

public art is a passion for her, having founded the in situ PORTLAND program for the Regional Arts & Culture Council.

Terri Cohn is a writer, curator, and art historian, and considers these facets of her career to be intertwined through her research and writings in the areas of conceptual art, gender, social sculpture, and new genre public art practices. She is the author of hundreds of essays, interviews, reviews, and catalog essays, and has been a contributing editor to *Artweek* for almost two decades. She is a Faculty Lecturer at the San Francisco Art Institute, and teaches modern and contemporary art seminars for the University of California, Berkeley, Extension.

Regina M. Flanagan is an artist and landscape designer living in Saint Paul, Minnesota, who writes about the intersection of public art, urban design, new technologies, and social concerns for *Landscape Architecture*, *Public Art Review*, and *Fabric Architecture*. She holds an M.A. and B.S. in Fine Art from the University of Wisconsin-Madison. From 1981 to 1998, Flanagan directed state government public art programs in Wisconsin and Minnesota, completing over 130 projects, and has authored numerous public art plans and studies. In 2001 she received an M. A. in landscape architecture from the University of Minnesota College of Design, and established Art • Landscape • Design, an umbrella for freelance endeavors including landscape design, teaching, and fine art photography.

Stephanie Anne Johnson is the Coordinator of the Institute of Visual & Public Art and has taught in the Visual and Public Art department at California State University, Monterey Bay, since the opening of the campus in 1994. She holds degrees from Emerson College, Boston, (B.F.A. in theater), San Francisco State University (M.A. in interdisciplinary studies), and the University of California at Berkeley (M.F.A. in art). For her mixed-media sculptures and installations, Johnson has been the recipient of grants, fellowships, and commissions from the National Endowment for the Arts, the Wallace Gerbode Foundation, the Margaret Calder Hayes Foundation, the Atlanta Arts Festival, the M.H. de Young Museum, and the City of Oakland: Public Arts Division.

Peggy Kendellen is a public art manager with the Regional Arts & Culture Council in Portland, Oregon. She manages an artist-in-residence program, public art projects for site-specific work, and the Visual Chronicle of Portland, a collection of works on paper. She has a B. A. and M. A. in art from University of Wisconsin-Milwaukee and received a Midwest Artists Fellowship from the National Endowment for the Arts in 1990.

Suzanne Lacy is an internationally known artist whose work includes installations, video, and large-scale performances on social themes and urban issues. Also known for her writing, Lacy edited the influential *Mapping the Terrain: New Genre Public Art* (Bay Press, 1995), a book that prefigures current writing on politically relevant performance art. She has published over 60 articles on public art. Lacy is the Chair of Fine Arts at Otis College of Art and Design in Los Angeles. In 1996–1997 she co-founded the Visual and Public Art Institute at California State University at Monterey Bay with artist Judith Baca.

Karl Lorenz is a public artist whose art practice is structured around the use of sculpture, mixed media, and photographic imagery in creative collaboration with local communities. Lorenz's commitment to public art centers around the notion of "artist as civic practitioner," where art becomes a tool for social change through cultural creation in partnership with communities. He holds a B.F.A. from Minneapolis College of Art and Design and has pursued graduate coursework in environmental ethics, aesthetics, and philosophy. Past commissions include the University of Minnesota, North and South Dakota State Universities, and national collaborations with the W.K. Kellogg Foundation and other institutions of higher education.

Malcolm Miles is the author of *Art, Space and the City* (Routledge, 1997) and *Urban Avant-Gardes* (Routledge, 2004), and co-editor of *The City Cultures Reader* (Routledge, 2000, 2nd revised edition, 2003).

Carrie Moyer is a New York-based painter and one half of the public art project, Dyke Action Machine! (DAM!). Her work has been widely exhibited and reviewed in both the US and Europe. Most recently her work was featured in "8 Painters: New Work," *Art in America*, November 2003. In 2004, her paintings were seen in "Two Women: Carrie Moyer and Sheila Pepe" at the Palm Beach Institute for Contemporary Art and "About Painting," a painting biennial at Tang Teaching Museum, Skidmore College. Moyer teaches at the Mason Gross School of the Arts, Rutgers University, and Queens College.

PLATFORM has been described as many things—an arts group, a forum for political dialogue, an environmental campaign—but in essence it is an idea, a vision of using creativity to transform the society we live in; a belief in every individual's innate power to contribute to this process. Since 1983 PLATFORM has established itself as one of Europe's leading exponents of social practice art, combining the talents of artists, social scientists, activists and environmentalists to work across disciplines on issues of social and environmental justice. PLATFORM works in London

and the Thames Valley, but its methodologies and strategies travel far beyond Britain's capital.

Jane Rendell is Reader in Architecture and Art and Director of Architectural Research at the Bartlett, University College London. An architectural designer and historian, art critic and writer, she is author of *The Pursuit of Pleasure* (Athlone Press, 2001), editor of "A Place Between," *Public Art Journal* (October 1999) and co-editor of *Strangely Familiar* (Routledge, 1995), *Gender Space Architecture* (Routledge, 1999), *Intersections* (Routledge, 2000), and *The Unknown City* (MIT Press, 2000). She is currently completing a new book for Reaktion Press, *From Art to Architecture*, and working on a project of site-specific writings.

Shelly Willis managed the University of Minnesota public art program from 1999 to 2004, including the development of temporary and permanent public art on campus throughout the university system. She taught in the Urban Studies Department and the College of Architecture and Landscape Architecture at the university and developed the curriculum for a public art minor. Willis came to Minnesota in October, 1999, after 10 years managing visual arts programming for the City of Fairfield, California. She founded and directed the city gallery and the city's public art program, with an emphasis on exploring community identity through temporary and permanent public artworks and exhibitions. Willis is a past president of FORECAST, Public Artworks, a St. Paul nonprofit organization that publishes *Public Art Review*, and supports and advocates for public art nationally. She is now the director of the city of Sacramento Art in Public Places Program.

Index